Looking at Art from the Inside Out: The Psychoiconographic Approach to Modern Art highlights the role played by the psychological world of the artist in shaping the subject matter and form of art works. Analyzing masterpieces by Manet, Gauguin, Magritte, and Picasso, Mary Mathews Gedo, who is trained in both art history and clinical psychology, details how the creative process can transform the artist's inner world into public statements meaningful for a broad audience. Demonstrating how biological predispositions, familial relationships, and childhood experiences of future artists play a pivotal role in shaping their careers, she merges formal, iconographic, and psychobiographical elements to provide unique insights into their oeuvres. Gedo's approach also restores to the artist his or her place at the center of art history and critical inquiry.

LOOKING AT ART FROM THE INSIDE OUT

CONTEMPORARY ARTISTS AND THEIR CRITICS

General Editor
DONALD KUSPIT
State University of New York, Stony Brook

Advisory Board

MATTHEW BAIGELL, Rutgers University
DIANE KELDER, The College of Staten Island and the
Graduate Center, CUNY
ANN GIBSON, State University of New York, Stony Brook
SUSAN DELAHARTE, Museum of Contemporary Art, Houston
UDO KULTURMAN, Washington University
CHARLES MILLER, *Artforum*

This series presents a broad range of writings on contemporary art by
some of the most astute critics at work today. Combining the methods of
art criticism and art history, their essays, published here in anthologized
form, are at once scholarly and timely, analytic and evaluative, a record
and critique of art events. Books in this series are on the "cutting edge"
of thinking about contemporary art. Deliberately pluralistic, the series
represents a wide variety of approaches. Collectively, books published
in this series will deal with the complexity of contemporary art from a
broad perspective, in terms of both point of view and writing.

Other books in the series

Building-Art, by Joseph Masheck
*The Exile's Return: Toward a Redefinition of Painting for the Post-
Modern Era,* by Thomas McEvilley
Signs of Psyche in Modern and Postmodern Art, by Donald Kuspit

LOOKING AT ART FROM THE INSIDE OUT

The Psychoiconographic Approach to Modern Art

MARY MATHEWS GEDO

CAMBRIDGE
UNIVERSITY PRESS

Published by the Press Syndicate of the University of Cambridge
The Pitt Building, Trumpington Street, Cambridge CB2 1RP
40 West 20th Street, New York, NY 10011-4211, USA
10 Stamford Road, Oakleigh, Melbourne 3166, Australia

First published 1994

Printed in the United States of America

Library of Congress Cataloging-in-Publication Data
Gedo, Mary Mathews.
Looking at art from the inside out : the psychoiconographic approach
to modern art / Mary Mathews Gedo.
p. cm. – (Contemporary artists and their critics)
The essays on Picasso are reprinted with minor revisions.
ISBN 0-521-43407-6. – ISBN 0-521-43567-6 (pbk.)
1. Psychoanalysis and art – France. 2. Painting, French.
3. Painting, Modern – 19th century – France. 4. Painting, Modern – 20th century – France.
5. Painters – France – Psychology. 6. Picasso, Pablo, 1881–1973 – Psychology.
I. Title. II. Series.
ND1158.P74G43 1994
759.06 – dc20 93-46635
CIP

A catalog record for this book is available from the British Library

ISBN 0-521-43407-6 hardback
ISBN 0-521-43567-6 paperback

*To my two principal dissertation advisors: the late
James D. Breckenridge, who died too young, and
G. Haydn Huntley, who has survived to enjoy the happy
old age he richly deserves.*

Contents

Illustrations

Preface

WHEN I completed my doctoral studies in art history more than twenty years ago, formalism still reigned supreme, and my psychoanalytically oriented dissertation, "Picasso's Self-Image," represented a radical departure from accepted scholarly practice. By contrast, in today's postmodernist art world, multiple interpretive approaches have become the norm, and psychoanalytic references a staple feature of "art-writing."[1] Such references occur in permutations ranging from more traditional "applied analytic" approaches to purely literary allusions, while the authorities cited reflect a corresponding range, from the writings of such seminal figures as Freud and Jung, to invocations of such leading lights of recent French psychoanalysis as Lacan and Kristeva.

My own adaptation of applied analysis – the method I have dubbed "psychoiconography" – reflects the fact that, unlike most art historians, I came to the discipline in midlife, following an earlier incarnation as a practicing psychologist who had specialized in testing and treating children and adolescents. Thus, rather than initially being grounded in the humanities, my education had been primarily in the biological and social sciences, with their emphasis on empirical research and scientific validation. Although I have been immersed in art-historical work for nearly thirty years, my methodology continues to be deeply imprinted by my original training and experience. My own clinical observations, reinforced by the teaching and example of the instructors I found most helpful, long ago convinced me of the validity and usefulness of Freudian psychoanalytic methods, as these have been refined and expanded by modern practitioners. The contemporary analytic authority with whom I have had the most extensive contact is, of course, my husband, John E. Gedo, who has published widely on the visual arts in addition to making contributions to the evolution of modern psychoanalytic theory. Our dis-

cussions about artistic creativity have inevitably modified and enriched the attitudes of both participants in this ongoing dialogue, now in its fortieth year.

My conviction that artists' biological predispositions, familial relationships, and childhood experiences play pivotal roles in shaping their adult careers represents the fundamental tenet of my method. My confidence in the validity of this approach has been reinforced by contemporary scientific research into brain development and its relationship to personality.[2] This research has uncovered abundant evidence demonstrating that experiences that occur during the first twelve years of life play key roles in forming the adult mind – and personality. Especially dramatic or violent events – such as the devastating earthquake Pablo Picasso witnessed as a child of 3 – are indelibly imprinted on the brain, exerting a disproportionate influence in shaping – or scarring – the mature individual.

Despite my long-standing conviction that the roots of artistic creativity are intimately linked to the artist's personal past, I recognize that no single viewpoint – including the psychoanalytic one – can do justice to the complex meanings encoded in works of art. The critique of T. J. Clark's Marxist interpretation of Manet's *A Bar at the Folies-Bergère* set forth in Chapter 1 of this book should not be regarded as an attempt to minimize or depreciate the impact the artist's cultural and socioeconomic milieu exerted on his production. To the contrary, I recognize that all of us – art historians, as well as artists and their public – inevitably belong to our own time and culture and reflect the viewpoint of the world in which we live.

Nonetheless, socioeconomic interpretations of the Clarkian variety invariably fail to account for the numerous individual differences observable in the output of contemporary artists from similar backgrounds. Even when two peers explore virtually identical subject matter, their contrasting compositions reflect the unique character of each person's temperament and attitudes. As Theodore Reff has pointed out, the vision of a young woman seated alone in a café created by Edgar Degas in 1877 seems much more "cynical and unsympathetic" than Manet's rendition of an almost identical motif, painted during the same year.[3] The similarly contrasting representations of women at their toilettes produced by these two artists during the late 1870s provide additional evidence attesting to their differing characters and viewpoints. Degas confronted his naked subjects with the determined objectivity of a clinician, whereas Manet responded wholeheartedly to the sensuous, erotic implications of his theme. The fact that both these men were eldest sons, born just two years apart into haut-bourgeois, Parisian families with similar value systems by no means resulted in their producing homologous oeuvres.

But precisely how does one determine what weight to assign to the individual character and experience of a Manet or Degas, as opposed to influences derived from the zeitgeist? My own solution has been to con-

centrate on artists whose careers have been so extensively documented that I feel comfortable about addressing myself primarily to psychological aspects of the person's creativity as reflected throughout the oeuvre. Ideally, such evidence includes personal correspondence, autobiographical writings, eyewitness accounts, and the like, in addition to complete catalogues raisonnés, biographical studies, and critical analyses reflecting varied philosophical viewpoints. In the absence of such documentation, I adopt other methods. (For example, my investigation into the career of the pioneering Chicago Abstractionist Maniere Dawson focused primarily on traditional art-historical problems involving sources and chronology.) Let me reiterate that my findings should be regarded as complements to other investigative avenues, research that provides glimpses into aspects of the artist's inner world, a world that art historians often tend to ignore or feel incapable of addressing adequately. Convinced that the shoemaker should stick to her last, I attempt to deal from what I believe to be my special strengths: the understanding of human motivation and adaptation that are the legacies of my life experiences and characterological predispositions.

Several years ago I published a methodological essay in which I set forth in some detail the principles and practices that have guided my psychoiconographic inquiries.[4] Rather than devoting the remainder of this Preface to reiterating these principles, I would like to share with the reader the insights into my methods (and myself) that I gained during the course of assembling this volume.

The eight essays comprising this collection are arranged chronologically by artist, an ordering that ironically reverses their dates of composition. Chapters 1 and 2, devoted respectively to Edouard Manet's *Bar at the Folies-Bergère* and Paul Gauguin's *Vision after the Sermon*, constitute my most recent work (1991–2) and appear here in print for the first time. Indeed, the article about Manet was completed just before this manuscript went to press.

Chapters 3–6, originally written between 1979 and 1985, focus on four key paintings by Pablo Picasso: *La Vie, The Old Guitarist, Les Demoiselles d'Avignon,* and *Guernica.* The last two chapters, which explore the career of René Magritte, date from the latter half of the 1980s.

With the exception of passages in the essay on *La Vie* that seemed in retrospect singularly opaque, demanding stylistic revision, the Picasso pieces have been reprinted with only minor alterations designed to eliminate duplicate information, or to include new biographical data that has come to light since they were originally published.

By contrast, the chapters devoted to Magritte have been more extensively revised to reflect vital new data about his personal and professional history that has recently been published (and continues to appear, as this manuscript goes to press with only the first volume of the five-part catalogue raisonné available). Fortunately, this new information has not only confirmed my previous hypotheses, but has permitted me to docu-

ment and expand my psychoiconographic interpretations of Magritte's oeuvre.

The four Picasso pieces should probably be regarded as postscripts to my 1980 study *Picasso – Art As Autobiography,* providing extended explorations of key works treated more synoptically in that volume. However, even the two earliest of these essays (the interpretations of *Guernica* and the *Demoiselles*) reflect a modification in methodology to which I have adhered ever since: They eliminate virtually all the references to current psychoanalytic theory or philosophical debates found in my book-length study. With the passage of time, I have become increasingly confident about presenting my interpretations in nontechnical language, grounding them exclusively in the available visual and biographical evidence, rather than involving myself in discussions of contemporary psychoanalytic issues. The ongoing controversies engaging various analytic schools operate at levels of abstraction that do not seem relevant for psychoiconography as I practice it. At the more concrete level of operation involved in my interpretations, analytic consensus reigns; the fact that I work inductively and concretely, building toward my conclusions in discrete steps, permits me to bypass such issues – and I have elected to do so.

Except for this modification, my procedures have changed relatively little over the years. When the material is available, I exploit the evidence that can be gleaned from extant preparatory drawings or x-radiographic studies; these data not only provide clues about the formal evolution of the work, but may reveal rare glimpses into the unconscious significance of a composition for its creator.

I have been equally concerned with elucidating the psychological impact of chronic diseases or physical disabilities that sap the artist's energy and may even drastically shorten his lifespan – problems that scholars often ignore, despite their profound implications for creativity.[5] Convinced that these questions must be addressed, I have relied on medical consultants to help me explore the nature and effects of such disabilities as the neurological disease that indirectly led to Manet's premature death at age 51.[6]

Although I was apprehensive that the collaborative effort on which artist William Darr and I engaged (an unique experience in the career of both authors) might require significant changes from my usual procedures, this happily proved not to be the case. The harmonious relationship that prevailed between Darr and myself throughout our joint project reflects not only our shared conception of Gauguin and the role played by *The Vision after the Sermon* in his creative and personal life, but our shared conviction in the validity of the psychoanalytic approach to art and artists.

The most important alteration in my method that has occurred during the thirteen years separating the earliest essay in this volume from the latest might more accurately be described as attitudinal, rather than pro-

cedural. Early on, I practiced my psychoiconographic method more intuitively than programmatically, and had never fully articulated how I went about it until the editor of a psychoanalytic journal asked me to contribute an essay describing my use of empathy to develop psychoiconographic portraits of artists.[7] This query brought me up short, forcing me to define my methods more precisely and to examine my attitudes more rigorously. Certainly an ability to empathize with an artist – to identify with, yet maintain a critical distance from my subject – seems central to my method. Problems growing out of the art historian's overresponsiveness to – or reactions against – his or her "special" artist probably affect scholarly research far more often than we realize.[8] Although such blind spots skew the results of even the most traditional art-historical studies, they can prove fatal to attempts to probe the psychological determinants of creativity. I try to guard against this difficulty by monitoring my personal responses to the artist under consideration throughout my investigation, and by repeatedly checking my hypotheses with my "in-house" consultant – who is quite alert to any tendency on my part to become too sympathetic or too severe vis-à-vis my subject.

The effort constantly to analyze my attitudes and procedures has made me increasingly sensitive to the role my personal predilections play in my work, and I should like to close this introduction by offering brief examples illustrating the role of these factors in determining my selection of themes and artists. The observant reader will not fail to perceive that, with the exception of Chapter 2 (which discusses the birth of Gauguin's Symbolist style), the essays selected for this volume all focus on art produced as the artist confronted his own mortality, or dealt with the loss of a loved one, particularly a primary family member. Moreover, this selection is quite representative of my work as a whole: I have been preoccupied with such issues throughout my art-historical career.

An artist friend of mine insists that all art is about death. Although that observation undoubtedly involves hyperbole, apprehensions about death, and the longing for immortality, have certainly played preeminent roles in art making from time immemorial. My own interest in the relationship between mourning and creativity is not the bitter fruit of tragic personal experiences comparable to those suffered by the artists featured in this book. Unlike Manet, I have always enjoyed good health; unlike Magritte and Picasso, I lost neither a parent nor a sibling during childhood, and I have been equally fortunate in my adult life: My husband and three sons are alive and well.[9] My preoccupation with mortality motifs can be attributed in part to my earlier professional experiences as a clinical psychologist; the relationship between mourning and creativity has long intrigued psychoanalysts, giving rise to a sizable bibliography devoted to this topic in the analytic literature. However, it would be disingenuous to pretend that my fascination with this topic does not stem from personal, as well as professional, sources. This confession will hardly surprise the reader, alerted by my attribution of my second career

as art historian to a "midlife reincarnation." Midlife is traditionally a time for taking stock, for confronting the inevitability of one's mortality, and these concerns have undoubtedly played their role in shaping my predilection for themes dealing with "dark death."

My self-scrutiny has also made me aware that my responsiveness differs not only from artist to artist, but may even affect my attitude toward different works by the same individual.[10] In order to avoid what psychoanalysts would include under the rubric of "transference problems," I have always concentrated my research on artists toward whom I could maintain the positively toned objectivity I regard as a prerequisite to the successful application of psychoiconography. My tendency to overreact to Paul Gauguin, whose callous treatment of his friends and family impressed me as morally irresponsible, long rendered him "off limits" to my approach, despite the personalized implications of his production. The opportunity to immerse myself in his oeuvre provided by the enormous Gauguin retrospective of 1988–9 (which remained on view here in Chicago for nearly three months) constituted a corrective experience from which I emerged with greater respect for Gauguin's professional achievements and personal qualities – and an enhanced ability to consider his work with the requisite objectivity. Having conquered my attitudinal problem, I look forward to devoting additional time to fleshing out the psychoiconographic exploration of Gauguin's art and life presented in Chapter 2.

In closing, I would like to thank Donald Kuspit for inviting me to represent the psychoanalytic approach to art and artists in the series he has organized to exemplify the varieties of art criticism prevalent today. My participation has provided an unexpected bonus: the opportunity to acquire new perspectives on myself and my methods. I hope that these insights will enhance the range and validity of my further endeavors to look at art from the inside out.

Acknowledgments

THE essays included in this volume span fifteen years and reflect the input of numerous consultants, colleagues, and friends who helped me along the way. I am grateful to the two experts who contributed so much to my understanding of Edouard Manet's *A Bar at the Folies-Bergère* (the subject of Chapter 1): Dr. Allan M. Burke, who shared his diagnostic acumen and knowledge of the history of diseases of the nervous system, and Prof. William Conger, artist and chair of the Department of Art Theory and Practice at Northwestern University, who lent his artistic skill and unusual mastery of the laws of perspective to the project.

Special thanks also to Timothy Lennon, Conservator of Paintings at the Art Institute of Chicago, who spent long hours pondering and discussing with me the composite x-radiographs of Picasso's *La Vie* and *The Old Guitarist* (the foci of Chapters 3 and 4).

I am especially grateful to Dr. Abraham M. Hammacher, renowned Belgian art historian and author, for his extraordinary kindness and patience in searching out answers to the many psychologically oriented problems in Magritte I posed to him. He not only shared his own professional and personal knowledge of the artist with me, but undertook lengthy interviews with important "Magritte survivors," most notably the artist's widow (who died not long afterward) and his closest friend, the late Belgian Surrealist writer, Louis Scutenaire, and his wife, Irène Hamoir.

My gratitude also to Terry Ann R. Neff, author, editor, and friend, who not only invented the book's title, but offered many constructive suggestions about its contents. Another friend, Eva Masur, acted as a kind of volunteer research assistant, performing myriad services with skill and enthusiasm. She saved me much time and energy, as did the staff of the

Ryerson/Burnham Library of the Art Institute of Chicago. I owe special thanks not only to its director, Jack Brown, but to Susan Perry, Alexis Petroff, and, above all, to Maureen Lesko, reference librarian par excellence and gracious purveyor of a thousand facts. At Cambridge University Press, I was most fortunate to work with Beatrice Rehl and Michael Gnat, whose skill and patience I deeply appreciate.

Last, and most important, I owe my profoundest thanks to my husband, Dr. John E. Gedo, who not only served as my psychoanalytic consultant, but who also read every draft of every essay in this volume and made helpful suggestions that improved their style and content.

1

Final Reflections
A Bar at the Folies-Bergère *as Manet's Adieu to Art and Life*

Introduction

GODDESS? Prostitute? Icon of modern Paris? Symbol of underclass alienation?[1] These are but a few of the varied symbolic roles contemporary scholars have assigned to Suzon, the beautiful barmaid of Edouard Manet's *A Bar at the Folies-Bergère* (1881–2).[2] These disparate interpretations reflect the ambiguity with which the artist endowed his central protagonist, whose dignified mien and melancholy air seem out of keeping with the tawdry surroundings in which she finds herself.

Frontal, pyramidal, centered, the barmaid presides over her station with all the dignity of an ancient priestess preparing to sacrifice before an altar (Fig. 1).[3] Alone among the personages portrayed in the picture, Suzon appears doubled, as both "actual" presence and reflected image, echoed on the background mirror that serves as the screen on which Manet projects the likenesses of the remaining members of his cast of characters. But the barmaid's mirrored self declares her psychological independence from her alter ego, bending forward to greet her customer (the overscaled, top-hatted gentleman whose reflection fills the right corner of the canvas, but whose "physical" counterpart appears nowhere in the painting) with a conviviality totally lacking in the "real" Suzon, who seemingly distances herself from, rather than welcomes, the outside world[4] (see Fig. 14, right-side detail).

That enormous, gilt-framed mirror, filling virtually the entire collapsed space behind the bar, reflects not only customer, barmaid, and countertop (the latter also represented with numerous arbitrary deviations from its "actual" prototype), but a broad segment of the music hall's interior. Beneath glittering chandeliers and glowing pilaster lights, we glimpse the fashionably dressed merrymakers who crowd the broad balcony shown opposite the bar, uniformly ignoring the performance of the female trapeze artist, whose shapely lower limbs and green-shod feet

1

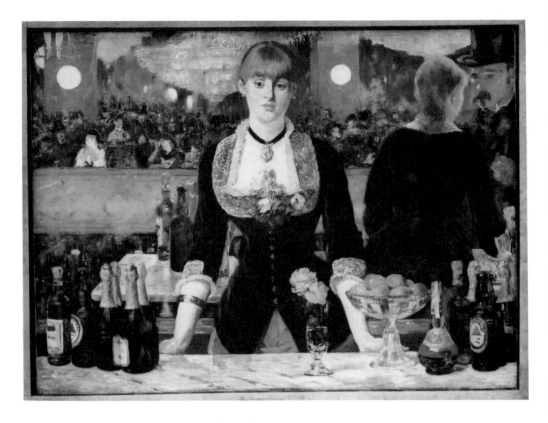

1. Edouard Manet, *A Bar at the Folies-Bergère,* 1881–2. Oil on canvas. Cour-tauld Institute Galleries, London.

appear in the upper-left corner of the mirror (see Fig. 13, left-side detail).

In contrast to the commanding size and presence of the trio at the bar (the waitress, her mirrored image, and that of her customer), the occupants of the balcony, rendered in unnaturally small scale and soft focus, seem more like mirages of the floating world than true reflections. However, the fact that at least three of these figures portray friends of Manet (the artist Gaston La Touche, the demimondaine Méry Laurent, and the actress Jeanne Demarsy) indicates that he treated these seemingly incidental personae with the utmost seriousness. The complex mélange of images reflected in that mirror of unreality behind the bar constitutes a treasure trove of references to the personal and professional life of the artist himself that demand decoding.

The formal and iconographic challenges presented by *A Bar at the Folies-Bergère* have attracted art historians of every stripe, from traditional formalists to radical revisionists, and the painting has generated an enormous – and ever-expanding – bibliography.[5] As David Carrier points out, scholarly interpretations of the "apparent contradictions" implicit

2

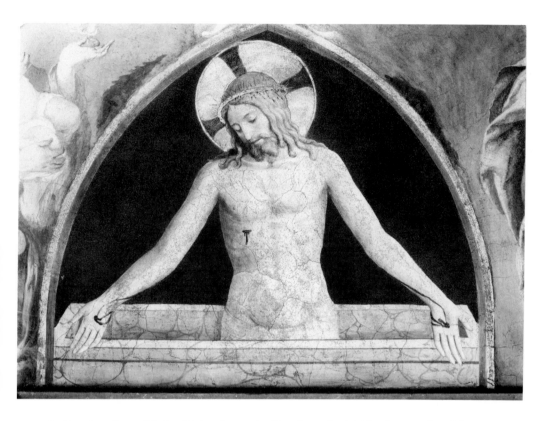

2. Fra Angelico, *Christ Rising from the Tomb,* early 1440s. Fresco, San Marco, Florence. Photo: Alinari / Art Resource.

in the composition regularly conflict with one another, suggesting that "each account imagines an implied artist," and that "every interpretation is partly personal and probably revisable."[6] Perhaps the two most extreme examples of such disparate readings (and implied artists) one might cite involve the radically different identifications of the barmaid proposed by T. J. Clark and Christopher Lloyd, respectively. Clark characterizes the young woman as an alienated, underclass girl, whose bourgeois male customers may assume that she – like the oranges and drinks she peddles – is for sale herself, "and in a sense it is part of her duties to maintain [this] illusion. Doing so is a full-time job."[7] Lloyd, by contrast, identifies the pose of the waitress, who stands with her arms outstretched and her palms resting on the countertop, with fifteenth-century Italian representations of the dead Christ standing in his tomb, stretching out his hands to exhibit his wounds. Lloyd even proposes a specific source for this image: a fresco by Fra Angelico in the monastery of San Marco, Florence (Fig. 2), a site that Manet is known to have visited during his second Italian journey of 1857.[8]

3

Neither scholar relates his interpretation to Manet's personal situation at the time he painted the *Bar.* In Clark's case, this omission reflects his methodological commitment: as a thoroughgoing Marxist-contextualist, he consistently isolates the work "from the personal circumstances that produced it – the artist's self, his cultural background and his aims."[9] Lloyd, perhaps wishing to avoid the ongoing debate over the significance of the *Bar,* refrained from offering any speculation about the implications of the connection he posited, beyond noting that, if valid, it would raise "some interesting questions" about contemporary interpretations of the painting. However, the fact that he specifically cites only Clark's reading of the *Bar* as the "most challenging interpretation" suggests that Lloyd would align himself with scholars opposing the Clarkian viewpoint.[10]

Clark's method is, of course, diametrically opposed to my own, which focuses on the connections between artists' personal motivation and experiences and the oeuvres they create. But nowhere does Clark's insistence on isolating "the dancer from the dance" seem more egregious than in the case of *A Bar at the Folies-Bergère,* the last major painting Manet completed before his premature death at age 51. The magnitude of the artist's achievement seems all the more amazing in view of the fact that, by the time he undertook this work, he was a chronic invalid, suffering from the debilitating effects of a disease of the central nervous system that curtailed his mobility and sapped his endurance.

Even as he struggled to complete the *Bar,* Manet surely must have realized that it would be his final major project, his painted last will and testament. In the light of this fact, Lloyd's proposal that Manet's barmaid derives from Fra Angelico's *Christ Rising from the Tomb* (Fig. 2) seems all the more persuasive. (Parenthetically, I should acknowledge that my conviction about the correctness of Lloyd's analogy is colored by the fact that I had independently come to the same general conclusion as he, although without pinpointing Manet's precise prototype for the figure of Christ.)[11] No evidence has come to light indicating that Manet was consciously aware of the relationship between his barmaid and Fra Angelico's Christ. However, given Manet's well-documented predilection for using figures and motifs borrowed from past art as the basis for provocative contemporary reinterpretations, it seems unlikely that he transliterated the Christ figure unknowingly.

Whether or not he consciously "lifted" his barmaid from Fra Angelico's fresco, it is appropriate to suggest that Manet might have been preoccupied with images and thoughts of death at the time he created *A Bar at the Folies-Bergère.* Doggedly painting away despite his deteriorating health and declining energy, Manet, no longer able to execute while standing at the easel, interspersed brief periods of working in a seated position with longer intervals of rest, stretched out on a couch from which he could study the picture in progress.[12] During the course of its pro-

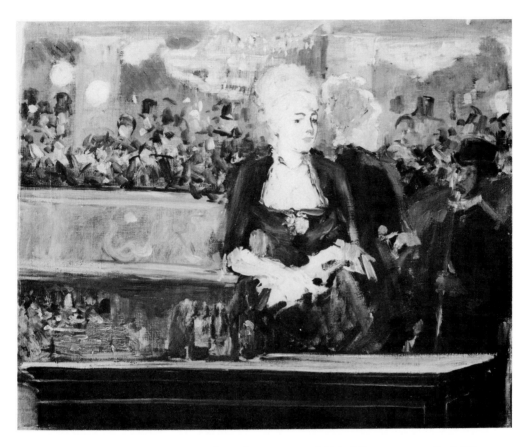

3. Manet, study for *A Bar at the Folies-Bergère,* 1881. Oil on canvas. Stedelijk Museum, Amsterdam, on loan from Ir. F. Koenigs.

tracted evolution, the composition developed from the more realistic conception reflected in the preliminary sketch now in the Stedelijk Museum in Amsterdam (Fig. 3), showing the barmaid as a pert young woman whose image is accurately captured in the mirror behind her, into the definitive painting in the Courtauld Institute, which transforms her into a remote icon, presiding over a world where mirrors no longer reflect the bald facts of objective reality.

Although many Manet scholars have recognized that the character of *A Bar at the Folies-Bergère* reflects its unique status as the artist's final masterpiece, to date no one has explored the implications of this connection in detail, as this essay attempts to do. Before presenting my interpretation of the painting, however, it seems relevant to discuss the history and nature of Manet's illness, as well as its impact on his physical status and personal life, and on the form and content of his art.

Manet's Situation at the Time He Painted the Bar

By the time he began work on *A Bar at the Folies-Bergère,* Manet had been suffering for at least three years from severe symptoms of the progressive neurological illness that would indirectly lead to his death. His plight had become public knowledge during the fall or winter of 1878, when he collapsed as he was leaving his studio one evening, seized with stabbing pains in his lower back and trembling of his lower limbs.[13] But he had been suffering from disquieting sensations long before this dramatic incident. Although he complained of foot problems as early as 1870, the history of his foot ailments had actually begun twenty-one years earlier: While he was a naval cadet, whose ship was moored in Rio de Janeiro, Manet allegedly suffered a snake bite on the (left?) foot that laid him low for two weeks.[14]

By the spring of 1878 (if not before), the artist was suffering from recurring dizzy spells, back pains, severe headaches, transient paralyses of the left leg, and fleeting sensations that the earth was moving, or falling away, beneath him.[15] That summer he returned from a sojourn at the chateau of his patron, Ernest Hoschedé in Montgeron, limping so badly that members of his circle were soon abuzz with speculation about the cause of the mysterious problem affecting Manet's left foot.[16]

Increasingly drained by fatigue, Manet found it more and more difficult to spend long hours standing before his easel; in desperation, he finally consulted his physician, Doctor Siredey. Reluctant to confront his high-strung patient, who led such a frantic existence, with the grave diagnosis that seemed to fit the clinical picture, the physician initially responded to the artist's questions with soothing evasiveness. But all too soon he was forced to share his conclusion with his patient: Manet was suffering from ataxia.[17] To the artist, hearing this news must have been tantamount to receiving a death sentence. His father, Auguste Manet, had also been diagnosed as ataxic, and he had spent the last four years of his life as a partially paralyzed recluse, refusing to receive even his most intimate friends.[18]

But precisely what did the term *ataxia* mean to Manet and his physician? Strictly speaking, ataxia is a descriptive, not a diagnostic, term; it merely refers to the victim's total or partial inability to coordinate bodily movements, but such incoordination can be caused by a variety of degenerative diseases of the central nervous system. Today it is common knowledge that ataxic symptoms may signal the presence of an underlying chronic (or tertiary) neurosyphilitic condition known as locomotor ataxia or, more accurately, *tabes dorsalis.* Typically, this condition does not develop until several years after the victim has been infected, and gestation can last as long as thirty years or more. During this lengthy quiescent period, the syphilitic spirochete invades the victim's spinal cord, where it gradually destroys the sensory pathways connecting the lower limbs to the brain; this causes progressive ataxia, loss of sensibility, shoot-

ing pains in the back and legs, and other unpleasant symptoms. In the late stage of the illness, sufferers, no longer aware of the exact location of their limbs in space, frequently lose their balance and fall. In order to avoid mishaps, victims (who typically require the support of two canes to remain erect) walk with a characteristic wide-based slapping or kicking gait, using visual cues concerning the placement of their feet in space in lieu of their lost spatial sensations.[19]

Aware of Manet's reputation as a ladies' man, and of the ubiquity of syphilitic infections in late-nineteenth-century European populations, a number of contemporary scholars have assumed that the artist suffered from neurosyphilis. I shared this conviction until I consulted Dr. Allan M. Burke, a neurological specialist interested in the arts, who agreed to review Manet's medical history with me.[20] Even the scanty data available soon convinced Dr. Burke that it was imprudent to conclude that Manet had necessarily been tabetic. Neither the artist's overt symptoms nor the course of his illness fit the typical tabetic picture closely enough to allow one to make such a definitive diagnosis. For example, eyewitness accounts of Manet's gait after he was stricken do not correspond to descriptions of the slapping walk characteristic of tabetics; to the contrary, the artist, who used only a single cane, appeared weak and tremulous. Manet's patchy medical history also suggests that he may have experienced partial remissions, periods when he seemed relatively more energetic and mobile. Both the artist's manner of locomotion and his history of remissions seem much more characteristic of multiple sclerosis than of neurosyphilis, which does not follow such an up-and-down course. The fact that Manet was visited by transient symptoms for many years before his illness became clearly manifest also fits the profile of the typical victim of multiple sclerosis.[21] In view of the fact that one cannot rule out the possibility that Manet suffered either from multiple sclerosis or from some rare familial ataxic disorder that affected both the artist and his father, a definitive diagnosis of syphilitic *tabes* seems unwarranted. (Like his son, Manet *père* is now sometimes cavalierly diagnosed as having suffered from neurosyphilis, although we know far less about his malady than that of his son. The artist, who blamed his condition on hereditary "rheumatism," claimed that several members of his family, including his cousin Jules de Jouy, as well as his father, had endured this familial disorder.)[22]

The question of Manet's diagnosis is complicated by the fact that, at the time the artist was stricken, neurologists had not yet definitively established the causal connection between tertiary neurosyphilis and *tabes dorsalis;* their understanding of multiple sclerosis was equally provisional, and even the leading neurological experts of the era would have had great difficulty in differentiating these two conditions.[23] In view of the rudimentary state of medical knowledge that prevailed when Manet was stricken, it seems extremely unlikely that Dr. Siredey could have definitively diagnosed his patient's illness as neurosyphilis, even though Perru-

chot implies that this was the case. However, Siredey surely realized that Manet's symptoms signaled the presence of a progressive, incurable ataxia, and this was probably the intelligence he hesitated to share with his patient.[24]

Whether Manet suffered from syphilis, multiple sclerosis, or some rarer ataxic disease, the precise cause of his death remains a mystery. He certainly did not die from "syphilitic gangrene," as one scholar has suggested – no such condition exists. Gangrene sets in when the blood supply to the affected part is cut off by injury or disease, and the tissue dies off and decays. If Manet actually suffered from *tabes,* it is possible that he injured himself unknowingly, and that the site of the injury became first infected and then gangrenous. But it is equally possible that a drug prescribed by one of the homeopaths the artist consulted – unbeknownst to his doctors – interfered with the circulation in his leg, causing the gangrenous infection that indirectly led to his death.[25]

Manet's Own Diagnosis of His Condition

Whatever the actual etiology and nature of Manet's malady, the artist himself seems to have believed that his condition was the unfortunate legacy of a youthful sexual indiscretion in which he had contracted syphilis.[26] The most compelling evidence for this speculation comes from the setting the artist selected as the site of his painting: the Folies-Bergère itself. By the time Manet depicted the music hall, it had become as celebrated for the prostitutes it attracted as for the spectacles it presented. Whores of every class and type, from elegant demimondaines to lowly streetwalkers, nightly congregated at the theater to solicit business from foreign visitors and local habitués.[27] The avant-garde artists and writers who portrayed the establishment reinforced its unsavory reputation by emphasizing (and perhaps even exaggerating) its role as a magnet for prostitutes – and their customers.[28] That the women who staffed the bars at the nightclub routinely doubled as part-time prostitutes was evidently well known, as is shown in the following excerpt from the extensive description of the Folies-Bergère provided by Guy de Maupassant in his novel *Bel-Ami* (1885), published just three years after Manet painted his celebrated picture:

> In the broad corridor leading to the circular promenade – thronged with gaily dressed prostitutes and men in dark suits – a group of women awaited newcomers in front of one of the three bars, at which sat enthroned three painted and faded vendors of love and liquor. The tall mirrors behind them reflected their backs and the faces of passersby.[29]

That Manet intended to call our attention to the association of the Folies with prostitution is suggested both by his inclusion of the portrait of the two demimondaines – and personal friends – Méry Laurent and

Jeanne Demarsy among the spectators shown in the balcony, and by the character of his portrayal of the barmaid's reflected encounter with her male customer, an interaction widely interpreted as the prelude to an assignation. Far from being peripheral or incidental to his central concern, the references to prostitution play a key role in the psychoiconography of *A Bar at the Folies-Bergère,* albeit one quite different from that of social commentary, as envisioned by T. J. Clark.[30]

Henri Perruchot claims that Manet's alleged syphilitic condition resulted from his initial sexual contact, an encounter with an infected slave he met during the festivities that marked the pre-Lenten Carnival in Rio de Janeiro, where he was briefly stationed in 1849, as a naval cadet just turned 17.[31] Although Pierre Daix dismisses Perruchot's reconstruction, arguing that a Parisian youth of Manet's day would scarcely have needed to travel to Rio to lose his virginity, the important point is not whether the boy had had intercourse previously, but whether he believed that he contracted syphilis from his Brazilian partner.[32] We know from his contemporary letters to his family that Manet did, in fact, pay close attention to Rio's female slave population and found some of them not unattractive.[33] Shortly after his putative sexual initiation, Manet was laid low by an infection that kept him confined to ship's quarters for two weeks. In a letter to his brother Eugène, the future artist attributed his illness to a snake bite suffered during a recent excursion to a Brazilian forest; but in the more detailed description of this expedition he provided in a letter to his cousin, Manet mentioned seeing snakes, but not being bitten. Was he actually poisoned by a snake, or did he experience some more generalized type of bacterial or viral infection, which he mistakenly interpreted as signifying the presence of a venereal disease?[34] This question remains forever unanswerable; one can only conclude that Manet died ignorant of the fact that he probably had multiple sclerosis, convinced, instead – as the psychoiconography of *A Bar at the Folies-Bergère* demonstrates – that he was the victim of a chronic syphilitic infection.

Manet's Premorbid Personality

Like that beautiful creature of his fancy, the barmaid of the Folies-Bergère, who shows one aspect of herself to the public while her reflected alter ego projects a very different personality, Manet kept his private face forever hidden from the world. The debonair, self-confident air he assumed in public masked the more anxious, vulnerable persona that he kept entirely private, just as the barmaid's reflection forever conceals her visage from our view.

Thanks to his mania for privacy and concealment, we know far less about Manet's personal life than about the well-documented histories of such colleagues and friends as Claude Monet, Berthe Morisot, and Camille Pissarro. The data we do possess reflect the success and consistency with which Manet assumed the public role of the flâneur, with a

mannered style of deportment that grew out of the English cult of the dandy, reflecting the Anglomania so prevalent in late-nineteenth-century France.[35]

Although many of the solidly middle-class artists and writers with whom Manet habitually associated shared his commitment to playing the flâneur, no one could enact this role with more suave self-assurance than he. His *haut-bourgeois* breeding, good looks, exquisite grooming, and elegant manners all admirably suited Manet to his chosen part. So all-encompassing was his conception of his role as flâneur that he publicly affected the swaggering gait and drawling accent of a Parisian street urchin, carrying out this enactment in a fashion that subtly called attention to his actual upper-class status.[36] He was also able to bring his unusual perceptual gifts to bear on the flâneur's primary assignment: that of maintaining the keen – yet distanced – observation of types and scenes encountered while stalking the broad boulevards of modern Paris, the preferred hunting grounds for members of this unofficial fraternity.

As celebrated for his attractiveness to women as for his popularity among his male friends, Manet has increasingly been described in the recent literature as a veritable Don Juan, despite the paucity of documentary evidence we possess attesting to his actual sexual behavior.[37] Like most men of his class and period, the artist undoubtedly devoted a good deal of time to socializing with women of charm and talent, if not necessarily unblemished reputations, and his connections with the world of the demimondaine became more accentuated during the final decade of his career, when he depicted a number of these women in his art. Although the speculations that Manet was a philanderer may well be correct, it is probably more prudent to suggest that, whatever the nature of his actual conduct, he certainly enjoyed playing the ladies' man, a part to which he brought the same level of talent and concentration that distinguished his enactment of the flâneur.

By the late 1870s, Manet had become such a celebrated Parisian figure that he was able to transform his studio into a kind of salon, where leading figures from the world of arts and letters congregated every evening after five to mingle with captains of commerce and industry as well as with celebrated courtesans, such as Méry Laurent, an intimate friend and frequent model of Manet's final period. Thanks to the success of these "salons," he was able to maintain a high level of socialization until very late in his illness. The eyewitness account provided by Georges Jeanniot, who visited Manet's studio while he was working on *A Bar at the Folies-Bergère,* revealed that the artist was still entertaining visitors to his atelier on a daily basis as late as January 1882, although by that time the debilitating effects of his condition had become painfully apparent.[38]

But what of the private self that Manet consistently kept hidden from the mirror of the world? The biographical data we possess suggest that this seemingly jaunty narcissist may have been far less self-confident and unconflicted than his public demeanor suggested. The inconsistent atti-

tudes toward art and class, toward liberal versus conservative political positions, reflected in his external behavior constituted symptoms of the artist's profound underlying ambivalence (perhaps even confusion) about his personal and professional goals, as well as the depth of his hunger for admiration and approval. His uncertainty and need for official approbation made it impossible for Manet to emulate the examples of friends like Degas, Monet, and Pissarro and turn his back on the official Salon, with its stifling policies, in favor of participating in the independent exhibitions organized by the Impressionists. Instead, Manet rejected the latter forum and continued to submit to the Salon, ever hopeful that he would some day gain the wholehearted approval of the conservative artists who dominated its juries.

Manet's ambivalence about aligning himself too openly with the artistic avant-garde can probably be explained, in part, by his deep commitment to the class values imbued in him by his *haut-bourgeois* heritage and upbringing, with its stress on traditional standards and time-honored values. His parents, Auguste Manet (1797–1862) and Eugénie-Désirée, née Fournier (1812–85), both came from distinguished families; prior to his illness, his father had enjoyed an illustrious career in the Ministry of Justice and had been made a Chevalier of the Legion of Honor.[39] Perhaps as the eldest son of such a distinguished father, the artist could never abjure his competitive striving to outshine Manet *père*, either by acquiring a symbol of equal distinction in the artistic realm (such as one of the gold medals annually awarded by the Salon jury) or, better still, by earning the right to wear the red ribbon of the Legion of Honor that was his father's proudest attribute.

Manet specialists have typically described the artist's father as a strict, authoritarian figure, a characterization that undoubtedly has some basis in fact. Still, one cannot help but wonder to what extent this vision of Manet *père* has been shaped by the attitude of the artist himself – his unconscious need to view Auguste Manet as a more awesome, severe figure than seems to have been the case in reality.[40]

As various biographers have suggested, Edouard seems to have been his mother's favorite child; she was certainly remarkably indulgent toward him throughout his adult life, and there is no reason to believe that she did not follow the same pattern during his childhood. His marked preoccupation with his physical appearance, his seductive charm with the opposite sex, as well as the pleasure he took in stimulating the jealousy of the women who loved or admired him, all suggest that he might have found special favor in his mother's eyes as the most adorable of her three sons – a privileged relationship he was by no means loathe to exploit.[41] If this reconstruction is accurate, Edouard's timidity vis-à-vis his father would have been related to unconscious fantasies of paternal hostility over having been bested by his son in the competition for the mother's affection. Perhaps, too, Manet's unending quest for official approval echoed childhood experiences in which he had repeatedly tried to win

plaudits from a father whose social conservatism no doubt paralleled the artistic conservatism of the Salon jurors.

Both Manet's penchant for secrecy and his dependence on his mother were reflected in the nature of his relationship with Suzanne Leenhoff. Prior to their marriage in 1863, apparently no one but the artist's mother was aware of Manet's involvement with Mlle Leenhoff, although she had been his mistress for at least twelve years before they legalized their relationship. When Suzanne became pregnant in 1851, his mother colluded with the young artist to conceal this development from the family, as well as from the outside world; presumably, she also helped Edouard meet his increased financial responsibilities by diverting money from the household accounts into her son's pocket.[42] At the time of little Léon-Edouard's birth (January 29, 1852), Suzanne legally acknowledged maternity, assigning paternity to a mysterious M. Koëlla, of whom no record has ever been found. When the child was baptized five years later, with Manet and Mlle Leenhoff serving as his godparents, he was "officially" supplied with a new identity and was subsequently known as Suzanne's youngest brother, Léon Leenhoff.[43] Although Manet assumed full responsibility for the boy's support from the time of his birth and eventually adopted him, he never acknowledged biological paternity, not even to Léon himself – a reaction that has encouraged recent (and, in my opinion, poorly documented) speculations that he was not really the artist's son.[44]

As this brief summary suggests, Manet possessed both an unusual degree of body narcissism and an equally marked penchant for secrecy. These characteristics undoubtedly made it even more difficult for him to cope with the effects of his progressive disability than it would be for the average person. Surely no experience could have been more humiliating for a man of Manet's stripe than to be stricken by a disease that not only caused extreme pain, but visibly marked its victims, whose unsteady gait advertised their handicapped condition to the world.

Despite the restrictions imposed on his behavior by his progressive disability, Manet continued to pretend, not only to others, but to himself, that nothing was seriously amiss. Of course, such a delusion cannot be entertained in a wholehearted way by a nonpsychotic person. This situation led to what psychoanalysts would term a *split*: Manet knew the truth, but he also refused to believe it.[45] This *disavowal* permitted the deluded part of Manet's personality to maintain his creativity until the end of his life, and to avoid a repetition of the creative paralyses that had beset him during earlier professional or personal crises.[46]

Manet's capacity for denial played an equally critical role in shaping his uncooperative attitude toward his medical consultants. Although he reluctantly followed their recommendations that he spend the summer months outside his beloved Paris, resting and undergoing hydrotherapy and massage (then the only approved treatment for such neurological disorders), he regularly sabotaged the efforts of his physicians by seeking

miracle cures from various quacks and ingesting the ineffective, and even dangerous, substances they prescribed. Although, in the presence of outsiders, he succeeded in maintaining his old facade of the jaunty boulevardier, he made the daily existence of his wife and mother hellish by his irritability and downright nastiness. During the prolonged physical and psychological crisis that preceded his death, the underlying ambivalence toward women, which Manet had previously been able to disguise, thus became nakedly apparent.[47]

Even his oldest chum, Antonin Proust, did not escape Manet's abusive tongue.[48] Fortunately, Proust remained loyal, and as soon as he was appointed Minister of Fine Arts in the cabinet of Léon Gambetta in November 1881, he made Manet a Chevalier of the Legion of Honor; thus, the artist finally enjoyed the satisfaction of achieving the same signal honor that had been his father's pride and joy.

During the late stages of Manet's illness, when the walking stick, once no more than an elegant accessory, had become his third and most dependable leg, the artist continued to behave in public as though nothing were wrong. Proust describes how indignant Manet became when, during their visit to a hat shop, the proprietress sympathetically offered the frail artist a chair. He curtly refused: "What do I need a chair for? I'm not an invalid." Once outside the shop, he continued to fume until he succeeded in distracting himself by recalling, for Proust's benefit as well as his own, the charms of a young Parisienne he had spotted the day before on the Pont de l'Europe.[49]

During the last summer of his life, Manet stepped up his campaign to squelch the rumors about his health that were circulating in the press with increasing frequency. He penned the following curt lie to the author of one of these gossip columns: "I am not in the least ill. I simply sprained my foot before leaving Paris. Would you be so kind as to reassure my *numerous friends,* as you call them, as soon as possible?"[50]

The Impact of Manet's Illness on His Oeuvre: His Initial Response

As George Mauner has observed, Manet's self-portraits and self-references prior to his illness had all been covert or indirect, "calling attention to himself in concealed but insistent ways."[51] Prior to 1878–9, when he suddenly painted the only formal self-portraits he ever created, Manet had included depictions of himself in only three works: *La pêche, Music in the Tuileries,* and the *Ball at the Opera* – self-images that all memorialized special moments in the artist's professional and personal life. For example, *La Pêche* (1861–3; Metropolitan Museum of Art, New York), in which Manet represented himself as the reincarnation of Rubens, has been widely interpreted as a betrothal picture, alluding to the artist's impending marriage to Suzanne Leenhoff.[52] Manet underscored the unique importance of the other two canvases in which he included self-images, *Music in the Tuileries* and *Ball at the Opera,* by in-

corporating references to both compositions into the fabric of *A Bar at the Folies-Bergère*. (Their significance will be discussed in conjunction with the interpretation of the latter work.)

Manet's more indirect self-references occasionally involved the substitution of an image of a brother or a brother-in-law for himself; more often, his putative son, Léon Koëlla-Leenhoff, was his doppelgänger of choice, and the youth appeared as Manet's alter ego in a long series of works that spanned virtually his entire career.[53]

During the late spring or early summer of 1878, at the very time when he was experiencing so many disquieting physical symptoms, Manet suddenly expanded his repertory of self-references to include a new personage: an amputee who had lost his left leg, perhaps during the Franco–Prussian War. The artist became fascinated with this poor beggar or workman, made two drawings of him, and subsequently included his image in *The Rue Mosnier with Flags* (Fig. 4), where he appears alone, in the lower-left corner of the composition, hobbling past the debris of a demolished building. His presence, in conjunction with the rubble, lends a decidedly unfestive note to this seemingly lighthearted, Impressionist rendition of the street bedecked with flags in celebration of the Fête de la Paix of June 30.[54] Manet's depictions of this poor cripple have received considerable attention from scholars committed to the sociopolitical approach, and these pictures have been interpreted as indicative of the artist's attitude toward the Franco–Prussian War, French nationalism, social progress, and so on.[55] Without discussing – or dismissing – these arguments, I would like to emphasize, instead, the self-preoccupation that would have facilitated Manet's identification with a model who had lost his left leg, the very limb that particularly troubled the artist throughout his mature life and would be amputated shortly before his death. Whether Manet's renditions of this cripple should be considered as a kind of "worst-case scenario" concealed self-image remains problematical, but the artist's own growing handicap surely helped direct his attention to the poor amputee's plight.[56]

Shortly after he had suffered the collapse of late 1878 that finally forced him to confront his progressive physical disability, Manet temporarily abandoned his practice of depicting himself in concealed ways to create his only two formal self-images: *Self-Portrait with a Palette* (Fig. 5) and *Self-Portrait with a Skullcap* (Fig. 6). Mauner identifies the former work as the nineteenth-century equivalent of the self-image Velázquez included in *Las meninas* (1656; Museo del Prado, Madrid): Like Velázquez, who used his self-representation to proclaim his status as official painter to King Philip IV, Manet created his self-portrait during the year in which he asserted *his* claim to the role of official painter of Paris by writing the municipal council and proposing that he decorate the new Hotel de Ville with an ambitious series of murals, to be given the collective title *Le Ventre de Paris* [the belly of Paris]. The council did not even deign to respond to this letter.[57] Mauner (who points out that Manet's

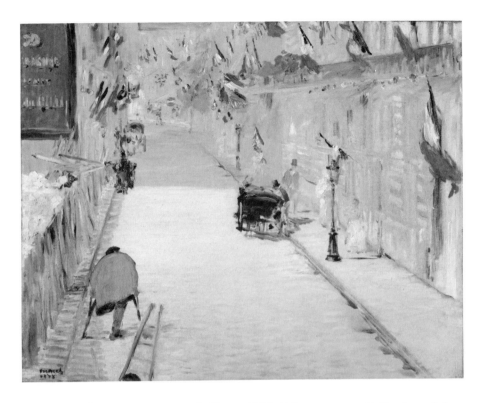

4. Manet, *The Rue Mosnier with Flags,* 1878. Oil on canvas. Collection of the J. Paul Getty Museum, Malibu, California.

health probably would not have permitted him to complete this commission had he received it) interprets this gesture "as a last desperate attempt to claim the status that he fervently desired and undoubtedly felt that he fully deserved by dint of his thoroughly Parisian temperament, as well as his talent."[58] One might add that Manet's proposal also constitutes additional evidence of his ability to disavow the gravity of his situation and behave as though he were suffering only minor health problems, rather than a life-threatening illness.

Theodore Reff also compares the artist's *Self-Portrait with a Palette* with Velázquez's self-image, but interprets both this self-representation and the more intimate *Self-Portrait with a Skullcap* as equally representative of his position as the stylish and successful "Parisian artist *par excellence.*"[59] However, Reff's observation seems much more applicable to the *Self-Portrait with a Palette* than to its companion, for the two images present decidedly contrasting aspects of the artist's self-concept, symbolizing the dichotomy that separated his public and private personae. In the *Self-Portrait with a Palette* (which was, not so coincidentally, superimposed over a portrait of his wife, Suzanne), the artist shows himself as the

15

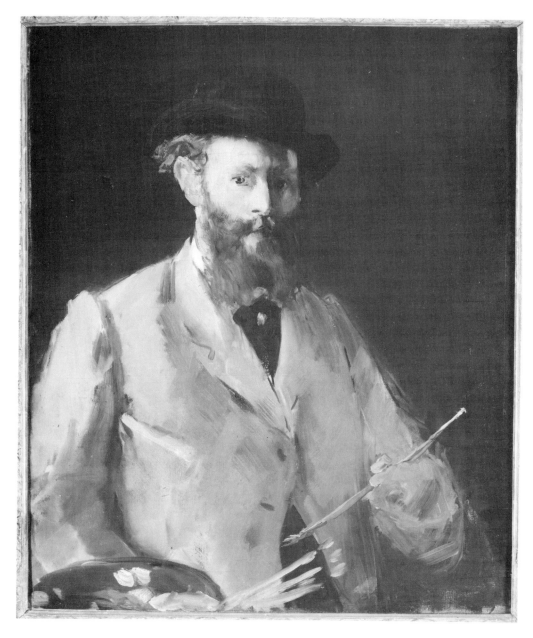

5. Manet, *Self-Portrait with a Palette,* 1878–9. Oil on canvas. Private collection. Photo: The Metropolitan Museum of Art, New York.

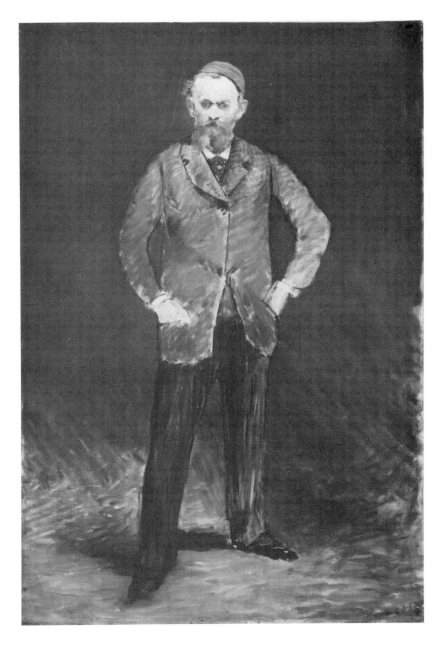

6. Manet, *Self-Portrait with a Skullcap*, 1878–9. Oil on canvas. Ishibashi Foundation, Bridgestone Museum of Art, Tokyo.

dashing, debonair boulevardier. His vigorous, youthful appearance belies his actual age – he was approximately 47 at the time – an impression enhanced by the way he has skillfully positioned his black bowler hat to hide the receding hairline all too apparent in contemporary photographs that show him bareheaded.[60] Although he represents himself poised with palette and brushes in hand, as if momentarily interrupted while painting, surely not even such a consummate dandy as Manet worked in the fashionable attire he sports in this picture. In short, this image presents the artist's public persona, the vision of himself he wished to share with the world, and it is not surprising to learn from Tabarant that Manet's friends were all invited to view this painting as soon as it was completed.[61]

The *Portrait with a Skullcap* shows a very different aspect of Manet's personality. Both more informal and more realistic than its companion, this image, despite its sketch-like state, more accurately represents the artist as the middle-aged, balding man he was at the time. By reproducing only the artist's upper torso, the *Self-Portrait with a Palette* evades the entire issue of Manet's illness – a condition we may be sure he did not wish to call to the attention of his friends. (Parenthetically, it should be noted that the three major protagonists of the *Bar* all appear in three-quarter-length views, their lower limbs hidden by the countertop.) The full-length *Self-Portrait with a Skullcap*, by contrast, represents its subject as he attempts to step forward, assuming the awkward, wide-based gait necessary to maintain his balance.[62] The more revelatory nature of the latter portrait is underlined by the fact that Manet chose it as the vehicle for the only fully frontal self-image he ever created. As Francis V. O'Connor has demonstrated, the fully frontal configuration has a special psychodynamic significance, almost invariably marking a point of transition and crisis in the life of its creator.[63] O'Connor's observation applies with particular forcefulness to Manet's situation at the time he created this picture, as he attempted to come to grips with the ominous implications of the symptoms of bodily decay he was then experiencing. The two overt self-portraits, then, represent the contrasting aspects of the psychological "split" that constituted Manet's response to his illness: the disavowal of physical deterioration versus the admission of vulnerability.

After completing these two pictures, Manet painted no more overt self-portraits, reverting instead to the veiled allusions to himself and his situation that had characterized his earlier practice. The reappearance in his late oeuvre of themes dealing with mortality constituted one such reference. Manet undertook his first explorations of this motif two years after his father's death, and probably in direct – if delayed – response to that event. He exhibited his first works of this type in the Salon of 1864, where he showed a pair of pictures evidently designed to illustrate contrasting secular and sacred aspects of death – the canvas now known as *The Dead Toreador* (National Gallery of Art, Washington, D.C.) and

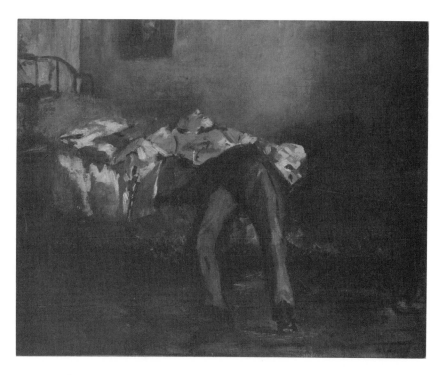

7. Manet, *The Suicide,* 1881. Oil on canvas. Stiftung E. B. Bührle, Zurich. Photo: Erich Lessing / Art Resource, New York.

The Dead Christ with Angels.[64] He continued his painted ruminations on death intermittently throughout the later 1860s, but the theme virtually disappeared from his oeuvre during the following decade, only to resurface in *The Suicide* (Fig. 7), painted in 1881.[65]

The Suicide, the grimmest and most realistic death image Manet ever created, shows the victim sprawled across his bed, his chest broken and bloodied, his pistol still clutched in his fist. It is surely no coincidence that the dead man's awkwardly positioned legs, metaphors for his psychological imbalance, form the central focus of the composition. *The Suicide* not only demonstrates Manet's mastery of the naturalistic style, but also reveals his empathy for the utter despair that led this poor wretch to his act of desperation. Clearly, Manet's own illness had sensitized him to the plight of fellow sufferers; perhaps in his darkest moments, he even contemplated taking his own life.[66]

The dark mood evident in *The Suicide* had surfaced a year earlier, while Manet was working on a painting ostensibly devoid of tragic connotations: the portrait of his old friend Antonin Proust (1879–80; Fig. 8). Manet depicted Proust as a dashing boulevardier, impeccably clad in top hat and frock coat. In size, format, and spirit, the image of Proust recalls

19

the 1867 portrait of the artist himself (Art Institute of Chicago) by Henri Fantin-Latour, which represents Manet as an equally handsome, elegant, self-confident personage. Perhaps, when he began Proust's picture, Manet quite consciously invoked the comparison between these two portraits, only to be overcome by sadness as he pondered the contrast between his situation at the time Fantin-Latour had portrayed *him* and his predicament thirteen years later, when *he* depicted Proust.

Shortly after completing this portrait, Manet dropped his guard and made the following extraordinary confession to his old friend:

> I always wanted to paint a Christ on the cross. Only you could be the model as I understand it. While I was doing your portrait, this idea pursued me. It was an obsession. [Instead] I painted you as a Christ with a hat, wearing a topcoat with a rose boutonnière. That is Christ going to Magdalene. But Christ on the cross – what a symbol! One could search to the end of time, and one would find nothing like it. Minerva is fine, so is Venus. But neither the heroic image nor the image of love will ever equal the rendering of suffering. It is the foundation of humanity. It is its poetry. "But enough," he said, as he got up, not without trouble, "I'm becoming sad. It's the fault of [Doctor] Siredey. Whenever I see the doctors, I always feel they represent the marshals of funeral homes. However, I feel much better tonight."[67]

The emergence of such dark themes and associations provides glimpses into the level of private despair that Manet surely experienced repeatedly during his final illness. However, he usually succeeded in splitting off, or disavowing, the true implications of his situation, and neither tragic themes nor melancholy associations dominated his late work. His conduct during this period was in marked contrast to his behavior earlier in his career, when he had suffered two depressive reactions accompanied by creative paralyses (one triggered by the outcry that greeted *Olympia* at the Salon of 1865, the other after his unsuccessful one-man exhibition of 1867).[68] By contrast, between the spring of 1878, when his symptoms began seriously to interfere with his life, and the time of his death in April 1883, Manet avoided creative paralyses of this type and worked to the limits permitted by his failing physical strength, producing an astonishing number of pictures in a variety of media. On the face of it, his behavior during the latter years seems extremely courageous. However, in view of the fact he maintained this brave front by means of splitting and disavowal, one might argue, to the contrary, that his reaction to the two earlier setbacks had been more resolute; in those instances he had faced his terrible disappointment, and, following a period of mourning or "working through," had resumed his normal creative and social roles. During the last five years of his life, he functioned by avoiding the issue altogether and pretending that nothing was wrong.[69]

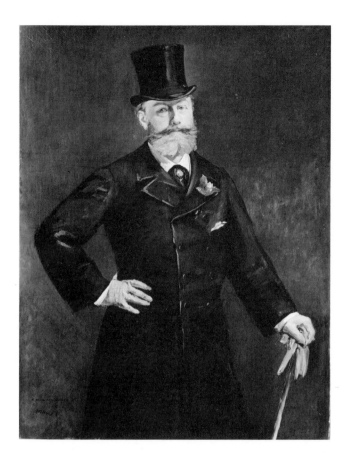

8. Manet, *Antonin Proust,* 1880. Oil on canvas. The Toledo Museum of Art, gift of Edward Drummond Libby.

Manet's Oeuvre during the Years Immediately Preceding the Creation of A Bar at the Folies-Bergère

Throughout his late period, Manet continued to be active as a portraitist and painter of still lifes. (Indeed, small-scale images of fashionable Parisiennes, in pastel as well as oil, proliferated in his late oeuvre.) However, far from lapsing into formulaic repetitions of earlier themes during these years, he continued to expand his artistic horizons and to explore the contemporary subjects and new techniques that had challenged him during the 1870s, paralleling his growing intimacy with the Impressionists and his increasing interest in transforming into high art motifs hitherto explored only in contemporary naturalist fiction, or in popular illustrations.[70]

21

Paintings portraying modern Parisians enjoying themselves – lolling on the beach, boating on the Seine, playing croquet on their lawns – proliferated in Manet's oeuvre during the early 1870s. Later in the decade he concentrated instead on depicting individuals engaging in leisurely indoor activities. One such series shows demimondaines bathing or dressing themselves; these paintings invite comparison with Degas's contemporary treatment of similar subjects, while revealing the workings of a very different temperament.[71] During 1877–81, Manet also turned his attention to the world of contemporary entertainment – to scenes set in the cafés, brasseries, and cafés-concerts that were growing increasingly popular – an interest that would eventuate in the creation of his last great painting, *A Bar at the Folies-Bergère*. As Wilson-Bareau notes, the three canvases to which the artist specifically gave titles referring to the café-concert all anticipate the *Bar* by featuring direct or reflected views of a stage with performers.[72] For example, in *Café-Concert* (1878; Fig. 9), Manet made provocative use of the background mirror to capture the reflection of "La Belle Polonaise," a diseuse, or monologist, portrayed in midperformance. Despite the witty quality of Manet's rendition of the young woman's profile, Philip Ariès is probably correct in suggesting that the real theme of the painting is neither amusement nor conviviality, but estrangement and isolation, loneliness in the midst of the crowd.[73] The poignant expression of the little shop girl of the *Café-Concert,* who appears lost in reverie, prefigures the melancholy of the barmaid at the Folies-Bergère, while simultaneously mirroring the situation of her creator, engaged in progressively distancing himself from the life he loved but was destined soon to leave.

The enigmatic structure of Manet's late pastel, *A Café on the Place du Théâtre Français* (1881; Art Gallery and Museum, Glasgow) directly anticipates the spatial ambiguity of *A Bar at the Folies-Bergère*. Like the scene reflected in the mirror of the latter painting, the sketchy background plane of the pastel promotes interpretive debate. It has been perceived as a window looking onto the street, as a mirror reflecting the café interior, and as an opening providing a glimpse into "an entertainment establishment similar to the Folies-Bergère."[74] A combination of the second and third interpretations probably provides the most satisfactory solution: the glassy plane *is* a mirror, reflecting the far wall of the theater, whose architectural features *do,* indeed, anticipate the structure of the balcony, piers, and pier lights reflected in the mirror of the *Bar.* Kurt Martin points out that the dichotomous structure shared by *A Café on the Place du Théâtre Français* and *A Bar at the Folies-Bergère* has profound interpretative implications: "[In both pictures] two planes are juxtaposed, two realities, separate and connected, interior and exterior, near and far, motionless and moving – the whole borne by the hushed and timeless present." Martin further emphasizes that *A Café on the Place du Théâtre Français* reflects "the atmosphere of desolation, the 'absent presence,' as Valéry called it, of modern life. Manet became the

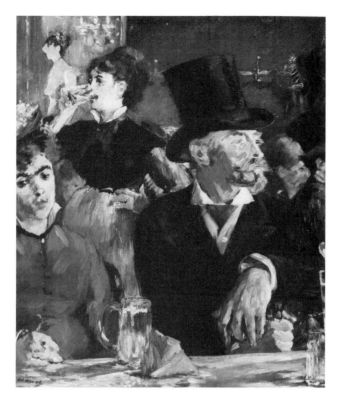

9. Manet, *At the Café (Café-Concert)*, 1878. Oil on canvas. Walters Art Gallery, Baltimore, Maryland.

first interpreter of that life because he had the gift of bringing out its profound significance."[75] While accepting Martin's reading of *A Café,* I would challenge his conviction that Manet's emergence as a premier interpreter of the desolation of contemporary life was primarily an expression of the artist's natural gifts. To the contrary, this development *was the direct outgrowth of the changes in his inner world induced by his illness.* As previously noted, the visions of modern Paris and its suburbs that Manet had created during 1872–7 were generally celebratory in mood, rather than pessimistic; during those same years he had interrupted the exploration of mortality themes that had engaged him during the 1860s and would reemerge in his oeuvre of the early 1880s. His concern with motifs of contemporary alienation first became evident in the artist's depiction of *The Rue Mosnier with Flags* (1878; see Fig. 4), with its implicit contrast between the plight of the crippled beggar and the gay trappings of the street on which he hobbles.[76]

During the last years of his life, Manet applied his creative talents to the problem facing any victim of a chronic, progressive illness: that of

distancing himself psychologically from everyone and everything he held dear, without succumbing to hopelessness and fulminating depression. *A Bar at the Folies-Bergère* constitutes Manet's definitive solution to this problem: With this picture, he succeeded at last in overcoming the split and abandoning the disavowal of his condition that had characterized his initial reaction to his illness. Thus, the *Bar at the Folies-Bergère* stands not only as Manet's last great artistic triumph, but also as a monument to the psychic healing and reintegration that he effected through the regenerative power of art.

The Folies-Bergère: The Theater and Its Attractions

The structure that housed the original theater of the Folies-Bergère still stands and continued until recently to serve as a venue for variety shows – albeit of a very different type than those that took place there during its first decades. However, the entire interior of the building was radically remodeled in 1926, and the archives of the establishment, including all the architectural drawings, were subsequently lost. Although Paul Derval, the director of the theater at the time the remodeling occurred, subsequently wrote a history of the establishment, it provides relatively little useful information and does not deal with such fundamental questions as the precise nature of the structural and cosmetic changes he wrought in the theater.[77] Consequently, scholars have been forced to rely on nineteenth-century engravings, posters, photographs, guidebooks, and the like to reconstruct the appearance of the music hall at the time Manet created his painting. The absence of secure documentation has promoted disagreements about the precise area of the music hall represented in *A Bar at the Folies-Bergère*.

We do know that, when the Folies-Bergère opened its doors on May 1, 1869, it featured a sumptuous foyer that gave onto a large, horseshoe-shaped auditorium accommodating hundreds of spectators in fixed seats; loges lining the two long walls on either side of the stalls provided additional orchestra-level seating.[78] A spacious balcony, supported on free-standing columns and surmounted by tiers of loges, ringed the perimeter of the structure on the second level. From the gallery walls sprang broad pilasters with gilded capitals, which helped to support the roof. The interior was illuminated by enormous gas-powered crystal chandeliers, supplemented by globe lights affixed to the pilasters. (All these features are visible in the reflecting mirror represented in *A Bar at the Folies-Bergère*.) From the stalls and orchestra-level loges, patrons could enjoy direct access to an enclosed garden, which was, in turn, surmounted by loges running along its two long walls. A grand double staircase located on an end wall of the garden provided access to the balcony level of the auditorium.

The outbreak of the Franco–Prussian War forced the Folies-Bergère to suspend operations, and during the conflict the theater served as a forum

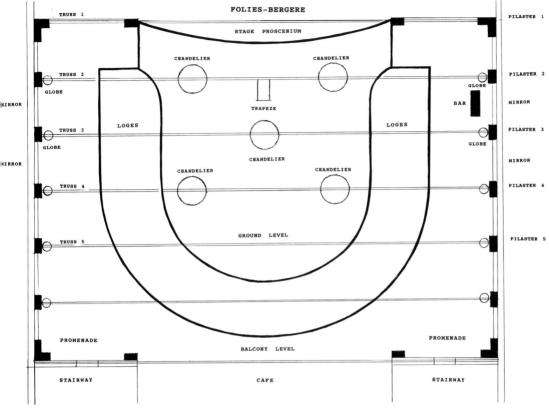

10. William Conger, the Auditorium of the Folies-Bergère as it appeared during 1875–1926. Ink on Bristol board.

for political meetings; Manet mentioned attending such an event in a letter to his wife written during the siege of Paris.[79] The music hall re-opened in November 1871 under the direction of Léon Sari, who master-minded a number of structural and programmatic changes that helped to transform the Folies-Bergère into a celebrated national institution.[80] By removing the last rows of seats at the back of the auditorium, Sari carved out a large open area, which became a *promenoir* or promenade, complete with three bars, where customers could stroll or sit at tables while enjoying a drink.[81] He created a similar space on the balcony level by reducing the number of loges to allow for the addition of small bars, a café-patisserie, and a second *promenoir*. A drawing (Fig. 10) made after an engraving of 1875 shows the interior of the theater as it appeared at the time, and notes the locations of the lower- and upper-level promenades.

In a second renovation campaign conducted in 1875, Sari embellished the winter garden, transforming it into a pseudo-Moorish fantasyland, hailed by a contemporary journalist as a "Mohammedan paradise,"

25

filled with "every kind of seductive temptation."[82] During this remodeling, the garden-level loges were encased with Mooresque cusping and lacelike woodwork, and the two long walls beneath fitted with small bars lined with mirrors, each presided over by an individual *dame de comptoir*.[83]

Although the Folies boasted its own orchestra and dance troupe, enabling Sari to stage operettas and ballets, the theater rapidly became especially celebrated for its circus-like variety shows featuring "jugglers, clowns, mimes, acrobats, wrestlers, singers, dancers, and animal acts from the best circuses in Europe."[84] A team of English gymnasts, known as the Hanlon-Lees and Little Bob, who not only performed on the trapeze but also acted out lurid pantomimes, enjoyed special popularity with audiences; they were engaged for several long runs at the Folies-Bergère during the 1870s.[85] A wood engraving of 1872 depicts the team performing at the theater, flying high above the spectators in the stalls.[86] Manet evidently counted himself among the troupe's admirers, for he reproduced a poster advertising the Hanlon-Lees in *At the Café* (1878; Sammlung Oskar Reinhart, Winterthur). However, the female aerialist whose lower limbs and green-shod feet we glimpse in the upper-left corner of *A Bar at the Folies-Bergère* could not have been a member of the Hanlon-Lees team, which consisted of five male acrobats; to date, she has not been securely identified.[87]

Sari's renovations and programming soon transformed the Folies-Bergère into a leading institution of popular culture, and by the time Manet painted the *Bar,* the theater had attained international celebrity; as already noted, its fame probably stemmed as much from its reputation as a magnet for prostitutes as for its other attractions. However, the clientele who frequented the Folies-Bergère by no means consisted only of whores, roués, and foreigners; to the contrary, it attracted a loyal following of Parisians from widely varying backgrounds and levels of respectability, as Guy de Maupassant's vivid description of the theater's patronage in the early 1880s indicates.[88]

The Evolution of A Bar at the Folies-Bergère

We do not know precisely when Manet became a habitué of the Folies-Bergère, but he was evidently a regular visitor to the theater by 1878–80, when he made a series of quick pencil drawings that formed the basis for the pen-and-ink sketch *At the Folies-Bergère*, which shows rapt spectators watching a performance from the balcony of the auditorium. As Wilson-Bareau points out, this drawing includes many architectural details that would reappear in Manet's definitive painting of the establishment.[89]

By the spring of 1881, Manet's condition had deteriorated markedly; increasingly anergic and pain-wracked, he grew ever more irritable and uncooperative with his physician.[90] Refusing to surrender to his weak-

ness (or, perhaps more accurately, continuing to deny the real gravity of his situation), the artist defiantly planned an important new painting, to be set in the glittery environment of the Folies-Bergère. Perhaps the fact that he had finally been awarded a second-class medal by the Salon jury of 1881 reinforced his ambition, inspiring him to prepare a major work for the Salon of 1882 with the goal of earning a coveted gold medal.[91]

Although his pilgrimages to the Folies-Bergère must have been more penance than pleasure, Manet evidently made several expeditions to the theater during the late spring and early summer of 1881 to refresh his memory of the establishment and to jot down in the pocket-size note-book he habitually carried with him quick sketches that might be incorporated into the work in progress. Once he had decided to make one of the theater's numerous bars the focus of his composition, he broadened the scope of his expeditions to include scouting out an attractive young *dame de comptoir* who would be willing to travel to his studio to pose.

The artist soon found an appropriate candidate, and he completed the preliminary oil sketch for the *Bar,* now on loan to the Stedelijk Museum in Amsterdam (see Fig. 3), before leaving for Versailles at the end of June. The records compiled by Léon Leenhoff during the posthumous inventory and photographic documentation of the artist's oeuvre note that this *esquisse,* although based on sketches made in situ, was actually painted in the artist's studio on the rue d'Amsterdam during the summer of 1881. Léon identified the setting as "the bar on the [balcony level], to the right of the stage and proscenium," and the male customer shown conversing with the barmaid as Henri Dupray (a painter of military subjects, who had his studio on the same block of the rue d'Amsterdam as Manet).[92] The Folies-Bergère was not equipped with any of the new-fangled elevators that were still a recent invention, so Manet must have ascended to the balcony level via one of the house staircases. Exactly how he managed this feat remains unclear, because as early as April 1880 he had informed Mme Zola in a letter that his physician had forbid-den him to climb stairs.[93] (Presumably, he navigated the stairs at the Folies with the aid of his cane and the supportive arm of his "godson," who accompanied him on these visits.)

After completing the preliminary sketch for the *Bar,* Manet, finally yielding to his physician's insistent recommendations, left to spend a quiet vacation at Versailles. The summer was not a success; the weather was wet and miserable, and Manet, increasingly enfeebled, was seldom able to undertake expeditions outside his immediate environs, or to complete much in the way of work, beyond painting a charming view of his own garden and a few small still-life studies.[94]

Although the artist returned to Paris in early October, it is not clear exactly when he resumed work on the *Bar.* Apparently, he spent the first weeks of the fall in a frantic round of activities designed to disprove growing rumors about his health. Perhaps his increased activity level co-incided with another slight remission of his symptoms. (According to

Dr. Burke, victims of multiple sclerosis typically do better in autumn.) During this same brief period of illusory improvement, Manet briefly entertained the notion of undertaking a major new project – the depiction of a modern steam locomotive and its crew – and even applied for permission to carry out preliminary studies at the Batignolles station. Needless to say, nothing ever came of this unrealistic fantasy. [95]

Tabarant, whose chronology regarding the *Bar* seems confused, assigns the evolution of the entire project, from preliminary drawings to final painting, to the late autumn of 1881, claiming that Manet initiated the campaign that fall with numerous visits to the music hall, whose magical atmosphere made him forget his pain and fatigue: "The central bar delighted him with the motley display on its shelf and the fairylike atmosphere of the gas lighting. He took note of its intimate decor."[96] Tabarant's confused time sequence notwithstanding, his assertion that Manet was deeply involved in the *Bar* project during the last few months of 1881 is surely accurate. Perhaps he was inspired to return to his unfinished composition in mid-November, when Proust was appointed Minister of Fine Arts by Gambetta. Well aware that his friend would lose no time in naming him a Chevalier of the Legion of Honor, Manet may have determined to finish the large *Bar* as quickly as possible, so as to have a major work ready to submit to the Salon under his new title of Chevalier.

If Manet actually revisited the Folies-Bergère several times that autumn, as Tabarant claims, it may also have been to search out a replacement for the barmaid who had posed for the Amsterdam sketch. Whether the original model disappeared from sight while Manet was at Versailles, refused to continue posing for him (a reaction shared by many of his other models, even close friends who sat for him), or was simply replaced because the artist found someone more to his liking, remains an unanswered question. At any rate, Manet's new model, whom we know only as Suzon (a nickname for Suzanne), proved a happier choice.[97] She evidently possessed the requisite patience to pose for the artist, and not only modeled for *A Bar at the Folies-Bergère,* but also for a pastel portrait (Musée des Beaux-Arts, Dijon) that depicts her wearing a stylish hat and the same melancholy expression that characterizes her in the *Bar*. (Suzon evidently formed a real bond with Manet and subsequently often dropped by the artist's studio. Manet executed the portrait now in Dijon during one of these visits.)[98] One wonders whether both Suzon's melancholy expression – which may have struck a particularly responsive note in Manet, given his own tragic situation – and her given name, which she shared with the artist's wife, played key roles in attracting the artist to her.

If we do not know precisely when Manet began working on the large *Bar*, we do have a terminus ad quem for the canvas: It was still in process when Georges Jeanniot visited the artist's studio in January 1882, but was completed in ample time to meet the deadline for Salon submissions.[99]

28

Although the final version of the *Bar at the Folies-Bergère* seems startlingly different from the preliminary sketch, a comparison of the two canvases (see Figs. 1 and 3) reveals that, by the time he completed the *esquisse,* Manet had already decided on several features that he would retain in the definitive canvas. Both pictures show a three-quarter view of the barmaid, posed before a mirrored background, which provides reflected glimpses of the spectators crowding the balcony presumably located directly across from the bar.[100] Even at the sketch stage, Manet softened the gaudy decor of the theater, substituting dusky roses for strident reds and reducing the lavish use of gold trim to light golden touches representing the pilaster capitals. However, the glowing illumination and exquisite harmony of roses, lavenders, blues, creams, and warmed grays that enfuse the definitive Courtauld picture with such a magical quality had yet to be developed.

Both the sketch and the final painting render the space between bar and background mirror as quite flattened; however, in the *esquisse,* this area appears so tight that the waitress and her reflection seem almost like Siamese twins, joined at the shoulders. When he turned his attention to the Courtauld canvas, Manet countered this somewhat claustrophobic atmosphere, creating a niche for the young woman's figure by including the frame of the mirror (which he did not represent in the sketch), more clearly delineating the reflected image of the marble countertop, and, finally, by moving the barmaid's reflection out of alignment with her physical counterpart, thus creating a larger illusory space for the "real" girl. In contrast to the definitive painting with its dazzling array of bottles, flowers, and fruit scattered along the countertop, the Amsterdam picture scarcely hints at the riches to come; the liquor bottles, barely delineated, appear as an almost fused mass, sequestered on the left side of the counter, while the right half remains disproportionately empty. Moreover, whether painted by Manet or retouched by another hand (a question still unresolved), the long, dark expanse of the wooden bar front shown in the *esquisse* seems rather muddy and pedestrian.[101] In the definitive canvas, Manet addressed these problems, first by elevating the viewpoint of the composition and moving Suzon's figure closer to the front of the picture plane, thereby simultaneously eliminating any view of the bar front and the edge of the countertop nearest the picture plane, and then by elaborating and redisposing the still-life elements to create the harmonious arrangement that prevails in the Courtauld painting.

The most striking differences between the sketch and the large canvas, however, involve the conception of the waitress, her reflection, and that of her customer. In the Amsterdam picture, the barmaid, represented as a pert, attractive blonde of petite proportions, assumes a casual, asymmetrical pose at the right of the composition. Holding her arms at waist level with her right hand clasping her left wrist, she turns toward her customer, whose tiny figure is reflected in the lower-right corner of the mirror. The young woman's mirror image has not yet assumed an inde-

pendent existence, and its relationship to the "real" girl still seems quite plausible. By contrast, the dwarfed proportions of the customer's reflection flaunt the canons of realism, recalling similar deviations from accurate perspectival diminution evident in earlier works by Manet. Even if one assumes that the waitress is standing on a raised platform, the discrepancy between her height and that of her customer remains preposterous. Clasping his round-headed cane to his chin, the bowler-hatted Dupray regards the barmaid with the somewhat nonplused air of a Lilliputian who unexpectedly finds himself in the country of the Amazons. The definitive composition would radically alter the sizes – and interrelationships – of these three key figures.

Despite the striking alterations that differentiate the definitive painting from the Amsterdam sketch, x-ray studies undertaken by the Courtauld Institute demonstrate that the ghostly remains of the original sketch design underlie the concealing layers of pigment that Manet subsequently applied to the large canvas. As the picture evolved, he strayed further and further from the more realistic guidelines provided by the *esquisse*, to produce the magisterial fantasy presented in the Courtauld picture. Although from the moment Manet initiated the large painting, he depicted the barmaid in her final central, fully frontal position, the x-rays (Fig. 11) reveal that she was originally a slimmer, smaller individual, who stood with her left hand resting on her right forearm, and her figure realistically reflected in the background mirror, exactly as Manet had portrayed her in the Amsterdam picture. Subsequently, he extended her arms and enlarged her entire form, transforming her into a persona endowed with the pyramidal monumentality of a Masaccio Madonna. (See Fig. 12; this schematic drawing clarifies the changes in the composition revealed by the composite radiograph.) During the course of the barmaid's evolution, Manet also elaborated details of her uniform and accessories, such as the color and texture of her lace-trimmed, black velvet redingote and the blue-gray of her silk skirt – features that had been only hinted at in the sketch. The rhinestone buttons decorating Suzon's jacket demarcate the center of the Courtauld canvas, providing an imaginary line that runs through her corsage and locket, bisects her facial features, and emerges at the top of the painting.[102]

After he had enlarged and positioned his "real" barmaid to his satisfaction, Manet turned his attention to her reflection, which he moved to the right in two stages, so that the image first approached, then altogether obscured, the figure of Dupray, still discernible as a small, phantom presence in the x-rays (Figs. 11, 12). Even after the artist had definitively positioned the barmaid's mirror image, he continued to modify the shape and pose of her reflection, enlarging her silhouette and straightening her back and arms to correspond more closely to the proportions and attitude of her "real" counterpart. Later still, he added the reflection of the top-hatted man whose figure confronts – and overlaps – that of Suzon.[103] The customer depicted in the large canvas seems to have been

11. Composite x-radiograph of *A Bar at the Folies-Bergère*. Conservation Department, Courtauld Institute Galleries, London.

12. William Conger, schematic drawing showing the changes revealed by the composite x-radiograph. Ink on Bristol board.

modeled by someone other than Dupray; most likely the painter Gaston La Touche, who later recalled posing for this figure (and who is also usually identified as the man seated in the first row of the balcony).[104] Surprisingly, in view of the fact that Manet revised the barmaid's body so extensively that the thick paint of her redingote has cracked in several places, he brushed in her face, pendant, and the flowers tucked into her bodice so lightly and rapidly that the priming layer of the canvas still shows through.[105] The clarity and certainty with which he modeled Suzon's head constitutes an objective measure of Manet's evident satisfaction with his model's appearance, as well as her ability to assume and maintain the pose and expression he had in mind.

Nor did the artist's revisions end with the transformation of his three principal personages; he extensively reworked large areas of the canvas, including the bottles, flowers, and fruits on the bar top. The only additional areas of the Courtauld painting covered as thinly as Suzon's face and neck are the front of the balcony and the figure of Méry Laurent, the woman in white who rests her elbows on the balcony railing.[106]

As previously noted, Méry Laurent is one of three occupants of the balcony who have been definitively identified, the other two being Jeanne Demarsy and La Touche. Demarsy, clad in beige, is represented directly behind the empty chair next to Laurent. Neither woman posed specifically for the *Bar;* instead, Manet reproduced their images from recent pastel portraits he had made of them.[107] When Proust commissioned Manet to create a series of allegorical portraits of women to represent the four seasons, the artist asked Laurent to pose for *Autumn* (1881; Musée des Beaux-Arts, Nancy) and Demarsy for *Spring* (1882; private collection); the artist's death supervened before he painted the two remaining seasonal images. That Manet associated his allegorical representations of the women with the iconography of *A Bar at the Folies-Bergère* is suggested by the fact that he exhibited it with *Spring* at the Salon of 1882. In the past, he had frequently selected thematically related, or contrasting, paintings for Salon exhibitions (as in his choices of 1864, discussed above in the section "The Impact of Manet's Illness on His Oeuvre"), a practice he apparently followed in this instance as well. Manet painted the image of the third known occupant of the balcony, Gaston La Touche, from life. (As previously noted, he modeled not only for the man shown in the left corner of the balcony, but for the customer whose reflection fills the right corner of the canvas). La Touche, a fashionable painter with a reputation as a dandy and aesthete, was famous for his large, luxuriant mustache, a feature that can easily be detected in both images.[108]

Manet undoubtedly represented other friends among the more prominent personages shown in the balcony, such as the women with the binoculars, but none of them (including Henri Dupray, who allegedly also posed as one of the balcony occupants) has been securely identified.[109] As I pointed out earlier, Manet's inclusion of these minute portraits of

32

intimates underscores the very personal significance of *A Bar at the Folies-Bergère* for its creator.

The evidence uncovered by the x-radiographic studies is in complete accord with the description of Manet's working methods provided by Georges Jeanniot, who visited the painter's studio while the *Bar* was in progress:

> When I returned to Paris in January 1882 [from military duty], the first visit I paid was to Manet. He was then painting *The Bar at the Folies-Bergère* and the model, a pretty girl, was posing behind a table laden with food and bottles. He recognized me immediately, held out his hand and said: "It's most irritating, forgive me, I have to remain seated. I've got a bad foot. Do sit down."
>
> I took a chair behind him and watched him work. Although he painted his pictures from the model, Manet did not copy nature at all. I noted his bold simplifications; the head of the woman had a sense of depth, but this modeling was not obtained with the means that nature offered him. Everything was abridged; the tones were clearer, the colors more vivid, the values closer, the shades more varied. The result was complete harmony tender and limpid...
>
> Other people came and Manet stopped painting to go and sit on the divan against the right-hand wall. It was then that I saw how illness had ravaged him; he walked with a stick and seemed to tremble; but he was cheerful and talked of his imminent recovery.[110]

The Psychoiconography of A Bar at the Folies-Bergère

Manet scholars have generally agreed that *A Bar at the Folies-Bergère* provides a superb synthesis of the artist's early and late styles, a fusion of his dark "Spanish" manner with his bright "Impressionist" technique. A similar consensus prevails concerning the identification of earlier works by the artist that served as precedents for the *Bar,* with *Music in the Tuileries* (1862), *The Luncheon in the Studio* (1868), and *Ball at the Opera* (1873–4) invariably cited. About all other aspects of the *Bar at the Folies-Bergère* controversy reigns: Scholars cannot agree even about such fundamental questions as the actual location of the bar that Manet represented, much less reach a consensus about the formal and iconographic puzzles presented by the picture. For example, Novelene Ross suggests that Manet used one of the bars located in the (ground-level) winter garden as the locus of his painting, combining the perspectives of the waitress at her station and "the vista of the grande salle ... in the single plane of the mirror glass."[111] However, this reconstruction does not jibe with the pictorial evidence, which shows that the bar Manet depicted was located on the balcony level, to the right of the stage and proscenium (shown in Fig. 10), just as Léon Leenhoff's inventory indicates.[112]

As has frequently been observed, the central, frontal position of the

33

barmaid dictates our primary *implied* position as viewers: We must be standing directly across the bar from Suzon. Our location in such close proximity to the mirror would provide the broadest possible vista of the corresponding area across the theater, encompassing the reflections of the opposing balcony and its occupants. Although Léon Leenhoff's inventory notation does not precisely clarify the question, the bar Manet painted must have been behind the loge located between the second and third pilasters of the balcony level (see Fig. 10). The fact that the reflection in the *Bar* mirror shows a portion of the balcony that extends *beyond* the pilaster nearer the left edge of the picture plane identifies this support as the second from the stage, while the pilaster represented directly behind Suzon's left shoulder must be the third.[113] Indeed, so extensive is the viewpoint Manet provides that, if the image of the mirrored customer did not obstruct our view, we might be able to glimpse part or all of the fourth pilaster. The location of the trapeze artist, whose lower limbs and swing appear reflected at the upper-left edge of the canvas, jibes with this spatial reconstruction. As nineteenth-century prints representing aerialists in action at the Folies-Bergère indicate, performers suspended their rigging from the roof truss springing from the second pilaster.[114] Manet depicts his mirrored aerialist accurately positioned in front of the second pilaster, as she would have been as she began her performance. However, he has used artistic license to rotate performer and perch ninety degrees, so that instead of perceiving her reflection from the side, as would have been the case in reality, we are treated to a frontal view of her calves, booties, and swing.

In the interests of heightening the effectiveness of his painted drama, Manet eliminated the images of passersby whose meanderings past any of the actual bars at the Folies-Bergère would have been recorded in its mirror, just as de Maupassant describes.[115] Including these personages would have obscured our view of the trio at the counter, as well as the reflection of the opposing balcony and its inhabitants, so Manet waved his magic wand and made them vanish.

At the time Manet created *A Bar at the Folies-Bergère,* the principal illumination of the theater was provided by five gas-fired chandeliers; the largest fixture hung above the center of the auditorium, while two pairs of smaller fixtures were positioned near the front and rear of the space.[116] Three of these chandeliers are reflected in the mirror of the *Bar,* but Manet has freely relocated (and apparently even resized) them. The fixture shown closest to Suzon's head presumably is the large, central chandelier. In reality, this light was suspended from or above – contemporary illustrations do not adequately clarify this question – the third truss, but Manet represents it as though it were hanging between the second and third trusses. Near the left edge of the canvas, we glimpse the reflection of one of the paired chandeliers closest to the stage. These fixtures were actually suspended from (or above) the second truss, but Manet has moved this one back slightly, so that the reflection of the

neighboring pilaster does not bifurcate that of the chandelier, as would have been the case in reality. The remaining chandelier shown in the *Bar* mirror must be one of the rear lights, but the artist has once again contracted the "real" space, so that this fixture, which hung from the fourth truss, has been moved closer to the center of the auditorium.

Another characteristic of Manet's mirror has not, to my knowledge, been recognized to date: The vista presented in the mirror records not only direct reflections, but *reflections of reflections* echoing from the mirror positioned directly across the theater from the bar – and the mirror – featured in the painting. Careful study of the upper-left background of the picture (Fig. 13) reveals minute, hazy images of a group of personages viewed from the back. They can only be the inhabitants of the loge actually located below, and in front of, the bar represented in the painting. Rather than realistically revealing the fragmentary view of this vista that would have been visible in the upper segment of "our" mirror, Manet chose to project this image onto the opposite glass, then relay it back to our mirror as the reflection of a reflection. Just above the heads of these individuals, one can perceive ghostly echoes of globe lights attached to pilasters likewise located on our side of the theater but beamed back to us by mirror-to-mirror communication. Additional glimmers of light appear here and there across the background, fragmentary signifiers of reflected reflections that cannot be matched to their parent fixtures with any degree of certainty.

Manet treated his mirrored personae as arbitrarily as the settings in which he placed them, crowding what appears to be a cast of hundreds into an area surely never so densely populated in the actual theater, and presenting his cast of characters one and all – large and small, near and distant, directly and indirectly reflected – as soft-focus, blurred images. Even the large-scale forms of Suzon and her customer, represented close up, appear unnaturally softened. (Indeed, only the figure of the "real" Suzon is firmly contoured, a fact that underscores her unique symbolic status.) As Anne Coffin Hanson observes, "normal mirror images do not blur or soften reflected forms. Instead, they often give the effect of heightening details." Hanson also points out that, no matter how painstakingly one attempts to reconstruct the layout of the bar as depicted in the painting, the scene echoed in the background mirror does not "stand up to rational analysis. It is impossible to chart a position for the imagined spectator which would explain the placement of his mirror image and still allow for the angle of the orthogonal on the edge of the reflection of the marble bar. Probably Manet never intended that such a static position be inferred."[117] Hanson is absolutely correct: The only way we as spectators can make even partial sense of the scene is by assuming several different perspectival positions vis-à-vis bar and barmaid.

To test the validity of this observation, I conducted an informal experiment, employing a mock-up of Manet's counter and mirror and substituting live "stand-ins" for the trio at the bar – Suzon, her reflection, and

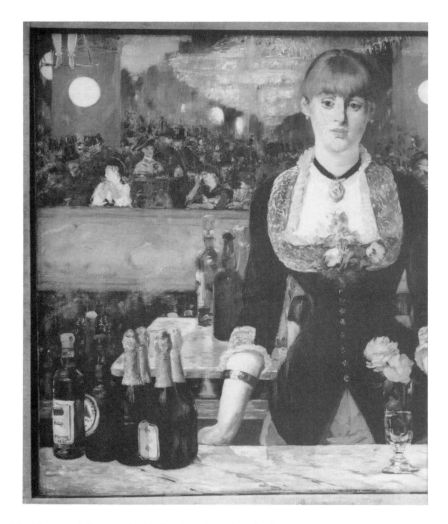

13. Manet, *A Bar at the Folies-Bergère,* detail of Figure 1. Courtauld Institute Galleries, London.

that of the top-hatted gentleman – while I assumed the role of the fictive customer supposedly positioned across from the barmaid. This experiment confirmed the hypothesis that one can visually encompass the scene Manet portrays in his mirror only by moving from the seemingly "logical" position opposite Suzon, where one begins this visual journey, to additional vantage points. In order to glimpse the blurred reflections of the activity below (depicted in the lower-left quadrant of the mirror, Fig. 13), one must assume an implicit position directly in front of the "real" bottles and directly beneath – but unnaturally far below – the aerialist springing high above. But neither from this vantage point nor from

36

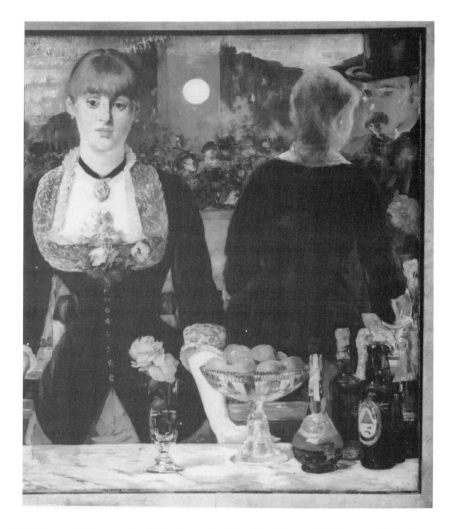

14. Manet, *A Bar at the Folies-Bergère,* detail of Figure 1. Courtauld Institute Galleries, London.

any spot near the center of the bar could an "actual" personage staring into the mirror perceive the reflections of Suzon and her customer, positioned so close to the right border of the canvas that his figure is bisected by its edge (Fig. 14). To discover them thus, one must view the couple from a high position, beyond the right boundary of the picture.

Although my experiment illuminated certain aspects of Manet's painted puzzle, it failed to resolve others, including the multiple discrepancies the artist introduced between the "real" collection of objects arrayed along the bar and those he chose to echo in his mirror.[118] Accordingly, I consulted William Conger, an artist and teacher as much admired

for his mastery of technical and theoretical problems as for the quality of his paintings. He responded to the challenge by constructing an elaborate sketch of the composition, overdrawn with linear perspectival constructions (reproduced as Fig. 15; see the Appendix for his detailed discussion of the significance of the lines and numbers represented in this diagram).

The experience of identifying the complex perspectival underpinnings of the painting led Prof. Conger to conclude:

> Although Manet probably did not employ formal perspective constructions in his *Bar at the Folies-Bergère,* his composition *seems* to be organized according to the logic of one-point linear perspective, except for the mirrored images of Suzon and her customer, positioned at the extreme right. The essential rule of perspective assumes that the viewer is in a fixed position relative to the scene depicted, so that the illusion of depth appears to be a rational projection of the spectator's line of sight. Manet seems to fix the viewer directly in front of Suzon, leading to the assumption that a single vanishing point would occur at about her eye level (cued by the angle of the marble counter), where it would be intersected by the horizon line, the viewer's level of sight. However, the artist introduces numerous discrepancies in the perspectival logic of the composition – multiple vanishing points, changing horizon lines and other organizational devices that locate the spectator in varied visual positions. These discrepancies in perspectival logic add to the strangeness of the painting, subverting the contemplative promise implicit in Suzon's centralized, frontal figure. One's quiet, introspective dialogue with her is contradicted by both clear and camouflaged pictorial devices that force the viewer continually to search – perhaps unconsciously and certainly in vain – for the ideal viewing position vis-à-vis the barmaid that will reveal pictorial coherence and permit vicarious identification with her. Looking at *A Bar at the Folies-Bergère* involves visual discomfort. *The composition subverts perspectival logic so consistently as to suggest that Manet deliberately followed a pictorial strategy that exploited perspective for the sake of maintaining ambiguity.*[119]

As the results of the researches undertaken by Prof. Conger and myself demonstrate, no matter how one struggles to reconcile Manet's final vision with observed reality, no matter how many theoretical positions one assumes vis-à-vis the *Bar,* in the end, his pictorial puzzle resists rational solution. As Conger wryly observed, "In order to view Manet's painting from all the vantage points he dictates, one must become disembodied, transformed into a ghost – or an angel."[120]

Whether or not Manet was consciously aware of the subversive nature of his procedures remains an unresolved question. Most likely he did not initiate work on the *Bar* with such a complex – and disturbing – perspec-

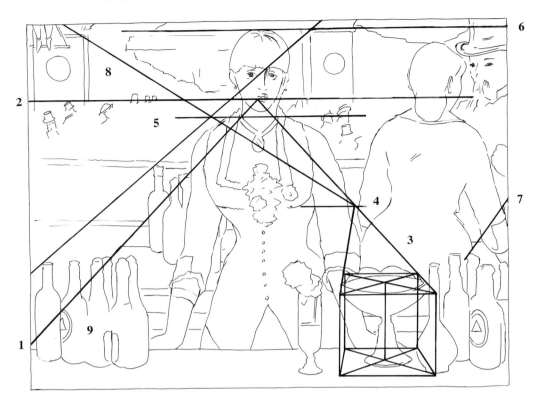

15. William Conger, diagram of *A Bar at the Folies-Bergère* overdrawn with linear perspectival constructions. Ink on Bristol board. (See Appendix for key to numbers.)

tival strategy in mind; instead, these complexities probably developed more or less instinctively, as the painting evolved. The quick drawings he made in situ, the visual residues of the spectacle retained in memory, the generic mock-up of the bar erected in his studio – even the presence of Suzon, dressed in her uniform and playing her real-life role of barmaid – all these visual aids served only as points of departure for the artist, guidelines designed to keep him from straying too far from observed reality into arcane fantasies. But as he proceeded, he relied more and more on his inner vision, a process that ultimately transformed *A Bar at the Folies-Bergère* into a grand synthesis of the real and imaginary, the observed and invented, a spectacle that taunts and haunts the viewer confronting its mysteries. From the tawdry surroundings of the actual music hall, Manet fashioned a private universe in which allusions to his personal history, current status, and future destiny fuse with references to the history of past art and the past history of his own art.

References to the Artist's Earlier Oeuvre in the Bar

In its definitive form, the *Bar* provides a synoptic overview of the artist's career from 1862 to 1882, but on every level these references to his professional life intermingle with allusions to his private world. It is surely no coincidence that the three paintings Manet scholars most frequently mention in conjunction with the *Bar* – *Music in the Tuileries, The Luncheon in the Studio,* and *Ball at the Opera* – are all notable not only for their high quality, but for the personal references they encode. The special significance of *Music* and the *Ball at the Opera* for their creator is underscored by the fact that each composition includes a rare self-portrait; the *Luncheon,* which represents Manet's "godson," Léon Leenhoff, also functions as a concealed self-image. (As previously noted, Léon appeared as Manet's pictorial surrogate in a long series of pictures spanning virtually the artist's entire career.)

The frieze-like organization, flickering brushwork, and contemporary subject of *Music in the Tuileries* (1862; National Gallery, London) anticipate many aspects of the *Bar*. In this composition, Manet succeeded for the first time in effecting a seamless fusion between the art of the past (in this instance, allusions to works by leading Renaissance and Baroque masters), and the representation of contemporary life, while simultaneously transforming into high art a motif that had hitherto been the provenance of popular illustration.[121] The half-hidden self-portrait Manet included in *Music* not only represents him as the handsome young dandy and companion of leading avant-garde figures of the period, but covertly refers to the similar self-portraits that artists like Raphael and Velázquez (masters with whom Manet here implicitly equates himself) incorporated into key works.[122]

Like *Music,* the *Bar* elevates its ostensible subject – the role of a humble *dame de comptoir* – previously explored primarily in popular (and often suggestive) prints to the level of great art.[123] But if *Music* constituted Manet's first great triumph in this genre, *A Bar at the Folies-Bergère* was destined to be his last – a fact of which he must have been poignantly aware as he struggled to complete the latter painting. One wonders, too, whether as he worked on the *Bar,* Manet's thoughts turned to the sad fate suffered by his friend Charles Baudelaire, whose portrait is included in *Music in the Tuileries*. Baudelaire had not only been a close friend, but had profoundly influenced Manet's artistic development during the early 1860s, and may well have played a key role in the evolution of *Music in the Tuileries*. Baudelaire's death, which occurred in 1867 – following a long, incapacitating illness – had deeply affected Manet, whose rendition of *The Burial* (1867–70; Metropolitan Museum of Art, New York) may constitute a painted eulogy to Baudelaire.[124] Ironically, this literary giant had succumbed to general paresis or "softening of the brain," a form of tertiary neurosyphilis that leads to profound dementia, paralysis, and, finally, death. (As with *tabes dorsalis,* the causative connection linking

chronic syphilitic infection to the development of general paresis was not established until 1882.)[125]

The Luncheon in the Studio (1868; Fig. 16) has been identified as another key turning point in Manet's career: "his first true 'naturalist' scene, initiating a series that would later lead to *A Bar at the Folies-Bergère...*"[126] Formal and iconographic features originally introduced in the *Luncheon* recur in the *Bar*. Not only do both pictures present the viewer with similarly enigmatic tableaux, but Suzon's pose loosely recapitulates that assumed by Léon Leenhoff thirteen years earlier. Léon was 16 when he modeled for the *Luncheon*, shortly after he had entered the adult world of commerce by accepting a minor position at a bank – a coincidence that has led to the interpretation of the painting as "a symbolic representation of young manhood coming of age."[127] Presented in three-quarter view, Léon faces us, his buttocks and outstretched hands resting on the table behind him. He seems equally oblivious to his surroundings and to his fellow protagonists – the woman servant and bearded man shown behind him – just as Suzon would later appear alienated from her surroundings, alone and lonely in the midst of a crowd of merrymakers.

But if Léon and Suzon both seem equally detached from their settings, their expressions and attitudes suggest that sharply different states of feeling underlie their withdrawal. The youth's deliberate casualness and bored expression seem mere affectations, the attempts of a callow boy to usurp the role of flâneur, which rightly belonged to his "godfather." (As Cachin suggests, Manet may well have been amused – but perhaps also somewhat flattered – by Léon's obvious attempts to emulate him.) By contrast, the young woman appears genuinely removed from her environment, absorbed by the private melancholy that preoccupies her. Her isolation and sadness echo the tragic situation of her creator; unlike Léon, portrayed at the time of his professional debut, Manet, now approaching the close of his life and career, was forced to detach himself from everyone and everything he held dear, including his putative son and the boy's mother, Suzanne Leenhoff Manet.

Perhaps, as Pierre Daix proposes, Manet's meditation on his family was tinged with remorse. According to Daix, the artist depicts Léon in *The Luncheon* as though he were "a still life, present-absent (as Suzanne is also absent from the scene)." Daix reads Manet's representation as an implicit admission of his heedlessness as a father and consequent feelings of guilt toward "a son who was not a son," and who was destined to be an ineffective adult.[128]

No painting in Manet's oeuvre shares more affinities with the *Bar* than *Ball at the Opera* (1873–4; Fig. 17). Both compositions feature the horizontal format that Manet favored, and both depict frieze-like crowd scenes set in an establishment of public entertainment. Background balconies cut broad swaths across both picture planes, bifurcating the compositions and underscoring their horizontality; in both instances, this

bifurcation is countered by the insistent verticals of two stout piers, high-lighted by attached lights. Both canvases also represent formally garbed merrymakers, in which somberly clad, black-hatted males predominate, their dark mass enlivened by contrasting accents provided by brightly clad women.

Like the Folies-Bergère, the opera ball enjoyed a reputation as a sexual hunting ground, and it is scarcely surprising that Manet discreetly veils the identities of the middle-class women shown in attendance by outfitting them in dominos. By contrast, the showgirls and cocottes appear in delightfully abbreviated costumes that advertise their charms and underline their availability. The shapely lower-right limb of one of these revelers, dangling provocatively over the balcony railing, prefigures the similarly truncated view of the trapeze artist reflected in the mirror of the *Bar*. In addition to their explicit thematic and compositional correlations, the *Ball* and the *Bar* share another commonality: Both function as *vanitas* pieces. While the *Bar* reflects on the approaching death of the artist himself, the earlier canvas commemorates the demise of a landmark. The old opera house on the rue Le Peletier, which serves as the painting's setting, burned down in October 1873. According to Tabarant, Manet painted the *Ball* in reaction to this loss, and it is perhaps no coincidence that the picture reminded Alain de Leiris of another funereal work, El Greco's *The Burial of Count Orgaz* (1586; S. Tomé, Toledo).[129] As if to underscore the special personal significance of the lost opera house for his peers and himself, Manet introduced another of his rare self-portraits into the *Ball*. Concealed among the revelers near the right edge of the canvas, Manet faces us; a discarded dance card bearing his signature lies at his feet.

Allusions to the Art of the Past Concealed in the Bar

In addition to its multiple allusions to Manet's own work, *A Bar at the Folies-Bergère* also refers to – and reaffirms his connections with – the art of the past. As previously noted, Lloyd has identified the image of Suzon (see Fig. 1) with Renaissance representations of Christ in the tomb, specifically with the fresco by Fra Angelico (see Fig. 2) located in San Marco, Florence:

> Whether the imposing monumentality of [the barmaid] was achieved as the consequence of the artist's having recalled Angelico's fresco is arguable, but the undeniable visual analogy between the three-quarters-length female figure and Christ standing in the tomb is suggestive. The space behind the bar, bounded in the front by the marble slab and in the back by its reflection, is comparable to Christ's sarcophagus. Admittedly, in Angelico's fresco Christ's head is inclined downward, but in at least two of the other frescoes in the cloister of San Marco known to Manet (*Saint Peter Martyr Enjoin-*

42

16. Manet, *The Luncheon in the Studio*, 1868. Oil on canvas. Bayerische Staatsgemäldesammlugen, Munich.

17. Manet, *Ball at the Opera*, 1873–4. National Gallery of Art, Washington, D.C. Gift of Mrs. Horace Havermeyer in memory of her mother-in-law, Louisine W. Havermeyer.

ing Silence and *Saint Thomas Aquinas)* the viewer is confronted by a challenging stare.[130]

We have no way of knowing whether associations to Christ in the tomb were already germinating in Manet's mind while the Amsterdam sketch was in process, or whether this analogy occurred to him only as the definitive composition evolved. However, it is interesting to note that the barmaid in the *esquisse* (see Fig. 3) is shown in three-quarter length, with her hands clasped in a pose similar to that assumed by Jesus in most Renaissance representations of Christ in his tomb – including a second fresco of this subject painted for the monastery of San Marco by Fra Angelico or a follower. [131]

Although Manet made quick drawings of details from several of the frescos at San Marco during his 1857 visit, none depicting *Christ Rising from the Tomb* has survived.[132] However, the artist need not have relied on sketches made in situ, or on his visual memory, to be reminded of Angelico's rendition of this motif. One of the Renaissance master's most celebrated altarpieces, the *Coronation of the Virgin* (1434–5, Fig. 18), together with its intact predella, has been in the collection of the Louvre since 1812. Ernest DeWald points out that this composition marks a turning point in Fra Angelico's development: For the first time, he shows the coronation occurring not in heaven, but on earth, with Christ, the Virgin, and the attendant saints and angels transported to our realm.[133] In view of Manet's evident admiration for the Louvre's Italian Renaissance collection, as well as the fame of the *Coronation,* it seems inconceivable that he would not have been thoroughly familiar with this picture.

Six of the altarpiece's seven predella panels (Fig. 19) portray scenes from the life of St. Dominic, but the central scene, positioned just below the vision of the enthroned Savior, represents *Christ Rising from the Tomb* with his arms outstretched in a pose that closely resembles the larger frescoed version at San Marco.[134] Unlike the majority of artists who have portrayed Jesus through the ages, Fra Angelico consistently represented the Savior as a light-complexioned blond; in the Louvre predella panel, he appears fully as fair-haired and complexioned as Suzon.

One cannot, of course, definitively demonstrate that Manet had Fra Angelico's *Coronation* in mind when he painted *A Bar at the Folies-Bergère.* However, it seems notable that the latter composition reverses the motifs and proportions of the Angelico altarpiece, so that the image of Suzon qua Christ, enlarged and displaced upward, becomes the dominant motif of the painting, while the occupants of the balcony, diminished in scale and relegated to the background of the composition, recall the throng of angels and saints arrayed in ranks across the upper register of Fra Angelico's altarpiece. The similarity becomes even more persuasive when one realizes that the Louvre predella panel depicting the dead Christ shows him standing before the horizontal arm of the cross, which

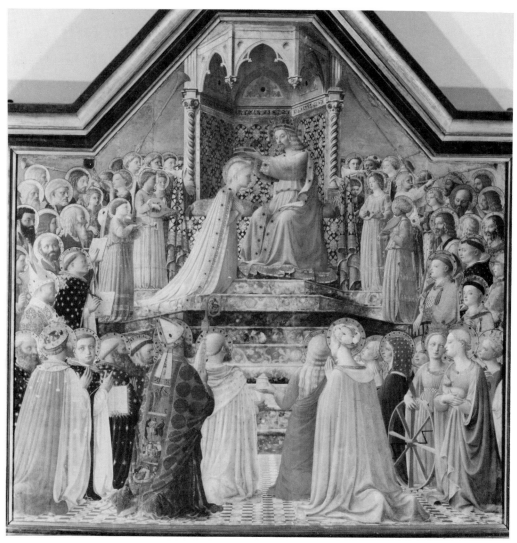

18. Fra Angelico, *The Coronation of the Virgin*, 1434–5. Tempera on panel.
Musée du Louvre, Paris. Photo © R. M. N.

19. Fra Angelico, *The Coronation of the Virgin*, detail: *Predella*. Musée du
Louvre, Paris. Photo © R. M. N.

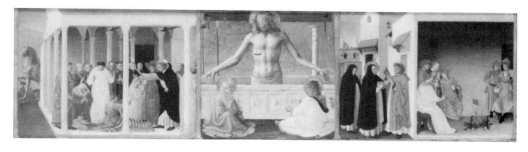

stretches across the upper background (the vertical bar presumably is concealed by his body), while the spear that penetrated his side, and the column against which he was scourged, stand sentry-like on either side of his figure – an arrangement that parallels the interplay of horizontals and verticals operative in the *Bar.* Moreover, the remaining predella scenes employ changing perspectives that require the implied spectator to study them from varied viewpoints, a condition shared (as we have seen) by the mirrored reflections of the *Bar.*[135]

The structure of the left half of the *Bar* (see Fig. 13) also bears a generic resemblance to another favorite motif of medieval and Renaissance masters: *The Last Judgment.* Like Manet's painting, these compositions typically include views of three different levels, symbolizing earth, heaven, and hell, while showing Christ in glory as he renders judgment. A marvelous version of this theme, again by the hand of Fra Angelico, hangs in the Museum of San Marco, which Manet surely visited during his 1857 tour of the adjoining monastery. An empty marble sarcophagus, placed parallel to the picture plane, dominates the central foreground of this *Last Judgment,* a feature that recalls not only the similar coffin represented in *Christ Rising from the Tomb,* but also the image of the marble countertop and its reflection as represented in the *Bar.*

That Manet should have based the pose of the protagonist of his last major work on an image of the dead Christ need not surprise. After all, he had recently confessed to his friend Proust that he was obsessed by an ambition to portray the crucifixion.[136] In the end, he painted not the Savior's agony and death, but the life-in-death vision of Christ in his tomb. Nor was this the first time Manet had essayed this theme: It will be recalled that in 1864 he had depicted *The Dead Christ with Angels* (Fig. 20). Manet's dead Savior appears more helpless and lifeless than Fra Angelico's: Half-seated, half-reclining within his grotto-like tomb, Manet's Christ extends his arms to reveal the wounds in his hands. Two angels accompany and succor him; the contrast between the despairing posture, somber garment, and gray wings of the left-hand angel, and the erect pose, bright raiment, and "triumphant blue" wings of the being on the right, who supports Christ's inert body, led Mauner to propose that the two spirits respectively symbolize Jesus' suffering and death, and his impending resurrection and ascension.[137] As indicated earlier, I believe that the preoccupation with mortality motifs that obsessed Manet during the latter half of the 1860s was triggered by his father's death, and that *The Dead Christ with Angels* represented the artist's elegiac tribute to his dead parent (pace Driskel).[138]

Although we cannot be certain that Manet consciously incorporated a covert reference to Fra Angelico's *Christ Rising from the Tomb* into the *Bar,* it seems likely that this gesture was a deliberate reference to his own impending death. But this motif does not refer solely – or even primarily – to death: To the contrary, it symbolizes Christ's triumph over human mortality, and his imminent resurrection. This is particularly true of rep-

20. Manet, *The Dead Christ with Angels*, 1864. Oil on canvas. The Metropolitan Museum of Art, bequest of Mrs. H. O. Havermeyer, 1929.

resentations, such as those created by Fra Angelico and his school, which portray Christ standing unaided in his sarcophagus, without the support of the ancillary figures shown in many renditions of this motif, including Manet's own composition of 1864. Indeed, the image of Christ featured in Fra Angelico's fresco and echoed in the predella of his *Coronation* seems so vibrant that its current title, *Christ Rising from the Tomb,* seems much more appropriate than *The Dead Christ* or *Pietà,* as it (like most versions of this theme) had previously been labeled.

A Bar at the Folies-Bergère contains yet another indirect reference to past art with funereal connotations. As I pointed out earlier, Manet evidently associated the images of Jeanne Demarsy and Méry Laurent featured in the *Bar* with his allegorical representations of the two women as *Spring* and *Autumn,* respectively. Allegorical depictions of the seasons, which originated during Roman times, continued to enjoy great vogue until the end of the eighteenth century. Although (as Manet was no doubt well aware) the French Rococo painters of *fêtes galantes* transformed this motif into scenes of young love, it had originally conveyed less lighthearted associations to the stages of human life, and hence to our mortality. Because of these connotations, reliefs representing the seasons are often found on Roman sarcophagi; typically, these reliefs depict the seasons as Erotes bearing appropriate attributes. Hundreds of sarcophagi featuring these allegorical figures have survived from antiquity; the vast Roman collection of the Louvre contains some prime examples, with which Manet may well have been acquainted. (He could also have encountered such seasonal sarcophagi in his travels about Italy.)[139] That the artist should have attached such implications to the miniaturized portraits of Laurent and Demarsy included in the *Bar* seems entirely congruent with the hypothesis that Suzon's image encodes a reference to the dead Christ. One might note, too, that the vase of overblown roses displayed on the bar counter constitutes a time-honored memento mori. (As Cachin points out, the flowers and fruit featured on the countertop are also reminiscent of the small still-life pictures that Manet himself created in abundance during the last years of his life.)[140] The fact that these objects cast no reflection in the background mirror reaffirms their funereal connotations: The echoes of the roses, tangerines, and liquor bottles arrayed on the counter have been forever obscured, absorbed into the blackness of the reflected forms of barmaid and customer, just as the artist himself was destined soon to be absorbed into the blackness of the tomb.

The Psychoiconography of the Bar: *Summary and Conclusions*

The preceding sections have presented a detailed analysis of the form and content of *A Bar at the Folies-Bergère,* elements I consider to be equally integral aspects of the psychoiconography of the painting. In this final section, I shall attempt to assemble these elements into an integrat-

ed portrait of Manet's psychological state at the time he painted this picture.

In my view, the Amsterdam sketch for the *Bar* functions as an iconographic, as well as compositional, prologue to the definitive painting. The interaction between barmaid and customer, as depicted in the *esquisse*, alludes to an incident from the artist's personal past that occurred, not in a Paris nightclub, but on the streets of Rio de Janeiro: his alleged encounter with a diseased prostitute-slave who infected him with syphilis. The setting of the *Bar,* amid the artificial gaiety of the Folies-Bergère – part theater, part café-concert, part whorehouse – recalls the similarly feverish atmosphere prevalent during those long-ago Carnival festivities, as described by the future artist in letters written in Rio.[141]

But it is the specific nature of the encounter between waitress and customer in *A Bar at the Folies-Bergère* that seems so redolent of Manet's own situation as an adolescent succumbing to the contagious excitement of Carnival. His selection of Henri Dupray as his alter ego of choice to replay this scenario in the sketch lends added weight to my reconstruction. Not only was Dupray a fellow artist and personal friend, he was known exclusively as a painter of military subjects. In the *esquisse,* he appears as Manet's surrogate, reenacting an episode from the latter's abortive military career as a teenage naval cadet. Regarded in this light, Dupray's diminutive stature becomes comprehensible: It symbolizes Manet's own psychological and biological immaturity at the time he supposedly contracted the syphilitic infection that he believed to be responsible for his progressive neurological disease.

But if Carnival is a time of gaiety and abandonment, permitting individuals from radically different social classes to intermingle freely (a situation that likewise prevailed at the Folies-Bergère), the festivities also serve as the direct prelude to Lent. At least in theory, if not always in practice, Carnival ushers in forty days of penitence and self-denial, designed to parallel the similar period that Christ spent fasting in the desert before beginning his public life.

In the Courtauld version of the *Bar at the Folies-Bergère,* the network of allusions Manet encoded in the composition grew in complexity, encompassing formal as well as iconographic aspects of the work. The instability of vision that Manet's pictorial strategy imposes on the viewer mimics the artist's own bodily weakness, transforming his tremulous gait and uncertain balance into psychological reactions experienced by the spectator. But the complex perspectival system serves another key purpose: It forces the viewer to participate psychologically in the artist's growing awareness of the tenuousness of the lifeline that bound him to his mortal existence. As he struggled to complete his last major project, Manet finally abandoned the disavowal and splitting off that had characterized his previous response to his illness. On the deepest – perhaps unconscious – level, the multiple viewpoints represented in *A Bar at the Folies-Bergère* symbolize the newfound ability of its creator to evaluate

his situation from every perspective and to accept, at last, the imminence of his own death.

When he painted his *Self-Portrait with a Palette* (see Fig. 5), Manet superimposed his own image over that of his wife. In creating *A Bar at the Folies-Bergère,* he reversed this procedure, concealing his ultimate self-image beneath that of another Suzanne. That the artist should choose a young woman as his alter ego should not surprise. Artists, like dreamers, freely assume roles that transcend age, gender, and other real-life limitations; in our nighttime fantasies, we permit ourselves to play every part, a license the artist also exercises in waking life, via the magic of creativity. Moreover, there was something rather soft and feminine about Manet's own nature (perhaps an outgrowth of his unusually close relationship with his mother and somewhat awed attitude toward his father) that might have predisposed him to select a woman as his final symbolic representative. In emulation of his countryman and peer, Gustave Flaubert, Manet might well have declared "Suzon, c'est moi."[142]

In *A Bar at the Folies-Bergère* (see Fig. 1), Suzon represents aspects of the artist's past, present, and future. Like his beautiful protagonist, whose psychological isolation from her surroundings has been the source of so much scholarly puzzlement, Manet now existed in a limbo – still *in* this world, but no longer *of* it, increasingly distanced from everyone and everything he had once held dear by the inexorable approach of death. Equally unmindful of the (unrepresented) promenaders parading by, of the (implied) customer standing before her, and of the reflected crowd captured in the mirror behind her, Suzon dwells apart. So, too, did her creator. The detachment that had once been part of Manet's deliberately assumed public persona had now become his lifeline, enabling him to maintain his integrity and dignity, no matter what his private turmoil, and to continue fulfilling his allotted role as witness to, and recorder of, the contemporary scene.

By virtue of her youth and beauty, Suzon also serves as a symbol of Manet's vanished halcyon days when he was one of the most handsome and admired of boulevardiers. If Steven Levine's provocative hypothesis is correct, the barmaid's image may indirectly refer to still other aspects of Manet's youth. Levine suggests that the gold bracelet adorning Suzon's right arm (see Fig. 13) may be the same jewel worn by Victorine Meurent in *Olympia* (1863; Musée d'Orsay, Paris), and by the artist's mother in the portrait her son painted in 1863 (Isabella Stewart Gardner Museum, Boston), which shows Mme Manet in mourning following the death of the artist's father. Presumably originally crafted for Manet's mother, this intricate bracelet features a pendant of lapis lazuli, which served as a precious casket for a lock of Manet's baby hair.[143] If Levine's observation is accurate, Manet's association of this family heirloom with images of these three women would suggest that he used this precious relic of his infancy as a special marker, a *signifier* in current par-

lance, indicating the covert bondage – emotional as well as artistic – linking him with the women who wore it: the mother who bore him, the model who posed for his most celebrated (and favorite) painting, and the barmaid who symbolized his ultimate self-image.

Behind her "real," frontal personification, Suzon appears reincarnated as a ghostly reflection (see Fig. 14), enacting other passages from her creator's private drama, on that flickering screen that Mauner has rightly labeled the mirror of the vanities.[144] Her cordial response to the mustached customer – himself a mere reflected phantom – may allude, once again, to the artist's own encounter with the prostitute in Rio. But the customer in the full-scale painting, in contrast to the one in the sketch, appears neither childlike in scale nor nonplussed; to the contrary, he has grown in size until, like a masculine Alice, he threatens to burst the boundaries of the canvas that barely serves to contain him. His grandiose stature correlates with Manet's contemporary reputation as the leading artist of Paris – a reputation that had been further enhanced by his recent induction into the Legion of Honor. But the exchange between this gentleman of somber elegance and the cordial barmaid may also allude to Manet's mature professional and personal relationships with women who led liberated lives and bestowed their sexual favors in accord with their inclinations: women like Méry Laurent and, much earlier, Victorine Meurent.

The customer's dandified appearance recalls that of Antonin Proust as Manet had portrayed him in 1880 – the image that had stimulated the artist's confession that he had painted his friend as "Christ going to Magdalene." None of the accounts in the New Testament explicitly describes Mary Magdalene as a whore, but rather as a demoniac whom Christ healed. However, a universal tradition has identified her with the unnamed, repentant prostitute who anointed Jesus' feet with precious ointment while he was at table in the house of the Pharisee (Luke 7: 36–50), and the Magdalene has often been portrayed in art with the alabaster jar symbolizing this incident. (Manet's seemingly irreverent comment to Proust suggests that he was well aware of the tradition linking Mary Magdalene with prostitution.)[145] However, all four Gospels specifically connect the Magdalene with Christ's passion and death: She is described as a sympathetic witness to Jesus' crucifixion, as a participant in his entombment, and as one of the women who discovered Christ's empty tomb when they went to anoint his body. The Gospels of Mark and John also identify her as the first person to whom Jesus appeared following his resurrection (Mark 16: 1, 9, 10; John 20), an encounter celebrated in numerous Renaissance paintings under the title *Noli me tangere*. (Parenthetically, it might be noted that among the frescos with which Fra Angelico adorned San Marco can be found beautiful depictions of these two scenes.)[146] It appears that Manet associated the two images of Suzon with Mary Magdalene's character and roles in the drama of Christ's

passion, death, and resurrection. (The tradition identifying the Magdalene as a dispenser of libations may have facilitated his association of her with his barmaid.)

The funereal connotations of the *Bar* for its creator are suggested by the ephemeral character of the still-life objects: champagne and ale, once opened, soon go flat; oranges must be consumed or decay; overblown roses drop their petals, becoming skeletal stalks. These implications are reinforced by the implicit references to the seasons of human life, symbolized by the portraits of Laurent and Demarsy. By the time he created *A Bar at the Folies-Bergère,* the spring and summer of Manet's own life were but bittersweet memories; his autumnal period was drawing to a close, and he must have been well aware that he would never live to experience the winter of old age. As Paul Isaacs suggests, the empty chair positioned next to Méry Laurent and directly in front of Jeanne Demarsy probably symbolizes the artist's imminent death.[147] But that vacant chair also recalls the biblical account of Mary Magdalene's expedition to visit Christ's tomb, only to find it empty and to be informed by an angel that Christ had risen. Soon after, Jesus appeared to her, confirming the reality of his resurrection.

Whether Manet, who was ostensibly a Roman Catholic, believed in personal immortality remains uncertain. Whatever his private religious convictions, the artist, like any dying person, was surely preoccupied with the prospect before him, with the necessity for separating himself from his world, and for bidding farewell to everyone and everything he held dear. These preoccupations impregnated the very fabric of *A Bar at the Folies-Bergère,* which gradually evolved into a painted document teeming with encoded references to Manet's past, present, and future, including, above all, his concerns about his posthumous reputation and the judgment posterity would render regarding his role as artistic innovator.

Although the entire painting abounds with such personal allusions, it is the central figure of the "real" barmaid who serves as Manet's principal alter ego. Presented in the overt guise of a simple working girl, she encodes the covert Christ image that constitutes Manet's final symbolic self-portrait as the Savior in the tomb, whose life-in-death status prefigures his imminent resurrection, the completion of his earthly mission, and his ascension to heaven. (An indirect reference to the ascension may well be embodied in the figure of the trapeze artist, who is represented in the *Bar* as lofted so far above our line of sight that we glimpse only her lower limbs and feet, just as the apostles watched Christ disappear from earthly view.)

Like his disguised Christ figure, Manet symbolically depicts himself as severed from this world, yet part of it; dying, yet destined to live forever in the corpus of paintings that would constitute his legacy to artists of the future and consolidate his reputation as a pioneer of that new dispensation, Modernism.

Appendix: Key to Figure 15

William Conger's explanation of the lines and numbers displayed in the perspectival diagram of Edouard Manet's *Bar at the Folies-Bergère* (see Fig. 15) follows:

1. The edge of the marble countertop reflected in the background mirror forms the most obvious perspectival angle in the painting. Extending this edge upward through the composition provides one reference for the placement of the central vanishing point, the assumed locus for a one-point perspectival construction. In the diagram, this diagonal line ends at the horizon line, indicated by 2.

2. The horizon line for the central vanishing point intersects it at the convergence of lines 1 and 3, just below the left corner of Suzon's mouth, focusing the viewer's attention there. The horizon line through this vanishing point passes between the top-hatted figures shown in the balcony. The rules of one-point perspective require the spectator to look up at objects positioned above the horizon line, and down on objects shown below it. Manet has accurately provided for the viewer to see the tops of hats below this line, and to look up at those shown above it. An extension of the horizon line 2 to the right puts it at the same location on Suzon's reflection as on her "real" figure.

3. The perspectival angle that represents a receding edge converging upward to the vanishing point on line 2 is determined by constructing a box around the compote displayed on the countertop. The size and position of the box is fixed by the oblique plane and shape of the compote rim, and by the vertical axis drawn through its stem. This axis indicates the placement of the diagonal crossings on the top and bottom planes of the box; they, in turn, dictate the position of the rear vertical plane of the box, relative to the corresponding plane at its front. By this means, the locations of the receding angles of the left and right sides of the box are defined; the right-hand line extends to the vanishing point on line 2, while the other on the left intersects it at 4.

4. The left side of the box (drawn to fit the compote exactly in perspective) intersects the perspective line of the right side of the box at point 4, thus setting a new horizon line and a new eye-level sight line for the viewer, well below the central point where lines 1, 2, and 3 converge. This new, lowered vanishing point brings the viewer downward to the right of the composition, into a better position to glimpse Suzon's reflection. More important, however, is the impact of this lower vanishing point in creating a subtle logic for Suzon's apparent monumentality, the sensation that she towers over the viewer, despite the fact that the original vanishing point puts the viewer on a level with her mouth.

5. Lines drawn through the capitals of the reflected pilasters (which are depicted in correct perspective) converge just above the "real" Suzon's right shoulder, establishing a new vanishing point and eye level for the spectator, thus moving the viewer to the left side of the composition. (The horizon line for point 5 is proven by its extension to the right, where it correctly passes between the hats shown above and below it.) The viewer's leftward drift is reinforced by the perspective of the real and reflected bottle on that side: An extension of the perspectival angle descending from the capital of the pilaster on the right aligns with the tops of the actual and mirrored bottle as shown on the left side of the counter and reflected in the mirror. Moreover, Suzon's gaze seems to be parallel to that angle; the direction of her glance reinforces the viewer's urge to follow it, to slide down that line, as it were, to the lower-left side of the composition; from this new location, one overlooks the mezzanine railing, into the blurred scene of activity below reflected in the lower-left quadrant of the mirror. This lowered eye level also increases the apparent elevation of the swinging performer in the upper-left corner.

6. In contrast to the vanishing points indicated by 4 and 5, the position of the reflected male figure places the viewer in a new, elevated position. Because the top of the man's hat brim is visible, it is evident (following the rule of one-point perspective) that the horizon line – and thus the spectator's line of sight – is above that level. This is proven by extending line 6 through the composition, using the reflected chandeliers as a guide. This horizon line falls above Suzon's head, revealing the crown parting of her hair and placing the viewer's line of sight above it.

7. Only the second of the bottles shown on the right side of the countertop is reflected in the mirror, where its neck can be seen just above the reflection of Suzon's cuff. A perspectival angle aligning this "real" bottle with its mirror image suggests an implicit vanishing point beyond the right edge of the picture. This urges the viewer to imagine being located directly in front, or even to the right, of the reflected customer. From this new, implicit location, the position of Suzon's reflection seems logical, despite the fact that other perspectival devices employed in the composition contradict it.

8,9. In formal terms, the light globes on the pilasters are frontal circles, implying a position for the viewer midway between them. This reinforces the perspectival position indicated by 5, placing the viewer to the left of Suzon's central image, but above 5, even with Suzon's own eye level. Conversely, the Bass Ale labels, with their distinctive triangles, constitute formal counterparts to the globe circles, also positioning the viewer between them, slightly to the right of Suzon and very low in the composition.

The very subtle twisting of Suzon's body – and the indication that she is balanced on her right leg, shifting her body to the left in *contrapposto* fashion – is echoed by the complex perspectival ambiguity of the painting, which establishes a more animated imaginary movement on the part of the viewer, through the positions of the varied vanishing points, which lead the eye hither and yon. While Suzon appears stable and meditative, the viewer, animated, anxious, and puzzled, searches in vain for an equally stable resting place within Manet's painted enigma.

2

Wrestling Anew with Gauguin's Vision after the Sermon

William Darr and Mary Mathews Gedo

"I HAVE just finished a religious painting, very badly made but that interested me to do and that pleases me very much." With these words, Paul Gauguin introduced *The Vision after the Sermon (Jacob Wrestling with the Angel)* to his friend Vincent van Gogh, in a letter written from Pont-Aven, Brittany, during the last week of September 1888.[1] Gauguin had every right to feel pleased: He had just painted his first real masterpiece; he had just discovered his mature style. This heady experience fired his creativity, and during the months that followed he produced the long series of bold and innovative works that have led scholars to identify the period between 1888 and 1890 as the most critical of his career.

The Vision introduces, in a fully developed form, stylistic and iconographic innovations barely hinted at in the canvases that immediately preceded it. The deliberately antinaturalistic, antiperspective character of the composition, the flattening of forms, the emphasis on contours and on the application of areas of intense, virtually unmodeled color – all these underline the revolutionary character of *The Vision*. Nor are there precedents in Gauguin's previous work for the dynamic thrust of this subject, whose religious narrative is reinforced by its strong psychological undercurrents.

The Vision after the Sermon (Fig. 21) portrays a group of pious Breton women; garbed in black highlighted with touches of bright green or blue and coifed in outsize bonnets of luminous white, they kneel, ringing a meadow of glowing vermilion. The artist depicts them as they simultaneously experience two psychological states: the sensation of belonging to the actual world of external observation, and that of participating in an internal vision that has the compelling force of reality. This group hallu-

21. Paul Gauguin, *The Vision after the Sermon (Jacob Wrestling with the Angel)*, 1888. Oil on canvas. The National Galleries of Scotland, Edinburgh.

cination has been induced by a powerful sermon based on Genesis 32: 22–24:

> And rising early he took his two wives, and his two handmaids, with his eleven sons, and passed over the ford of the Jaboc. And when all things were brought over that belonged to him, he remained alone: and behold a man wrestled with him till morning.[2]

Hypnotized by the priest's words, the good women envision this illusory combat, represented by two wrestling figures whose diminutive dimensions contrast with the gigantic scale of the five peasants whose heads loom up in the foreground. Linked by their linear and spatial juxtapositions, these figures form a human screen through which we view the scene from a viewpoint seemingly a bit above and behind them. The lower-left corner of the composition is occupied by a woman whose closed eyes and folded hands attest to her piety. Gauguin has boldly bi-

sected her form, so that only her right shoulder, face, and hands are visible. Her masculine counterpart, filling the corresponding space in the lower-right corner of the canvas, mirrors her pious demeanor. Painted in *profil-perdu*, he consists only of a visage and a fragmented left shoulder. He kneels next to two women who turn their backs to us, proudly displaying their enormous peasant bonnets, in which hidden images seem to lurk. The young woman who claims the center foreground space acts as the fulcrum around which the composition revolves. The only participant depicted with her head erect and her eyes open, she stares fixedly at the two biblical figures positioned directly across from her. Her unique role is further underlined by the fact that she wears a distinctive coif, smaller and more transparent than those of the other women. Ranged around the left perimeter of the painting are two additional clusters of kneeling women, whose arbitrarily diminished sizes and flattened forms reflect Gauguin's willful disregard of the laws of perspective and illusionism. These two groups are linked to one another and to the foreground figures by their overlapping silhouettes, which underline the commonality of their fervor and the shared character of their visionary experience. A tree trunk arcs across the picture plane in a bold diagonal, bisecting the canvas, separating pious peasants from visionary contestants. The foliage of the tree spreads canopy-like across the top of the picture plane, half obscuring the two most distant female figures. A miniature cow, no larger than a lapdog, gambols directly across from the wrestlers, its muzzle nuzzling the tree trunk. The angel, his blue robe fluttering, grasps the bearded Jacob by both shoulders, but the struggle will soon come to an end. Day is breaking; in the light of the rising sun the angel's wings and hair gleam golden, and the tree trunk glows.

Defining the Problem

More than a century has passed since Gauguin painted this great picture, now universally recognized as one of the icons of modernism. Despite its status as a key monument in the history of art, the painting has long been the focus of ongoing scholarly debates. Questions concerning the precise date of its creation and the correct interpretation of its iconography periodically recur. The most controversial of these unresolved problems concerns the putative role that Emile Bernard (1866–1941) played in the genesis of *The Vision*. At the time Gauguin created this picture, Bernard was his admiring disciple, working beside the master at Pont-Aven. Their relationship remained very friendly until 1891, when G.-Albert Aurier (1865–92) published "Symbolism in Painting: Paul Gauguin."[3] This article, which began with a long, poetic evocation of *The Vision*, hailed Gauguin as the leader of the new Symbolist movement. The resulting publicity enhanced the artist's reputation, but it also kindled the rage and vengefulness of Bernard, who had persuaded Aurier to write about Gauguin in the first place, only to find his own art and role in the evolution of Sym-

bolism ignored in Aurier's essay. As the years passed, Bernard became more and more convinced that Gauguin had created *The Vision* by cannibalizing Emile's contemporaneous canvas, *Breton Women in a Meadow*. Bernard published his first full-blown account of this alleged plagiarism in December 1903:

> The Pardon had just been held at Pont-Aven and I, taking this local custom as my theme, had painted in a pre-conceived yellow-green a sunlit field, illuminated with Breton bonnets and blue-black gowns. Taking my painting as his starting point, Gauguin did his *Vision after the Sermon*, a picture in which the bonnets became the main theme, as in mine. He defined his foreground against a preconceived red backdrop, in which two wrestlers, borrowed from a set of Japanese prints, were deployed to represent a vision. This flat-tinted painting was so different from the previous work of Paul Gauguin that it amounted to a complete negation of it, and it was so similar to my own *Breton Women in a Meadow* as to be practically identical to it.[4]

Throughout the remainder of his long lifetime, Bernard returned to the attack again and again; as he aged, he portrayed his role in shaping Gauguin's artistic evolution in ever more grandiose terms, eventually effectively reversing their roles, so that he became the juvenile prodigy who instructed, while Gauguin was cast in the role of the grateful recipient of these lessons.[5]

Although a number of Gauguin scholars have responded to Bernard's allegations with skepticism, for many others the forcefulness of his assertions has carried the weight of conviction. The authors of the catalogue that accompanied the recent Gauguin retrospective of 1988–9 adopted the latter position. After hailing Bernard as one of the inventors of Cloisonism, Claire Frèches-Thory, who wrote the entry on *The Vision*, added:

> [T]he importance of Bernard's painting in the genesis of [*The Vision*] should not be underestimated either. Both works contain the same single-color idea in the background with simplified silhouettes starkly outlined; and both abandon realism in favor of a more decorative, Japanese notion of art.... Bernard's painting and Japanese sources – for the diagonal tree and for the struggle between Jacob and the angel, which was inspired by illustrations of wrestlers in Hokusai's *Mangwa* prints – appear to have served as a catalyst for Gauguin's poetic imagination.[6]

This essay focuses on these three unresolved problems concerning *The Vision*: its genesis, date, and iconography. We present evidence to support the thesis that Gauguin began this painting, not in mid-August – the date most commonly accepted – but rather in mid-September, immediately following the celebration of the annual pardon at Pont-Aven,

which in 1888 occurred on September 15 and 16. Next, we hope to demonstrate that *The Vision* represents a highly personal statement on the part of its creator, encoding in its iconography references to Gauguin's contemporaneous experiences, reactions, and relationships. Finally, we reexamine Bernard's assertion that his *Breton Women* directly inspired *The Vision*, a claim that we believe was deeply colored by the younger artist's complex, ambivalent attitude toward Gauguin, both during the period when they worked together at Pont-Aven and in the years that followed.

Gauguin at Pont-Aven

Gauguin painted *The Vision* during a lengthy sojourn in Pont-Aven that began in February 1888 and ended on October 21 of that year, when he left for Arles and his fateful encounter with Vincent van Gogh. This time of rapid artistic transition coincided with equally profound transformations in Gauguin's inner world; during this period changes in his character and interests that had been in process during the past few years became quite explicit. As Amishai-Maisels points out, around this time "Gauguin began to think in symbols" and to consolidate the development of a personal mythology structured around his claim that he possessed a bifurcated, or double-sided, personality, in which the "Inca savage" and the civilized Frenchman vied for preeminence.[7]

Gauguin's growing preoccupation with his alleged savage heredity fed his interest in "primitivism" (already evident in ceramics he had created as early as 1886) and his craving to explore remote and exotic places that would provide suitably picturesque settings for his art. The Caribbean voyage on which he embarked in the spring of 1887 represented his first sustained exploration of this sort.[8]

Only three months after he returned from this arduous trip (which lasted from April until November 1887), Gauguin left Paris for Brittany. A complex set of motives triggered this decision. He was certainly well aware that this region would offer excellent opportunities for living cheaply and finding interesting motifs to paint, because he had already made a lengthy stay at Pont-Aven in 1886, when he had lived in the village from July until November. During that visit, he had stayed at the inn owned by Joseph and Marie-Jeanne Gloanec, who offered the cheapest accommodations in Pont-Aven, providing room and board for sixty francs a month. When he returned to Brittany in 1888, Gauguin once again sought out Pont-Aven and the Gloanec inn. In a celebrated letter to his friend Emile Schuffenecker (1851–1934), written a few weeks after he had resettled in the village, Gauguin explained his motivation for the move as follows: "I love Brittany. I find wildness and primitiveness there. When my wooden shoes resound on this soil of granite, I hear the muffled, dull, and powerful tone that I try to achieve in my painting" (M. 141).

John Rewald wryly observes that, despite Gauguin's endorsement of the inspirational qualities of Brittany, the first canvases he painted there in 1888 seemed "muffled and dull, though by no means powerful."[9] Rewald attributes this problem to Gauguin's difficulties in integrating his impressions of Brittany with his recent experiences in the tropics. Despite his proclivity for seeking fresh inspiration in new locales, Gauguin did not find it particularly easy to accustom himself to such changes in his surroundings. The fact that the move to Brittany coincided with a transitional phase in his artistic evolution, in which he was actively searching for new forms of expression, prolonged the uncertainty that followed this relocation.[10]

His artistic problems constituted but one aspect of the multiple difficulties that beset Gauguin during the spring of 1888. Lacking any other source of income, he was totally dependent on the efforts of Theo van Gogh, who had recently become his dealer, to sell the pictures and ceramics that the artist had left on consignment at the gallery of Boussod, Valadon and Company in Paris, where van Gogh was employed. These sales were so erratic and infrequent that Gauguin was forced to take full advantage of Mme Gloanec's generosity in extending him virtually unlimited credit (plus free space in the inn's attic to use as a studio); even so, he could not always afford to buy painting materials. The recurring bouts of dysentery and malaria that he suffered – the unfortunate double legacy of his Caribbean sojourn – sapped his creative energies, slowed his adaptation to his new surroundings, and increased his indebtedness, saddling him with medical bills that he could not pay, any more than he could settle his mounting tab at the inn. He must also have been terribly lonely during his first four months at Pont-Aven. Although the region, already celebrated as an art colony, was crowded year-round with painters from France and abroad, Gauguin held himself aloof from the other artists, whom he regarded – not without reason – as academic hacks.

When Gauguin turned 40 on June 7, 1888, he "celebrated" his birthday alone at the Gloanec inn. (Appropriately enough for one who proudly proclaimed his double-sided nature, the artist was born under the astrological sign of Gemini, the twins.) Like Dante before him, Gauguin must have felt that, midway through the path of life, he had lost the way.[11] Bitterness permeated the letter he wrote his estranged wife, Mette, a few weeks later, in which he upbraided her for mentioning her own needs in her last letter, while he had passed his fortieth birthday without garnering any statements of admiration or support from his family comparable to those he received from relative strangers (M.154).

During the next few months, however, Gauguin's situation underwent a sea change, and by the end of September he had found the artistic path that he would follow for the remainder of his abbreviated lifespan. The warm weather brought additional artists to Pont-Aven, and Gauguin soon attracted a coterie of devoted disciples whom he respected, and with whom he could exchange ideas. The presence of this little band

played a key role in enhancing his creativity and accelerating the rapid artistic evolution he now experienced.

Charles Laval (1862–94), Gauguin's first and most loyal disciple, and his companion on the ill-fated Caribbean voyage, rejoined the master in July.[12] Around the same time, two young Breton painters, Henri Moret and Ernest de Chamaillard, became adherents of Gauguin.[13] Sometime during the first half of August, the 20-year-old Emile Bernard arrived on the scene, bringing with him a number of radical canvases that he had painted at Saint-Briac (Brittany), where he had been working since the spring. This was not the first meeting between the two artists: Bernard had also worked in Pont-Aven during the late summer of 1886, when he had attempted to strike up a friendship with Gauguin, only to be met with what he later recalled as a chilling rebuff.[14]

This time around, Bernard came armed with a personal recommendation from Vincent van Gogh, with whom he had established a comradely relationship during 1887, when van Gogh, the first person to take Bernard seriously as an artist, had painted with him on the banks of the Seine at Asnières.[15] After the Dutch artist moved to Arles in February 1888, he and Bernard continued their lively exchange by post; these contacts played an important role in shaping the latter's ongoing artistic research during that spring and summer.[16] Gauguin, who was deeply involved with both the van Gogh brothers by that time, and who was also carrying on a regular correspondence with Vincent, treated the latter's endorsement very seriously and cordially welcomed Bernard into his circle. Gauguin must have been even more delighted to encounter Bernard's beautiful young sister, Madeleine. Depending upon which of her brother's memoirs one chooses to credit, Madeleine either accompanied Emile from Saint-Briac, where she had joined him earlier, or traveled with her mother directly from Paris to Pont-Aven.[17] Whatever the precise facts and date of her arrival, Madeleine apparently remained in Pont-Aven (together with her mother) until the second week in October.[18]

During the final days of the vacation season, another young painter, Paul Sérusier (1864–1927), joined the ranks of Gauguin's disciples. The latecomer, then an advanced student at the conservative Académie Julian, had spent the month of September at Pont-Aven, hovering wistfully around the periphery of Gauguin's circle, too timid to approach the master directly.[19] The day before his scheduled return to Paris, Sérusier finally summoned his courage and, with Bernard acting as intermediary, presented to the ailing Gauguin, once again laid low with dysentery, a canvas he had painted at Pont-Aven. Gauguin, galvanized by the encounter and realizing that there was no time to be lost, offered to leave his sickbed and meet Sérusier the following morning in the nearby wooded area, the Bois d'Amour. There, working under the older artist's direct tutelage, Sérusier rapidly painted the little oil on panel *Landscape at the Bois d'Amour at Pont-Aven,* now known as *The Talisman* (Musée d'Orsay, Paris), the picture that would earn him an immortal niche in the

history of art.[20] This radical little picture has lost none of its shock value with the passage of time; as Rewald observes, Sérusier, with the enthusiasm of a proselyte, had gone much further in abstraction than Gauguin himself.[21]

As a student administrator (*massier*) at the Académie Julian, Sérusier had extensive contacts with his fellow pupils.[22] He immediately displayed his little panel to his special friends at the academy, while simultaneously indoctrinating them with his interpretation of the "master's" theories. Sérusier's friends, all students several years younger than himself, included Pierre Bonnard, Maurice Denis, Paul Randon, Félix Vallotton, and Edouard Vuillard. This youthful band of enthusiasts began to meet regularly and soon formalized their association as the Nabis (a Hebrew word meaning "prophets"), thus institutionalizing their variation on the Symbolist style that Gauguin had developed in Pont-Aven, as interpreted by Sérusier.[23]

Despite the importance of Sérusier's role in helping to establish Gauguin's broader reputation, Emile Bernard had a far more direct impact on the master's contemporary art and life. The canvases that Bernard brought from Saint-Briac, with their thickly outlined forms and flat tints, surely struck a responsive chord in Gauguin, then in the midst of his struggle to abandon his former Impressionist manner in favor of a new style that had many points in common with Bernard's.[24]

Although Gauguin's ceramics of 1886 and 1887, with their deliberately rough, primitivizing character, reflected his growing fascination with naive and non-Western art forms, it remained for Bernard and his sister to direct the older artist's attention to the inspirational character of the indigenous religious art of Brittany.[25] The Breton churches, with their colorful stained glass and crudely painted statues, as well as the wayside shrines with their scenes from the Passion and their charming images of native saints, had deeply impressed Bernard during the course of the walking tours of Brittany he had made in 1886 and 1887. These impressions had played a prominent role in shaping the Cloisonist style he had subsequently developed in company with Louis Anquetin and others.

Bernard's impact on Gauguin was magnified geometrically by the fact that his beautiful sister, Madeleine, assumed a prominent role in the day-today activities of the master and his little band. Madeleine and her brother were deeply attached to one another; she shared his commitment to art and supported his resolve to become a professional painter, despite the mean-spirited opposition of their tyrannical father. Fully as mystical, intense, and religious as Emile, she, too, was fascinated by the piety of the Bretons and the naive, but forceful, character of their artifacts. Shortly after her arrival in Pont-Aven, Madeleine acquired a Breton peasant woman's costume, which she often wore, purportedly in order to set an example for the young women of the region, who were abandoning their traditional dress for contemporary clothing, but no doubt

also because it was extremely becoming, as the photograph that Emile took of her in costume that summer attests.[26] At age 17, Madeleine was young enough to be Gauguin's daughter; nonetheless, he quickly became infatuated with this girl, whose lively mind attracted him as much as her beauty. Indeed, several scholars are convinced that, far from being merely attracted to Madeleine, Gauguin fell deeply in love with her.[27] At least in retrospect, Emile Bernard seems to have concurred in this judgment; in his late autobiographical account, *Souvenirs inédits,* he notes: "Gauguin, consoled by my sister, who had the true character of a saint and an artist, fell in love with her and planned to carry her off, but my father interfered in time."[28]

Although she ultimately chose his sickly disciple, Charles Laval, in preference to Gauguin, Madeleine was not indifferent to his attentions that summer, and her brother's assertion that she functioned as the muse of Gauguin, Laval, and Emile himself during those weeks at Pont-Aven seems quite justified.[29]

When Gauguin asked Madeleine to pose for her portrait (Fig. 22), she evidently readily acquiesced. As Françoise Cachin suggests, this portrait was made at a time when both the artist and his model "were searching for a direction for their lives and for some kind of justification of their aspirations.... As the painting shows, an ambiguous relationship sprang up between Gauguin and his adolescent model, with her mystical nature, her singularity, and her yearning for independence."[30] If, as Cachin also proposes, the extra-large coat wrapped about Madeleine's shoulders actually belonged to the artist himself, he represented his garment enjoying the kind of intimate physical contact with the young woman that he himself no doubt longed to experience, but did not dare to attempt with this very properly brought-up, convent-bred girl. (The little Chinese or Persian slippers nestled together on the table beside the model may also symbolize this longing for closeness.)

Unable to express the true nature of his feelings for Madeleine, Gauguin assumed – or pretended to assume – the role of an affectionate and protective older brother vis-à-vis the young woman. The simulated character of this fraternal attitude seems evident in the letter he wrote her the following October, soon after Madeleine returned to Paris from Pont-Aven. Addressing her as his "Dear Sister," the artist rather pretentiously advised her about the path she should follow in order to achieve the Christian virtues, a sense of personal worth, and the desirable state of androgyny.[31]

Although Gauguin's correspondence prior to 1888 had never been notable for expressions of religious sentiment, such references cropped up in several of the letters he composed during the late summer of 1888. For example, on August 14th, he wrote Emile Schuffenecker:

A bit of advice, don't copy too much after nature. Art is an abstraction; extract it from nature while dreaming before it and think more

22. Gauguin, *Madeleine Bernard*, 1888. Oil on canvas. Musée de Grenoble.
Photo © Erich Lessing / Art Resource, New York.

of the creation than of the result; this is the only way to ascend to-
ward God in doing as our divine master does, creating....

My last works show good progress, and I believe that you will
find [in them] a particular note, or rather the affirmation of my pre-
vious researches, the synthesis of a form and of a color in only con-
sidering the dominant one. Come, have courage, may God take you
in his holy care in crowning your efforts. (M. 159)

65

Another letter to Schuffenecker, preserved only in fragmentary form, included this enigmatic reference: "What an artist this Jesus, who sculpted in humanity itself, and what a bore this Solomon." This missive concluded with the following rather lofty sentiments:

> In the absence of religious paintings, what beautiful thoughts form and color can evoke. How happily earthbound these pompous hacks are with their trompe l'oeil of nature. We alone sail on the phantom ship with all our whimsical imperfection. The infinite seems to us more tangible before an undefined object. The musicians enjoy with their ears, but we with our insatiable eye, we taste pleasures without end. Later when I'll dine, the beast [in me] will be satisfied but my thirst for art never. (M. 162)

It is often assumed that the changed tone of Gauguin's correspondence directly reflected Bernard's influence. Such an assumption seems logical enough, not merely because Bernard had alerted Gauguin to the inspirational potential of Breton religious art, but also because the young artist was especially preoccupied with religious ideas that summer. Reared in a rigidly authoritarian Catholic household, Bernard had been something of a childhood religious fanatic. But during his adolescence, his former fervor had given way to recurring crises of doubt about his faith. He had weathered another of these storms and had triumphantly reaffirmed his Catholicism shortly before joining Gauguin, with whom he undoubtedly shared the details of this conflict and its resolution. Moreover, the impact of Bernard's own fervor would have been reinforced by that of Madeleine. As Amishai-Maisels suggests, it seems likely that Gauguin accompanied the Bernards when they attended services at the parish church in Pont-Aven, which was located just a stone's throw from the Gloanec inn.[32]

However, there was another unseen but important player in this drama: Vincent van Gogh. The effects of the written dialogues about art and religion he carried out with Gauguin and Bernard individually were amplified by the fact that they shared this correspondence with one another. The good counsels that van Gogh provided to Bernard during the religious crisis and the depression he had suffered at Saint-Briac not only helped him to resolve this conflict, but, by extension, also exerted a profound influence on Gauguin. That the latter was thoroughly familiar with these epistles becomes obvious when one realizes that the puzzling passage from Gauguin's fragmentary letter to Schuffenecker (M. 162) quoted above is a garbled condensation of an excerpt from a letter that van Gogh had written Bernard while he was at Saint-Briac.[33] As Amishai-Maisels (who emphasizes the important role that van Gogh played during this period in helping to shape Gauguin's artistic and religious concepts) observes, it was also in the exchange of letters with van Gogh that Gauguin first formulated the ideas about art as an abstraction that he later communicated to Schuffenecker. "Van Gogh had inaugurated this dis-

cussion, and it was to his theories, rather than to Bernard's that Gauguin repeatedly reacted."[34] Nor were these exchanges limited to the verbal realm: The artists frequently enclosed compositional sketches with their letters. In addition, van Gogh and Bernard sent one another separate packets of drawings; shortly after his arrival in Pont-Aven, Bernard assembled his collection of van Gogh's sketches into an album, which he shared with Gauguin.[35]

The importance of van Gogh's role in this triangular drama becomes still more apparent when one recalls that he had also tried his hand at creating a religious painting that summer. During July the artist, perhaps inspired by the recent dialogue he had held with Bernard about the latter's crisis of faith, made two abortive attempts to paint a *Christ in Gethsemane*, only to destroy both pictures. He may have written Gauguin about this project in a letter that is now lost, and such information probably helped to inspire the latter to try his own hand at a religious work.[36]

In a letter to van Gogh written around September 7–9 (that is, about a week to ten days before the artist most likely started to work on *The Vision*), Gauguin included the following meditation:

> It is a long Calvary to be traversed, the life of an artist, and perhaps that's what makes us live. The passion vivifies us and we die when it has no more nourishment [to give us]. Let's leave these paths filled with bushes of thorns, which nonetheless have their wild poetry. (M.158)

As the evidence introduced here suggests, the complex network of interactions, interconnections, and shared influences existing that summer among van Gogh, Bernard, and Gauguin can never be completely disentangled. However, it seems safe to assert that this exchange heightened the creativity of each member of the trio, and certainly played an important part in inspiring Gauguin to attempt the first of many major religious paintings he would subsequently create: *The Vision after the Sermon (Jacob Wrestling with the Angel)*.

The Vision *and the Pardon at Pont-Aven*

The naive piety of the Breton peasants and the intense quality of their religious practices were nowhere more dramatically reflected than in their special festivals known as *pardons*. These annual celebrations, usually held in honor of the patron saint of a local church, owed their generic name to the fact that they provided the pious with opportunities to earn forgiveness for sins by performing penances and by receiving special indulgences.[37]

Gauguin, his followers, and his muse, the beauteous Madeleine, no doubt attended as many of these colorful celebrations in the region as possible. They would certainly have participated in the pardon at Pont-

Aven, which formed the climax – and the close – of the summer season there. Madeleine undoubtedly seized this opportunity to appear in her becoming local folk costume, the "uniform" also worn by the village women who participated in the festival. At that time, the pardon at Pont-Aven involved a two-day celebration.[38] Traditionally held on the third Saturday and Sunday of September, a date close to the autumn equinox, the festival kept alive ancient Celtic pagan rites connected with the harvest and the sun, veiled beneath a veneer of Christian symbolism.

The proceedings began on Saturday, with the advent of the pilgrims, the preparation and decorating of the church and the procession route, followed by the special ceremonies of the pardon eve.[39] On Sunday morning, local and visiting pilgrims, carrying banners, approached the village by every route, singing to the accompaniment of bagpipes and *bombards* (oboe-like instruments).[40] High mass followed, an event so heavily attended that three-fourths of the participants were forced to follow the service huddled outside the church door. After mass everyone adjourned to enjoy a lavish picnic, then reassembled at the church for vespers. Following this service, the grand procession of the festival took place, featuring local and visiting clergymen, accompanied by a large group of women and girls dressed in their characteristic costumes and carrying candles, banners, statues of saints, and reliquaries. The most athletic young men, who trained for the event for months in advance, carried the heaviest statues and banners. After the procession returned to the church, the secular events connected with the occasion began – the characteristic music, dances, and games.[41]

Traditionally manifestations of piety and penitence, the pardons were also times of betrothal and renewal – aspects of the celebration that once again revealed its pagan origins. Prior to the festival, local bachelors in search of wives permitted their hair and beards to grow, then were ritually barbered during the festivities. These courting bachelors usually wore distinctive fur-edged caps, while young maidens intent on finding husbands tucked their long, uncut hair beneath lace caps, and displayed a characteristic lovelock on their foreheads as a sign of their availability. At marriage, brides cut off their long hair (presumably to make them less attractive to other men) and put on the distinctive coifs worn by local matrons.[42] These bonnets formed part of the characteristic costumes that differed not only from one region to another, but even from locality to locality within a single region. For example, women in Morbihan wore dark blue or black bonnets, while those in the neighboring region of Finistère, to which Pont-Aven belonged, wore white. However, the shapes of the coifs worn by the women of Pont-Aven and nearby Concarneau were distinctly different from those of Quimper, the capital of Finistère.[43]

During the last quarter of the nineteenth century, the pardon of Pont-Aven was one of the most celebrated in lower Brittany, attracting foreign as well as French visitors eager to witness its celebrated dances and wrestling matches.[44] On the open meadow where these events took

place, tourists in their silks and satins, protected from the sun by parasols, mingled with the tanned Bretons in their colorful costumes. The wrestling matches followed a prescribed procedure. The contestants, who wore heavy canvas tunics and short breeches, grasped their opponents by the shoulders, in a hold characteristic of Pont-Aven, and attempted to get a fall by applying a sudden twist – a technique similar to that employed by Japanese wrestlers.[45]

The high mass offered on pardon Sunday would have provided a unique opportunity for the clergyman who delivered the sermon to display his eloquence. Did the priest or bishop who gave this homily at Pont-Aven in 1888 allude to the incident in the book of Genesis, which describes how Jacob wrestled with the angel on the banks of the river Jabbok? The introduction of such an analogy, veiling this secular event in religious symbolism, would have helped to mask the pagan origins of the wrestling contests that played such a major role in the Pont-Aven pardons.

Such a sermon may also have been the stimulus that directly inspired *The Vision after the Sermon (Jacob Wrestling with the Angel)*. As Matthew Herban emphasizes, one must seek the sources of this great work in the contemporary real-life events that fired the artist's imagination: "Even in [Gauguin's] most symbolic works, he was still very much compelled by Romantic ideals to use a real experience as the basis for the expressive content of his painting."[46]

That the real event that inspired Gauguin had involved hearing an eloquent sermon and noting its effect on a group of gullible listeners is made quite clear by the description the artist provided in the letter to van Gogh cited in the introduction and quoted here in full:

I have just finished a religious painting, very badly made but that interested me to do and that pleases me very much. Groups of Breton women are praying, their costumes a very intense black, their bonnets a very luminous yellow-white. The two bonnets at the right are like monstrous helmets. An apple tree crosses the canvas in somber violet and the foliage has been drawn in masses like clouds, in emerald green, and the interstices are the yellow-green of sunlight. The ground, pure vermilion. At the church, it descends and becomes red-brown. The angel is dressed in violent ultramarine blue and Jacob in bottle green. The wings of the angel are pure chrome 1. The angel's hair is chrome 2, and the feet are flesh orange. I think I have achieved a great simplicity in the figures, very rustic and superstitious. The overall effect is very severe. The cow under the tree is tiny in comparison with reality and she bucks. For me in this painting the landscape and the fight only exist in the imagination of the people praying because of the sermon, which is why there is a contrast between the natural people and the non-natural landscape which is out of proportion.[47]

In his account of the events of 1888 published in 1903 (quoted above), Bernard unequivocally states that the creation of both his own *Breton Women in a Meadow* and Gauguin's *Vision after the Sermon* (allegedly derived from Bernard's version) followed directly upon the celebration of the pardon at Pont-Aven.[48] By contrast, Gauguin's account, contained in the letter to van Gogh, is more vague, and he fails to state precisely where or when he heard the sermon that inspired his painting. This omission, coupled with the fact that Gauguin wrote Vincent no more than nine to twelve days after the close of the Pont-Aven festival, has aroused the skepticism of scholars, who question whether he could have completed *The Vision* within such a brief time span.[49]

In point of fact, Gauguin worked rather rapidly, and it would have been uncharacteristic of him to spend an entire month on a painting, as Frèches-Thory suggests he did in the case of *The Vision*.[50] He painted his self-portrait, *Les Misérables* – which he worked on immediately after finishing *The Vision* – very quickly, and wrote van Gogh on October 1st to announce the completion of this self-representation (M. 166). From remarks van Gogh included in letters written to his brother while Gauguin and he were living together in Arles, we learn that his companion normally required about a week to ten days to complete a canvas.[51]

However, the most compelling evidence connecting the pardon at Pont-Aven with *The Vision* comes from the painting itself. The picture teems with images referring to Breton pardons in general – such as the secular wrestling contests, watched by the local peasants in their colorful costumes – and that of Pont-Aven in particular. The "monstrous helmets" worn by Gauguin's protagonists were as characteristic of this village as the "signature" Pont-Aven hold with which the angel grasps Jacob's shoulders. A comparison of *The Vision* with Sérusier's *Breton Wrestling Match (The Wrestlers)* (Figs. 21 and 23), which depicts a pair of contestants probably observed during the pardon of 1893 at Pont-Aven, provides dramatic visual evidence that Gauguin found his inspiration in events he had witnessed during this annual celebration. Both pictures portray the contestants applying the characteristic Pont-Aven hold, and both represent an audience consisting primarily of peasant women from the village, clad in their picturesque costumes and kneeling in a meadow.[52]

The Vision after the Sermon also alludes to the themes of redemption and betrothal so intimately associated with the Breton pardons. Both the bearded Jacob and the clean-shaven young man in the right foreground wear fur-edged caps, as though Gauguin intended them to symbolize Breton suitors before and after redemption.[53] The central female figure, depicted with her head raised and her eyes open, has the attributes of a Breton virgin, with her long hair tucked under a light lace cap and a lock on her forehead. The artist established an implicit connection between this virgin and the young man wedged into the right foreground by linking their profiles via the rhythmical outlines of the "helmets" worn

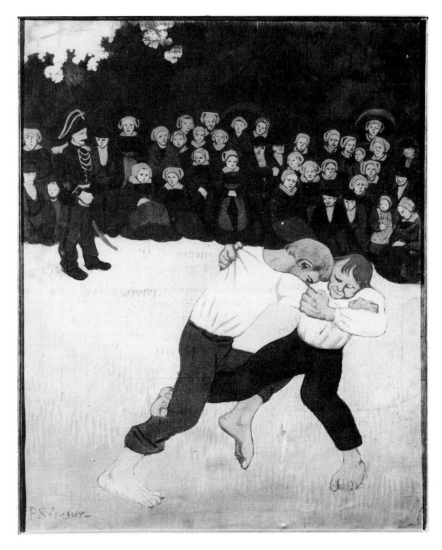

23. Paul Sérusier, *Breton Wrestling Match,* c. 1893. Oil on canvas. Musée d'Orsay, Paris. © R. M. N.

by the two women who ostensibly separate them. Perhaps Gauguin thus subtly implies that the young couple are a courting pair.

The Encoded Personal Iconography of The Vision

One of Gauguin's most impressive accomplishments in *The Vision after the Sermon* consists in the almost magical level of cohesiveness he achieved in his composition, transcending the divisive forces – the delib-

71

erate discrepancies in size, scale, and levels of reality, the willful bifurcation of the picture plane – that seek its disintegration. This impression of cohesion derives, in part, from Gauguin's skillful manipulation of plastic devices. But the mysterious integrative force of *The Vision* exceeds the sum of its formal qualities and must be sought, instead, in the underlying narrative that binds every element of the composition into an impressive gestalt. Herban correctly identified the principal unifying themes of this narrative as those of redemption and reconciliation:

> Gauguin's subjective reactions [to events he had observed during the pardon] were synthesized and transformed into a subtly dimensioned expression of man's struggle to understand life – his need for reconciliation with his fellow men, with nature, and with God. This is presented by analogy to ancient Celtic and Breton customs, to the Old Testament of Jacob and Israel; and to the era of Christ...[54]

Gauguin resonated with his magnum opus on many levels, and he reinforced the impact of the underlying narrative by introducing multiple alter egos, who function as central actors in his painted drama. The fact that the artist based the physiognomy of the young man who appears in the right foreground on his own features has been widely recognized, although the psychological implications of this observation have not been explored to date. Gauguin's overt appearance is echoed by his covert reintroduction in the guise of the biblical Jacob, who assumes a key role in the composition that belies his miniscule size.

Before attempting to ferret out some of the autobiographical implications of these self-references, we should like to return for a moment to the description of the painting that the artist provided for his friend van Gogh in the letter quoted above. In view of the size, position, and apparent symbolic importance of the images of the Breton virgin and the courting bachelor (the latter based on the artist's own self-image) to *The Vision,* it seems little short of amazing that Gauguin failed to mention either personage in his letter to van Gogh. The quick sketch of the composition that he included in the same letter omits altogether the head of the young man, while transforming that of the nubile maiden into a featureless ovoid. Amishai-Maisels proposes that Gauguin probably reworked his canvas *after* he had written van Gogh, adding this male image at that time.[55] However, a comparison of the sketch with the detail showing the same area of the definitive painting (Figs. 24 and 25) reveals that this could not have been the case. When Gauguin made the drawing after his oil, he subtly shifted the positions of the two women wearing the enormous bonnets, as well as that of the Breton virgin, to fill the spatial gap created by his *deliberate suppression* of the male head from the right corner. Paradoxically, he made no comparable effort to bridge the hiatus the latter shift opened up between the figure of the maiden and that of the pious woman positioned immediately behind her; as a result, the latter personage assumes a more isolated character in the drawing than in

24. Gauguin, sketch for *The Vision* included in a letter to Vincent van Gogh, c. September 25–27, 1888. Vincent van Gogh Foundation, National Museum Vincent van Gogh, Amsterdam.

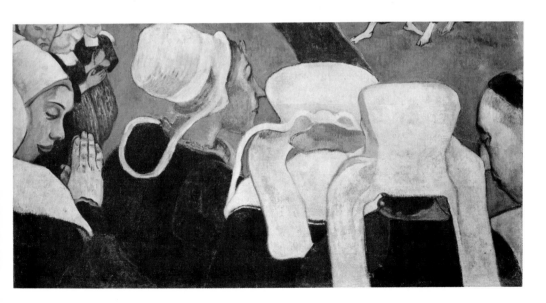

25. Gauguin, detail of *The Vision:* the five foreground figures. The National Galleries of Scotland, Edinburgh.

the painting, where her silhouette overlaps that of her neighbor. These changes make the foreground area of the drawing appear more tentative and loosely integrated than the corresponding section of the oil. Why did Gauguin resort to this subterfuge?[56] It cannot be a coincidence that the male head he willfully eliminated was based on his own self-portrait, rendered in a pose that emphasizes his "Inca" profile, thus combining in a single image allusions to his savage, pagan self and his civilized, Christian aspect. And what of the maiden, reduced by a stroke of the pen to the status of an anonymous oval – does she, too, possess a hidden identity? A comparison of her features as they appear in the painting with that of Madeleine as Gauguin depicted her in the portrait that he had executed a few weeks earlier underlines the similarities of their physiognomies: Both women possess the same shapely eyebrows, high cheekbones, sharp noses, and strong chins; moreover, both wear their long, chestnut-brown hair upswept, with a lock on the forehead. Thus, in his Symbolist masterwork, Gauguin cast himself in the role of the courting bachelor and Madeleine Bernard, with whom he was so infatuated at the time, as the eligible virgin being courted. We can only surmise the nature of his motivations for hiding this truth from van Gogh; tolerant and understanding of human nature as he was, one wonders whether he would have approved the notion that Gauguin, a married man and the father of five young children, had designs on a convent-bred girl young enough to be his daughter. Gauguin, whether because he feared that van Gogh might be shocked by this confession, or because he simply considered his love for Madeleine too personal, too secret, too new to share with anyone, quietly eliminated this iconographic information from his missive to his Dutch friend.

The ambiguous character of Gauguin's self-portrait in *The Vision*, which can be read – as it has been by a number of scholars – as the representation of a tonsured priest, rather than that of a courting bachelor – seems especially appropriate, not only because of the artist's insistence that he possessed a bifurcated personality, but also because of his actual situation at the time he painted this picture: Like a celibate priest, the artist was not eligible to marry; yet, like a young bachelor, he was actively – if surreptitiously – courting a lovely maiden.[57] It should also be noted that the theme of redemption so central to the painting seems equally applicable to both readings of this figure. As the clean-shaven Breton peasant, Gauguin represented himself as one who has been redeemed by the experience of participating in the pardon and receiving the sacraments. As the priest, he portrayed himself as an individual specifically empowered by Christ to redeem sinners (by granting them absolution through the sacrament of confession), and to repeat Jesus' sacrifice on Calvary (via the consecration and distribution of the Eucharist).[58]

Although it may strike the reader as unreasonable to assign such seemingly contradictory identifications and interpretations to a single image, there is no reason to suppose that Gauguin (or any other artist) would

hesitate to present such paradoxical condensations. As Freud demonstrated long ago, human behavior is always overdetermined, and our conduct invariably results from the interaction of a whole range of causal factors. Certain contemporary psychoanalysts have extended this theory, pointing out that many individuals can – and do – consciously entertain mutually exclusive motives without subjective discomfort.[59] Gauguin, with his fluid self-concept, continually espoused such contradictory states in his everyday life and in his writings; in *The Vision*, he provided his alter egos with equally varied and seemingly incompatible identities.

If Gauguin utilized the image of the Breton bachelor/priest as the vehicle for his overt self-references, that of the biblical Jacob provided the mirror in which he reflected his more covert autobiographical allusions.[60] Hearing the sermon extolling the exploits of the Old Testament hero fired Gauguin's poetic imagination, and the striking analogies between Jacob's history and his own soon found their way into the fabric of *The Vision*. Like the biblical Jacob, twin to the wild and hairy Esau, Gauguin possessed a savage double with whom he continually vied for dominance. But the artist harbored his Esau within his own psyche, where – so he claimed – the "Inca savage" struggled unceasingly against the civilized Frenchman. Again, like Jacob, Gauguin was living "in exile"; as previously noted, his decision to abandon the sophisticated atmosphere of Paris for the rude environment of Brittany reflected his determination to cultivate his "primitive" self and to discover analogous subjects for his art.

Just as Jacob's love for Rachel was thwarted by the duplicities of her father, Gauguin's passion for Madeleine was potentially threatened by the rigidity of M. Bernard (who would soon put an end to Gauguin's attempt to correspond with her), and perhaps also by the growing jealousy of her brother. Like Jacob, the artist was saddled with an unwanted wife, a mate who pleased him (at least at this stage in his life) no more than Leah suited Jacob. But unlike Jacob, who eventually wed Rachel as well as Leah, Gauguin could not solve his dilemma by entering into a polygamous union with both women. The innocence and religiosity of his virginal love – to say nothing of the sense of propriety of Madeleine's rigid parents – made any solution of that sort inconceivable. Instead, the artist strove to become the seminal figure in a great new artistic movement, just as Jacob had become the progenitor of the twelve tribes of Israel. Like the artist's explicit alter ego, the bachelor/priest, his covert doppelgänger, Jacob, encompasses multiple symbolic references and identities.

The artist alerts us to the symbolism encoded in the personae of Jacob and the angel by subjecting their images to a process of condensation akin to that experienced in a dream, wherein visual symbols typically simultaneously encompass many meanings. Thus, the struggling, intertwined forms of Jacob and the angel readily transform themselves into the visual analogue of a single four-footed beast, not unlike the Breton

cow positioned directly opposite them on the canvas.[61] But their inter-
locked postures also recall the poses of the wrestlers depicted by Hoku-
sai in his *Mangwa* albums of 1815, while simultaneously evoking associa-
tions to the relief sculptures found on French Romanesque churches:
The stylized fluttering of the protagonists' draperies, as well as Jacob's
scissors-gaited stance, recall the similar characteristics of the sculptures
of such major twelfth-century edifices as Vézelay, Moissac, and Souil-
lac.[62] These condensations not only refer to Gauguin's professional in-
terest in borrowing, and successfully synthesizing, artistic ideas from di-
verse times and places, but also to his wish that he might transcend his
personal dichotomies and weld his fragmented personality into a new
synthesis.

Although Gauguin never succeeded in arriving at a parallel internal in-
tegration, he admirably achieved this goal with his bifurcated composi-
tion, *The Vision after the Sermon*. One device that promotes this binding
is the fact that "the praying women are united with Jacob in a common
spiritual quest which overcomes their separate natures."[63] Gauguin re-
affirmed this commonality by having the Breton peasants double as pro-
tagonists in the Jacob story. Herban was the first scholar to identify this
phenomenon, suggesting that the twelve Breton women also represent
the twelve sons of Jacob, the future founders of the tribes of Israel.[64]
Extending Herban's observation still further, one might add that the art-
ist, who depicts his doppelgänger as the unredeemed Jacob, reappears as
his own persona not only as the bachelor/priest of the Breton courtship/
redemption drama, but also as the biblical Jacob, blessed, renamed, and
reunited with his wives and concubines on the other side of the river Jab-
bok. In this reading of the composition, the apple tree becomes the bed
of the river Jabbok, while the four outsized women who rim the fore-
ground of the canvas double as the wives and concubines of Jacob.[65] The
two faceless women, notable chiefly for their enormous headdresses,
substitute for the handmaids of Rachel and Leah, who each bore Jacob
two sons, but who are accorded no real sense of personal identity in the
biblical account; the praying woman in the lower-left corner stands in
for Leah, while the Breton virgin symbolizes Jacob's beloved Rachel, as
well as Gauguin's beloved Madeleine. One might also speculate that, in
the hidden iconography of the painting, the image of Leah doubles as that
of Mette, Gauguin's estranged wife. The psychological ties linking these
five personages appear on the canvas as overlapping silhouettes and
rhythmical linear connections.

As previously noted, these alternative interpretations of the protago-
nists portrayed in *The Vision* do not necessarily contradict one another,
as each of Gauguin's personae incorporates multiple hidden identities
and autobiographical references. The artist successfully unified this com-
plex network of personalized allusions by the emphasis on the themes of
redemption and reconciliation encoded in the painting.

Despite his past indifference to religion, Gauguin clearly conceived of this painting as a religious act, a notion that would gain great currency among the Symbolists, but which also had a more private significance for the artist, then apparently attempting to reconcile himself to the Catholic church and to redeem himself through the love of a good woman. From the beginning, he apparently planned to present *The Vision* to the church at Pont-Aven, most probably the setting in which he had heard the sermon that had originally inspired the painting.[66] However, as Gauguin informed van Gogh in the letter of late September in which he described *The Vision,* the local parish priest had refused his proffered gift.[67]

Apparently undaunted by the humiliation he must have suffered on this occasion, the artist next offered the canvas to the Romanesque church in the neighboring hamlet of Nizon. Bernard provided a dramatic description of this church:

[A]ustere and granitic, it had a heavy feudal aspect [with] primitive, even grotesque, saints carved in wood and highlighted in ochre.... Gauguin wanted to hang his painting, which was also simplistic, grotesque, and naive, in this ancestral setting. He signed his name and added in blue on the white border: "A gift of Tristan de Moscoso." It seems that, because of his grandmother, Flora Tristan, he valued this Peruvian nobility.[68]

While Bernard went to search out the priest, Gauguin selected the most suitable spot for his canvas. When the priest heard the news that the church was about to receive a valuable gift, he became very excited; but when he caught sight of Gauguin's painting, he politely but firmly rejected the offering, unswayed by the artist's insistence that his picture directly related to the wooden saints decorating the church. "We brought the painting back to Pont-Aven, extremely upset, and this for the future glory of Gauguin, because it was this painting that made it possible for him to be named head of the pictorial Symbolists in Paris [i.e., following the publication of Aurier's article in 1891]."[69]

Gauguin's gesture in inscribing the frame of his picture with the words "A gift of Tristan de Moscoso" should probably be understood as a reference to his attempt to merge his bifurcated self-image into a new synthesis. In the center foreground of the picture, above the original white frame (now lost) on which this inscription appeared, one confronts the two anonymous female figures in their "monstrous helmets." Gauguin may have employed this phrase more advisedly than we imagine, for close inspection reveals that each bonnet harbors a subliminal face (Fig. 26 reproduces a sketch of these images).[70] These strange visages recall those found on the Peruvian effigy pots that Gauguin knew from his childhood.[71] By juxtaposing the references to these ceramics with the allusion to his aristocratic, Spanish-born, Catholic ancestor, Gauguin

seemingly attempted to merge his savage–civilized, pagan–Christian "split personality" into a new unity, and to confirm the sanctity and permanence of this merger by donating his painting to the church as a kind of votive offering symbolizing his reconciliation with Catholicism.

It is easy to empathize with the disappointment Gauguin must have felt following the double rejection of his proffered gift, as conveyed by the tone of the account he wrote his dealer, Theo van Gogh:

> The painting of the church is coming to you, and you can exhibit it. Unfortunately, it was made for a church and will not have the same effect in a salon as in those surroundings of [stained] glass and [bare] stone.[72]

Initially, Gauguin's apprehension about the art-going public's response to *The Vision* seemed well-founded; the picture remained unsold at Boussod and Valadon until 1891, and the visitors who saw it when it was shown at the "Exposition des XX" in Brussels in 1889 proved no more appreciative of the painting than had the priests at Pont-Aven and Nizon.[73] However, the picture's fortunes soon changed; it fetched the highest price of any of the paintings that Gauguin included in the special exhibition-auction of his art held at the Hôtel Drouot on February 22 and 23, 1891, to help finance his first voyage to Tahiti. A few weeks later, Aurier's essay on Gauguin's role in the genesis of Symbolism appeared.[74]

Bernard and Gauguin: The Controversy Reconsidered

As previously noted, these events – the auction and the subsequent publication of Aurier's essay, "Symbolism in Painting: Paul Gauguin" – provoked a permanent estrangement between Bernard and Gauguin. One can hardly blame Bernard for feeling resentful. Aurier's failure even to mention the younger artist and his role in the evolution of the so-called School of Pont-Aven, coming on the heels of Gauguin's successful sale, proved more than Bernard could bear. Embittered over what he perceived as Gauguin's betrayal, Bernard permanently ruptured his relationship with his former mentor around this time, allegedly following a public quarrel provoked by Madeleine.[75]

The fact that Bernard should have felt piqued at the time Aurier's article appeared seems understandable enough; however, the tenacity and bitterness with which he pursued this vendetta for the next half-century in publication after publication seems so excessive that one must seek other explanations for his motivation. Perhaps he was jealous not only of Gauguin's fame, but also of his involvement with Emile's beloved sister, Madeleine. Bernard's relationship with her was apparently the most

26. Sketch of faces concealed in the bonnets of Breton women in the foreground of *The Vision*.

meaningful emotional tie of his life. He never recovered from the shock of her premature death in 1895, and it seems likely that his paranoid tendencies congealed around this loss. His posthumous idealization of Madeleine knew no bounds, and he frequently used his publications to extoll her virtues.

For example, in a tract written around forty-four years after her death, he praises Madeleine's saintliness and moral probity to such an extent that, when he confesses that he still treasured the Breton costume she had worn in 1888, one cannot help but wonder whether he venerated the garment in a reliquary.[76] In this same publication, he assures the reader (and himself) that her relationship with her fiancé, Charles Laval, had been selfless and platonic:

> Too good, too sacrificing, she had believed it to be her duty to offer moral consolation to this great boy, victim of his own excesses. She paid for it with her life. My sister, I can say it without exaggeration, was a *saint*. There was never anything between Laval and her except the most pure affection; a sort of divine commiseration on her part; for she never loved Laval romantically; she had simply pitied him.[77]

79

Madeleine's death hardened Bernard's heart against Gauguin; Bernard's first – and still embryonic – reconstruction of his role in the evolution of Symbolism appeared in June 1895, while Madeleine was dying of tuberculosis and Gauguin was preparing for his second voyage to Tahiti. Using the format of an open letter addressed to the Symbolist poet Camille Mauclair, Bernard protested the "accusation" that he had plagiarized Gauguin:

> That the artistic personality of Paul Gauguin was born of mine, that would be mad and even imbecilic in the extreme to wish to say. Paul Gauguin is a savant, an estimable artist; but that he has benefitted of a part (the largest part) of my efforts, the facts are too well proven for me to deny.[78]

In December 1903, four months after word of Gauguin's death (on May 7, 1903) in the distant Marquesas had reached France, Bernard, using the *Mercure de France* as his vehicle, published his "Notes sur L'école de Pont-Aven," containing the more fully developed charges (quoted above in the first section, "Defining the Problem") that Gauguin had cannibalized his *Breton Women* to create *The Vision*.[79]

During the twilight of his life, Bernard's claims about his role in the development of Symbolism grew ever more grandiose as his reality testing weakened:

> 1888 is the major date in the evolution of Paul Gauguin toward synthesis and toward the systematization of art that has since been named pictorial symbolism. Gauguin, transformed by the encounter with me, by my experiments, by my ideas, definitively left Impressionism, and even became antagonistic to it.[80]

In another of his quasi-mythical reconstructions of his youth, Bernard portrays himself, soon after his arrival at Pont-Aven, delivering a little lecture about color theory to Gauguin, using his *Breton Women in a Meadow* as the example of enlightened procedures. This information so excited Gauguin, Bernard asserts, that he immediately painted *The Vision*, using not only the younger artist's ideas about color,

> but the very style of my *Breton Women in a Meadow*, after having established a willfully red background as opposed to the yellow-green I had employed. In the foreground he put the same large figures in their monumental ladies' headdresses. He was so happy with this painting that he continued in the path it had opened to him thereafter and definitively abandoned the Divisionism he had taken from Pissarro.[81]

When one compares such grandiose retrospective claims with surviving documentary evidence about the actual nature of Bernard's relationship with Gauguin during 1888, a very different picture emerges. Although their association remained quite cordial throughout their joint sojourn at Pont-Aven, certain passages in Gauguin's surviving correspondence suggest that, as the summer gave way to autumn, his disciple's personality problems became increasingly evident to the older artist.

Gauguin's earliest references to Bernard were unequivocally admiring: In the letter he wrote Schuffenecker on August 14, Gauguin commented, "little Bernard [Gauguin always referred to the artist in this somewhat condescending, if affectionate, manner] is here and has brought some interesting things from Saint-Briac. There is one who fears nothing" (M. 159). However, as he became better acquainted with Bernard, Gauguin modified his assessment, and in a letter to van Gogh from around September 7–9, he observed:

> I am studying little Bernard, whom I know less well than you; I believe that you are good for him and he needs you. He has naturally suffered, and he has entered life full of venom, driven to see only the bad side of mankind. I hope that with his intelligence and his love of art, he will perceive one day that goodness is a force against the others, and a consolation for our own miseries. (M. 163)

Van Gogh's correspondence with his brother during these same weeks provides further insights into these matters. For example, in a letter written around August 22–23 (CLVG3: T526), the artist noted that Gauguin and Bernard each spoke highly of the other's work. In his next missive to Theo, Vincent reported that "Gauguin and Bernard now talk of painting like children" (CLVG3: T527). But by mid-September van Gogh viewed the situation between Gauguin and Bernard in rather a different light: "In his letter Bernard speaks of Gauguin with great respect and sympathy, and I am sure that they understand one another. And I really think that Gauguin has done Bernard good" (CLVG3: T538). A few days later, Vincent informed Theo:

> Today while I was working I thought a lot about Bernard. His letter is steeped in admiration for Gauguin's talent. He says he thinks him so great an artist that he is almost afraid, and that he finds everything that he does himself poor in comparison with Gauguin.

Later in this same missive, the artist remarked:

> [Bernard] says he dare not do Gauguin as I asked him [i.e., attempt to paint the older artist's portrait] because he feels afraid in front of Gauguin. Basically, Bernard has so much temperament! He is sometimes stupid and vicious....[82]

81

These quotations all suggest that, at the outset, Gauguin had been pre-
pared to treat his young colleague more like a peer than a disciple. They
would study van Gogh's compositions together, and together they would
paint "like children." But Bernard soon proved unable to sustain such an
association of equals. Perhaps he became too overwhelmed by the sheer
force of Gauguin's talent, an impression that may have been reinforced
by the younger artist's susceptibility to what psychoanalysts would dub a
"transference reaction," that is, to perceive Gauguin, who was old
enough to have sired Emile, as though he were, in fact, his autocratic and
intimidating father. In view of the almost incestuous character of Ber-
nard's attachment to Madeleine, it seems unlikely that he reacted with
pleasure to Gauguin's growing infatuation with his sister, and he re-
mained preoccupied throughout his life with the question of her feelings
about the older artist. Although Bernard insisted that Madeleine was
drawn to Gauguin only by the wish to console him for his sufferings, Ber-
nard never claimed either that she rejected Gauguin's attentions, or that
she had been horrified to learn of his alleged plan to carry her off.[83] Did
Emile finally convince himself that Gauguin had stolen not only the
affection of his beloved Madeleine, but also his rightful place in the histo-
ry of art?

Whatever the changing dynamics of their relationship during the sum-
mer of 1888, Gauguin and Bernard obviously both profited artistically
from their association. One hundred years after the fact, one cannot hope
to identify the exact nature and extent of these reciprocal effects, the
more so since van Gogh also actively participated in this exchange from
his outpost in Arles, and Madeleine, too, played her role as the joint
muse of both artists. Jirat-Wasiutynski perceptively summarizes the gen-
eral character of this reciprocity:

> In the *Breton Women* Bernard has produced one of his strongest
> works to date; such a Cloisonist demonstration piece presupposes
> the challenge of Gauguin's company and the example of his figure
> painting. Gauguin's *Vision after the Sermon* is as much indebted to
> Bernard's ideas as it is to the visual precedent, if such it be, of the
> *Breton Women in the Meadow*. [*The Vision*'s] chief Cloisonist fea-
> ture, the unified red ground, parallels the green ground of the Ber-
> nard, while the bold collaging of clusters of kneeling women seen
> from different viewpoints against this ground, parallels the arbitrary
> scale and anti-perspectival placement of the figures in Bernard's
> work. Both devices are anti-naturalistic and the result of a synthetic
> approach; the artists are working from memory, that is, using their
> imagination and "thinking more of the resulting creation than of
> copying nature."[84]

If both men really did work from memory, as Jirat-Wasiutynski as-
sumes, the results achieved by Bernard demonstrate the limitations of his

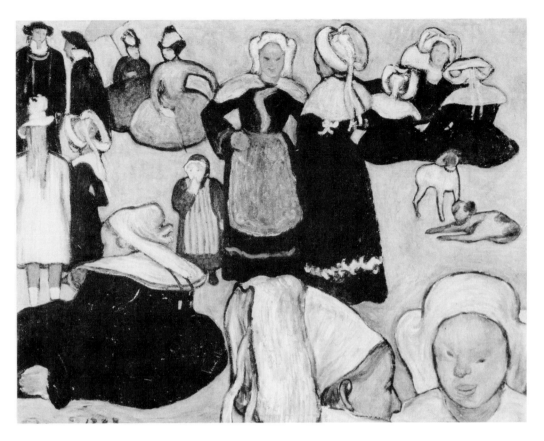

27. Emile Bernard, *Breton Women in a Meadow*, 1888. Oil on canvas. Present whereabouts unknown. Photo: *Emile Bernard,* exh. cat. 1990, no. 7.

imaginative capacity. *Breton Women in a Meadow* (Fig. 27) remains too closely tied to its origins, betraying the fact that the artist had transformed a quick sketch made during (or immediately after) the pardon into a painting, by the simple stratagem of imposing antinaturalistic devices on a scene observed from life.[85]

No matter what position scholars espouse in the controversy concerning Bernard's putative role in the evolution of *The Vision,* they unanimously recognize that the *Breton Women* possesses none of the emotional charge that makes Gauguin's painting so compelling.[86] Unlike the latter, Bernard's canvas is not really "about" anything, least of all religion. It is a decorative genre scene that might just as easily represent a crowd glimpsed at a fair as the participants in an important religious celebration. It seems ironic that if, as he claimed in 1903, Bernard really had been inspired to paint his picture by witnessing the pardon at Pont-Aven,

it was strictly the secular aspect of this event that caught the eye of this young man supposedly so preoccupied with religiosity and impressed with the piety of the Breton peasants.[87] Instead, he left it to Gauguin to create a great masterpiece from the visual "raw material" provided by the religious aspects of the pardon, while he contented himself with creating a genre picture that, although advanced for its time, could never have been considered profound. By contrast, Gauguin's painting provides religious and personal references on multiple levels, past and present, Christian and pagan, public and private.

Well aware of the crucial differences between these two works, Jirat-Wasiutynski suggests that they reflect, to some extent, the different temperaments of the two artists. "More importantly, they reflect different levels of emotional and artistic maturity. Gauguin was forty years old; Bernard only twenty."[88] But these differences also provide a measure of the chasm that separates a minor talent from a major innovator. Bernard enjoyed his most creative interlude and painted his finest pictures while associated with van Gogh and Gauguin. Separated from these two important figures by the death of one and the alienation of the other, Bernard attempted to forge new alliances with artists long dead, giants of the past, like Titian and Michelangelo; but these relationships proved too ephemeral to provide the support Bernard required to maintain himself in satisfactory psychological equilibrium. He solved his dilemma by creating a personal mythology that he mistook for reality. His envy and resentment of Gauguin gradually evolved into the paranoid conviction that his ex-mentor had usurped the special niche in the history of art that Bernard became more and more convinced rightly belonged to him.[89]

If the creation of the *Breton Women in a Meadow* marks the high point of Emile Bernard's career, the beginning of his brief days of glory, *The Vision after the Sermon* enjoys a very different position in the history of Paul Gauguin's artistic evolution. This was merely the first of a long series of innovative works – including many with religious themes – that Gauguin would produce during the remaining fifteen years of his abbreviated lifespan.

Appendix: Synopsis of the Relevant Portions of the Story of Jacob as Recounted in Genesis (Chapters 25–33)

The rivalry of Esau and Jacob, the twin sons of Isaac and Rebecca, began in utero. They struggled in Rebecca's womb until the distraught woman sought comfort and guidance from the Lord. He explained that she was incubating two nations, from whom two peoples would be divided, "and one people shall overcome the other, and the elder shall serve the younger."

Esau, the firstborn of the brothers, issued from the womb red and hairy like an animal, whereas Jacob was born fair and hairless. Esau developed into a peerless hunter and his father's favorite, while Jacob, his mother's pet, stayed close to the tents and the women.

By a bargain, Jacob secured his brother's birthright as firstborn and, with his mother's active participation, deceived his blind, dying father into believing that he, Jacob, was Esau, thus obtaining the paternal blessing and patrimony. In order to protect him against Esau's wrath, Rebecca sent Jacob to live with her brother, Laban, a prosperous herdsman who dwelt in Mesopotamia.

While en route, Jacob experienced a vision of angels ascending and descending a ladder to heaven, and the Lord appeared to him, prophesying that Jacob would become the father of Israel. As Jacob drew near his uncle's dwelling, he encountered Laban's younger daughter, Rachel; the two immediately fell in love, and Jacob readily agreed to serve his uncle for seven years in exchange for Rachel's hand. However, when the wedding day arrived, Laban tricked the unknowing Jacob into marrying his elder daughter, Leah, instead. Not until his nephew had promised to serve Laban for an additional seven years was the youth awarded Rachel as his second wife.

In the polygamous arrangement that resulted, Leah bore four sons to Jacob, while Rachel remained barren. Desperate, she offered her servant, Bala, to Jacob as her surrogate, and the latter bore him two more sons. Not to be outdone, Leah, who "had given off bearing," presented Jacob with *her* handmaid, Zelpha, who promptly had two sons. Subsequently, Leah recovered her fertility and produced two more sons and a daughter. Meanwhile, the Lord heard Rachel's prayers, and she bore Joseph, Jacob's eleventh son.

Under Jacob's stewardship, Laban's affairs prospered, and he became enormously wealthy, but he and his sons demurred about providing Jacob with his due reward, so that he could finally return to his own country. Obeying an injunction of the Lord (who was always firmly on his side), Jacob fled, carrying off his wives, handmaids, and children, along with the servants, flocks, and goods he believed to be rightly his. Subsequently, Laban and his sons caught up with the party but pardoned them and returned to Mesopotamia.

When they came to the ford of the Jabbok, Jacob escorted his family and possessions across, then returned to the other bank to spend the night in solitude. An angel appeared and wrestled with him until morning without vanquishing him. As they parted, the angel blessed Jacob, renamed him Israel, and prophesied that he would prevail among men as he had over God's representative. Jacob and his family subsequently encountered Esau, with the latter's wives and children, and the two brothers were reconciled.

Following their return to Jacob's native land, Rachel died in childbirth, after safely delivering Benjamin, Jacob's twelfth and last son.

His sons became the ancestors of the twelve tribes of Israel, fulfilling God's prophesy at the time he appeared to Jacob during the vision of the ladder: "In thee and thy seed all the tribes of the earth shall be blessed."

3

The Archaeology of a Painting
A Visit to the City of the Dead
beneath Picasso's La Vie

DESPITE its status as *the* key picture of the Blue Period and the earliest of Picasso's major autobiographical statements, *La Vie* has not often been explored in depth. Critics typically allude briefly to its obscure symbolism and personalized references, then hurry on to some less troublesome picture. Among Picasso scholars, only Theodore Reff has seriously addressed himself to the painting's origins and iconography.[1] But Reff published his conclusions before the Cleveland Museum of Art undertook its revealing radiographic study of the canvas in 1976. These radiographs not only uncovered numerous pentimenti to the extant picture, but also revealed the remnants of a complete earlier painting, which Picasso had exhibited in February 1900.[2] These discoveries provide many new clues, not only about the artist's working methods, but about the picture's private significance for its creator.

In a discussion of the equally dramatic findings revealed by the radiographic analysis of *The Family of Saltimbanques,* E. A. Carmean has compared such evidence to the data derived from an archaeological dig.[3] Just as each of the layers of an archaeological site adds to our understanding both of the vanished culture under study and of the epochs that succeeded it, so, too, do all the levels of *La Vie* relate to and illuminate one another. In the essay that follows, I try to establish the interconnections not only between *La Vie* and its pentimenti proper, but also those linking the surface composition to the picture buried under it. The evidence suggests that Picasso's selection of the specific earlier canvas he chose to cover with *La Vie* was determined neither by chance nor by economic considerations, but by highly personal motivations.

Because the radiographic findings are crucial to this discussion, I shall begin with a brief review of these results. My summary derives from the

87

report published by M. McCully and R. McVaugh in the *Bulletin of the Cleveland Museum of Art,* supplemented by personal observation of the radiographs, which the Cleveland Museum graciously permitted me to examine at the Art Institute of Chicago, with the supervision and aid of Timothy Lennon, Conservator, and other members of the Conservation staff.[4]

La Vie *and Its Radiographs*

La Vie (Fig. 28) features an icy palette that echoes its chill emotional tone; cold blues and blue-whites predominate, accented here and there with touches of a sickly greenish-blue. It represents three larger-than-life protagonists in a mysterious interaction: A loving couple confronts an older woman who clasps a babe in arms. The lovers are positioned near the left margin of the painting, she totally nude, he wearing a brief slip. The young woman, tender and trusting, turns toward her lover, resting her head and arms on his breast. But he scarcely seems aware of her presence; his attention is riveted on the older woman who stands opposite him, clad in a classical, floor-length garment and mantle. The glances of youth and mother interlock, and he points the forefinger of his left hand toward her in a stiff, puzzling gesture. We see the woman's face only in profile, but her grim, disapproving expression provides a marked contrast with that of the blissfully sleeping babe she holds.

This unpleasant meeting apparently occurs in an artist's studio, a rather primitive place with a rough round-headed door (or sealed arch) and bare plaster walls. Two unframed paintings, one stacked above the other – without visible means of support – occupy the center background of the composition, separating the two figural groups. No clues allude to the whereabouts of the artist who painted these canvases, nor to the reason these three individuals have come together in an atelier.

The radiographs (Fig. 29) reveal that virtually every area of *La Vie* has been reworked. Only the figures of the mother and baby remain as Picasso initially conceived them, and they were added late in the evolution of the composition. Initially, the picture featured only the two lovers, standing next to a large easel on which a single painting was displayed. Picasso gave the man his own features, but later thought better of this idea and substituted the visage of his dead friend, Carlos Casagemas, for his own. In the course of this same reworking, he altered the features of the young woman to make her resemble Germaine Florentin, a girl with whom both Casagemas and Picasso had been deeply involved.

Although Palau i Fabre once argued that Picasso added the slip to cover the young man's genitalia only after he decided to transform his own image into that of the "impotent" Casagemas, the radiographs do not bear out this assumption.[5] To the contrary, they demonstrate that the male protagonist wore his concealing loincloth in both incarnations and was never provided with genitalia.

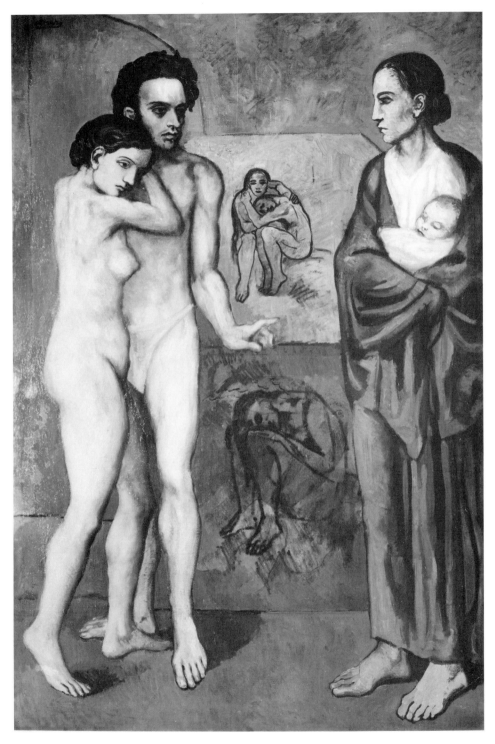

28. Pablo Picasso, *La Vie*, 1903–4. Oil on canvas. The Cleveland Museum of
Art, gift of the Hanna Fund; © 1993 ARS, New York / SPADEM, Paris.

89

Some time after he painted the torso of the male protagonist, Picasso added the representation of the lower propped canvas – which does not extend behind the man's figure. During this same campaign, he enlarged the dimensions of the picture depicted in the upper background, changing its original rectangular shape to the definitive larger, square format. Presumably, he introduced these alterations in order to cover all traces of the easel, which he had decided to eliminate, apparently because it had created an awkward, "leggy" space in the center of the composition, a defect he corrected by covering it with the two propped paintings that now bridge the gulf between lovers and mother.

Picasso had already determined the composition of the upper background canvas (originally displayed on the easel) in preliminary drawings, and he made no changes in this imagery once he had painted it, except to increase its size. This painting-wthin-the-painting represents a pair of sorrowful, nude women; one of them stares at the spectator, as if calling attention to the plight of her still more grief-stricken companion, whom she embraces.[6]

The scene depicted on the lower propped canvas gave Picasso more trouble, and he later hastily repainted it. Initially, he represented a composite creature with the head and wings of a bird, but the body of a nude man, hovering over a sensuous, reclining nude. Parts of this motif can now be discerned with the naked eye, beneath the thin surface image, which shows another sorrowful, crouching nude woman; she rests her head on her knees in an almost fetal position similar to that of the figure represented directly above her, in the upper propped canvas.

The artist did not add the figures of the mother and child until after he had sketched in at least the perimeters of the lower background painting – the woman's garments obscure parts of the borders of this canvas. After making all these changes and additions, he abruptly stopped work on *La Vie*, leaving it in a rather unintegrated state, as McCully and McVaugh point out:

> A full understanding of *La Vie*'s development through both the drawings and the painting process is particularly important, for the painting was never fully finished. The figures to the viewer's left and the upper background painting are finished with considerable care, while the right-hand figure and the lower painting remain rough and unfinished. Picasso often used different techniques in his work, but within each individual painting, the technique was normally consistent. As an unfinished work, *La Vie* does not necessarily represent a coherent image with which the artist was satisfied.[7]

The radiographs also disclosed the existence of a discrete earlier picture beneath *La Vie*. If one turns the composite photo of the radiographs ninety degrees counterclockwise, portions of that earlier composition be-

29. Composite x-ray of Picasso's *La Vie* (Fig. 28). The Cleveland Museum of Art, Department of Conservation.

30. Composite x-ray of Picasso's *La Vie* (Fig. 28) rotated 90° counterclockwise. The Cleveland Museum of Art, Department of Conservation.

come visible (Fig. 30). These remnants convinced McCully and McVaugh that the painting must be identical with a canvas entitled *Last Moments* that Picasso had exhibited at Els Quatre Gats in February 1900, and that was described as follows in a contemporary review:

> [The painting shows the] young priest standing with a prayer book in his hand contemplating a dying woman. The light of the lamp radiates weakly and is reflected in the spaces of the white mattress of the bed on which the moribund lies. The rest of the canvas is in shadow which dissolves the figures into indecisive silhouettes.[8]

Numerous preliminary sketches related to this submerged painting survive, but none of them corresponds exactly to this description. McCully and McVaugh suggest that a sketch once called *Kiss of Death* (Fig. 31) best approximates the lost painting;[9] however, another drawing from this series, *The Death Bed* (Fig. 32), which does not portray the male protagonist as weeping, probably more closely approximates the composition shown in 1900. Although McCully and McVaugh do not comment on this detail, it seemed to Lennon, his staff, and myself that this buried picture also contained pentimenti that suggested that Picasso

92

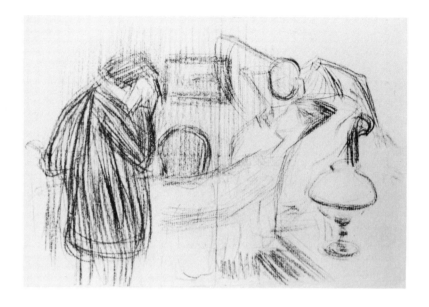

31. Picasso, *Kiss of Death,* 1899–1900. Conté crayon on paper. Museo Picasso, Barcelona; © 1993 ARS, New York / SPADEM, Paris.

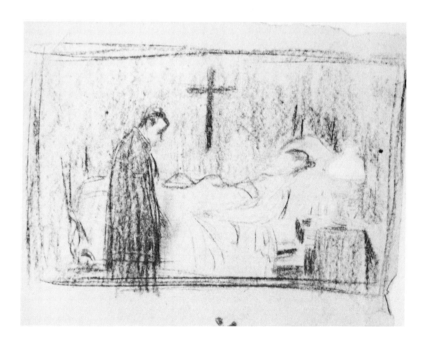

32. Picasso, *The Death Bed,* 1899–1900. Conté crayon, chalk, and charcoal on paper. Museo Picasso, Barcelona; © 1993 ARS, New York / SPADEM, Paris.

93

had originally shown the young man weeping, as in the *Kiss of Death,* but that the artist had later overpainted this detail.[10]

Casagemas and His Role in Picasso's Life

In order to decipher the psychoiconography of *La Vie,* in which the image of Carlos Casagemas plays such a prominent part, it seems relevant to present a brief summary of his role in Picasso's life. Casagemas, a fellow art student and committed *decadente,* became Picasso's intimate friend around 1899. Early in 1900, they established a joint studio – a move subsidized by Casagemas, who came from a more prosperous family than did Picasso. That autumn they set off for Paris together, for what would prove to be the first of four trips to the French capital Picasso would make between that date and 1904.

The biographical data suggest that Casagemas must have been an extremely disturbed young man; he had a history of recurring depressive episodes, and he had made at least one earlier suicidal attempt.[11] No sooner had the two youths arrived in Paris than Casagemas fell madly in love with – or, perhaps more accurately, became obsessed by – a rather promiscuous young woman known as Germaine Florentin (née Gargallo; later Pichot). Picasso and Casagemas "inherited" Germaine, her sister Antoinette, and her friend Odette, along with the studio they took over from another Spanish painter, Isidore Nonell, who had decided to return to Barcelona at about the same time Picasso and Casagemas arrived in Paris. Germaine (who was apparently married, but not overly committed to her husband) did not really reciprocate Casagemas's affection, but nonetheless consented to become his live-in companion, while Picasso paired up with Odette. The arrival of Manuel Pallarès, who joined his fellow Spanish artists a few weeks later, transformed this *ménage à quatre* into a *ménage à six,* with Antoinette becoming his live-in lover.[12]

But neither Germaine's allure nor the charms of Paris could insulate Casagemas against his underlying melancholia, and within a few weeks of his arrival he once again became profoundly depressed. Picasso, who considered himself responsible for his friend's welfare, felt that he had to watch over him every moment to prevent a disaster.

Although scholars and biographers have typically attributed Casagemas's problems to his alleged impotence and frustration over his inability to satisfy Germaine sexually, such explanations fail to recognize the pervasive nature of his personality problems, which were by no means confined to – nor primarily triggered by – his sexual difficulties. Rather, he appears to have been a person whose adjustment was so fragile that his underlying craziness bubbled to the surface whenever he encountered anxiety-provoking situations, to which he invariably reacted by becoming depressed and suicidal.[13] Both Casagemas's unrequited passion for Germaine and his alleged impotence should be recognized as symptoms, not causes of his psychological collapse. (In fact, severe depression is

almost invariably accompanied by impotence.) In view of his friend's checkered mental-health history, Picasso's decision to invite Casagemas to accompany him to Paris seems, to say the least, imprudent.

Soon wearying of his role as Casagemas's keeper, Picasso persuaded his friend to return to Barcelona with him shortly before Christmas, and then to accompany him and his family when they returned to their native Málaga for a New Year's reunion with relatives. But Picasso's therapeutic scheme presently proved ineffectual; the warm sunshine of Málaga failed to dispel Casagemas's melancholy, and he spent most of his time sitting around the local taverns and whorehouses in a drunken stupor. Although no drunkard himself, Picasso loyally accompanied Casagemas on his sodden rounds, until he once again grew resentful over his role as caretaker. Meanwhile, Picasso's parents and relatives were growing increasingly indignant over the bohemian garb and wild ways of the two youths, and Pablo's quarrels with his family escalated. After loading Casagemas aboard a vessel bound for Barcelona, Picasso abruptly quitted Málaga, fleeing alone to Madrid; there he stayed until spring, when he finally reconciled with his parents and returned to Barcelona.

Casagemas, left to his own devices, soon headed back to Paris and his unresponsive love. His psychological state continued to deteriorate, and on February 17, 1901, he fatally wounded himself in the presence of Germaine, Odette, and a group of his Spanish chums. Casagemas had evidently planned his suicide as part of a bizarre, public love–death enactment, and he died believing that the shot he had fired at his sweetheart moments before had proven fatal.[14]

The myth that a postmortem examination conducted on Casagemas revealed that he had been impotent enjoyed considerable currency in the Picasso literature devoted to *La Vie* until I pointed out that an autopsy cannot evaluate genital function, only genital anatomy.[15]

Picasso was still in Madrid when Casagemas committed suicide, and he did not return to Barcelona for the memorial services that followed his friend's interment in Paris.[16] However, when he began his second Paris sojourn in May 1901, Picasso not only took up residence in the studio Casagemas had occupied at the time of his death, but also conducted an affair with his friend's femme fatale, Germaine. As autumn approached, the artist became more and more preoccupied with Casagemas's suicide, an obsession that eventuated in the creation of a series of votive paintings that recounted the story of his friend's death and served as direct precedents for Picasso's nascent Blue Period. The most dramatic of these pictures depicts Casagemas as he collapses, immediately after firing the fatal shot into his temple; the next two compositions show him lying in state in his coffin. (The fact that Picasso retained these three canvases in his private collection, unpublished and uncatalogued, for more than fifty years after Casagemas's death, provides some measure of the lasting impact of this event on him.)[17] The two remaining oils from the group depict the funeral of Casagemas: *The Mourners* (private collec-

tion) represents friends and family gathered around the dead youth's bier, while *Evocation* (private collection), with its mythic presentation of Casagemas's burial and apotheosis, provides a more optimistic postscript to his sad tale.

The Chronology of La Vie

McCully and McVaugh propose a termination date early in 1904 for *La Vie,* although it is usually assigned to mid-1903.[18] A drawing that corresponds quite closely to the original version of *La Vie* (as revealed by the radiographs) is sketched on the back of an official announcement of a memorial service for a professor at the School of Fine Arts (La Llonja). This study (Fig. 33) bears a notation in the artist's hand, "Barcelona, 2 mayo, 1903."[19] Picasso must have begun work on the painting soon after making this drawing, because he completed a version of the picture (although almost certainly not the one we know today) in time for its inclusion in an exhibition that was reviewed in the June 4 edition of the Barcelona newspaper *El Liberal.* The critic mentioned *La Vie* in flattering, but regrettably vague, terms:

> Pablo Ruiz Picasso, the well-known Spanish artist, who has had so many triumphs in Paris, has recently sold one of his works for a respectable price to the Parisian collector, M. Jean Saint-Gaudens.... The picture ... entitled *La Vie* is one of those works which can at a stroke establish an artist's name and reputation. The subject is interesting and provocative, and the conception is of such strength and intensity that it is one of the few truly impressive works to have been created in Spain for some time.[20]

Whether because the purported purchase of the picture fell through, or for some other reason, *La Vie* evidently remained in Picasso's possession well after its reported sale, for he later recalled that he had worked on it after moving to his Commerce Street studio, a space he did not occupy until the end of 1903 or the beginning of 1904.[21] Most likely he made the final changes in the canvas at that time. Perhaps it was *La Vie* that Jaime Sabartés, Picasso's intimate friend and companion during these years, discovered his friend in the process of completing when he visited Picasso's studio in January 1904:

> At the beginning of the following year [1904], he rented a studio for himself alone in Commerce Street. He wanted to paint, to do something bigger than usual.... Picasso's father prepared for him a panel of huge proportions, as if the moment had arrived for achieving the great definitive work, but as soon as the panel was in the studio, he filled it up immediately by painting a group as quickly as he would on any canvas. His need for having a studio unto himself alone, his idea of having a panel prepared as if he were to paint an altarpiece,

33. Picasso, study for *La Vie,* dated May 2, 1903. Pencil on paper. Private collection; © 1993 ARS, New York / SPADEM, Paris.

and his thirst for solitude were manifestations of his extreme restlessness.[22]

Although Sabartés failed to identify the subject matter of this "huge" painting (and misidentified it as a work on panel, rather than on canvas), it is difficult to imagine that he could have been referring to any picture except *La Vie* – by far the largest of Picasso's Blue Period pictures. Even Sabartés's wry observation that Picasso behaved as though he were painting an altarpiece seems relevant; the composition of *La Vie* does, indeed, recall those Gothic and Renaissance *Sacre Conversazioni* that show a central image of the Virgin surrounded by saints. While preserving the symmetrical and hieratic quality of such compositions, Picasso simply replaced the usual enthroned Madonna and Child with a pair of propped canvases. Reff points out that many of Picasso's important Blue Period

97

paintings resemble secularized altarpieces, an observation that seems particularly apt for *La Vie*.[23]

Picasso evidently concealed the true history of *La Vie* from Sabartés, allowing his friend to believe that Picasso's father, Don José Ruiz y Blasco, had especially prepared the support for this work at the beginning of 1904, whereas he had probably merely arranged to have the canvas Picasso had exhibited in 1900 transported to his son's new studio. Perhaps Sabartés arrived one day to find Picasso hastily brushing in one of the many reworked areas of *La Vie* and mistakenly concluded that the artist had painted the entire canvas with equal impetuosity.[24]

If Picasso actually completed the definitive version of *La Vie* at the end of 1903 or the beginning of 1904, the painting had a total gestation period of at least eight or nine months from conception to completion. During the early years of his career, Picasso frequently attacked special problem pictures in two separate campaigns; his dual attacks on the *Portrait of Gertrude Stein* and *Les Demoiselles d'Avignon* merely constitute the most celebrated examples of a procedure that he probably also followed in the case of *La Vie*. During his initial campaign, which apparently lasted no more than a month, Picasso presumably depicted the loving couple standing next to the easel displaying the painting-within-the-painting. He soon decided to eliminate the easel (but not the picture represented as standing on it), and subsequently added the image of the lower propped canvas to camouflage this change. Whether he also transformed the identities of the lovers during this same campaign remains an unresolved question. In one or more later phases of *La Vie*'s evolution, he added the figures of the mother and infant, and replaced the menacing bird-man and nude originally shown on the lower propped picture with the image of the crouching woman it now represents.

This hypothetical reconstruction best fits the visual evidence supplied by the surface appearance of *La Vie*, and by the radiographs revealing its evolution. The x-rays indicate that both the figures of the lovers and of the bird-man and nude originally shown on the lower canvas were carried out in a similar, consistent technique. These areas all show strong contours, detailed modeling, and careful facture. The figures of the mother and child, by contrast, were brushed in with large, bravura strokes of a quite different character, leading Lennon to conclude that they might have been painted in a single sitting.[25] The mother's figure is made up primarily of draperies. No anatomical details underlie her floor-length garments: She consists only of face, feet, and clothing. By completely covering her arms and hands with her mantle, Picasso negated the necessity of painting those details, except for adding a few suggestive lines to the mantle's surface. The crouching nude shown on the lower background painting is an equally sketchy creature; beneath her quasi-transparent figure one can readily discern the bird-man's red head, right wing, arm, and hand, as well as segments of the lower torso of the reclining female nude over whom he hovered.

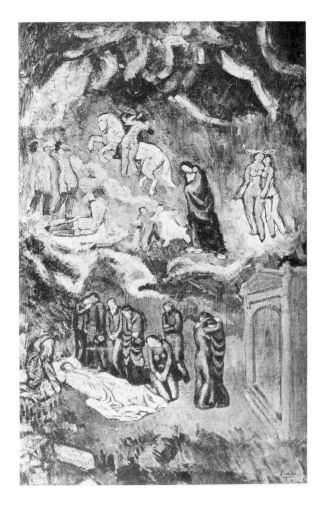

34. Picasso, *Evocation (The Burial of Casagemas)*, 1901. Oil on canvas. Musée d'Art Moderne de la Ville de Paris; © 1993 ARS, New York / SPADEM, Paris.

The Preliminary Studies for La Vie

Images and ideas that Picasso would develop more fully in *La Vie* appear in nascent form in a picture created two years earlier, *Evocation* (Fig. 34), the climactic work of the series he painted in 1901 to commemorate the death of Casagemas.[26] The figures in *Evocation* shown surrounding Casagemas's bier or accompanying his triumphal passage to heaven recur in later Blue Period works, culminating in *La Vie*. For example, the pose of the grieving couple represented at the head of Casagemas's bier anticipates that assumed by the lovers of *La Vie*. An ancestress of their counterpart, the mother with the infant, can also be discovered in the

99

guise of the woman being guided into the heavenly realm by two little children or angels. (As Reff points out, she is the most prominent figure depicted in *Evocation;* his suggestion that she represents Casagemas's mother, depicted as though she had joined him in death, seems quite plausible.)[27] Well before Picasso reintroduced this personage as the mother of *La Vie,* he adapted her figure and pose for that of the chaste sibling in *Two Sisters (The Meeting)* (Fig. 35), a work from 1902 depicting the poignant encounter between a prostitute from the St. Lazare Prison Hospital (where women prisoners suffering from venereal diseases were treated), and her virtuous sister, whom the artist later identified simply as "a mother."[28]

In creating *The Embrace* (Fig. 36), Picasso again turned to *Evocation* for inspiration; for example, he borrowed the pose of the two grieving women represented at the foot of Casagemas's bier, transforming them into the guilty lovers of *The Embrace* by changing the right-hand personage from a woman to a man and stripping both figures of their clothing.[29]

Other, less direct analogies link figures originally developed for *Evocation* to *The Two Sisters* and *La Vie.* For example, in *Evocation,* the woman represented standing apart from the other mourners, with her arms tightly folded, reappears – turned ninety degrees and depicted nude, but virtually unchanged in pose – in preparatory drawings for the prostitute of *The Two Sisters* and the young lover featured in preliminary studies for *La Vie.* Other mourners who originated in *Evocation* share more general relationships with those of pathetic, depressed women Picasso would portray during 1901–2, images that share a generic relationship to the despairing figures he would later represent in the two background canvases featured in *La Vie.*

In view of their common roots in *Evocation* and their common preoccupation with sexuality, it is far from easy to sort out which drawings Picasso originally conceived as studies for the *Two Sisters, The Embrace,* and *La Vie,* respectively, and scholars have demonstrated considerable confusion in assigning these sketches to their proper companion paintings. For example, J. E. Cirlot identifies a group of sketches from 1903 showing a pair of nudes – a bearded man and his pregnant companion – as preliminary conceptions for *The Embrace.* Currently, most scholars identify them, instead, with *La Vie,* while labeling another drawing Cirlot believed to be for the latter work as a study for the *Two Sisters.*[30]

Cirlot's problems in deciding which drawings belonged to *The Embrace* and which to *La Vie* seem understandable. Picasso developed both compositions virtually simultaneously; most likely, he did not begin these sketches with two separate compositions in mind, but simply started drawing, perhaps with some vague notion about portraying the emotional reactions of a couple who have conceived a child out of wedlock. Gradually, alternative conceptions of this theme occurred to him, variations that he ultimately developed into two distinct compositions.

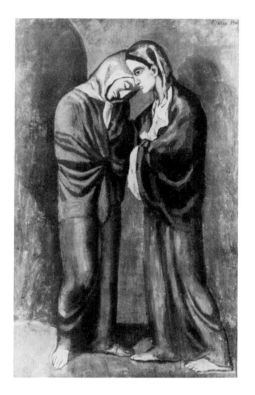 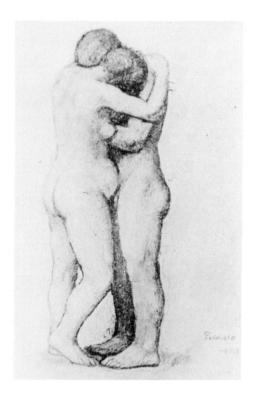

35. Picasso, *The Two Sisters (The Meeting)*, 1902. Oil on canvas. The Hermitage Museum, St. Petersburg; © 1993 ARS, New York / SPADEM, Paris.

36. Picasso, *The Embrace*, 1903. Pastel on paper. Musée de l'Orangerie des Tuileries, Paris, Collection J. Walter-Paul Guillaume; © 1993 ARS, New York / SPADEM, Paris.

Initially, another of Cirlot's misidentifications seems more puzzling: his misattribution of a sketch actually related to *The Two Sisters* to *La Vie*. After all, Picasso had finished the former picture more than a year before beginning work on the latter.[31] What caused Cirlot's confusion? Comparison of the drawings in question (both Museo Picasso, Barcelona) makes his error more understandable. Each shows a couple huddled together, two women in one instance, a man and woman in the other. The left-hand figure in each drawing depicts a nude, frontal female, who stands with her arms folded and her head bowed in despair. The young woman featured in the study now assigned to *La Vie* appears to be pregnant, while the condition of the woman in the other drawing seems more ambiguous. Although there can be little doubt that the latter picture really is a study for *Two Sisters* (one can perceive the ghostly outline of the chaste, fully clothed sister next to the nude), it represents an atypical idea for that composition. A number of additional studies survive, all rep-

101

resenting both sisters fully clothed and facing one another. Nor do any of these sketches suggest that Picasso intended to depict the prostitute as pregnant, although her virtuous sister is always shown holding a young infant. The repeated attribute of the baby suggests that Picasso may have intended *The Two Sisters* not only as a modern allegory of sacred and profane love, but also as a message that the wages of sin is sterility, while that of chaste conjugal love is fecundity.[32]

If Picasso intended *The Two Sisters* to symbolize the evils befalling women who engage in loveless sex, he probably originally conceived of *La Vie* as an example of the dilemma of those who love not wisely, but too well: All the early studies now associated with the latter work represent the heroine as a tearful young woman in the second trimester of pregnancy. Her bearded companion, presumably the father of the unborn child, reacts to her situation in widely different ways in alternative explorations of the motif. Sometimes, he throws up his hands in a helpless gesture; other times, he embraces and comforts his beloved. A third variation, however, depicts a more violent reaction in which the man seems bent on solving his problem by eliminating his partner. One of these compositions portrays the woman sinking to the ground helpless as her partner pummels her with his fists.[33] In another version (Fig. 37), the young woman covers her head with her arms in a vain attempt to protect herself from the rain of blows her lover directs at her. After completing this sketch, Picasso obliterated the young man's head, transforming him into a faceless, anonymous killer.

The man featured in several of these preparatory sketches wears a short, curly beard. Although Picasso sported a mustache during these years, no photographs indicate that he ever wore a beard; however, he did portray himself with such a beard in one drawing from this period (Museo Picasso, Barcelona). Whether the artist went through a brief bearded phase at this time, or simply tried out this effect in a sketch because he planned to base the lover of *La Vie* on a quasi-disguised, bearded self-image, remains unclear. However, by the time he had begun the actual painting, Picasso had evidently abandoned this idea; the radiographs (see Fig. 29) reveal that he was shown as clean-shaven in the self-image now submerged beneath that of Casagemas, who also appears clean-shaven in the painting, as in real life.

Even after Picasso had hit upon the notion of presenting the young lovers of *La Vie* in an artist's studio, as though posing for a painting, he continued to portray the young woman as pregnant. Several sketches (such as Fig. 38) that predate the definitive study of May 2 depict her as four or five months pregnant. Both the agitated quality of the line and the numerous pentimenti apparent in the area of the woman's abdomen in several of these drawings reflect an uncharacteristic uncertainty – or perhaps anxiety – about this aspect of the composition. By the time he executed the May 2 sketch (see Fig. 33), Picasso had eliminated this bothersome feature.

37. Picasso, study for *La Vie,* 1903. Conté crayon on paper. Museo Picasso, Barcelona; © 1993 ARS, New York / SPADEM, Paris.

38. Picasso, study for *La Vie,* 1903. Conté crayon on paper. Museo Picasso, Barcelona; © 1993 ARS, New York / SPADEM, Paris.

The May 2 drawing also eliminated, or at least failed to include, the third person represented in earlier sketches for the composition: the artist in whose atelier the drama unfolds. These studies represent the artist as an emaciated, bearded man, who gestures actively toward the couple. His rather seedy appearance puzzled Reff, who comments that the man looks more like a Blue Period beggar or madman than a professional artist, whereas Cirlot unconvincingly proposes that he represents Casagemas.[34] In fact, the man closely resembles the obscure Catalan sculptor E. V. Fontbona, whose gaunt form Picasso had captured in an ink sketch of 1902 or 1903.

Whether Picasso actually considered modeling the artist of *La Vie* on Fontbona remains an unresolved question. However, his appearance vaguely recalls images of another bearded artist who had figured prominently in Picasso's art and history: his father, Don José Ruiz y Blasco. Many years later, Picasso would confess to Brassaï that all the bearded men he ever created represented his father.[35] If, on some level, the art-

ist in these drawings for *La Vie* symbolized Don José, the situation depicted reversed Picasso's real-life experiences during adolescence. In these studies, Picasso and his companion pose for the bearded artist; in reality, Don José repeatedly modeled for his son. He appears in numerous drawings and paintings from the artist's youth, and posed for the principal male figure of two of Pablo's most ambitious early paintings: *The First Communion* (1896; Museo Picasso, Barcelona) and *Science and Charity,* painted at the beginning of 1897.

At one point, Picasso also briefly considered basing the image of the artist on his own image. Both Tinterow and Reff point out that a drawing now in the Fogg Museum (Fig. 39) represents Picasso, shown in the pose assumed by the bearded artist in the sketches just discussed.[36] Chapters 4–6 in the present volume provide numerous illustrations of the freedom and fluidity with which Picasso exchanged the roles and genders of key figures depicted in preparatory drawings for *The Old Guitarist, Les Demoiselles d'Avignon,* and *Guernica.* This same fluidity governed the development of the right-hand protagonist in *La Vie,* who represented, in turn, a bearded older man possibly based on Picasso's father, the artist himself, and finally, the Madonna-like mother. These three images successively occupy the same space and – by implication – the same role in the picture. This interchangeability reflects Picasso's insight into his identifications with those closest to him.

Several critics have suggested that the picture displayed on the artist's easel in the May 2 study for *La Vie* derives from another drawing that also involves a self-portrait, *The Couple* (Fig. 40).[37] This sketch shows two lovers seated on a bed; the weeping woman covers her face with her hands, while her uncomfortable-looking partner, who has Picasso's own features, stares determinedly down. This love-and-guilt motif recalls that of *The Embrace;* however, in the latter picture the lovers draw comfort from each other, whereas in *The Couple* each person remains isolated in remorse.

The May 2 drawing for *La Vie* (see Fig. 33) treats the facial features of the man represented in the canvas on the easel so sketchily that it is impossible to determine whether Picasso planned, at this stage, to represent himself both as the young man posing for the artist and as the male protagonist of the picture-within-the-picture. When he turned his attention to the painted version of *La Vie,* however, Picasso transformed the lovers of *The Couple* into a pair of sorrowing women, simultaneously eliminating both the sexual and the self-referential implications of the preparatory drawing. Once again, Picasso converted his own image into that of a female protagonist.

As previously noted, the artist evidently made up his mind to add the lower propped canvas shown in *La Vie* without carefully working out the composition in advance. Two drawings now in Museo Picasso, Barcelona, seem to be related to his initial conception for this painting-within-the-painting. The earlier sketch shows a Junoesque, winged nude

39 (*right*). Picasso, *Self-Portrait Standing,*
1903. Ink on paper, Fogg Art Museum,
Cambridge, Massachusetts; © 1993 ARS,
New York / SPADEM, Paris.

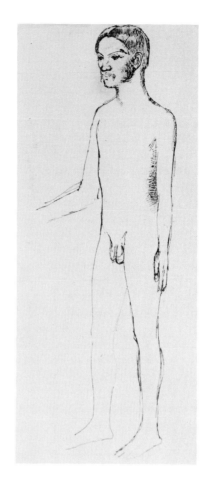

40 (*below*). Picasso, *The Couple,* 1902–3.
Ink and colored crayon on paper. Private
collection; © 1993 ARS, New York /
SPADEM, Paris.

woman hovering, arms outstretched, above a schematically indicated couple who are evidently about to make love. In the second interpretation of this theme (filled with pentimenti and difficult to read), a benign, winged male figure, also nude, has replaced his female counterpart, although vestiges of her quasi-eradicated form can still be detected in his chest area. This sketch portrays the lovers more realistically, and the young man closely resembles the artist himself. With outstretched arms and erect penis, he eagerly kneels before a reclining nude who reaches out to him with equal enthusiasm.[38]

Before transferring this motif to canvas, Picasso fused the two male figures from the drawing into the composite image of the bird-man, a creature who seems far more ominous than amorous as he hovers above the reclining nude. Perhaps the artist himself found the symbolism of this composition so disturbing that he later covered it with a crouching female nude, rapidly and sketchily painted. Anthony Blunt has suggested that the latter figure may derive from van Gogh's celebrated drawing *Sorrow* (private collection, London), while Françoise Cachin suggests that the source for Picasso's crouching woman can be found in the similar figure represented in Paul Gauguin's enormous canvas *Where Do We Come from? What Are We? Where Are We Going?* (1897; Museum of Fine Arts, Boston).[39] Either or both of these works may have inspired Picasso, but the most direct ancestress for his lower background figure seems to be the very similar image he depicted on the upper propped canvas of *La Vie*. In haste to eliminate his predatory bird-man, Picasso apparently indulged in a bit of perseverative borrowing from himself.

The Madonna-mother who rounds out the cast of characters in *La Vie* constitutes another instance of "auto-borrowing." No preparatory works for her figure survive, although, as previously noted, she resembles a number of earlier sorrowing Blue Period mothers who trace their common lineage back to the mother of *Evocation*. Without exception, these women appear in pictures with morbid themes, a fact that may provide further clues for the interpretation of the symbolism of this figure in *La Vie*.

Preliminary Studies for the Painting beneath La Vie

The description of *Last Moments* quoted earlier in this essay (in the section "*La Vie* and Its Radiographs") suggests that the picture was probably oversentimental and inadequately realized. Despite its questionable effectiveness, Picasso apparently struggled long and hard over the composition, as attested by the survival of a spate of related preparatory drawings.[40] Several of these motifs seem potentially more interesting than the drawing Picasso eventually chose to translate into oil. In fact, *Last Moments* represented an atypical variation on the preliminary sketches in that it showed a nonrelative keeping vigil at the dying girl's bedside. Without exception, the remaining studies represent family mem-

bers in this situation, suggesting that Picasso originally intended to create a picture that emphasized the impact of a death in the family on its surviving members. Far from resembling a priest, the young man shown in several of these drawings (see, e.g., Fig. 31) appears to be a bereaved brother or husband who buries his face in his handkerchief and gives vent to his grief. Meanwhile, Death, a skeleton bearing a scythe, materializes at the head of the bed to plant his fatal kiss on the girl's forehead. In another variation (also in the Museo Picasso, Barcelona), a young man embraces a girl whose body has become so emaciated that her persona seems to have fused with the skeletal image of Death.

Several other drawings from this group represent an entire family gathered around the patient's bed. Everyone seems distracted with grief, especially the two men shown. A small oil sketch from this same period, *Kissing the Corpse* (Museo Picasso, Barcelona), presents the next chapter in this sad drama, as the family gathers around the bier to bestow a final gesture of affection on the corpse. The narrative continues in other drawings that seemingly portray the period of acute grief immediately following the funeral. In one instance, a sorrowing couple huddles together on a couch in a pose that anticipates that of the two nude women on the upper background canvas of *La Vie*. Another study shows a grieving man standing alone in a cemetery; his bearded features and slim figure strongly recall the appearance of the artist's father.

A group of conté-crayon sketches from this same period (Museo Picasso, Barcelona) portraying a desperate mother kneeling at the bedside of her sick child constitutes yet another variation on the theme of family illness that preoccupied Picasso at the time.[41] He returned to this motif several years later in the pastel *Mother and Child*, or *The Sick Child* (1903; Museo Picasso, Barcelona). The mother figure of this maudlin picture presents her wan child to the spectator with all the solemnity of the Virgin exhibiting the body of the dead Christ. This composition constitutes yet another of Picasso's secularized altarpieces.

Interpretation

After exhibiting *Last Moments* in 1900, Picasso evidently consigned the enormous canvas to storage until the spring of 1903, when he began to overpaint it with *La Vie*. Before reusing the canvas, the artist turned the support ninety degress, so that the horizontal format previously employed became emphatically vertical. Lennon observed that when Picasso reused a support, as he frequently did during the early years of his career, he often laid in his new composition right over the earlier one, without either overpainting or changing the orientation of his ground. (He followed this procedure in the case of *The Old Guitarist*, the subject of Chapter 4.) Did he change the orientation of his support before executing *La Vie* because he did not wish to confront the old motif with its death-drenched associations?[42]

Picasso's initial conception for his new painting seemed quite appropriate for its title, *La Vie*. He apparently devised this rather highfalutin name himself – an uncharacteristic step for this artist, who seldom titled his pictures and generally disapproved of the names devised for them by dealers or critics. This atypical behavior seems significant: The composition originally painted on this support had been dedicated to death; its replacement would emphasize life, love, and fecundity. (Whether Picasso was attracted to the motif of illicit pregnancy because he thought it would add a daring modernist touch, or because this theme reflected some adventure in his private life, remains unclear.) In any case, he began *La Vie* as a highly personalized statement featuring himself as the central male protagonist. As indicated earlier, he contemplated – at least fleetingly – making multiple appearances in this work, representing himself as the lover, the artist whose atelier forms the setting for the painting, and the male figure depicted in the canvas shown on the easel.

As previously noted, Picasso soon decided to eliminate the pregnancy theme from *La Vie,* a change that meant that his original allegorical concept had to be scrapped and some other unifying theme adopted. It also necessitated that he modify the imagery of the painting shown on the easel, since its motif of love and remorse was directly related to the pregnancy theme. Eventually Picasso substituted the vision of the two despairing women now featured in the upper canvas for the guilty lovers depicted in the May 2 sketch for *La Vie*.

Picasso's initial resolve to shape *La Vie* into a grand statement emphasizing the joys and sorrows of earthly love should be regarded as a magical gesture, consciously or unconsciously invoked to counter the associations to death and mourning permeating this reused canvas, which had originally served as the vehicle for *Last Moments*. But Picasso proved unable to elude the inexorable pull of that death-drenched motif. This compulsion was operative from the start: As we have seen, the principal figures of *La Vie* derive from personae originally created for *Evocation,* another composition dealing with death and mourning. Even the fact that Picasso executed the definitive drawing for *La Vie* on the back of an invitation to a memorial service for a professor at La Lonja cannot be considered mere coincidence;[43] rather, it represents another link in the chain of circumstances binding *La Vie* to *la mort*.

Picasso's decision to add the predatory bird-man to *La Vie* may have been the step that made the preliminary version of his new composition insupportable. Later, as a mature artist, he would often portray his own darkest impulses; many of his images of his alter egos, the Minotaur or fighting bull, suggest the same fusion of erotic and hostile drives implicit in the bird-man. But in 1903, he was either not yet ready to reveal his darker side in his work, or, at least, not yet bold enough to risk alienating his potential public by showing his violent impulses so openly. Perhaps during the same painting campaign in which he obliterated the bird-man, Picasso transformed the features of his male protagonist so that he no

longer resembled the artist himself, but his dead friend, Casagemas. "It was not I," this painted denial reads, "but my self-destructive friend, Casagemas, who confused his amorous and hostile wishes and tried to kill the girl he loved."

Even this substitution failed to quell Picasso's unease: He could escape the compelling death qualities of *La Vie* only by escaping the painting itself. Abruptly, he returned the canvas to storage and turned to other projects. Perhaps it was at this time that he executed the gouache and pastel versions of *The Embrace*. Utilizing virgin grounds uncontaminated by death associations, he revived the theme of love and remorse, represented in *The Embrace* with unusual sensitivity. In creating the two versions of this composition, he successfully denied the underlying grief and guilt that had compelled him to return to, then reject, the ground on which he had once portrayed *Last Moments*.

The following January, alone in his new studio, Picasso surrendered to his obsession to complete the conversion of *La Vie* into *la mort*. Several factors combined to compel his return to this elegiac canvas. For one thing, the third anniversary of Casagemas's suicide was approaching. Picasso was always quite prone to such anniversary reactions, and his thoughts surely turned to his friend as February 17, the date of Casagemas's death, drew near.[44]

But other, more critical anniversaries – milestones in the young artist's past life – coincided with the advent of the New Year, and the fact that he elected to begin his independent existence around the beginning of January cannot have been fortuitous. The holiday season always represented an especially distressing period for the artist, who associated a number of particularly unpleasant memories with this supposedly joyous time. The terrible Málaga earthquake of 1884 had begun on Christmas night and – at least as he remembered the sequence of events – this calamity had triggered another: the birth of the first of his two sisters, Delores (Lola). Later, Picasso would return from each of his first three Paris sojourns around Christmas time (or, in the case of his third visit, as soon thereafter as he could scrape together the fare), undoubtedly because unconscious memories of past traumas reactivated his separation anxiety on these anniversaries.[45]

The New Year also ushered in another, grimmer anniversary: His baby sister, Concepción (Conchita), had died on the fifth of January 1895. We know very little about this child, who was six years Picasso's junior, or about the nature of their relationship. This paucity of data undoubtedly reflects the artist's own reticence. The same lacunae obtain in the visual sphere: Not a single image that can securely be identified with Concepción survives, although during these same years Picasso frequently portrayed Lola, the older of his two sisters. The paucity of visual and biographical evidence need not indicate that Conchita was unimportant to Picasso; to the contrary, it may betoken the exact opposite. As a mature adult, Picasso carefully refrained from creating any identifiable portraits

of two people with whom he formed especially significant relationships: his artistic partner, Georges Braque, and his mistress, Eva, who died of tuberculosis in December 1915.[46]

However their relationship ultimately developed, little Pablo surely did not greet Conchita's arrival with equanimity. As I shall attempt to demonstrate in Chapter 6, Lola's birth had triggered a major traumatic reaction on the boy's part that contaminated his response to his second sister's arrival. Conchita's birth in 1887 also coincided fairly closely with the beginning of Pablo's school career – and the onset of his severe school phobia. The latter problem – generally a symptom of extreme separation anxiety on the child's part – may have been triggered or exacerbated by Pablo's resentment over the appearance of this new rival for his parents' attention and affection.[47]

The artist's well-documented readiness to believe, even as a mature adult, that he was somehow responsible for the demise of friends, such as the sculptor Julio Gonzalez, probably reflects the persistence of early, deep-seated death wishes toward his sisters. It also reveals, once again, the fragile nature of Picasso's personality integration, the ease with which he confused past and present, external events and interior states. In Conchita's case, his evil wishes became a reality: She died of diphtheria shortly before the family moved from Corunna to Barcelona. We gain some insight into the impact of this catastrophe on the future artist when we realize that, throughout his life, he misremembered the actual chronology of this sad event. He invariably told everyone – including Françoise Gilot – that Conchita had died in the autumn of 1891, shortly *after* the family moved to Corunna, rather than at the beginning of 1895, shortly *before* they moved from Corunna to Barcelona.[48] The artist's permanent disorientation about the date of this tragedy suggests that the child's death left him reeling – he must literally have been "out of it" during the months that followed her fatal illness, so much so that he never succeeded in regaining an accurate perspective concerning its time and circumstances.[49]

During the final days of Conchita's life, her distraught older brother made a desperate attempt to save her by making a solemn promise to God to give up his beloved art forever if she were spared. To no avail: Pablo's proffered sacrifice failed to save Conchita.[50] This was the first *known* instance of a pattern of failed rescue attempts that Picasso would repeatedly undertake during his long lifetime. (It seems unlikely that his effort to save his sister constituted the first instance of such magical thinking on his part; powerful, magical convictions of this kind are typically imprinted on the personality early in life, around the time that language develops.) Some years after Conchita's death, the artist would make another, similarly futile attempt to save Casagemas. This need to enact the role of magical savior would dominate Picasso's mature romantic relationships, and he repeatedly became deeply involved with

women who suffered from extreme psychological or physical problems;[51] but his attempts to rescue and restore these partners would prove as futile as his earlier efforts to preserve Conchita and Casagemas.

The potential self-sacrifice involved in Picasso's vow to abandon his future artistic career in exchange for Conchita's life did little to assuage his guilt over her demise. Gilot emphasized that when she met him nearly fifty years after the child's death, the artist still seemed preoccupied with, and guilty about, her loss. Diphtheria has been almost eradicated today, and its effects largely forgotten, but it was a particularly agonizing and horrifying disease that caused death by asphyxiation. Gilot believes that Picasso's chronic anxiety about choking to death, as well as his corresponding conviction that his children might suffocate while they slept, stemmed from memories of his sister's illness, those final hours when she lay gasping for breath, her face permeated by the cyanotic blue tinge brought on by acute oxygen deficiency.[52]

The shock of losing Conchita must have devastated the entire family. A small oil panel from 1895 (Museo Picasso, Barcelona) reveals a desolate family scene: Picasso's mother, father, and Lola are shown seated around the dining room table. Mother and daughter busy themselves with reading, but Don José stares desolately into space; the hanging lamp above the table recalls the similar light depicted in *Last Moments*. Several other portraits of Don José executed within a few years of Conchita's death likewise emphasize his melancholy.[53]

Picasso's biographers typically reveal much more about his father's reactions to this tragedy than about the response of his mother. Typically, too, these accounts assure us that Doña Maria behaved optimally, bearing up under her grief, while Don José felt devastated by the loss of this child, the only one of his three offspring who resembled her slim, blond father. (Such descriptions, repeated by various biographers, of the differing reaction of Picasso's parents to any adversity should, in my opinion, be treated with extreme skepticism.) However depressed Don José may have felt, he succeeded, shortly after Conchita's death, in effecting a sea change in his life situation that surely distracted him from his grief: He arranged to trade teaching posts with a professor of art assigned to the School of Fine Arts (La Lonja) in Barcelona. As soon as the transfer was approved, Don José put the exchange into effect; he moved to Barcelona in April 1895 to take up his new duties, leaving his family behind in Corunna until the end of the school year.[54] Thus, Doña Maria was left alone to cope with her sorrow, while her spouse fled Corunna and their domestic setting, with its reminders of his lost child. A little watercolor portrait of his mother (Fig. 41), which Picasso painted in 1896, probably provides a more accurate assessment of her reaction to Conchita's loss than does the idealized account later provided to biographers. Portrayed in profile view with downcast eyes, she seems lost in bitter reminiscences

41. Picasso, *The Artist's Mother*, 1896. Watercolor on paper. Museo Picasso, Barcelona; © 1993 ARS, New York / SPADEM, Paris.

that shut her off from the outside world; her expression anticipates that of the dour mother depicted in *La Vie*.

Almost exactly two years after his sister's death, Picasso finished his first major painting, *Science and Charity* (Fig. 42). Begun at the end of 1896 and completed during the first weeks of 1897, this picture contrasts the detachment of the physician (shown disinterestedly taking his patient's pulse) with the warmth of the attending Sister of Charity, who has brought the woman's little daughter to her bedside. Don José not only proposed the motif of this picture to his son, but also posed as the physician. That father and son should bend their joint efforts toward the creation of a major work focused on illness, during the very weeks that coincided with the anniversary of Conchita's final illness and death, cannot be coincidental. Although *Science and Charity* promotes the cheerfully sentimental idea that compassion and empathy can accomplish

42. Picasso, *Science and Charity*, 1897. Oil on canvas. Museo Picasso, Barcelona; © 1993 ARS, New York / SPADEM, Paris.

miracles denied to science, that assumption had proven quite invalid in Conchita's case, as father and son were well aware.

Precisely three years later, Picasso created *Last Moments,* another painting that focused on illness and death and that once again functioned as a memento mori commemorating Conchita: Perhaps because his grief and remorse had been cushioned somewhat by the passage of time, in *Last Moments* Picasso was able to portray the death, rather than the implied future recovery, of his protagonist. This time he also represented the dying person as an adolescent girl or young woman, an individual somewhat closer to Conchita's actual age and station than the mature mother featured in *Science and Charity.*

As already noted, the preparatory drawings indicate that, in composing *Last Moments,* Picasso moved – as he often did – from a more personalized, to a more objective, less charged conception of his motif. His early sketches reflect the full impact of the trauma he had experienced during the final days of Conchita's life, the period when the entire family kept watch around her bedside, as they are shown doing in these

113

sketches. He experimented with many variations on this motif until he eliminated all these intimate references save one: the vision of the weeping young man, maintaining his vigil at the girl's bedside with only Death for company (see Fig. 31); as the x-radiographs reveal, an earlier version of *Last Moments* featured this despairing youth. But the artist soon realized that further modification and objectification of this theme were necessary, and his revised depiction of the motif transformed the bereaved youth – who surely symbolized the artist himself – into a "priest" who appears appropriately compassionate, but controlled, as he attends his dying parishioner.

Throughout the Blue Period, Picasso continued to be preoccupied with disease, depression, and death; however, he did not again allude directly to the devastating effect of a terrible illness on a family until he painted *The Tragedy* (Fig. 43) in 1903. Most likely, the tragedy to which this composition refers is, once again, the death of Conchita. The iconography of the painting corresponds perfectly to Picasso's garbled memory of the chronology and circumstances surrounding Conchita's final illness, which, as previously noted, he mistakenly associated with the family's arrival in Corunna. The protagonists' representation beside the sea recalls the fact that they arrived in Corunna by boat. The boy featured in *The Tragedy* appears to be about 10, Pablo's age when the family relocated, as well as the age he would have been had his sister actually died in 1891, rather than in 1895. The mother portrayed in this canvas once again derives from her counterpart in *Evocation,* while prefiguring the Madonna-mother of *La Vie* in both costume and pose. Daix and Boudaille point out the close thematic relationship linking *The Tragedy* to *Woman and Child on the Shore,* a picture the artist completed at the end of 1902 or beginning of 1903; it seems likely that he executed *The Tragedy* soon after, and that the latter work constitutes another votive painting, commemorating Conchita's death.[55] Shortly after completing *The Tragedy,* Picasso created the *Mother and Child,* or *The Sick Child* (Museo Picasso, Barcelona), which may also refer to his sister's final illness.

Later that spring, Picasso initiated his preparatory studies for *La Vie.* From the outset, his conception of this composition, consciously intended as a grand, positive statement about Life, was literally subverted by the death-drama depicted in the work originally executed on the canvas, *Last Moments.* These associations infected every aspect of its successor. Yielding to his inner compulsion, Picasso gradually transformed *La Vie* into a major votive painting, commemorating both his beloved dead ones, Conchita and Casagemas, and bearing witness to the artist's failures as would-be savior. The mournful quality of *La Vie* is reflected in every protagonist, from the image of Casagemas, "resurrected" from the dead

43 (*facing*). Picasso, *The Tragedy,* 1903. Oil on panel. National Gallery of Art, Washington, D.C., Chester Dale Collection; © 1993 ARS, New York / SPADEM, Paris.

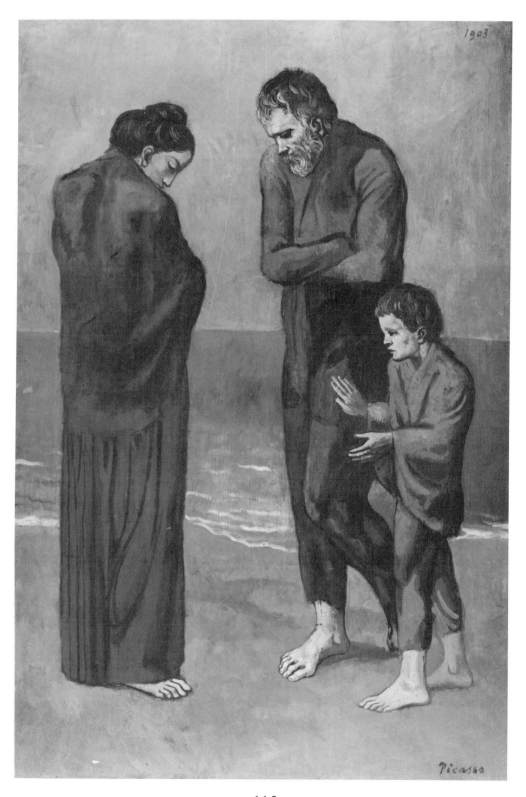

and reunited with his *femme fatale,* to those of the sorrowing mother and her attendant Greek chorus – the despairing female figures inscribed on the two propped canvases separating the major players in this grim opus.

The elegaic appearance of the mother figure recalls her origins as the representation of Casagemas's mother in *Evocation,* while the infant she clasps to her bosom seems more symbolic attribute than flesh-and-blood child. But despite her Madonna-like garb and pose, the mother of *La Vie* seems vaguely menacing, even sinister. It was no doubt this aspect of the figure that prompted Blunt and Pool to propose that she may have been inspired by the characterization of Death as portrayed by Maurice Maeterlinck in *The Intruder,* a drama that had been translated into Catalan and may have been familiar to Picasso.[56] Whether or not Maeterlinck's play inspired Picasso's imagery, the hypothesis that the mother of *La Vie* represents Death seems quite valid. The babe-in-arms she holds appears so inert and doll-like because it does not represent a living child, but rather the souls of Picasso's beloved dead. Just as many medieval and early Renaissance altarpieces, particularly depictions of the death of the Virgin, symbolize the soul as a small babe wrapped in Christ's mantle and about to be wafted to paradise, so Picasso portrays Conchita as a virgin spirit, enclosed in the mantle of her Death-mother. (This device probably also represented an unconscious attempt on Picasso's part to project the guilt for Conchita's death from himself onto his mother.)

But *La Vie* encodes another level of meaning apart from its elegaic quality. Recurring fantasies of violence toward women are reflected in the preparatory drawings depicting the abused pregnant woman, as well as in the (eradicated) image of the predatory bird-man. Reff, who studied the quasi-transparent bird-man without benefit of radiographs (and thus did not know that he was not simply a bird, but a composite creature), nonetheless perceptively emphasized the strange mixture of sensuality and menace implicit in this motif, which he compared to images of Leda and the swan and the monster who threatens the female protagonist of Henry Fuseli's *The Nightmare.*[57] Picasso's decision to excise the menacing bird-man, as well as to replace his own image with that of Casagemas, reflects the artist's need to deny and distance himself from the profound misogyny revealed in these discarded concepts associated with *La Vie,* attitudes rooted in the artist's early childhood experiences with his mother and sisters.

But precisely how do those suppressed images of the young man physically abusing his pregnant partner fit into this schema? They suggest that Picasso unconsciously regarded his mother's pregnancy with Lola – and subsequently with Conchita – as "illegitimate." The bird-man, simultaneously erotic and menacing, represents the artist's grandiose, destructive childhood fantasies – his wish to possess the mother sexually, while simultaneously killing off those two "illegitimate" rivals for her love and attention, Lola and Conchita. On the deepest level, the suppressed death associations encoded in *La Vie* represent rejected aspects of the artist's

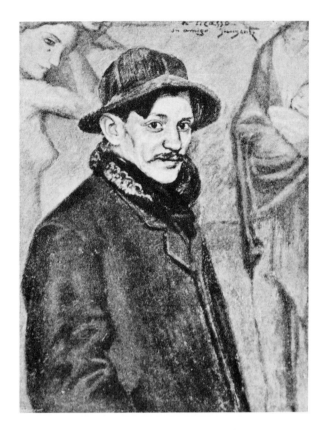

44. Sebastian Junyent, *Portrait of Picasso*, 1904. Reproduced in *Forma*, Barcelona, 1904.

own character projected onto the image of Casagemas, who had in a sense attempted to transform himself into the winged figure of death by snuffing out his own life and (unsuccessfully) trying to murder his indifferent love. The degree of rage and resentment that little Pablo must have felt at the time of Conchita's birth can be measured by the lasting legacy of guilt her loss entailed for him. Small wonder he offered to sacrifice his beloved art to save the little girl he had so earnestly wished to destroy!

Elsewhere I have suggested that *La Vie* "really tells us about Picasso's own dilemma, torn between his desire for a suitable sexual object and his duty toward a sorrowing, unyielding mother who, like the figures portrayed in the two background canvases, might collapse if abandoned. If this is correct, the ambiguous gesture Casagemas makes could be an injunction to the mother to keep her distance and stop interfering with his life."[58] When his friend Sebastian Junyent painted Picasso's picture (Fig. 44), reproduced in a volume of *Forma* published in 1904, the artist elected to pose before his magnum opus, *La Vie*. He appears in

Junyent's portrait centered between his images of loving woman and woeful mother, symbolically replacing Casagemas (represented only as a fragmentary, anonymous torso to which Germaine clings) in this tense domestic drama. Piccaso's pose transforms his psychological dilemma into concrete representation: Had his little sister lived, the artist might have felt less conflicted about leaving home and making an independent life for himself, since the child's continued presence in the household would have cushioned the blow to his mother of losing her only son. But *La Vie* projects Picasso's own conflict about separation onto the persona of the reproachful mother figure, whose intrusion into the lovers' realm the youthful male protagonist attempts to ward off with his cautionary gesture.

In view of Picasso's subsequent amorous history, it seems especially fascinating that his attempt to eradicate the image of the menacing bird-man from *La Vie* should have proven so ineffective. The passage of time has rendered this suppressed motif progressively more visible, forcibly reminding us that the artist's repeated attempts to rescue the many fragile women he loved would invariably be undermined by his underlying hostility. Again and again, his rescue efforts would derail, resulting not in the salvation of these broken blossoms, but in their complete psychological disintegration.

4

A Youthful Genius Confronts His Destiny

Picasso's Old Guitarist *as a Prognostication of His Future*

THE image of the blind minstrel has its origins deep in antiquity. According to tradition, it was the sightless Homer who carried the legends of the great Greek heroes from city to city, accompanying himself on his lyre as he sang their exploits. In Spanish art and literature, the figure of the itinerant bard gradually evolved into that of the blind guitarist; Pablo Picasso's (1881–1973) great Spanish predecessor, Francisco Goya (1746–1828), was particularly fond of this motif and portrayed blind guitarists in a number of his paintings and prints. This theme was but one of several associated with Goya that the young Picasso would adopt and make his own.[1] He painted his masterful version, *The Old Guitarist*, during the last weeks of 1903, a time that simultaneously marked the climax and the closing phase of Picasso's Blue Period.

Picasso's Blue Period: A Brief History

The history of Picasso's Blue style coincided with a period of restlessness in his young life, a time when he seemed almost as rootless as his itinerant guitarist. Between October 1900, when he celebrated his nineteenth birthday, and April 1904 he made four journeys from Barcelona, where he lived with his parents, to Paris, a city he evidently regarded as a kind of artistic Mecca. He created his first Blue pictures during the course of his second and most extensive Paris stay, a visit that lasted from the late spring of 1901 until the following January. Although he had initiated this visit on a note of zestful productivity, he gradually became morosely preoccupied with the suicide of his friend Carlos Casagemas, an event that had occurred the previous February.[2]

During the fall and winter of 1901–2, Picasso gradually developed his full-blown Blue style, abandoning the warmer colors of his palette to

119

concentrate almost exclusively on shades of blue, enlivened by occasional touches of red or yellow-green. Concurrently, he renounced his rich, van Gogh–like brushwork to paint in thin, even strokes reminiscent of the technique of Gauguin, who would become an important influence during Picasso's Blue Period. He peopled his new-style pictures with an entirely new cast of characters. Except for occasional portraits of himself or his friends, most of Picasso's 1901 and 1902 Blue pictures feature destitute women – alcoholic outcasts, or drooping madonnas whose seemingly boneless bodies almost fuse with those of the infants they hold. *The Crouching Woman* (Fig. 45) admirably represents compositions of this type. Destitute and abandoned, she has withdrawn into an almost fetal state of helplessness. Her pitiable condition recalls Josep Paulau i Fabre's contention that the underlying motif of Picasso's entire Blue Period production is one of accusation, as his protagonists berate us for being so prosperous and well-fed in the face of their abject poverty.[3]

In October 1902, Picasso returned to Paris for a third visit. This time he enjoyed none of the financial security that had made his first two trips more pleasant, and he lived a hand-to-mouth existence there until he finally earned the train fare back to Barcelona in January 1903.[4] On his return to Barcelona, he resolved to stay at least a year in order to create a significant body of work, a goal he had not accomplished during his relatively unproductive stay in Paris.

During the next fifteen months, Picasso's Blue Period reached its apex as he executed the most ambitious and memorable of these pictures. Early in 1903, the artist painted several canvases depicting mournful family groups, such as *The Tragedy* (see Fig. 43). This painting shows a bereaved mother, father, and son standing by the seashore – a setting that recalls Corunna, the city on the Atlantic coast where Picasso's family lived at the time of his younger sister's death. Another group of multi-figural compositions portrays young lovers. (*La Vie*, the most important example of the latter type, is the subject of Chapter 3.)

The Old Guitarist (Fig. 46) forms part of yet another series Picasso explored during the fall and winter of 1903, representing pitiable male indigents. These half-naked beggars, nearly always depicted as blind or psychotic, appear to be more dramatic masculine counterparts to the female outcasts that Picasso had featured at the beginning of his Blue Period. Their elongated, angular physiques and slender, tapering fingers recall the similar anatomical anomalies of the final figurative style of El Greco, who had become a cult hero in the avant-garde artistic circle that Picasso frequented in Barcelona.[5] This physical type, to which *The Old Guitarist* belongs, characterizes Picasso's style throughout the closing phase of his Blue Period – a fact that corroborates other evidence suggesting that this picture was probably painted during the last weeks of 1903.[6] *The Old Guitarist* shows close formal links with another of Picasso's final Blue paintings, *Woman with a Helmet of Hair* (also Art Institute of Chicago), painted during the late spring or summer of 1904. The

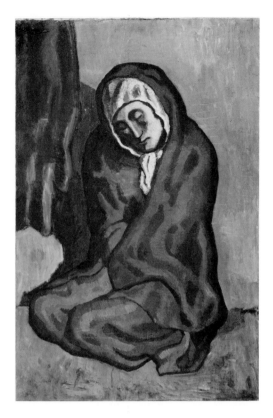

45. Picasso, *Crouching Woman*, 1902. Oil on canvas. Art Gallery of Ontario, Toronto, anonymous gift, 1963; © 1993 ARS, New York / SPADEM, Paris.

artist created the latter picture in Paris, where the final chapter of the Blue Period was written; in April 1904, he had made his fourth journey to Paris. This move proved to be permanent: Picasso spent the rest of his life in France, returning to Spain only as a visitor.

The Old Guitarist is unique among Picasso's Blue Period works in showing the protagonist spiritually transported by his creative effort, rather than mired in hopeless passivity. This characteristic enhances the figure's effectiveness, while simultaneously relieving us of yet another of those reproachful encounters so many of Picasso's Blue Period characters seem to demand. The guitarist's creativity, like his blindness, encloses him in a protective cocoon: Transported by the beauty of his song, he dwells in a world apart, a state that surely mirrors the creative joy of the young artist himself. In order to emphasize the old man's self-containment and the power of his activity, Picasso has squeezed him into a pictorial format that seems too small to hold him. Should the guitarist ever unfold his legs or raise his head, he would burst the pictorial bounds that encase him. But like an obedient jack-in-the-box, he remains forever

121

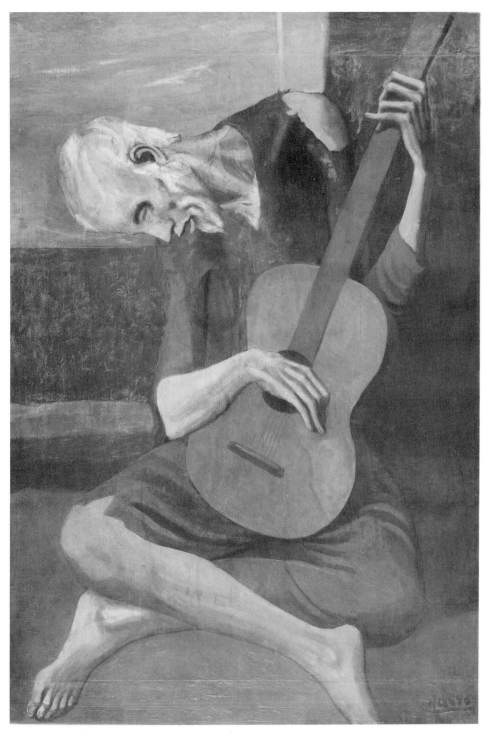

46. Pablo Picasso, *The Old Guitarist,* 1903–4. Oil on panel. The Art Institute of Chicago, Helen Birch Bartlett Collection; © 1993 ARS, New York / SPADEM, Paris.

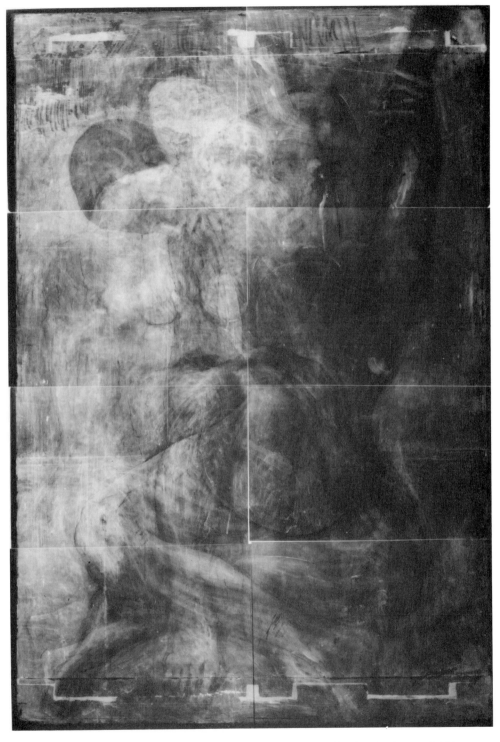

47. Composite x-ray of *The Old Guitarist* (Fig. 46). The Art Institute of Chicago, Department of Conservation.

123

locked into the container in which his creator fitted him, conveying the sensation of compressed energy.

The Old Guitarist *and Its X-rays*

In studying *The Old Guitarist,* the discerning viewer soon becomes aware of another presence behind the musician, the ghostly image of an earlier composition painted on the same panel. Time has rendered the disguising layers of paint ever more transparent, and this earlier incarnation of the guitarist has become increasingly visible to the naked eye. In contrast to the old man, the figure beneath was feminine, young, and voluptuously nude – characteristics revealed even more clearly by the x-radiographic studies (Fig. 47). Whereas the guitarist is attuned only to his inner world and oblivious to the viewer, the young woman stared directly out at the spectator.

The Old Guitarist is but one of several pictures from Picasso's Blue Period known to have been painted on a reused support, a procedure dictated by economic necessity.[7] Nor did Picasso abandon this practice once the Blue Period had passed: The beautiful 1906 picture, *Nude with a Pitcher,* also in the Art Institute of Chicago, demonstrates that Picasso continued this custom into his Rose Period. This idealized image began her painted existence as a full-length, rather than a three-quarter, representation, and one readily perceives the bare feet of this earlier version right at the groin level of the extant figure.

The x-rays of *The Old Guitarist* and *Nude with a Pitcher* reveal that Picasso followed the same procedure in repainting both pictures; that is, he simply covered over the original figures with the new without bothering to turn his support 90 or 180 degrees, or even to interpose an obliterating layer of paint.[8] Picasso's ability to rework a picture in this manner without being distracted by his own earlier image reveals unusual powers of concentration. (The most complex and fascinating reuse of such a support involves *La Vie* – one of the relatively rare known instances in which Picasso turned a painting before reusing it; for an interpretation of this work and its x-rays, see Chapter 3.)

Unlike the x-rays of the *Nude with a Pitcher,* which disclose the complete configuration of the underlying figure, the radiographs of the guitarist provide only fragmentary information about the nude submerged beneath. One readily perceives the young woman's head and shoulders, as well as her long, loose hair. (In fact, these features can be observed without the aid of x-rays.) Below her head, and to her left, a second, more ghostlike female visage appears, her head seemingly bowed as though sunk into her chest. The radiographs also reveal an extended left arm, held palm upward, and two bare lower legs and feet, the latter firmly planted between the guitarist's own (see Fig. 48). It is not clear from this fragmentary evidence which female figure belongs to these limbs, nor which head Picasso executed first. The successive layers of paint masking

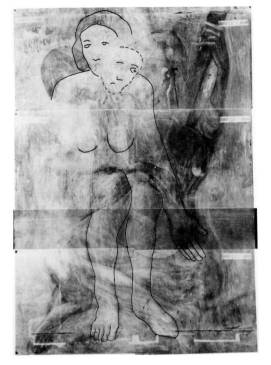

48. Reconstruction of the two female figures revealed by x-rays of *The Old Guitarist* (Fig. 46).

49. Picasso, *Figure, Head, and Guitar,* 1902–3. Pen and ink on paper. Museo Picasso, Barcelona; © 1993 ARS, New York / SPADEM, Paris.

the remainder of the torso(s) proved to be impervious to other laboratory techniques that were implemented.

Reconstructing a convincing pose for either of these submerged fragments that would explain the peculiar bodily proportions suggested by the x-rays seems difficult, especially because the figure's left hand appears below her knee level, suggesting that the woman had to be seated or crouching. A drawing now in the Museo Picasso, Barcelona (Fig. 49), shows a seated nude with her arms extended, duplicating perfectly the position of the feet and left hand of the figure beneath the guitarist. The sketch represents an aging woman with sagging breasts; she looks down and to her left with a beseeching, troubled expression, so that one reads her open-armed gesture as one of entreaty.[9] The pose of her head seems more congruent with that of the lower obliterated face than with that of the more upright, younger woman. However, neither the right shoulder nor the voluptuous breasts apparent in the x-rays matched those of this aging personage. Perhaps remnants of two distinct figural compositions underlie the guitarist, one of them resembling the sorrowful woman of the drawing, the other closer in age and in spirit to the model depicted in

125

a surviving painting of a young woman, *Blue Nude* (Fig. 50), whose sensuous form and provocative expression seem much closer to those of the younger woman who gazes out so boldly from beneath the guitarist.[10]

Late in 1903, Picasso seemed quite preoccupied with portraying nudes who extended their arms in gestures similar to that of the woman submerged beneath the guitarist. Several of these personages seem to have been conceived as decorations for a fireplace, toward which these pathetic figures stretched their arms; perhaps this was an unrealized commission of the period.[11] Two other drawings feature quasi-mythical beings: in one case a nude winged man, in the other a similar female figure. In both instances, the winged individuals seem to be making gestures of benediction or protection over a pair of nude lovers whose positions recall those of a couple that originally appeared in *La Vie* (see Fig. 28) in the area now occupied by the nude in the lower background. This area at first showed a winged bird-man with a feathered head and a human body hovering over a reclining nude. (For a discussion of this imagery and its significance, see Chapter 3.) In this connection, it should be noted that a lost painting now known only from photographs, *Nude with Crossed Legs,* features the same young girl who probably posed for the figure beneath the guitarist and reads almost like a mirror image of the woman shown in the lower background of *La Vie.* The latter's bent head, in turn, echoes the pose of the guitarist himself. Such coincidences suggest that the two paintings probably share an underlying thematic relationship.

Thematic Interpretations *of* The Old Guitarist

In an important essay devoted to the symbolism in Picasso's *Old Guitarist*, R. W. Johnson posits a connection between that painting and *La Vie,* suggesting that their commonalities derive from the themes of love and death shared by both pictures. Specifically, he hypothesizes a connection between the death of Casagemas and the initial appearance of the guitar in Picasso's oeuvre, noting, too, that members of the artist's intimate circle anthropomorphized the guitar, to which they ascribed not only a feminine form, but a feminine psychology.[12] The substitution of the old guitarist's image for that of the young woman followed, he believes, from that equation. In other words, Picasso's painting conveys the message that the artist has the same relation to his medium that characterizes that of other men to their sexual partners.

Johnson emphasizes that the members of the Catalan artistic circle to which Picasso belonged were imbued with Nietzschean aesthetics.[13] He believes that Nietzsche's *Birth of Tragedy from the Spirit of Music,* which connects the development of tragedy with the Dionysiac spirit as exhibited in the Greek chorus, exercised a particularly strong influence on Picasso, who may have fused such ideas with the Spanish tradition of *cante jondo,* or song of the gypsies, a type of music that emphasized the tragic side of life and the heroic position of the victims of social injustice.[14]

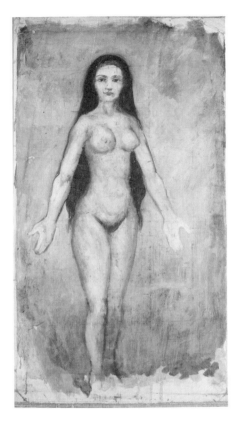

50. Picasso, *Blue Nude,* 1903. Oil on canvas. Museo Picasso, Barcelona;
© 1993 ARS, New York / SPADEM, Paris.

There can be little doubt that Johnson has correctly identified the pro-
grammatic determinants of Picasso's tragic view of life. The critic did not,
however, address the reasons why certain aspects of the contemporary
cultural matrix exerted a much stronger pull on Picasso than others. By
the time that the artist's Blue Period had fully developed, the Symbolist
style of painting it reflects/embraces had crested and begun to wane. For
the only time in his career, then, Picasso hitched his wagon to a fading,
rather than a rising, star. Thereafter, he would take the lead in develop-
ing revolutionary new modes of art; yet, he ignored the proto-Fauve ele-
ments implicit in the oeuvre of Gauguin and other Post-Impressionists to
whom he was exposed during his Paris sojourns, leaving the develop-
ment of that new style to Henri Matisse and his peers.

The style and subject matter that Picasso pursued in his Blue Period
surely reflected his personal experiences and subjective attitudes as well
as the impact of his cultural milieu. It was this potent combination of in-

127

dividual and communally shared factors that shaped his work of 1901–4. Picasso himself repeatedly emphasized that his entire oeuvre possessed such an explicitly autobiographical character; it seems plausible, then, that the young artist utilized his Blue Period oeuvre as the forum in which to play out his conflicting feelings about his age-appropriate wish to assume a mature, independent sexual role and his unresolved attachment to his family.[15] Certainly, separation had always posed difficult problems for Picasso. As a child, he suffered from a severe school phobia, a prime symptom of separation problems.[16] To an unusual degree, he had relied on his parents, particularly his artist father, to organize his life and protect him, as well as to teach him the principles of the craft he would later practice with such dazzling mastery.

It is surely no coincidence then that Picasso initiated his Blue Period in Paris, where he was living independently without the emotional and financial support that his parents had provided. His earliest Blue Period pictures, featuring the lonely female outcasts and impoverished mothers mentioned above, may be read as symbols of the artist's own mother, whom he may have imagined as psychologically impoverished by the threat of his nascent independence. Nor is it an accident that he terminated each of his first three Paris visits right around Christmas, or as soon thereafter as he could finance his return home. That the approach of the holiday season can exacerbate homesickness is too well known to require elaboration.[17]

As has already been stated, Casagemas's suicide had a strong effect on Picasso. The fact that his death had been connected to his unsuccessful attempt to establish an independent existence and commit himself to a romantic relationship must have reinforced Picasso's baseless fears and feelings of guilt about the possible untoward effects of his efforts to separate himself from his parents. The artist's resolve to stay in Barcelona after he returned from his fruitless third Paris sojourn in January 1903 suggests an underlying awareness that he had to work his separation problems out on his home ground rather than through literal flights.

We may now be ready to draw the multiple levels of meaning encoded in *The Old Guitarist* together into a coherent statement. This picture, with its complex allusions, once again refers to the principal players in Picasso's domestic drama: his mother, his father, and himself. His earliest conception for this panel, the drawing in the Museo Picasso, portrayed not the sensuous young nude he eventually painted and then obliterated, but the figure of an older woman with sagging breasts and a mournful expression. She extends her arms, not in sexual supplication, but as if to entreat her lost child to return to her bosom. In contrast, the alternative image, that of the provocative nude, seems to have symbolized his simultaneous sexual longings and desire for an autonomous existence; eventually, he overlaid both images with that of the blind artist that concluded his work on this panel.[18] Once again, this figure, like the condensed images of a dream, represents not just the young Picasso him-

self, but his artist father as well and, by extension, all of his artistic progenitors. The image asserts the priority of Picasso's vocation over his obligations as a son.

The theme of blindness, too, possesses many ramifications. Blindness protects the sightless against many of the visual provocations that assail the rest of humanity; specifically, they do not – cannot – see beautiful temptresses like the alluring nude whom the artist painted out, protecting us, as well as himself, from this potential source of stimulation and focusing instead on his artistic activity. In this light, John Berger's hypothesis that Picasso's preoccupation with the motif of blindness during this era probably stemmed from his fears that he would suffer venereally induced blindness as a punishment for his sexual transgressions should not be ignored.[19] Blindness also refers to the fate of Picasso's father, an artist whose progressive visual difficulties forced him to give up producing paintings of his own in favor of living vicariously through the achievements of his talented son. In this connection, it seems quite fascinating that the last painting Picasso completed before his definitive move from his parents' home to his own residence in Barcelona (where he stayed from January to April 1904), was *The Old Jew (Old Man and Child)* (Fig. 51).[20] This canvas depicts another aged, emaciated beggar, probably based on the same model who posed for the guitarist. He hugs a small boy who sadly munches a crust of bread, evidently the only bit of food the pair possesses. Although the old man is scantily clothed and barefooted, the boy appears securely wrapped in a flowing cloak. The painting silently conveys the implicit message that the old man has sacrificed himself to save the boy – whatever meager food and clothing they possess belong to the child. This theme reinforces those of other contemporaneous pictures, suggesting that in this, his last Blue phase, the artist finally confronted his extreme dependency on his father and the dire implications that he perceived for his father's emotional prosperity following the young artist's imminent defection.[21]

A preparatory drawing for *The Old Jew* strengthens the posited connection between this picture and *The Old Guitarist*. On a sketchbook sheet, Picasso depicted the model for the guitarist, this time sighted and staring intently to the left, where a drawing for the boy from *The Old Jew* appears. A wealth of lightly drawn female nudes separates these two figures, including one who stands facing the lad, her arm extended palm outward in a gesture recalling that of the lost nude beneath *The Old Guitarist*. The drawing indicates that Picasso continued through the end of 1903 to struggle with his conflict between adult concerns and his lingering feelings of guilty loyalty toward his father. Moreover, this sketch, which shows a preliminary version of the guitarist, suggests that Picasso had not yet worked out the final configuration for this painting at the time that he completed *The Old Jew*.

Perhaps, then, *The Old Guitarist* was actually the final picture Picasso painted before he moved out of his parental home, or even the first that

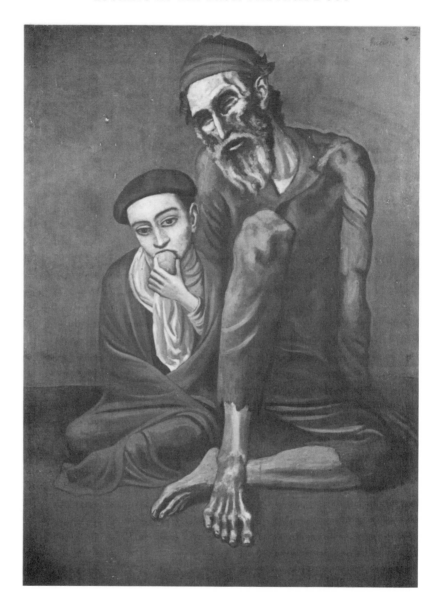

51. Picasso, *The Old Jew (Old Man and Child)*, 1903. Oil on canvas. Moscow, Pushkin State Museum of Fine Arts; © 1993 ARS, New York / SPADEM, Paris.

he executed in his new studio in 1904. Certainly, the self-contained pose of the guitarist, absorbed in his own creativity, symbolized the road that Picasso would soon follow, deliberately blinding himself to his family and his past to dedicate himself totally to his art and to his professional future. On another level, too, *The Old Guitarist* seems prophetic, for Picasso would live to become the great old master of twentieth-century

52. Picasso, *Self-Portrait*, 1972. Pencil and colored crayons on paper. Japan, private collection. Photo: The Solomon R. Guggenheim Museum, New York; © 1993 ARS, New York / SPADEM, Paris.

painting. In his final self-portraits, the aged artist would show himself as a living death's head (Fig. 52), closely resembling that of the aged musician he had depicted so vividly seventy years earlier. It is Picasso's complete identification with his guitarist that ultimately makes this the most powerful and beloved of his Blue Period pictures, and one of the greatest treasures of the Art Institute of Chicago.

Postscript

The Conservation Department of the Art Institute of Chicago recently completed a new series of x-radiograph studies of *The Old Guitarist*. They reveal the presence of yet another figure beneath the definitive composition: The image of a naked boy around three or four years of age can be discerned standing near the left margin of the canvas, suckling at the full breast of the young woman whose ghostly form was disclosed by the earlier radiographs. I plan to explore the symbolism of this newly discovered image more fully in an essay to be published in a future volume of *The Art Institute of Chicago Museum Studies*.

However, it should be noted that the creation and deletion of the child's image seems entirely congruent with the interpretation offered here that *The Old Guitarist* recapitulates Picasso's successful struggle to master his dependency needs and emancipate himself from his family of origin and his native Spain. Ultimately, he overlaid the image of the nursing boy, arguably a concrete symbol of his creator's own repressed infantile needs and wishes, with that of the old guitarist, immersed in his own creative experience and blinded to the outside world.

5

Art as Exorcism

Picasso's Demoiselles d'Avignon

PICASSO once characterized each of his paintings as "a sum of destructions."[1] No picture he ever created better suits that description than his *Les Demoiselles d'Avignon* (Fig. 53), which he abandoned unfinished during the latter half of 1907.[2] This painting owes its great fame, of course, to the fact that it exists as a sum of destructions on the metaphoric, as well as the physical, level. Widely hailed as *the* proto-Cubist canvas, it stands as the ancestor of all the hundreds of full-fledged Cubist paintings Picasso would create between 1909 and 1917.[3] The *Demoiselles,* however, differs from such progeny because of the more primitive quality not only of its Cubism, but also of its emotional tone. The pictures Picasso would produce during his full-fledged Cubist period remain virtually unmatched in his subsequent career for their more objective, classical quality.[4] By contrast, the *Demoiselles* is one of his most expressionistic creations, a work of awesome intensity. Although his earlier art of 1900–6 had also been quite emotional, it was sentimental and poignant rather than vicious in tone.

The savage emotionality of the *Demoiselles,* then, sets it apart from the creations that immediately preceded and followed it. How are we to account for this abrupt outburst of ferocity, or for the almost incoherent impression this unintegrated work creates? Picasso himself probably would have brushed such questions aside, claiming, as he so often did, that the power of the *Demoiselles* reflects the potency of the unfinished work, one that has not been "killed" by too careful polishing and attention to detail.[5] Nonetheless, a comparison between the *Demoiselles* and any of Picasso's other outstanding paintings immediately makes it apparent that this picture's lack of cohesion puts it into a world apart. *Guernica,* for example, usually considered Picasso's masterpiece, as well as one of the great humanitarian statements in the history of art, achieves its

133

mastery without either sacrificing integration or invoking crude expressionism; rather, the mural reveals its theme with all the nobility of some great Renaissance depiction of the crucifixion. Indeed, with its broad pyramidal organization and its symmetrical arrangement of figures and objects, *Guernica* shares many of the formal qualities of such Cinquecento works. (See Chapter 6 for a discussion of this work.) The *Demoiselles*, by contrast, brutally deprives the viewer of such orientational clues: Here chaos, confusion, and asymmetry reign, and we face those implacable demoiselles unprotected and unprepared.

Critics, naturally quite cognizant of these characteristics of the *Demoiselles*, have tended to attribute them to the excessive ambitions of its youthful creator, to his need to challenge and undermine in one fell swoop all the time-honored principles of painting.[6] Undoubtedly, Picasso's ambition contributed its share to the painting's incoherence, but its savagery reflects a far more personal, disruptive attitude on his part. I believe that he found this work so deeply disturbing that he finally abandoned it without resolving its organizational and stylistic dissonances. Even as an elderly man, he remained especially prickly and defensive about this picture and never frankly discussed its sources, development, and symbolism. In fact, his behavior went beyond mere lack of cooperation: He actively sabotaged attempts to reconstruct the exact history of the canvas. His refusal ever to acknowledge that he had repainted the right half of the picture under the initial impact of his response to African art constitutes merely the most celebrated of these actions.[7] Much more striking – and detrimental to scholarly investigation – was the manner in which Picasso hamstrung Christian Zervos's efforts to construct an accurate catalogue raisonné of the numerous preparatory drawings and painted sketches for the *Demoiselles*. The artist either failed altogether to disclose the existence of a great many of these works to Zervos until many years later, or he shared them with his cataloguer but explicitly forbade him to photograph and publish them at the time he catalogued the painting itself. As a result, the original Zervos catalogue devoted to this canvas and its preparatory phase is woefully incomplete. During the ensuing decades, Picasso gradually relented, gradually releasing most of these studies for cataloguing. Shortly before his death, he finally permitted Zervos to publish an entire sketchbook for the *Demoiselles* hitherto secreted in his own collection, unknown to public and scholars alike. As a result of these irregular procedures, the researches that led to the creation of the *Demoiselles* appear scattered through four different volumes of the catalogues raisonnés, a fact that makes it extremely difficult, if not impossible, to reconstruct the picture's chronology accurately.[8]

The posthumous survey of the contents of the artist's studio, which required several years, unearthed still more unpublished studies for the *Demoiselles*. Pierre Daix, who knew the artist intimately, makes it quite clear that this piecemeal publication resulted not from careless oversights (a theory to which descriptions of the artist's untidy housekeeping

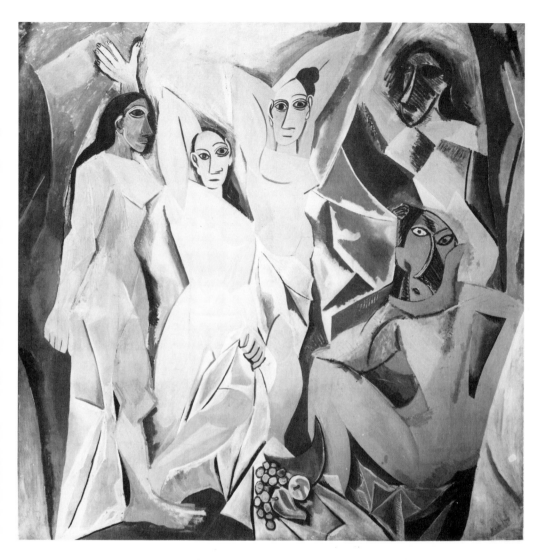

53. Picasso, *Les Demoiselles d'Avignon*, 1907. Oil on canvas. The Museum of Modern Art, acquired through the Lillie P. Bliss Bequest; © 1993 ARS, New York / SPADEM, Paris.

habits might incline one), but from a deliberate policy consciously followed:

> Picasso kept in his own possession pretty well all the drawings and studies leading up to the first version [of the *Demoiselles*]. Many have only recently been published in Zervos XXVI, but many remained unpublished [at the time of Picasso's death]. This is all the more astonishing as the works connected with the revisions made to

135

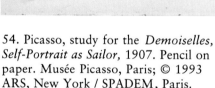

54. Picasso, study for the *Demoiselles, Self-Portrait as Sailor,* 1907. Pencil on paper. Musée Picasso, Paris; © 1993 ARS, New York / SPADEM, Paris.

55. Picasso, study for the *Demoiselles, Self-Portrait as Student,* 1907. Pencil on paper. Musée Picasso, Paris; © 1993 ARS, New York / SPADEM, Paris.

the first version have nearly all been put on sale. It looks as though Picasso was not keen to publish the studies that contributed to the realization of his large canvas, perhaps for fear of being involved in discussions of his sources, discussions which irritated him profoundly.[9]

Daix seems understandably uncertain about advancing the theory that Picasso kept all these works sequestered primarily to avoid discussions of his sources. In fact, the major disputes of this type have all involved Picasso's second painting campaign on the canvas, not his first; yet it was the studies for the initial version that he kept hidden unpublished in his own collection. I propose that Picasso withheld these works not to avoid questions about his artistic sources, but to avoid revelations about himself that he preferred to keep private.

Numerous drawings from that sequestered notebook published in Z. XXVI indicate that Picasso's initial conception of the *Demoiselles* followed the same autobiographical course that generally characterized his oeuvre.[10] He began the picture as an allegorical drama featuring a cast of seven, two male figures plus the five women who alone survive in the definitive version. Subsequently, he identified the two men as a student and a sailor, respectively. Sketches published in earlier volumes of the

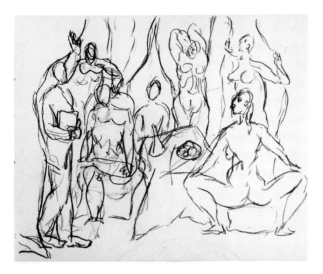

56 (*above*). Picasso, study for the *Demoiselles, Seven Figures,* 1907. Pencil on paper. Musée Picasso, Paris; © 1993 ARS, New York / SPADEM, Paris.

57 (*above right*). Picasso, study for the *Demoiselles*, Student Holding a Skull and Book, 1907. Pencil on paper. Musée Picasso, Paris; © 1993 ARS, New York / SPADEM, Paris.

catalogue (Z. II [pt. 1]: 6, 7) had already indicated that the second of these figures probably derived from a self-portrait, a supposition confirmed by several additional studies for the sailor included in Z. XXVI (e.g., Fig. 54). The latter catalogue also revealed that the student – previously known primarily in drawings depicting him as a faceless being – was also based on a self-image (Fig. 55). Picasso's secretiveness about the identity of these two figures supports my hypothesis that they reflected various aspects of his own character that he subsequently prudently decided to withhold from his public.

In the early full compositional studies, the sailor plays a pivotal part, appearing seated at a central table surrounded by women, food, and wine (the latter contained in a typically Spanish drinking vessel, the *porrón*). The student, by contrast, assumes a much more peripheral, enigmatic role (Fig. 56): He stands at the left margin of the painting, where, with his left hand, he draws back the curtain to reveal the scene to us, while clutching an obscure object in his right. Picasso later identified this object as a skull, although in the studies previously published it had more often resembled a portfolio or book. Additional drawings reproduced in Z. XXVI show that the artist later substituted a book for the skull, and, in at least one sketch, the student grasps both objects (Fig. 57). When

questioned shortly before his death concerning the skull and its sym-
bolism, the artist diverted the question by emphasizing that the young
man was a "medical student" (as if to imply that this explained why
he entered a bordello carrying a skull!).[11] Picasso's continued reticence
about discussing the iconography of the picture so many years after its
completion again suggests its very private significance for him.

Whether motivated primarily by his growing awareness that the male
figures were too self-revelatory or by purely artistic considerations, Picas-
so decided to eliminate them well before transferring his composition to
canvas. Artistically, this decision proved very sound. It relieved the pic-
ture of its heavy-handed symbolism while simultaneously enabling the
artist to modify the composition's shape from oblong to square. This al-
teration transformed the rather traditional idea with which he began into
a more dynamic and original work.

The Genesis of the Demoiselles

During the summer of 1906, Picasso and his mistress, Fernande Olivier,
vacationed in Spain. After a brief stopover in Barcelona to see the artist's
parents, the lovers settled in the little village of Gosol. Fernande later
recalled this interlude as an idyllic one. To her, Picasso always seemed
more contented in Spain, and she could never understand why he insist-
ed, instead, on residing in France, a decision she believed reflected his
tendency to self-torment. Apparently, he never confessed to her, as he
would many years later to Françoise Gilot, that he had exiled himself
from Spain in order to escape his tyrannical mother.[12]

The paintings that Picasso created in Gosol certainly reflect the con-
tentment Fernande describes. Here, the classicism and serenity that had
been apparent in his work the previous spring reached its glowing cli-
max. Elsewhere, I have presented my interpretation of the events that
culminated in this transformation. Briefly, I propose that these changes in
Picasso's work and behavior reflected the constructive effects on his
emotional adjustment of his move to France and the relationships that he
forged in his new home, not only with his mistress, but with the poets
Max Jacob and Guillaume Apollinaire. Picasso's partnership with Apol-
linaire was crucial in enabling the artist to overcome the unresolved
maturational problems that had so strongly influenced the style and con-
tent of his paintings during 1901–5.[13]

That summer in Gosol, Picasso created the series of idealized visions
of Fernande that Alfred H. Barr has compared to the art of Praxiteles.[14]
Among these paintings, *Figures in Pink,* or *The Harem* (Fig. 58), seems
especially interesting as a kind of prelude to the theme of the
Demoiselles. Like the latter, *The Harem* depicts grouped nudes in an in-
terior, yet the mood and spirit of the two pictures seem light-years apart.
In what may be a gentle parody of Ingres's *Turkish Bath,* Picasso's har-
em scene represents four odalisques – all modeled on Fernande – as they

58. Picasso, *Figures in Pink (The Harem)*, 1906. Oil on canvas. Cleveland Museum of Art, Leonard C. Hanna, Jr., Collection; © 1993 ARS, New York / SPADEM, Paris.

complete their toilettes under the watchful guardianship of a withered crone and a benign giant.[15] The nude giant closely resembles Picasso's slightly earlier caricatures of Apollinaire as a muscle-bound devotee of "physical culture."[16] In this picture, the poet evidently appears as a surrogate for the artist himself, the absent "sultan" into whose seraglio we have gained admission. Thus, in a single canvas, Picasso pays tribute to the beauty of his mistress and the loyalty of his friend, while simultaneously alluding to his own desire to be lord and master of a harem.[17]

Back in Paris the following autumn, Picasso's style turned less classical, more sculptural, as he became increasingly fascinated with the pre-Roman Iberian sculpture of his native Spain. During these same months, he was digesting his reaction to the art of Cézanne, whose paintings had been exhibited at the Autumn Salons of 1905 and 1906.[18] The rather stocky, cylindrical figures that now emerged from Picasso's hand reflected his attempts to amalgamate and integrate these dual sources of inspiration. As he developed his new style, his pictures became increasingly objective and abstract, and the sentimentality that had characterized the personae he created during 1900–5 disappeared from his oeuvre. Even his portrayal of an imaginary family group depicting Fernande and himself with their make-believe infant (Z. II [pt. 2]: 587) reflects a new vigor and detachment. As such, it makes an interesting contrast with the tender family pictures he had created the previous year, showing his alter ego, Harlequin, with a wife and baby (Z. I: 244, 298–9).

Picasso's new Iberian style enabled him to resolve the difficulties that had prevented him from completing his portrait of Gertrude Stein (Z. I: 352), begun months before; he now quickly reinterpreted his model's face as a masklike visage without so much as calling her in for an additional sitting.[19] In subsequent drawings and paintings, he explored the motif of paired female nudes, showing two women who sometimes seem like variant mirror images of one another; their buff-to-deep-rose flesh tones suggest that these dense, squat figures might be pictorial renditions of terra-cotta sculptures.[20] Their rather inexpressive faces show no emotion more profound than a dreamy self-absorption. By contrast, Picasso's earlier Blue and Circus Period figures seem much more poignant, wistful, and anxious than these stalwart creatures of late 1906.

Picasso's contemporaneous self-portraits convey a similar mood of peaceful introspection (Fig. 59). Perhaps the artist, on the verge of momentous new discoveries, was preparing himself by quietly gathering his forces, reflecting on his past art and life. Several of these self-images closely resemble women modeled after Fernande during the same weeks (Fig. 60).[21] The strikingly similar poses, features, and expressions of these male and female representations make them read like depictions of the masculine–feminine aspects of a single being. The artist's relationship with his mistress had been particularly felicitous that summer and autumn. These matched images may represent his meditations on the close

140

59. Picasso, *Self-Portrait,* 1906. Oil on canvas. Musée Picasso, Paris; © 1993 ARS, New York / SPADEM, Paris.

ties that bound him to Fernande in a kind of psychological twinship, a unanimity of being and feeling. I emphasize the importance of these "twin" portraits for two reasons: first, because many of the studies for the heads of individual demoiselles show a similar androgyny; second, because the metamorphosis of Picasso's self-image from the student into the figure of a demoiselle plays an important role in the evolution of the *Demoiselles.*

60. Picasso, *Bust of a Woman*, 1906. Oil on panel. Art Institute of Chicago, gift of Mr. and Mrs. Samuel A. Marx; © 1993 ARS, New York / SPADEM, Paris.

The Motif of the Prostitute and Its Origin

Picasso's first exploration of the motif of the *Demoiselles d'Avignon* occurred during the late fall or early winter of 1906–7.[22] These representations, small-scale sketches of three or four nudes in an interior, derive directly from the earlier series of paired figures. The rather tentative, timid quality of these works seems quite surprising when one recalls the assurance with which the artist had handled a similar theme a few months

142

61. Picasso, study, *Head of a Woman*, 1907. Pencil on paper. Musée Picasso, Paris; © 1993 ARS, New York / SPADEM, Paris.

earlier when he had painted *Figures in Pink*. Like his paired nudes, these ancestresses of the *Demoiselles* are short, squat, and thick.[23] Picasso was still far from his definitive conception of the demoiselles, with their much more elongated proportions, flattened, faceted bodies, and brazen stares. These early forebears seem benign and self-involved, oblivious of the spectator (Z. I: 349). Concurrently, Picasso also began to make drawings and paintings for the heads of individual demoiselles (Fig. 61). They, too, show the same pleasant, dreamy expressions that had charac-terized all his creatures that autumn (Z. II [pt. 1]: 10; [pt. 2]: 617–18). When David Douglas Duncan photographed the first of these demoiselle heads, prior to its publication some fifty years after it was painted, he astutely observed that her face closely resembled the artist's own.[24]

Scholars have suggested a wide variety of additional sources for the theme and style of the *Demoiselles,* especially Iberian sculpture and the paintings of Cézanne.[25] The simplified facial shapes, features, and hair treatment have often been cited as proof of the demoiselles' Iberian pa-rentage, while their poses have been linked to prototypes found in one or another of Cézanne's canvases of bathers. Exactly why Picasso decided to transform the French master's bucolic revelers into closeted whores confronted by a man with a skull has seemed far more puzzling. John Golding suggests that, initially, Picasso may have been more influenced by Cézanne's early erotic canvases than his later, more classical depic-

tions of bathers. The critic points to such prototypes in Cézanne's art as *The Eternal Feminine, Afternoon in Naples,* and the various versions of *The Temptation of St. Anthony,* with which the *Demoiselles* shares such features as the figure who raises the curtain, the prominent still-life details, and the erotic implications of the theme.[26] Theodore Reff also emphasizes the importance of Cézanne's versions of the *Temptation* as a thematic source for Picasso. Reff points out that the artist had been preoccupied with this motif as early as 1901 (perhaps before he knew any of Cézanne's interpretations of it?). The critic also cites a precedent for the memento mori theme in Picasso's own work: a drypoint from 1905 that shows Harlequin confronting Fernande with a skull.[27]

To date, the critical literature does not refer to the fact that Cézanne himself had once painted a picture of grouped whores. Known as *The Courtesans,* this awkward little panel depicts four prostitutes grouped around a table. Only one appears nude; she leers out at the spectator with a singularly hideous, masklike visage. The outsize, masklike character of her face reminds one of the rather similar countenances of the two right-hand demoiselles in the Picasso canvas. Could he have known this Cézanne painting? Provocative similarities between the themes, settings, and even details of the poses of certain figures suggest that this might have been the case.[28]

But Picasso really had no need to turn to external sources to discover the theme of the prostitute: It had been a mainstay of his art since his adolescence. During the 1890s, he made a great many erotic drawings in Barcelona bordellos, works that remained unpublished and unknown until relatively recently.[29] Later, prostitutes starred as the protagonists in some of the artist's most important canvases. These paintings fall into two separate subgroups, reflecting radically opposed moods and modes on Picasso's part. The earlier group, painted during the first half of 1901, depicts not lowly inhabitants of public houses, but successful courtesans dressed for public appearances in ostentatious gowns and hats whose soft plumes contrast forcefully with their hard faces and vicious expressions (Z. I: 32, 39, 67, 68, etc.). The ferocity of their creator's mood apparently matched that of his creatures, a fact indicated by the aggressive brushwork and explosive bursts of pointillist dots that often surround these images. The savagery Picasso suggests in many of these pictures comes closer to the hostility that characterizes his *Demoiselles* than any other works he created prior to this epoch-making canvas. In these earlier pictures, however, he functions as the sympathetic but distant onlooker; the *Demoiselles* would engage him much more directly. He initiated the courtesan series in Madrid after he had fled to the capital from a family reunion in Málaga, following a bitter quarrel with both parents and relatives over the unacceptable bohemian customs and dress he had acquired during his initial visit to Paris, terminated a few weeks before. (For additional details, see Chapter 3.) An account that may be apocryphal alleges that, after an earlier family row in 1899, young Pablo had taken up

residence in a bordello for several weeks.[30] Whether the latter tale is true or part of Picasso's personal mythology, the artist evidently viewed his interactions with prostitutes as a vehicle for the expression of his defiance of parental standards. The challenging leers with which so many of his painted courtesans of 1901 regard us suggest that the young man must have felt particularly indignant toward his mother, whose controllingness apparently fully matched her son's rebelliousness.[31]

Picasso began his second Paris sojourn around June of 1901; that same summer and autumn, as his celebrated blue mood descended, he abandoned the motif of the tough, successful courtesan to concentrate on her failed counterpart, the prostitute-victim, ground down by poverty and disease. Basing his canvases upon observations made at the St. Lazare Prison Hospital for Venereal Diseases – and the surrounding bars, where the outpatients congregated – Picasso explored the pitiful, solitary lives led by these women. (According to Patrick O'Brian, the artist made similar observations in a Barcelona hospital during 1902, gaining admission to a gynecological ward through the good offices of a physician friend.)[32] Most often, he depicted these women huddled in despair in some dark corner. More rarely, he showed one of them grasping her baby with such hungry eagerness that her body almost fuses with that of her infant (Z. I: 109–10, 115, 117).

Picasso terminated his representations of diseased prostitutes with a flourish, when he painted the sentimentalized *The Two Sisters*, or *The Meeting* (see Fig. 35), supposedly inspired by a reunion he had witnessed between a patient of St. Lazare and her sibling, a chaste mother. This scene – or, more accurately, Picasso's fantasies about it – must have made a deep impression on the artist, who created a number of variations on the motif.[33] In one variation, *La Soupe,* a pregnant, bowed woman closely related to both protagonists in *The Meeting* (the latter seem almost like mirror images) wearily presents a bowl of broth to an eager child (Z. I: 131). In another, the mother receives, rather than gives, as a young man presents *her* with soup.[34]

Such pictures suggest that Picasso's preoccupations with his own dependency needs and his unresolved relationship with his mother may have become intertwined with his recollections of this scene, which obviously possessed great meaning for him.

After 1902, the artist continued periodically to explore the theme of the downtrodden woman, but none of the representations that postdate *The Meeting* specifically portray prostitutes. By the beginning of 1904, his interest in such lugubrious subjects was waning, along with his blue mood, and not until nearly three years later, when he began his research for the *Demoiselles,* did he again turn to the subject of the whore.

As I have already indicated, Picasso initiated his researches for the *Demoiselles* in an apparently contented mood. Only his introduction of the skull motif hints that a more ominous change might be underway. As Leo Steinberg emphasizes, the artist's initial concept of the composition

seemed quite traditional and conventional.[35] He provided a deep, broad, illusionistic interior for his protagonists, definitively positioning their dense forms within the picture plane, each in its own comfortable niche (Fig. 62). Only later did the dynamic quality of his composition escalate, along with the rage that overtook him as he worked out the details of the painting.

Early Studies for the Demoiselles

In 1972, Leo Steinberg published his two-part essay "The Philosophical Brothel." This study focused new attention on the preparatory drawings for the *Demoiselles,* whose stylistic and iconographic problems the critic actively explored.[36] Challenging the generally accepted theory that Picasso had begun the picture as a memento mori, Steinberg insists that, although Picasso might have linked sex with danger, he did not connect it with sin. The critic proposes an alternative interpretation of the student's attributes, the book and skull, noting that they serve:

> as symbols of knowledge, and of a particular brand of knowledge – non-participatory and theoretical. They herald the deadening approach of analysis. Hence the death's head in the hand of the student – as against the sailor's ithyphallic life symbol. [Steinberg refers to the *porrón* of wine; he perceived its erect spout as a reference to the lad's virility.] For while the naive sailor behind his Bacchic *porrón* is in the thick of it, his counterpart, the knowing man at the curtain, becomes the outsider. Not a personifier of pious death consciousness, nor ... a man condemned by entering into sin, into that house of women which goes down to the chambers of death, but the opposite – a man apart, self-exiled by reliance on studious dissection, condemned for not entering.[37]

Steinberg believes that the *Demoiselles* began "not as a charade on the wages of sin, but as an allegory of the involved and uninvolved in confrontation with the indestructible claims of sex."[38]

Despite its many merits, this explanation leaves us with certain unresolved problems. For example, if Picasso intended his student to symbolize a type of arid intellectualization foreign to his nature, why did he create this man in his own image? Surely the student possesses yet another, more personal meaning. Second, why do so many aspects of the sailor's appearance and attitude seemingly contradict his ithyphallic symbolism? As Steinberg also points out, the sailor's pose seems strangely passive and demure for one in his situation. "He is the man inside, yet within this band of five mannish whores, his one distinction is an effeminate personality."[39] Picasso usually depicts the sailor with his eyes cast down, carefully concentrating all his attention on the cigarette he rolls (Fig. 63). Daix interprets this behavior as an indication of the sailor's indifference

62. Picasso, study for the *Demoiselles, Medical Student, Sailor, and Five Nudes in a Bordello*, 1907. Charcoal and pastel on paper. Kunstmuseum, Basel; © 1993 ARS, New York / SPADEM, Paris.

to the whores, but someone uninterested in their charms would hardly so resolutely avoid glancing at them.[40] Steinberg's suggestion that the sailor may represent "a timid candidate for sexual initiation" seems more consistent with the attitude pictured.[41] In the end, for Steinberg, the sailor remains an enigmatic personage; the critic comments that, although the sailor was obviously meaningful to Picasso, "the meaning eludes." He suggests that an interpretation would have to proceed from the contrast Picasso drew between the two men in the picture, "one well inside, of effeminate temperament, inundated by woman-kind; the other half in and half out, halting at the divider..."[42]

William Rubin, who knew Picasso personally, had the opportunity to examine and discuss the suppressed sketchbook with the artist shortly before its publication. Rubin observed that, although Picasso's insistence that the man with a skull represented a medical student obviated any need to read the picture allegorically, it by no means eliminated the possibility that it also functions at that level.[43] Rubin suggests that Picasso's two self-images might symbolize, respectively, the life of the mind and the life of the senses, the two poles between which the artist's work would oscillate during the remainder of his career:

63. Picasso, *Head of a Sailor*, 1907. Oil on canvas. Private collection; © 1993 ARS, New York / SPADEM, Paris.

The sailor ... represents Picasso's instinctive, sensuous side as established during childhood (sailor suit, surrounded by women in the home) while the student represents Picasso's mind and intelligence (book and skull).... At the same time, the skull is a studio prop of the artist (Picasso says he had a skull at the time, and it appears not long afterward in the Hermitage still life of his studio). Thus the medical student may be assimilated to that side of Picasso whose science will anatomize the world.[44]

Rubin's theory that the sailor represents Picasso's childhood self seems quite consistent with the visual data, explaining the youth's helpless, passive attitude. Moreover, we know that Picasso owned a sailor suit as a little boy, for he appears in this garb in a photo taken when he was 7 years old.[45] But a painting that Picasso created many years after the *Demoiselles* indicates that he may have owned his first sailor suit

64. Picasso, sketchbook, *Dog Suckling Puppies,* 1907. Pencil on paper. Musée Picasso, Paris; © 1993 ARS, New York / SPADEM, Paris.

much earlier. In this canvas, known as *The Butterfly Hunter* (Z. IX: 104), Picasso portrays himself as a little mariner who appears to be about 3 years of age. Lest we have any doubt that the sailor represents himself, the artist emblazoned his own name across the child's hat-band.[46] Picasso completed this painting around the time that his little daughter, Maya (the child of his mistress, Marie-Thérèse Walter) approached the age of 3. The coincidence between her actual age and the apparent age of the little butterfly hunter not only suggests the artist's identification with his daughter, but also leads one to question whether her age and appearance stirred up old memories of the time when the artist himself had been that age. Elsewhere, I have presented detailed evidence suggesting that Maya's birth recalled to Picasso the most traumatic experience of his own childhood: the birth of his sister, Dolores (Lola), which occurred when the future artist was 3.[47] I believe that *The Butterfly Hunter* is a memorial to Picasso's paralyzed reaction to Lola's arrival – a paralysis he reexperienced, following Maya's birth, in the form of an inability to continue making art. Like the child of *The Butterfly Hunter,* the sailor of the *Demoiselles* recalls the artist's helpless childhood state, his immobilization in the family situation where he, like his sailor, dwelt among five women (his mother, maternal grandmother, two maternal aunts, and a maid).[48]

While Picasso worked out the composition of the *Demoiselles,* he was simultaneously preoccupied with another, seemingly unrelated motif: that of a bitch (surely his beloved canine, Fricka) tenderly nursing and grooming her pups (Fig. 64). Images of this scene begin early in the

sketchbook published in Z. XXVI (beginning with no. 21), and recur again and again, interspersed among both full compositional studies and detailed drawings for the individual figures. At one point, Picasso even introduced Fricka into his composition, showing her joyously jumping on the man with the skull as he enters the bordello (see Fig. 57). Once he had executed this drawing, Picasso must have recognized its incongruity, and he immediately suppressed this idea.

Why did the image of Fricka nursing her pups obsess Picasso so? Perhaps it unconsciously reminded him of the long-ago period when his mother nursed his little sister while he watched on the sidelines, bereft and helpless. But this imagery also suggests another idea, which apparently did not occur to Picasso until later in the painting's evolution: his belief that the bordello he portrayed existed not only in his imagination, but in reality, in the studio-dwelling he shared with Fernande. The fact that he later named one of his painted whores "Fernande" suggests that this composition may also allude to her history of promiscuity. (Pierre Cabanne even repeats an old rumor that she had actually prostituted herself when she lived with a previous painter, a shiftless fellow who turned her out to whore, then slept the days away.)[49]

The fact that Picasso repeatedly interspersed sketches of the nursing bitch among his *Demoiselles* studies leads one to speculate that the *porrón* may function not only as a phallic symbol, but also as an embodiment of the theme of nourishment. Although stationary *porróns,* like those shown in the *Demoiselles* drawings, are often made of glass, a portable variety made of skin also exists. Like the human breast, the latter *porrón* is soft, rounded, and filled with liquid. The *porrón* is worn slung over the shoulder; when the bearer wants a drink, he maneuvers it into position and lets the wine trickle down his throat. (The glass variety is also often used as an individual drinking bottle in this fashion, rather than as a pitcher.) The man who possesses his own *porrón* can drink whenever he pleases. One might say that, on a symbolic level, the person so equipped can nurse himself. Perhaps during the years following Lola's birth, Picasso gradually realized that his developing artistic ability was his "*porrón.*" As he matured, he learned to sustain himself through his art, rather than to rely on his mother or female relatives for dependency gratifications. His father, Don José, assumed an active role in this "weaning" process: He became the child's first art instructor as well as his intimate companion on tours about Málaga. The boy became extremely dependent on his father to help him maintain his brittle organization, and was quite panicked when separated from him.[50]

The sailor's unwavering concentration on his own activity – rolling the cigarette – as he sits among the women may represent Picasso's childhood interest in drawing and painting, and the way he utilized these skills to isolate himself from his mother. This supposition is based, in part, on the fact that the earliest conceptions for the sailor derive from self-portrait sketches showing the artist with his brush and palette, often

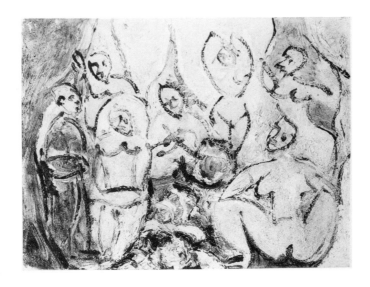

65. Picasso, study for the *Demoiselles, Medical Student and Six Nudes,* 1907. Oil on panel. Private collection; © 1993 ARS, New York / SPADEM, Paris.

gazing downward (as his sailor does) while mixing colors (Z. XXVI: 2–7).

The hypothesis that the sailor represents Picasso's early childhood self is by no means incompatible with Steinberg's suggestion that the young man represents a timid candidate for sexual initiation. In this role, too, the sailor serves as a surrogate for the artist, who had also found himself in this exciting, yet embarrassing, situation during his early adolescence. According to Cabanne, Picasso loved to boast to friends about his sexual precocity, recalling how he had made his initial brothel visit while still "just a little fellow," "well below the age of reason."[51] These statements represent only a slight exaggeration, for he apparently became an habitué of the brothels around the age of 14 or 15.

The symbolism of the other self-image Picasso introduced into the *Demoiselles* – that of the medical student – presents a more complex interpretative problem. The artist's suppression of *all* the preparatory drawings showing this figure had originated as a self-portrait suggests that the image of the student symbolized some particularly discomforting aspect of Picasso's own past history. Soon after he created this young man, Picasso transformed him from a short, stocky fellow, whose physique resembled his own, into a tall, slender, faceless being. Later – most likely, as Steinberg proposes, just before suppressing this image altogether – Picasso remade the student once more, this time into the form of his close friend, Max Jacob (Fig. 65).[52] As a homosexual pederast, Jacob

151

hardly seems to have been a likely candidate to patronize a bordello of the type portrayed in the *Demoiselles*, and his fleeting presence suggests that an additional layer of symbolic meaning accrues to this figure.

Finally, Picasso merged his student self-image with that of a demoiselle, who moved left to assume his old position and role as revealer (Fig. 66). By this merger, Picasso changed his composition from an interaction between the whores and the student bearing the memento mori into a confrontation between demoiselles and spectators. The artist suppressed his student's attributes, the skull and book, along with his masculine identity. The brief flirtation with the memento mori theme suggests a temporary retreat or regression to the old artistic ideas that had preoccupied the artist during 1901–5 when, as Reff points out, Picasso's work so often reflected an obsession with love and death.[53]

On a more concrete level, Picasso's initial conception of the *Demoiselles* as a confrontation between the medical student – the objective man of science – and the closeted whores echoed the artist's own experiences of 1901–2, when he frequently observed and portrayed hospitalized prostitutes. Cabanne (who does not name his sources) claims that the artist originally planned to call his great canvas "The Wages of Sin."[54] This putative title seems quite appropriate for the first version of the composition of the *Demoiselles*, but it might have served equally well for any of the dozens of representations of syphilitic prostitutes the artist created during those years.

Picasso's insistence to Rubin that the male revealer represented a "medical student" also suggests a reference to his paternal uncle, Dr. Salvador Ruiz y Blasco, a successful physician and public health official in Málaga who played an important role in Picasso's life from the start. Present at the boy's delivery, he saved the future artist's life by his alert action in inducing him to breathe. During 1897–8, he helped subsidize Pablo's advanced artistic studies in Madrid – until he became disgusted with his nephew's lack of application and withdrew his support. Dr. Salvador also assumed a leading role in the memorable family quarrel that precipitated Picasso's flight to Madrid at the beginning of 1901. Such a stormy interpersonal relationship might indicate that Dr. Salvador would have been an unlikely identification figure for Picasso. However, the artist always greatly admired people of strong determination, and his uncle was a much more effective, successful man than Don José (who was quite dependent on this younger brother). For these reasons, Uncle Salvador the scientist may have served as a secret model for his nephew.[55]

No one has unraveled the meaning of Picasso's abortive decision to have his medical student function as a memento mori. It seems likely that he was motivated by considerations other than a desire to employ this time-honored theme as a bow to artistic tradition. (Certainly, he did not intend the *Demoiselles* to be a traditional painting.) Instead, the skull may refer to the fact that somewhere, sometime during his youthful amatory career, Picasso himself had contracted a venereal infection. Gilot,

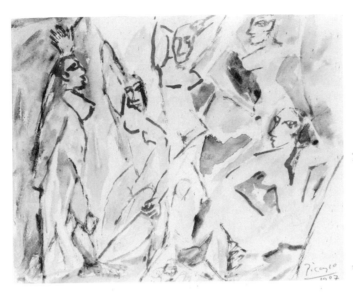

66. Picasso, study for the *Demoiselles, Five Nudes,* 1907. Watercolor. Phila-
delphia Museum of Art, A. E. Gallatin Collection; © 1993 ARS, New York /
SPADEM, Paris.

who gave me this information, knew no details; the artist merely told her
that he had undergone a successful cure well before his marriage in
1918.[56] Could he have received medical confirmation of his infection
around the time he began the *Demoiselles?* Whatever the facts, his sup-
pressed self-portrait as the medical student evidently reflects his double-
edged experiences as both objective observer and subjective victim of
diseased prostitutes. At least, in view of the frequency with which he
consorted with whores, it seems logical to assume that he contracted his
disease through them. But if Cabanne's story about Fernande's past is
true, it is also possible that she infected the artist. If so, that drypoint of
1905 in which the Harlequin shows her a death's-head assumes added
piquancy.

Long after he had weeded out the two male figures with their complex
self-references, Picasso continued to respond to his canvas in a very con-
crete, personalized manner. Proceeding as though these creatures he
himself had made were magically endowed with life, the artist assigned
real names and identities to his painted whores. As he later recalled it,
one of his prostitutes had been named after his own sweetheart, Fer-
nande, another for Apollinaire's friend, Marie Laurencin, and the third
for Jacob's grandmother (allegedly because she came from Avignon),
"all of them in a brothel in Avignon."[57] This reminiscence has a hostile
bite, suggesting that the three young men seized this opportunity to venti-
late their not inconsiderable rage toward women. They all came from
households in which the mother played a dominating – indeed, a tyranni-

153

cal – role. The demoiselle ostensibly named after Jacob's grandmother probably served as a thinly disguised surrogate for the poet's mother, a witchlike creature who physically abused Max throughout his childhood and encouraged his brothers to beat him as well.[58] No wonder Max grew up to be a homosexual pederast (and, hence, like his mother, a child abuser, albeit of a different variety) who avoided women. However, the fact that he won great fame among his intimates as a peerless female impersonator suggests his underlying identification with his all-powerful mother, whose role he assumed in more playful, harmless guises as he imitated chanteuses and toe dancers.[59]

So far as we know, Apollinaire's mother never mistreated him physically, but she was not only a domineering, difficult woman but also, for her time and station, an extremely unconventional one. Both Apollinaire and his brother were illegitimate children, uncertain of their paternity (thus, in the context of early-twentieth-century mores, the poet's mother had truly behaved like a whore, and Apollinaire really was the son of a "bitch"). Her transient sexual liaisons scarcely provided the poet with a stable paternal image that might have counterbalanced this pervasive maternal influence. Although Apollinaire finally moved away from home, he remained very much under his mother's influence until his enlistment in the army at the onset of World War I forcibly separated them.[60]

Apollinaire's sweetheart, Marie Laurencin, seemed a more proper young lady whose behavior scarcely justified the comparison between her and one of the demoiselles. Actually, however, Marie also was an illegitimate child, and may have earned her admission to Picasso's painted company in this manner. Like her lover, Marie was very much under her mother's thumb, a situation that played a part in the inconsistent, "bitchy" manner she sometimes assumed with Apollinaire. She lived at home during the entire period of their romance; both mothers vigorously opposed this liaison and took turns sabotaging it until its stormy dissolution in 1912.[61]

Buttressed by the support he enjoyed from his two fellow victims of maternal domination, Apollinaire and Jacob, Picasso utilized his researches for the *Demoiselles* to explore his ambivalence toward women. (One must remember, too, that his memories of his mother had been sharpened by the return visit he had paid his parents the previous summer.) The increasing violence with which he endowed the painting as it evolved mirrors the increasing vehemence with which he expressed his rage, not only toward his mother and other early caretakers, but also toward Fernande. Those tender, idealized portraits painted at Gosol reveal only part of the story: the positive aspects of his heterosexual relationships. His identification of Fernande as one of his whores reflects the other side of the coin: his underlying hostility and resentment over her past promiscuity.

Finally, the artist's excitement and rage became so intense that they invaded every aspect of his composition. This is evident not only in the sav-

agery with which he endowed his demoiselles but, perhaps even more dramatically, in his treatment of the pictorial space. Well before beginning work on his canvas (which he had specially constructed and reinforced in advance), Picasso decided to substitute a square format for the oblong shape he had originally envisioned. However, he painted the picture as though the bordello salon were actually being squeezed down from its former rectangular shape into its definitive 1:1 ratio before our very eyes. This device transforms the comfortable interior with which he began into a dynamic vision of a cataclysmic world in flux. Outer walls move inward while the floor glides forward, inexorably propelling the demoiselles right up into the forefront of the picture plane. We recoil, threatened by the prospect that these monster women, assuming life, will transcend the painted boundary separating them from us. To increase the spectator's anxiety vis-à-vis his demoiselles, Picasso systematically deprived his protagonists of every vestige of stability and clearly defined position within the picture plane. In the definitive version of the painting, the comfortable niches in which the women originally reclined have given way to flattened, congealed areas that seem to have been pried apart with a giant can opener, then squashed together once again. The demoiselles hover indefinitely in this bizarre world. Their instability seemingly causes them no anxiety, but their unblinking stares and shaky stances arouse our most primitive fears. Only the artist's surrogate, the revealer demoiselle at the far left, retains any semblance of stability in that heaving universe, for she plants one large, flat foot firmly outside the limited pictorial depth in which her sisters dwell. Even in her case, Picasso has introduced a note of uncertainty: She apparently possesses only that right limb and foot; her left appendage disappears abruptly at mid-thigh.

In *Les Demoiselles d'Avignon,* then, Picasso expresses his budding Cubist style more fully in his treatment of the setting than of the human figures. The latter, particularly the two women on the right, show startling disproportions and deviations from traditional perspective. Nonetheless, they remain *relatively* more illusionistic than does their faceted, airless environment. This fragmentation of the pictorial space mirrors the artist's own early experience, not only the concrete fragmentation that he experienced during the cataclysmic Málaga earthquake (in the midst of which, his sister Lola was born), but his own concurrent inner sensations. Both as a small child and a mature adult, Picasso remained quite vulnerable to such psychological sensations of disintegration. The biographies written by his intimates provide many vivid descriptions of his behavior on such occasions, invariably triggered by a disturbance or disruption in a vital relationship.[62] The more serious this disruption, the more profound and prolonged was his reaction. On the most personal level, then, Picasso's Cubism reflects his own primitive vulnerability, concretized – but controlled and sublimated in his art. In the *Demoiselles,* the earliest (and the least securely controlled) of his proto-Cubist works, he

portrays these experiences as they must first have impressed him: not only as an inner state of unbearable anxiety, but as a perceptual experience of a world in dissolution, the external parallel to his internal disintegration. As he gained more mastery over his new Cubist manner, Picasso extended it to portraiture with greater and greater success. Finally, during the autumn and winter of 1910, he painted the three great portraits that initiated his high Cubist phase. These reflect his growing mastery over his own fear of fragmentation; however, the long months that Picasso spent on each of these paintings constitute measures of the tension and anxiety involved in this "dicing" of the features of the models, his friends Ambrose Vollard, Wilhelm Uhde, and D. H. Kahnweiler (Z. II [pt. 1]:214, 217, 227). (Picasso's insistence on such lengthy, formal modeling sessions marked a real departure from his usual informal procedures.)[63] Although these portraits destroyed the integrity of his friends' faces and forms, the artist was careful to supply clues ("attributes," as he called them) that would help the viewer reintegrate and identify each subject.[64]

At the time Picasso painted the *Demoiselles d'Avignon,* he had not yet attained the level of mastery over his new style – or his old anxieties about fragmentation – that he would achieve in the years to follow. The tenuous integration of the composition reflects its creator's own tension as he attempted to produce a picture whose revolutionary qualities would propel him into the front ranks of the avant-garde, while simultaneously expressing his deep-seated ambivalence toward women. This ferocity is especially apparent in the Medusa-like countenances of the two figures at the right, the area of the canvas that Picasso reworked after the picture had ostensibly been completed. The grotesque disproportions and jarring colors employed here reinforce the horrifying effect of these two demoiselles, and the drama comes to a sinister climax as we confront these nightmarish apparitions.

In the anecdote he related to Kahnweiler, Picasso supplied identities for only three of his five demoiselles. The other two remain anonymous, unspecified; but surely they also represented specific women with specific character traits. Picasso evidently did not wish to share this information with his dealer, and may not even have shared the identities of these demoiselles with his two fellow conspirators, Apollinaire and Jacob. The numerous references to the artist's own childhood and adolescence encoded in the early compositional studies suggest that the unnamed demoiselles represent aspects of the artist's mother and his vision of her as an irrational, savage being. During his long amatory career, he repeatedly allied himself with severely disturbed women; Dora Maar, who suffered a flagrant psychosis while associated with him, merely constitutes the most celebrated example of his proclivity for such women.[65] Clinical experience has shown that men who repeatedly select such troubled partners have usually grown up with an equally troubled parent, most often a disturbed mother. Perhaps the apparent determination and control that

Picasso's mother exerted was actually a brittle tenacity born of fragility rather than strength.

Of course, on another level, Picasso's demoiselles also represent the artist himself. His identification with his figures is reflected both in the androgynous character of his preliminary sketches for the women and in his final substitution of the leftmost demoiselle for his self-image. The dramatic revelatory gesture of this alter-ego figure as she lifts the curtain to expose the remaining whores suggests that the artist never entirely eradicated all vestiges of the composition's original allegorical character. The position and pose of this revealer figure show analogies with similar figures in such Renaissance allegories as Agnolo Bronzino's *An Allegory with Venus and Cupid* (c. 1540–5; National Gallery, London).[66] In this latter painting, Time and Truth together expose the sin of sexual voluptuousness (represented by incest between Venus and Cupid). In other, less loaded variations on this motif, such as Bernini's statue of the *Truth Unveiled,* Time lifts concealing draperies to expose naked Truth, personified as a beautiful nude. For his allegory, Picasso eliminated the figure of Chronos, condensing the symbolism into the single figure of the leftmost demoiselle; she enacts the double role of both Truth the revealer and Truth revealed. While she shows us the horrifying women who inhabited the artist's past and present, she herself is in the process of being unveiled or exposed. Her clothing, primarily attached to her right torso, slips from her form; her breast has already been bared, and the mass of drapery bunching about her feet suggests that we shall soon confront Truth in all her nakedness. Unlike her Renaissance prototypes, Picasso's Truth reveals no universal verities, points to no generalized moral. Instead, she discloses the artist's painful, private confession: the history of the genesis and development of his misogyny. Simultaneously, she exposes another Truth: Together with her sister whores, she represents the artist's own childhood savagery, his identification with a mother whom he perceived as a "wild" woman.

Picasso never lost that childhood ferocity but, thanks to his artistic genius, he usually succeeded in transforming it into images of compelling power. The *Demoiselles d'Avignon* constitutes his earliest major transformation of this type. The two prostitutes on the right, with their threatening African-masklike faces, especially symbolize the artist's inner ferocity. Barr was probably the first to suggest the probable African origin of the faces of these two demoiselles. He proposed that Picasso might have recast these figures in the autumn of 1907, after his introduction to African art, especially masks from the French Congo region. He illustrated an Itumba mask as a likely prototype for the standing demoiselle at the right, who thrusts her truncated torso and muzzle through the blue curtain.[67] Barr's observations triggered a long-standing scholarly debate over the precise identity of the African prototypes that had inspired the artist, a question extensively revisited by William Rubin in 1984.[68]

Picasso's utilization of imagery derived from African art to remodel

the visages of his two right-hand demoiselles seems so obvious that his obdurate denial of this fact is quite puzzling. Why couldn't he admit the truth? André Malraux supplies a convincing clue. In *Picasso's Mask,* the author quotes the artist's reminiscences about his initial visit to the old Trocadéro Museum of Ethnological Art in Paris. Although this conversation actually took place in 1937, Malraux discreetly refrained from publishing it until after Picasso's death. Here is how the artist remembered his first glimpse of African sculpture:

> The masks weren't just like any other pieces of sculpture. Not at all. They were magic things. But why weren't the Egyptian pieces or the Chaldean? We hadn't realized it. Those were primitive, not magic things. The Negro pieces were *intercesseurs,* mediators; ever since then I've known the word in French. They were against everything – against unknown, threatening spirits. I always looked at fetishes. I understood; I too am against everything. I too believe that everything is unknown, that everything is an enemy! Everything! Not the details – women, children, babies, tobacco, playing – but the whole of it! I understood what the Negroes used their sculptures for.... They were weapons. *To help people avoid coming under the influence of spirits again, to help them become independent.* They're tools. *If we give spirits a form, we become independent.* Spirits, the unconscious (people still weren't talking about that very much), emotion – they're all the same thing. I understood why I was a painter. All alone in that awful museum, with masks, dolls made by the redskins, dusty manikins. *Les Demoiselles d'Avignon* must have come to me that day, but not at all because of the forms; because *it was my first exorcism painting* – yes absolutely![69]

Thus, thirty years after he completed the *Demoiselles,* Picasso finally confessed the reason for his peculiar behavior: He employed those African mask forms for exactly the same purposes as the Africans who originally made and used them. Just as in secret society ceremonies and dances African warriors sometimes don female masks and assume female identities, so here the artist represents himself as the evil female spirits over whom he wishes to gain power. By means of these powerful, magical tools, Picasso hoped to secure and maintain his independence from his mother. He could no more share these intimate details with the world than the members of African secret societies can share their mysteries with the uninitiated. Had he revealed these secrets, his demoiselle-effigies might have lost their secret power to control his female evil spirits – or they might even have turned on him, to destroy their creator!

Before he considered the *Demoiselles* completely finished, Picasso began to show the painting to selected friends and patrons. Their horrified reactions amply demonstrated to him how completely he had caught the spirit of the African magic he had invoked. Perhaps the shocked reactions of his peers spread to the artist himself so that he, too, became intimidat-

ed and awed by his own potent image magic. Whatever his motivations, Picasso abruptly abandoned his painting in its present tenuous state.[70] Unresolved though it may be, the *Demoiselles d'Avignon* stands as one of the major monuments of modern art, an outstanding achievement of twentieth-century painting. Like the Roman god, Janus, this picture looks toward both the past and the future. It not only foretells the imminent birth of Cubism; it also reveals its creator's private past.

Behind his masked demoiselles lurks the persona of the artist-shaman, destroying the universe of his childhood, triumphing over his private female demons. The *Demoiselles d'Avignon* is not only art as autobiography – it is painting as exorcism.

6

Art as Autobiography
Picasso's Guernica

MORE than fifty years have passed since Pablo Picasso painted *Guernica* (Fig. 67). In the interim, the picture has become one of the most celebrated paintings of the twentieth century, yet its iconography remains an unresolved puzzle. We lack agreement even about the significance of the bull and horse, central figures in the mural and fixtures in Picasso's art since his childhood. Although the artist obviously intended the picture to be a great public statement – in 1945, he singled it out as his only allegorical work – the enigmatic nature of its symbolism suggests that *Guernica* actually partakes of the same intimate autobiographical quality that generally characterizes Picasso's oeuvre.[1] Indeed, the mural owes its effectiveness precisely to this personalized quality: Painted in the heat of passion, *Guernica* communicates to the viewer the same powerful emotions with which Picasso invested it. Probably only when such a fusion occurs can an artist create effective propaganda that is also great art.

Picasso's Other Political Paintings

Picasso later attempted to rediscover the magic formula he had applied so effectively in *Guernica* in the creation of other political paintings, but he never succeeded in producing another picture with a message to rival his mural. The relatively impersonal compassion that motivated him to begin canvases like *The Charnel House* (Fig. 68) and *Massacre in Korea* (1951; Musée Picasso, Paris) could not sustain him until their completion. In fact, he never succeeded in finishing *The Charnel House*, though he labored over it for months, perhaps years, whereas *Massacre in Korea*, though complete, seems stilted and lifeless.[2]

In contrast to *Guernica*, the iconography of both these pictures appears relatively transparent, a characteristic probably also indicating that

neither theme touched the artist in the deeply personal way *Guernica* had. This ease of legibility may also reflect the fact that neither composition was completely Picasso's personal invention. Perhaps less inspired because less involved, he turned for assistance in composing both pictures to the art of his great predecessor, Francisco Goya. The latter had been a lifelong ideal and model for Picasso, who while he worked on *Guernica* had become quite preoccupied with Goya's depictions of the massacres of *The Third of May, 1808* (1814; Museo del Prado), perhaps because he realized that his mural would inevitably be compared to Goya's masterpiece.[3] Picasso must have studied reproductions of this painting once again while working on *Massacre in Korea,* which repeats both the general form and many specific features of Goya's composition, a fact widely recognized in the Picasso literature. The connection between *The Charnel House* and the art of Goya seems less obvious, but many of the latter's designs for the *Disasters of War* include similar mounds of corpses. Robert Rosenblum is probably correct, however, in suggesting that a specific print from this set, the "Ravages of War," which shows an interior that juxtaposes a tumble of dead bodies with still-life objects, may have played a part in inspiring Picasso.[4]

One prominent feature in *Guernica,* the figure of the broken warrior or statue that occupies the left frontal plane of the picture, may also allude to a painting by Goya, but, in general, Picasso's mural seems much more intimately related to his own production of the previous decade than to any external source.[5] He began the picture shortly after he had emerged from a profound personal and artistic crisis that had preoccupied him during the mid-1930s. Troubled by his inability to choose between his love for his young mistress, Marie-Thérèse Walter, and his loyalty to his disturbed wife, Olga Koklova, the artist suffered a complete creative paralysis for several months following the birth of his baby daughter to Marie-Thérèse in October 1935.[6] It would seem that Picasso equated this crisis with the conflict that shortly thereafter rent Spain, perceiving in his country's self-destructive struggle the strongest parallels to his own past and present psychological conflicts. His decision to portray the tragedy at Guernica as a drama involving his totem animals, the bull and horse, is a measure of the intimate terms in which he visualized this struggle.

The Bull of Guernica

Anyone familiar with Picasso's art from the 1930s knows the many paintings, drawings, and prints in which the bull or Minotaur appears as the artist's pictorial alter ego. Yet the symbolic meaning that Picasso attached to this figure in *Guernica* is by no means clear, as the varied interpretations assigned to this imagery attest. Many critics have perceived the animal as a sympathetic figure, a symbol for beleaguered Spain, despite the fact that the artist himself specifically identified the bull as the agent

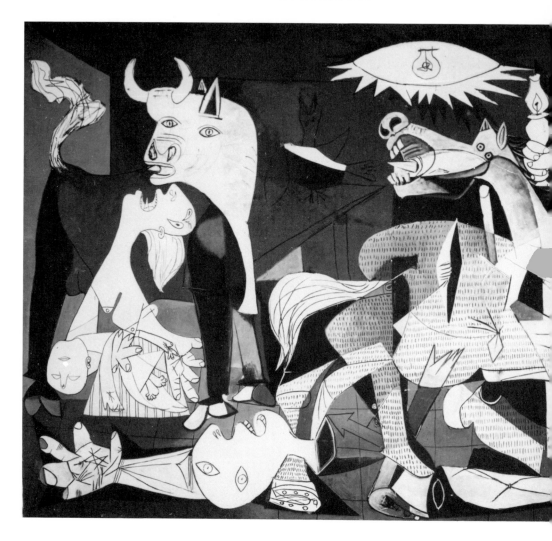

67. Pablo Picasso, *Guernica*, 1937. Oil on canvas. Museo Nacional de Reina Sofiá, Madrid; © 1993 ARS, New York / SPADEM, Paris.

of brutality and darkness, the horse as the symbol of the suffering people.[7] The reluctance of critics and public alike to accept this identification can probably be explained by the bull's humanized expression and quiet demeanor, which do not suggest brutality. Also, it seems almost inconceivable that Picasso would identify this animal, his famous pictorial doppelgänger, as the instrument of evil.

The bull certainly performs no such ignoble role in the etching suite *The Dream and Lie of Franco*, which Picasso completed while he

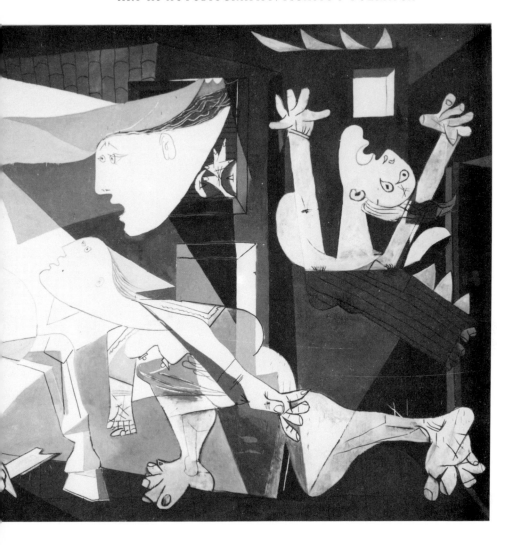

worked on *Guernica*. The imagery of the final four scenes from this etching bears a close relationship to that of the mural, yet in the print the bull acts the hero's part as he confronts and disembowels the Franco monster, represented as a horselike being with a polyp's head (Fig. 69). However, Picasso's close friend Roland Penrose made a most striking observation about Picasso's relationship to this polyp image:

The Spanish war had made itself felt so acutely to Picasso that he could not avoid becoming personally involved. The loathsome shape he had invented for Franco came from a personal image of a monster which he understood as lurking within himself. Not long

163

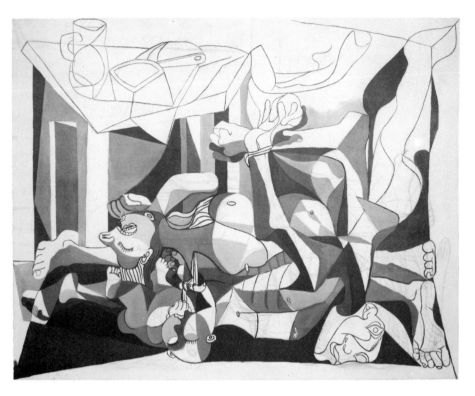

68. Picasso, *The Charnel House,* [1944]–1945. Oil and charcoal on canvas.
The Museum of Modern Art, New York, Mrs. Samuel A. Lewisohn
Bequest (by exchange) and Purchase; © 1993 ARS, New York / SPADEM,
Paris.

after he had finished the series, I asked him to sign a copy I had
bought. He did so, but when he had written my name beginning
with a small p, I was astonished to see that the capital letter with
which he commenced his own signature had fundamentally the
same form as the twisted grotesque head [the polyp] that he had in-
vented for the man he hated most. The strength he gave to the im-
age borrowed subconsciously from so intimate a source was an in-
dication of the degree to which he felt himself involved. The desire
to implicate himself by means of his own initial could not be more
convincing. Just as formerly he had often based the image of the
hero, Harlequin, on an idealized self-portrait, here, in reverse, the
subconscious origin of the shape he gave to the man he most hated
was equally personal.[8]

Does the bull of *Guernica*, then, represent another aspect of the inter-
nalized monster Picasso recognized as part of his own psyche?

69. Picasso, *The Dream and Lie of Franco*, 1937. Etching and aquatint, plate 2 of 2, state 3. Private collection, Chicago; © 1993 ARS, New York / SPADEM, Paris.

The Preparatory Drawings for Guernica

The numerous preparatory drawings for *Guernica* suggest that the artist certainly did not begin the mural with such a fixed conception of the bull's role in mind, for the animal's nature and activity underwent many metamorphoses as the mural progressed. In the earliest schematic drawing, from May 1, 1937, both the woman holding the lamp and the dying horse assume more prominent positions than the bull, who stands quietly at the left while a little bird alights on his back.[9] His passive attitude seems still more pronounced in the next sketch, where he is depicted saddled, bridled, and tamed, with a tiny Pegasus rider (Fig. 70; this drawing is apparently a more evolved stage of the bird image from the first sketch). The next three drawings did not include the bull, but he reappears in the elaborate sixth and final drawing from May 1, where he is shown crowned with a wreath of flowers, staring off into the distance with an innocent, even vacuous expression, apparently oblivious to the

165

70. Picasso, compositional study for *Guernica,* May 1, 1937 (II). Pencil on blue paper. Museo Nacional de Reina Sofiá, Madrid; © 1993 ARS, New York / SPADEM, Paris.

71. Picasso, compositional study for *Guernica,* May 1, 1937. Pencil on gesso on wood. Museo Nacional de Reina Sofiá, Madrid; © 1993 ARS, New York / SPADEM, Paris.

tragic events that swirl about him (Fig. 71). His detached behavior persists in the elaborate gouache Picasso created the following day showing the animal leaping along above the scene of carnage much like the nursery-rhyme cow who jumps over the moon (Fig. 72). As Picasso developed his compositional ideas, he continued to seem ambivalent about the bull's nature and role; motifs that depicted the animal as a youthful, ennobled, even childlike creature (Fig. 73) alternated with those in which

166

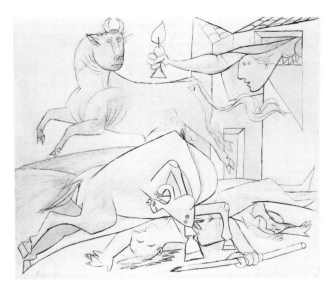

72. Picasso, compositional study for *Guernica,* May 2, 1937. Pencil and gouache on gesso on wood. Museo Nacional de Reina Sofiá, Madrid; © 1993 ARS, New York / SPADEM, Paris.

73. Picasso, compositional study for *Guernica,* May 11, 1937. Pencil on white paper. Museo Nacional de Reina Sofiá, Madrid; © 1993 ARS, New York / SPADEM, Paris.

he appeared more mature, awesome and aggressive, although still quite humanized. Only one drawing – an undated sketch usually assigned to the first week in May – depicts the bull in a more overtly threatening pose, as he menaces the agonizing horse.[10] However, neither in this instance nor in the remainder of the sketches does the ferocity of the bull ever equal the savagery he displays in those pictures from 1934 that show the maddened beast destroying his universe.[11]

167

Although Picasso continued to struggle over details of the horse's pose and location until the mural neared completion, its emotional state never varied: From the beginning, the horse apparently symbolized suffering and death, and the beautiful fifth preparatory drawing the artist made on May 1 already contained the essence of his final vision of the horse and its place. He subsequently discarded this idea only to return to it in the definitive stage of the painting, where the horse is shown in almost an exact mirror image of the pose it assumes in this drawing.

But the horse underwent another transformation, one that contains a vital clue to the private associations that *Guernica* held for its creator: In that final drawing of May 1, Picasso showed the horse giving birth to Pegasus through the wound in her side, as though the mare were the dying Medusa. Herschel Chipp perceptively relates this drawing to the 1936 sketch for *The Minotaur Moves His House*, which shows a horse foaling her colt in a cart pulled by the Minotaur, an image Chipp interprets as a revelation of the artist's painful rejection of Marie-Thérèse following Maya's birth.[12]

Picasso no sooner devised this Pegasus imagery than he suppressed it; none of the subsequent drawings refer to Pegasus, though in the later stages of the mural's evolution he suddenly included a flying bird, which probably represented his ultimate transformation of this imagery.

The third key figure in the iconography of the mural, the mother holding the dead child, did not make her initial appearance until May 8. Rudolph Arnheim correctly notes that, in the artist's first two depictions of the woman, the closest conceptual and compositional links unite the figure of the mother with that of the horse.[13] Picasso soon succeeded in differentiating their poses and roles, but that underlying fusion – or confusion – lingered in the full compositional sketch from May 9, which shows the mother plunging her right arm into the wound in the horse's side, almost as though the woman's limb were a tree trunk, the horse's body its root system (Fig. 74).

Picasso's early sketches of the mother with the infant endow her with two unique features that provide the clue to her identity and significance: She wears an elaborately patterned kerchief on her head, and her infant, as Arnheim astutely observed, appears in the process of being born (Fig. 75): "The child's head, as though still half unborn, is enclosed in a diamond-shaped cavity: and although the child continues to show vaginal connotations, it is now animated by an alarm of its own. Two ripe breasts, ready to offer nourishment, rest on the baby's body yet are separated from it by dark blood."[14] Picasso's treatment of the latter feature soon makes it clear that the blood spurts from the baby's own body, which seems to have been ripped asunder: The child is one gaping, bloody wound from neck to groin.

While Picasso worked on the figure of the mother with the child, he suppressed that of the woman with the lamp; at one point, he even posed

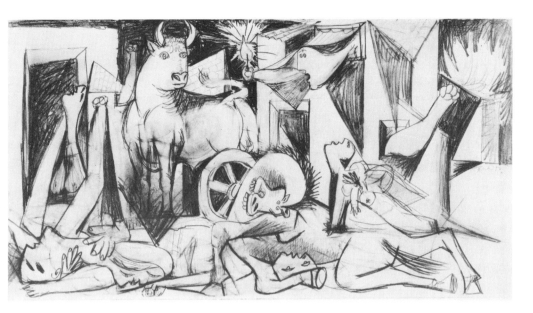

74. Picasso, compositional study for *Guernica,* May 9, 1937 (II). Pencil on white paper. Museo Nacional de Reina Sofiá, Madrid; © 1993 ARS, New York / SPADEM, Paris.

the woman with the baby in the position on the ladder eventually occupied by yet another figure in the final stage of the mural. Arnheim suggests that Picasso, slow to accept "the splitting of the female element into several figures," could only transfer, not multiply his imagery.[15] By the time Picasso sketched his preliminary outline on the great canvas (May 11, 1937), however, the mother with the dead child had assumed her final position just beneath the bull's head. Picasso subsequently moved the bull's body a full 180 degrees, but by turning his head back toward the left he preserved the close relationship he had established between the open mouth of the screaming mother and the muzzle of the roaring bull just above her. In fact, the mother seems almost to merge with the bull's dark bulk, which pushes forward against her light-colored figure.

Interpretation

As several critics have suggested, Picasso may have derived some of his imagery for *Guernica* from photographs of the ravaged city. But he possessed a source deep within himself for such imagery, for he had once witnessed a tragedy that paralleled the devastation of Guernica: the destructive earthquake that rocked his native Málaga from December 25 to

169

27 in 1884, when the artist was 3 years old. Fifty-seven years later, Picasso vividly described this event to his biographer, Jaime Sabartés, recalling that when the earthquake began his father rushed home that Christmas night to evacuate his little family to the greater safety of a friend's abode, which backed up against the base of the rocks near the seashore. "'*My mother was wearing a kerchief on her head. I had never seen her like that.* My father grabbed his cape from the rack, threw it over himself, picked me up in his arms, and wrapped me in its folds leaving only my head exposed....' That night of the earthquake was a night of anguish for Málaga, and Christmas was not 'Merry' that year. But in the midst of all these trials, Picasso's sister was born."[16]

If one studies the mural and its evolution with this story in mind, the puzzling pieces fall into place. The screams, the confusions, the destruction, the flames, the sudden transitions from indoors to outdoors – all these must have been part of the artist's own confused recollections of that long-ago night in Málaga. That he certainly connected the tragedy of 1937 with that of 1884 is indicated by several of his earliest drawings for the mural, especially the third and fourth sketches from May 1. Many critics have commented on the peculiar childlike quality of these drawings – unique in the artist's oeuvre – without offering any very plausible explanation of this characteristic. Perhaps the real explanation is that the artist, forcibly reminded of the terrible trauma he had suffered at age 3, began to draw as if he were once again a 3 year old. The content of these two drawings seems especially significant. The fourth sketch (Fig. 76) shows the gravid horse standing intact, unwounded, its belly great with foal. Does it represent Picasso's mother at the beginning of their journey that night, the journey that (at least as Picasso later recalled the sequence of events) terminated in Lola's birth?

The other drawing seems much more complex and difficult to interpret (Fig. 77); it presents five figures, but only one of them can be identified with ease – the woman with the lamp, who already bears a close resemblance to Marie-Thérèse Walter. Just below, Picasso depicted a perplexing scene, here interpreted as the moment of the baby horse's birth. The larger horse on the lower left bends back; a circular line connects its body with that of a smaller figure, also apparently a horse; from the latter's central cavity, curling lines emanate. Arnheim perceives this mass as the entrails of the disemboweled horse; instead, it may represent the placenta, and the line connecting the two figures the uncut umbilical cord.[17] These sketches suggest that Picasso himself witnessed his baby sister's delivery, an event also symbolically portrayed in the elaborate final drawing from May 1, showing the birth of Pegasus, a traumatic scene from which the confused-looking young bull turns away. Does he represent the artist as the helpless toddler of 1884, vainly trying to carry on some childish activity (symbolized by his wreath, reminiscent of the clover chains children weave) but paralyzed by the events in which he participates?

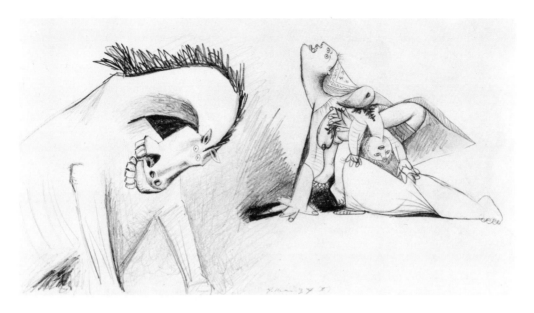

75. Picasso, compositional study for *Guernica*, May 8, 1937 (II). Pencil on white paper. Museo Nacional de Reina Sofiá, Madrid; © 1993 ARS, New York / SPADEM, Paris.

76. Picasso, compositional study for *Guernica,* May 1, 1937 (IV). Pencil on blue paper. Museo Nacional de Reina Sofiá, Madrid; © 1993 ARS, New York / SPADEM, Paris.

77. Picasso, compositional study for *Guernica,* May 1, 1937 (III). Pencil on blue paper. Museo Nacional de Reina Sofiá, Madrid; © 1993 ARS, New York / SPADEM, Paris.

171

That Picasso experienced his sister's birth as the equivalent of a bombing attack we may infer from the activity of yet another figure who appears in that enigmatic third sketch of May 1: the animal in the upper-left corner. Its identity and role seem unclear; Arnheim convincingly suggests that it is a horse, but neither he nor other critics have commented upon the fact that the animal appears to be airborne.[18] Indeed, it functions as an animated bomber, for its side has a clearly defined rectangular opening like the bomb bay of an airplane, and the artist drew a sharply descending arc from the center of this aperture, as though depicting the path of a bomb. For a second, then, the horse shifts roles to become the aggressor, reminding us that the Franco-monster in *The Dream and Lie of Franco* appears as a polyp-headed horse. Picasso quickly eliminated this motif from *Guernica,* but the bomber-horse cannot be unrelated to the levitating bull of May 2, a substitution that suggests complex equations among horse, bull, and bombers.[19]

Although Picasso ultimately eliminated all these more direct allusions to Lola's birth, the reference to her – and, by implication, to the artist's little daughter Maya – remains, in the theme of the mother with the dead infant. Ironically, while he created his chef d'oeuvre, Picasso simultaneously accomplished on canvas what he had been too small and impotent to accomplish in reality: the murder of the baby. How brutally he disposed of the infant in those initial drawings for the mother with the dead baby, which depict the child as one terrible wound (perhaps the way Lola seemed to him when she arrived, covered with blood)! Eventually, the artist also eradicated this feature, electing finally to render the baby seemingly intact, but lifeless.

As Arnheim has surmised, Picasso's initial conception of the mother grew out of imagery devised for the horse. Indeed, for the artist both figures apparently symbolized the same being, the same events, the same trauma. The underlying unity of all three female figures in the mural probably reflects also those early memories of the time when the artist's mother was the only real, significant person who existed for him. By extension, all other women shared her identity, and *Guernica* in its final form probably apportions to different figures visual memories that were all originally associated with the artist's mother and her behavior during the earthquake. For example, she probably really held a lamp to light their way that night in Málaga, while her husband carried their little son.

The fusion of horse and woman probably grew out of an experience that did not actually involve Picasso's mother, but which the confused child soon connected with her: recollections of his initial experiences at the bullfight. According to Sabartés, the artist began to attend the weekly bull ritual with his father soon after reaching age 3. About the same time, he started accompanying his father on visits to friends and on strolls around Málaga. The boy also started drawing lessons under his artist-father's tutelage, sketching the pigeons that crowded the square before their home.[20]

The fact that Señor Ruiz suddenly made his son his boon companion was probably causally, rather than coincidentally, related to the events of Christmas 1884. Evidence presented in detail elsewhere led me to conclude that Picasso had enjoyed an unusually intense relationship with his mother during his earliest years.[21] Lola's birth disrupted this symbiosis: Her demands preempted his mother's energy and attention; at the same time, the boy actively withdrew from her, unwilling to accept his new role as second fiddle. Gradually, this withdrawal shaped itself into a confirmed policy of loyal estrangement vis-à-vis his mother, which he maintained throughout his adolescence and young adulthood, until he left Spain forever in 1904. Thereafter, he saw his mother quite infrequently.[22]

The terrible circumstances that so closely coincided with Lola's birth surely intensified its traumatic effects on Picasso; it seems likely that the lifelong abnormality in the pattern of his sleep, his reversal of the usual rhythm and activity of night and day, began in response to the earthquake. The nocturnal onset of that disaster must have fixed an unbreakable association between darkness and death in the child's mind that he never succeeded in shaking off. As a young artist, he habitually slept until late afternoon, then worked through the night, and even as an elderly man he continued to paint until dawn approached, when he finally surrendered to sleep.[23]

Picasso may also have suffered another symptom in the wake of the earthquake, one that his parents surely would have found still more distressing: fecal incontinence. At least, a peculiar anecdote, again supplied by Penrose, raises such a possibility. Penrose relates that Picasso, as he worked on *Guernica,* behaved as though the characters he was creating on canvas were alive, and, as an example of this attitude, Penrose tells this story: During a discussion concerning *Guernica* and the nature of realism in art, the artist suddenly ran and got a long streamer of toilet paper, which he attached to the hand of the woman portrayed running in from the right in the mural. "'There,' said Picasso. 'That leaves no doubt about the commonest and most primitive effect of fear.'"[24] This strangely concrete behavior suggests that the artist was again reliving old memories and that, as a small child, he himself had experienced this "most common" effect of panic.

Picasso's father may have intensified his contacts with his son in an attempt both to alleviate such symptoms and to relieve his wife, doubly burdened with the care of a newborn baby and an older child whose behavior now often simulated that of an infant. Señor Ruiz's choice of the bullfight as a suitable diversion for an anxious child may seem questionable, although Sabartés notes that Picasso's father was an ardent aficionado; perhaps he simply could not bring himself to forego the weekly bullfight and so dragged Picasso along, or perhaps he disavowed the true extent of the cruelty this sport entails.[25] In any case, the sights Picasso witnessed at the bullfight made the most profound impression. In those

days, horses faced the bulls without any protective armor, so they regularly suffered disembowelment and agonizing death. Such horrifying scenes must have recalled the boy's confused visual memories of Lola's delivery, forever fixing in his mind an equation between horse and woman, sex and sadism, birth and death, that he would later utilize so tellingly in his art.

The bull, making the earth tremble in his wrath, must also have deeply impressed the child. It seems likely that little Pablo, unable to distinguish between internal rage and external devastation (not an unusual kind of confusion at that age) came to believe that *he* had caused the Málaga earthquake, a notion that the behavior of the maddened bull vividly recalled. Gradually, the bull assumed the status of Picasso's doppelgänger, representing himself as the magical destroyer, an aspect of his identity he shared with the world both in *Guernica* and in the bullfight and Minotaur pictures that preceded it.

Picasso's work during the 1930s suggests that, as a mature artist, he possessed a rather sophisticated knowledge of the Greek myths; but when he attended the bullfights as a small child he cannot have been aware of the close connection that ancient Greeks made between Poseidon (whom they worshipped as Enōsichthōn, the instigator of earthquakes) and horses and bulls. They believed that this god created all horses, and they associated dark-colored bulls with Poseidon's dark wrath, especially his activities as precipitator of hurricanes and tidal waves.[26] Black bulls were regularly sacrificed to the god, and in Ionia and Thessaly – regions that were especially beset by earthquakes – bullfights were held in his honor. Euripides, in his tragedy *Hippolytus*, describes a monstrous bull that appears magically from the sea as the instrument of the hero's destruction by a combination of seiche and earthquake. The dramatist notes that, as the bull leaps to the beach, he fills the land with his bellowing, while the earth echoes his cries "with shuddering emphasis," a series of events that causes Hippolytus' horse to stampede and drag the youth to his death.[27] With his close ties to so many French poets, Picasso surely knew *Phèdre,* Racine's version of this tragedy, if he did not know Euripides' original drama. Knowledge of the myth must have reinforced the connections he had forged long ago between the bull's role as earthshaker and his own, perhaps influencing his decision to utilize this animal as his alter ego in those pictures that emphasize the beast's terrible destructive powers, including his appearance as the agent of brutality and darkness in *Guernica.*

Indeed, the visual evidence from the early sketches for *Guernica* indicates that Picasso initially identified himself not only with the bull but with the horse and the Pegasus figure as well, and these animals were also intimately involved with Poseidon. In fact, all the figures represented in the painting as separate individuals were probably originally interchangeable in the artist's mind, a notion he spells out in the early

sketches of the woman with the dead infant, whose equation with the horse and the other female figures is made quite plain. Then, as he assumed greater conscious control over his creative processes, Picasso eradicated the evidence pointing to such interchangeability. For example, in the third sketch from May 1 the artist portrayed figures representing his mother, his sister, and himself in equine guise, but the next day he transformed the airborne horse into the levitating bull. This exchange correlates with other evidence from Picasso's art and life to suggest that originally he was so closely tied to his mother that he often experienced real confusion concerning his separate role and identity. The painful associations that the bombing of Guernica aroused led him, momentarily, to reexperience that confusion, to become like a child again. The broken warrior who inhabits the front plane of the mural may concretely represent the subjective fragmentation that Picasso suffered during and after the earthquake. Like the other figures in *Guernica,* this warrior conveys a more universal symbolism to the average viewer – undoubtedly one also intended by Picasso – for he recalls a disintegrated marble statue evocative of the classical past, the cultural heritage that war decimates. Yet this figure, too, had its analogies in the artist's personal memories: Picasso, the child who fragmented, remained an adult constantly threatened with disintegration. As a child, he warded off such confused episodes by magically fusing himself in fantasy with the powerful figures who surrounded him; initially, such fusions involved his mother, but later the artist's father assumed this symbiotic function. Picasso's dramatic retrospective description of how terrified he felt as a little child in school as he anxiously awaited his father's return reveals the pathetic extent of this dependency and of his need for such fusions.[28]

That same self–other confusion probably also involved Lola; it certainly involves imagery associated with her in *Guernica.* The horse, after all, gives birth to the Pegasus, a winged creature that, like the airborne bomber-horse and the leaping bull, transcends gravity. The mythic origins of the Pegasus also intimately link him to Poseidon, for the god fathered the winged steed on the Medusa, who was changed into a monster after Poseidon had intercourse with her in a temple sacred to Athena. Pegasus, born from the Medusa's blood after the hero Perseus slew her with Athena's aid, finally joined the immortals on Olympus, where he became the purveyor of thunder and lightning for Zeus.[29] In the Greek mind, then, both Pegasus and black bulls are intimately associated with Poseidon and with climatic disturbances. By the time Picasso created *Guernica,* he was surely aware of the close mythical links uniting the earthquake god to these animals. His final transformation of the Pegasus into a bird offers further confirmation that his childish confusion and tendency to merge with others also involved his father. In retrospect, Picasso vaguely identified this bird as "a chicken or a pigeon." The latter – his father's totem animal and a creature to whom Picasso often referred in

his own art – must actually be the bird represented. Thus, Picasso's father secures his symbolic place in the mural, along with the other members of his family.

Conclusions

This attempt to explore the private, personalized roots of Picasso's conception of *Guernica* should not make the miraculous seem mundane or drag the sublime into the dust. Rather, Picasso's ability to control, then transform, his traumatic private associations with the tragedy at Guernica displays the splendor of genius in its most dazzling light. The same sensitivity that made him especially vulnerable to his terrible childhood experiences also made him keenly aware of the need for transforming the archaic reactions that the initial sketches for *Guernica* reveal into the great public statement he finally evolved. Thus, he suppressed the Pegasus/ childbirth motif almost as soon as he had conceived it, and he treated the bull with deliberate restraint – a restraint that has made the artist's frank identification of this beast as the instrument of brutality and darkness puzzling to his public. The impact a work of art possesses depends, in the last analysis, on the universality of its meaning. A painting so private and enigmatic that its significance remains completely hidden from everyone except its maker seems foredoomed to failure. But in *Guernica* Picasso created a masterful balance of these features: Effective as a depiction of the horrors of war, *Guernica* also recapitulates elements of the artist's most private history. Without fully comprehending the nature of the latter symbolism, we respond to Picasso's personal angst: From this source derives *Guernica*'s great power. Picasso's explanation that the bull of *Guernica* represents brutality and darkness suggests that he was willing to share these private associations with viewers astute enough to comprehend that the bull represented himself as a kind of Shiva, god of destruction as well as god of creation. He identified himself both with the bull-destroyer and with the dreadful polyp image he had devised for Franco because, like the Fascist general, Picasso had once laid waste his native land – at least, that must have been his original childish understanding of the cause of the Málaga earthquake.[30] In *Guernica* Picasso simultaneously represents his country – caught in the destructive vise of a civil war – and himself as both the innocent victims of destruction and the causative agents of that same destruction. The mural says in effect, "We humans are all like that: We destroy what is most sacred to us." Picasso's old enemy Francisco Franco must have understood this implicit meaning very well, for he never ceased to covet the mural for Spain, despite its overtly anti-Fascist message. Picasso had taught him that the Spanish monster that existed both within the artist and himself has universal meaning.[31]

7

Meditations on Madness
The Art of René Magritte

O NE of René Magritte's most provocative paintings from the late
1920s, the period when he first hit his stride as an artist, portrays a
young man staring fixedly at what appears to be a blank tabletop. The
picture's title, *Person Meditating on Madness* (*Figure Brooding on Mad-
ness*) (1928; Fig. 78), does little to illuminate its enigmatic imagery. Is the
youthful protagonist merely meditating on the nature of madness, or is
he experiencing a psychotic state himself? His inappropriate expression
and strange half-smile certainly suggest that he may be projecting a bi-
zarre inner vision onto the blank surface before him, a hallucination
from which the spectator is forever excluded.

I believe that this picture occupies a unique position in Magritte's
oeuvre, constituting a painted statement of the genesis of his Surrealist
style, as well as a forecast of the program that he would follow during
the remainder of his career.[1] For the art of René Magritte seems to me
best defined as an unending meditation on the nature of madness, con-
ducted by an investigator who may well have demanded the maintenance
of that exploration to contain his affectivity without lapsing into depres-
sion or mania.

Resurrecting the Lost Mother

Certainly, Magritte possessed impeccable credentials for undertaking
such a program. Throughout his childhood, he lived in the closest intima-
cy with a woman he perceived as mad: his mother, who finally terminat-
ed her tortured existence by drowning herself in 1912, when the future
artist was 13 years of age.

As Magritte later remembered it, when they retrieved his mother's
body from the River Sambre in the Belgian town of Châtelet where the

family then made its home, "they found her nightgown wrapped around her face. It was never known whether she had covered her eyes with it so as not to see the death she had chosen, or whether she had been veiled in that way by the swirling current."[2] The relationship between this vivid description (as David Sylvester has demonstrated, it is a reconstruction more mythic than accurate) and the repeated images of veiled female figures that recur in Magritte paintings like *The Lovers* (1928; R. S. Zeisler Collection, New York), has not escaped critical attention.[3] Psychologically oriented critics have pointed out numerous additional connections between Magritte's female imagery and his mother's suicide. For instance, Elena Calas cites *The Elusive Woman* (*The Unattainable Woman*) (1928), with its repeated depictions of "hands searching blindly but avidly along a wall in a fruitless attempt to reach a nude woman 'attached' to the wall, in full view of the beholder," as but one example of Magritte's continued search for the mother from whom he had been so prematurely and traumatically separated.[4] The late psychoanalyst of children, Martha Wolfenstein, points out many other images that refer to the artist's mother, including paintings in which the woman simultaneously seems "both alive and dead, there and not there. *The Inundation,* 1928, for example, shows a nude woman standing beside the sea; the upper part of her body fades out and her head is invisible."[5]

No one, however, not even Wolfenstein, has emphasized the equally obvious relationship among the unique character of Magritte's imagery, his portrayal of a bizarre world, and the severe psychological disturbance from which his mother undoubtedly suffered for many years prior to her suicide.[6] This essay attempts to define and explore this connection, to demonstrate how the artist's unique relationship to his mad mother formed and fueled his creativity, setting his brand of Surrealism apart from that of such contemporaries as Max Ernst, whose art certainly had a profound effect on Magritte, but who created a more playful, benign fantasy world than did his Belgian counterpart. This study focuses exclusively on the pictures that Magritte painted during his first Surrealist phase (1925–30), especially those canvases completed between 1926 and 1928, a period of great productivity for the artist, who later recalled that he painted more canvases during 1926 than ever again in his career.[7] This heightened creativity seems to have been accompanied by heightened anxiety, a quality reflected in the expressionistic character of many of these paintings, with their unpleasant, dark, metallic colors and bizarre, anthropoid creatures. As Louis Scutenaire notes, many of these pictures cannot be viewed, even today, without uneasiness.[8] Both the palette and the imagery employed in *The Palace of Curtains II* (1928; private collection) typify this type of painting. Despite its title, the bizarre beings depicted in this canvas can hardly be identified either as "curtains" or as a palace. Rather, these phantoms seem to be formed from some type of metal or rubber piping, animated, like Frankenstein's monster, by the hand of their creator.

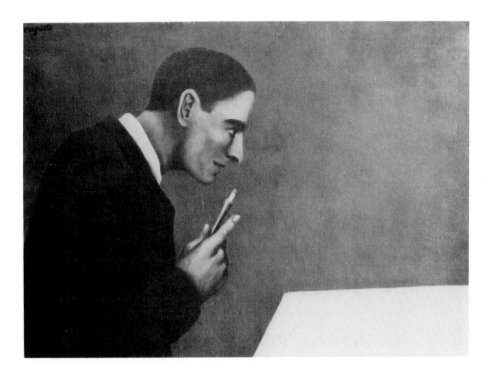

78. René Magritte, *Person Meditating on Madness (Figure Brooding on Madness)*, 1928. Oil on canvas. Private collection, Brussels; © C. Herscovici / ARS, New York.

In such canvases, Magritte forces the viewer to share his personal anxiety without making the audience privy to the sources of this tension. Their expressionistic angst also sets these works apart from certain others from the late 1920s that seem more typical of the artist's later oeuvre. The latter paintings feature brighter, clearer colors and recognizable objects and figures that are surreal only because of their improbable juxtapositions or contexts.[9] Although many of the motifs and protagonists that Magritte initially introduced in his more disturbing early pictures recur throughout his career, they appear in their later incarnations in toned-down, transformed states.

To date, these strange works from Magritte's first Surrealist phase have not received the kind of detailed psychological examination they deserve, even though many critics have recognized that they seem almost to demand psychoanalytic interpretation as the painted equivalents of a patient's dream. Far from providing a definitive psychological reading of this type, the present study offers only a beginning: It identifies a number of the major personalized themes that Magritte developed between 1925 and 1930, illustrating each of them with only a fraction of the relevant pictures he produced during this prolific phase.

We can only speculate about Magritte's motivations for abandoning the expressionistic style of his early Surrealist phase. It seems possible that he made this decision solely on aesthetic and practical grounds, because he realized that the raw power of these works made them too unpalatable and hence unsalable. Whatever role such considerations may have played, one should not dismiss the possibility that this change in style also mirrored a change in Magritte's inner world. His earliest paintings convey an atmosphere of extreme anxiety, accompanied by suicidal preoccupations. By contrast, his oeuvre of the 1930s does not often reveal such overt indications of emotional distress. The history of the artist's adolescence, briefly reviewed below, certainly suggests that Magritte must have veered dangerously close to psychosis in the years immediately following his mother's death. His marriage in 1922 produced a very salutary effect on the artist, and the gradual change in his Surrealist style, increasingly evident by 1929 and 1930, may reflect the fact that the effects of his terrible childhood were gradually healing over and he no longer needed to probe the open wounds so deeply. If this reconstruction is valid, whatever else may have determined this stylistic departure, it reflects a change for the better in Magritte's psychological status. The fact that an enforced separation from his wife in 1940 triggered renewed suicidal obsessions and led to another wrenching change in the artist's style suggests that one should not underestimate the therapeutic effects that Mme Magritte exerted on her husband. (Chapter 8 focuses on Magritte's career after 1940 and the psychoiconography of his major stylistic changes during and following World War II.)

The limited biographical information available about Magritte's personal life reflects the artist's lifelong resistance to providing data of this type. "I detest my past and that of others," he declared, and he lived by this precept. Apparently he did not share personal reminiscences of this type even with his wife; at least, during interviews conducted after the artist's death, she expressly denied that he had ever mentioned his mother's suicide during their forty-five years of marriage.[10] The most provocative biographical data available comes primarily from the writings of Magritte's intimate friend, Louis Scutenaire, with whom the artist did share a few revelations of this type, supplemented by information provided by his widow, his younger brother, Paul, and members of his inner circle.[11]

As loathe to discuss the iconography of his art as the story of his personal past, Magritte always insisted that his images were not symbols, but rather poetic mysteries – mysteries that he evidently intended his public to contemplate, but not to penetrate. He inveighed against psychoanalysis and psychoanalytic interpretations with such frequency and vehemence that one can only conclude that he feared that psychologically informed investigations of his imagery might reveal aspects of his character and experiences that he wished to keep forever submerged – perhaps even from his own awareness.

The bare-bones facts reveal that René, the eldest of the three Magritte sons, was born on November 21, 1898, in Lessines, Belgium, to Léopold and Régina Magritte (née Bertinchamps), whose families had both been resident in the area for generations. The future artist's brother, Raymond, followed in 1900, and Paul in 1902. Although Léopold's occupational record seems somewhat vague, he apparently earned his livelihood primarily as a salesman of edible oils.[12] In 1904, the family moved to Châtelet, where M. Magritte's business affairs flourished; seven years later, they built a substantial new home there in the town. This change of domiciles coincided with an escalation in Régina Magritte's emotional problems; following the move to the new home, she made several failed suicide attempts before she succeeded in drowning herself on February 25, 1912. Seventeen days later, her battered body was recovered from the River Sambre that runs through the town. The future artist was 13 at the time.[13]

It seems revealing of the emotional climate that prevailed in the Magritte household that as soon as the children could communicate with one another, René and his younger brother, Paul, formed a coalition against the middle boy, Raymond – a conspiracy of hatred that evidently endured until the artist's death.[14] A surviving family photograph taken when René was about 6 or 7 shows Raymond standing alone, ignored, while his father embraces Paul, and René and his mother pose with arms intertwined.[15] The visual evidence derived from Magritte's paintings of 1925–9 corroborates the impression obtained from this picture, suggesting that he may have been his mother's favorite, the child to whom she most often confided her bizarre misperceptions of the world of reality.

Even prior to his mother's death, René thought and behaved in an eccentric manner. A childhood mystic, obsessed with guilt, preoccupied with thoughts of "Jesus, His mother, His dove, and the saints of the stained glass windows," the boy frequently played at saying Mass before a little altar he had fashioned. He suffered from numerous tic-like facial grimaces, distorted expressions that Scutenaire loyally attributes to the boy's religious hyperscrupulosity.[16] These tics apparently persisted throughout Magritte's life, long after he had abandoned all his religious convictions – a fact that may not be unrelated to the inappropriate facial expression of the protagonist depicted in Person Meditating on Madness. Despite his renunciation of all religious beliefs, a goodly number of Magritte's paintings suggest an underlying identification of himself with Christ, or other deities.[17] In the light of such iconography, it is probably no coincidence that he chose the dove or pigeon as his favorite totem animal, an identification perhaps related to his early interest in the dove of the Holy Spirit.[18]

In retrospect, the artist claimed that his only reaction to his mother's suicide had been a thrill of pride in his new identity as "the son of a dead woman." His behavior following this event, however, scarcely accorded with this optimistic description. He now stopped "saying Mass" but sub-

stituted bizarre public rituals for his former private devotionals. "Hands folded, mumbling what sounded like prayers and genuflecting rapidly, he would make ten or twenty lightning-fast signs of the cross, to the stupefaction of those present. This behavior greatly upset the maids, who complained to the head of the household."[19] To put the most favorable light on it, such behavior suggests that Magritte must have reacted to his mother's death with extreme panic and disorganization. It seems likely that the repetitious rituals were designed to fend off internal experiences that the boy concretized as "demons," demonic presences that may have involved actual hallucinations as well as disturbing, frightening thoughts, although we do not have the confirmatory data to evaluate definitively the significance of this interlude.

In the light of such behavioral descriptions, it is scarcely surprising to learn that, a few years later, Magritte withdrew from his academic studies without securing his baccalaureate degree. In November 1915, the 17-year-old youth moved alone to Brussels, apparently with his father's approval, despite the fact that World War I was then raging and Belgium was under German occupation. The following October, he enrolled in the Académie des Beaux-Arts in Brussels, where he apparently also attended class irregularly and also failed to graduate.[20]

Magritte described the origins of his inspiration to become an artist in terms that match the eccentric character of his other childhood reminiscences. As a boy he spent his summers with his grandmother in a small town in the Belgian countryside. His favorite occupation there involved exploring a disused cemetery in the company of a special little girl. One day, as they emerged from an underground vault, the children came upon an artist from the capital who was serenely working at his easel among the broken stone columns and piles of dead leaves. From that moment painting seemed a magical occupation to Magritte, and the course of his future was determined.[21] At least as he chose to remember – or reconstruct – his personal history, his artistic vocation was, from the beginning, associated with an atmosphere of mystery and death. As Wolfenstein suggests, his predilection for depicting scenes in which darkness and light coexist in a single time and place probably derives from this memory. Like the story of his mother's death, this account seems quasi-mythical and probably constitutes another instance of what psychoanalysts would call a *screen memory*.[22]

The paintings that Magritte executed prior to his Surrealist breakthrough of 1925 reflect his youthful indebtedness to a range of contemporary avant-garde painters, including Fernand Léger, André Derain, and Robert Delaunay, among others. During the early 1920s, Magritte gradually became intimate with various progressive literati then resident in Brussels. The members of this circle all shared a similar affection for detective and mystery stories, as well as an interest in the expiring Dada and burgeoning Surrealist movements then active in Paris.[23] It was probably in 1923 that one of his literary associates called Magritte's attention

to the art of Giorgio de Chirico, whose paintings struck the young Belgian with thunderclap force.

Characteristically, Magritte never discussed the genesis of his Surrealist style in much detail. It seems quite certain, however, that he quickly became aware of the interest that the French Surrealist poets and painters evinced in evoking preconscious (often erroneously called unconscious) fantasies by inducing hypnogogic states. Magritte surely made use of similar techniques to tap the wellspring of memories that he introduced into his early Surrealist paintings. As a mature artist, he stressed the importance of the ideas that came to him during the half-awakened (i.e., hynopompic) state that precedes rising for the day.[24]

In 1922 (a year before he saw his first reproduction of a de Chirico canvas) Magritte married Georgette Berger. He had met this beautiful young woman many years earlier, when they had both ridden the carousel together during a town fair at Charleroi, where Magritte's father had temporarily moved the family following his wife's death. The horse imagery that would play such a significant role in Magritte's art probably should be attributed to this encounter. (However, his frequent representations of *grelots,* the small, spherical, silvered bells, used on horses' harnesses, certainly had a different origin, for he associated the latter objects with his mother, rather than his wife.)[25]

If de Chirico provided Magritte with the grand example, and his Belgian literary friends provided stimulus and support, his marriage to Georgette gave him the stability he required to undertake these daring new artistic ventures. She became, in a very real sense, his lifeline, and the artist's intimates all testified to his unusual devotion to her. With Georgette, Magritte re-created the best aspects of his relationship with his mother, the tender intimacy they sometimes shared – an intimacy that bound him to her memory forever. Unlike the artist's mother, however, his wife possessed a solid sense of self; she created an orderly (perhaps even compulsively rigid) domestic atmosphere that permitted his creativity to flower.[26] One of Magritte's Surrealist pictures of 1928 documents this theory that Georgette represented the "good" replacement for the original "bad" mother. *The Invention of Life* (Fig. 79) – both its title and the fact that it belonged to Scutenaire seem significant – depicts a vibrant young woman in a seashore setting, standing beside a shrouded figure, veiled as Magritte believed that his mother had been swathed by the river that had swallowed her.[27] Here the water has disgorged her, and she stands beside her replacement, a silent but omnipresent specter destined to haunt Magritte's art forever.

The Genesis of Magritte's Surrealist Symbolism

The first major composition that Magritte created in his new style, *The Lost Jockey,* deals still more dramatically with the central issue of his art and life: his unending preoccupation with the internalized image of his

183

mother. The artist created three versions of this motif during a relatively brief time span in 1926; the earliest of the trio, the collage and gouache reproduced here (Fig. 80), depicts a realistically rendered horse and rider in a decidedly surreal setting. The parted draperies of the foreground plane allude to a theatrical presentation, a metaphor that would recur regularly in Magritte's art. Although the jockey whips his horse as steed and rider strain frantically ahead, both seem forever frozen in their space, caught in the delicate network of lines stretched across the picture's central space. Giant balusters or *bilboquets,* magnified versions of the turned wooden forms commonly used as decorative table legs or, in smaller editions, as wooden chess pieces, surround horse and rider. Here the *bilboquets* appear transformed into wintry trees, their trunks composed of collaged bits of sheet music, with painted bare branches that stretch heavenward like the arms of female choristers in a Greek tragedy.

The *bilboquet* soon became a central motif in Magritte's art; his subsequent use of it leaves little doubt that it constituted one of his principal symbols for his mother. Hammacher, who knew the artist personally, has written most perceptively about the complex symbolic implications of this form:

> Instead of accepting conventional things as they were, Magritte began a challenging game with them to resuscitate not only their stranger aspects but those which cannot be named; to this end, he devised new functions for them. For instance, he transformed ordinary boring table legs made of turned wood into chessman in a copse. As his source of inspiration for these figures Magritte himself mentioned only the table legs. But the term "bilboquet" which was later applied to these forms, I can see only as a reference (not meant to be taken literally) to something that falls over and rights itself again. It also indicates an old-fashioned toy, used in the cup-and-ball game – a small wooden ball attached to a cup by a string – metaphorically (see Littré, *Dictionnaire de la langue française*) a thing which always lands on its feet. In addition the term is used for a person lacking stability.[28]

The varied meanings that Hammacher proposes for the *bilboquet* all seem pertinent to Magritte's motivations in selecting this object as a symbol for his mother: like the *bilboquet,* she lacked stability and may have collapsed and righted herself again psychologically many times before her final breakdown; the analogy with the game of ball-and-cup is equally appropriate. As a small child, necessarily involved in her bizarre thoughts and actions, Magritte may have felt like a battered ball in a particularly useless and sadistic game of ball-and-cup.

If the lost jockey symbolizes Magritte himself and the *bilboquet* his mother, the horse probably alludes to his wife, Georgette, the long-ago partner of the carousel ride. In *The Lost Jockey,* then, Magritte por-

79. Magritte, *The Invention of Life*, 1928. Oil on canvas. Private collection, Brussels; © C. Herscovici / ARS, New York.

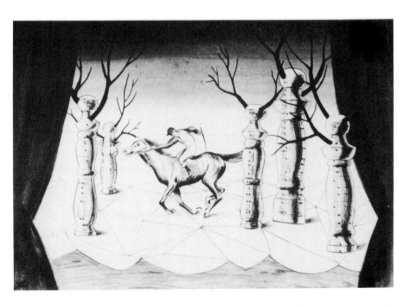

80. Magritte, *The Lost Jockey*, 1926. Collage and gouache on paper. Collection Harry Torczyner, New York; © C. Herscovici / ARS, New York.

trayed himself aided by Georgette as he struggles to escape from the wintry wood of his past, with its ice-mother *bilboquets.*

The jockey motif had so much valence for Magritte that he went on repeating variations on it throughout his career. In a version painted in 1960, just seven years before his death, the artist again portrayed a horse and rider, but this time they attempt to flee from an interior, a room with paintings recalling favorite Magrittian motifs resting against the wall. Only one *bilboquet* appears in this version, standing like a tall sentry at the open doorway, as if threatening to block the rider's exit. Beyond the door one glimpses a wooded grove. As discussed below, the tree was another of Magritte's principal symbols for his mother. This duplication of her symbolism, occurring both inside and out-of-doors, indicates that no haven could offer the artist protection against the internalized image of the mother that accompanied him everywhere throughout his life. Magritte gave this particular canvas a new title, *The Childhood of Icarus,* a name that recalls the fate of the youth whose hubris caused him to suffer death by drowning.

The anthropomorphic *bilboquet* appears as the chief protagonist in two other canvases from 1926, both painted in strong, dark colors and filled with an expressionist tension absent from *The Lost Jockey.* These paintings seem to refer to the period immediately preceding the mother's suicide. *The Birth of the Idol* (Fig. 81) takes place at night during a wild storm at sea. Whitecaps breaking from all sides suggest that the wind blows from the four cardinal points simultaneously. The waves dash against the idol's base, a large platform that floats on the sea like a raft. Above, phosphorescent clouds skitter across the sky, reinforcing the impression of agitation conveyed by the waves. At the rear of the platform, a blind staircase terminates in a precarious parapet overlooking the sea. Just anterior to the stairs, a wood-framed mirror and a large form that resembles a sheet of richly veneered plywood rest against the parapet. This mysterious object, which resembles a discarded leftover from a carpentry project, has several rectangular holes punched in its surface that have been identified by various critics as open doors or windows. Veneered flats of this type reappear in several of Magritte's earliest Surreal compositions and may constitute early references to the mother's wooden quality – an analogy the artist would make more explicit in successive pictures.

Looming up in the right foreground of the picture plane, the idol itself teeters on the neck of the cutout silhouette of a wooden mannequin, which is stretched out on a table with only three visible legs. As if to underscore the *bilboquet*'s helplessness, Magritte has endowed it with a plaster arm that dangles uselessly at its side, attached to its body by a single thread.

Although many details of *The Birth of the Idol* reflect the influence of de Chirico, the high level of anxiety Magritte conveyed in this composition constitutes its fundamental originality.[29] One of his earliest painted

references to his mother's suicide – there would be many others – the work re-creates the sensations of desperation and helplessness that she must have experienced preceding her death. The blind stairs, the holes in the veneer, the dangling arm – all these features symbolize her inability to improve her precarious situation, the latter suggested by the idol's position on that makeshift mannequin-cum-diving board, from which she seems about to be catapulted into the foaming sea.

Since the idol seems in imminent danger of destruction, rather than about to be born, Magritte's title initially appears quite puzzling. This paradox resolves itself when we realize that the artist's process of idealizing his mother – a process expressed much more emphatically in many of the paintings he produced after 1930 – may have been initiated by her death. Her demise as a bizarre mortal, then, may have coincided with her rebirth as an idolized being. The title also suggests references to the myth of the foam-born Venus and the underlying fantasy that the mother might reemerge from the waters of the Sambre as Venus had from the sea, a theme also suggested by *The Garment of Adventure* (1926; Kawamura Memorial Museum of Art, Sakura, Japan), which shows a shapely nude floating down a sand-colored stream in a pod-shaped fabric vessel that resembles a shroud. Like some modern-day female Moses, she seems to await discovery by Pharaoh's daughter. Above her, a gigantic sphargis turtle hovers, a ponderous, airborne guardian, or perhaps, instead – as Sylvester proposes – a representation of the angel of death.[30]

Magritte dealt with the theme of the mother's suicide in another fascinating composition from 1926, *The Difficult Crossing* (Fig. 82). This painting reintroduces variations on the humanized *bilboquet*, blind staircase, and wooden flats with cutouts featured in *The Birth of the Idol*, but in this instance they appear, not on the ocean, but enclosed in a room. The *bilboquet*, equipped with a wild human eye, now stands on the floor, while the nearby tabletop (which has one of its wooden legs replaced by a shapely female limb) holds only a detached classical hand – another de Chirico reference – imprisoning a live, struggling bird. In this composition, Magritte depicted the turbulent sea as a marine painting that fills the back wall of the room. This picture-within-the-picture shows two storm-tossed sailing ships foundering in the wild ocean, the scene illuminated by dramatic flashes of lightning. The larger vessel, apparently on the verge of going down, has rolled over on its side, while the smaller ship, though clearly endangered, remains upright.

Because we confront the agony of the endangered *bilboquet* so directly in *The Birth of the Idol*, this picture initially impresses us as more anxiety-provoking than *The Difficult Crossing*. However, the latter canvas contains pessimistic references to Magritte's own psychological status not present in *Idol*. For it seems likely that the trapped bird of this painting represents not only the mother's *anima*, struggling to free itself from its earthly coils, but also, on another level, the artist himself, locked in the stony prison of his memories. The smaller ship shown in the back-

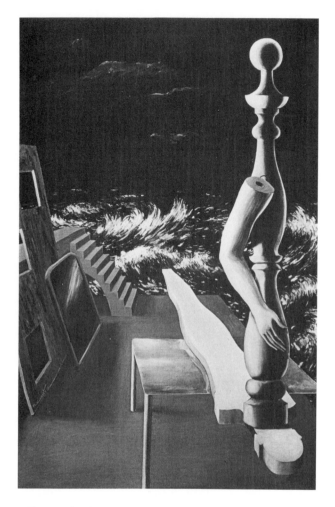

81. Magritte, *The Birth of the Idol,* 1926. Oil on canvas. Sobela, Inc., Montréal; © C. Herscovici / ARS, New York.

ground painting constitutes another apparent self-reference, reflecting Magritte's underlying identification with the mother, an identification directly related to the suicidal preoccupations that haunted him at intervals throughout his life and are discussed in greater detail below.

The predominance of bird imagery in *The Difficult Crossing* links this picture to Magritte's two earliest Surrealist experiments, both painted in 1925, in which similar bird images play predominant roles: *The Window* (private collection) and *Nocturne* (Menil Collection, Houston).[31] The artist himself later called attention to the seminal role *The Window* had played in his artistic evolution: "It was in 1924 [*sic*] that René Magritte painted his first picture. It represented a window seen from an interior.

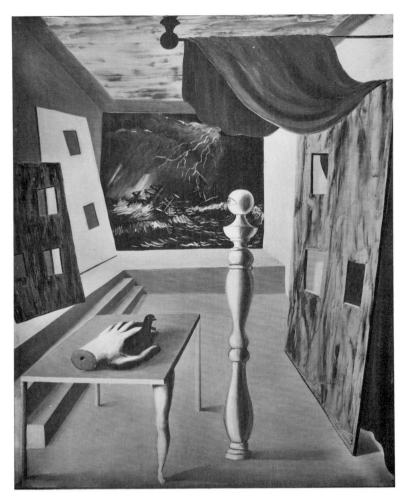

82. Magritte, *The Difficult Crossing*, 1926. Oil on canvas. Private collection, Brussels; © C. Herscovici / New York.

In front of the window, a hand seems to be trying to grasp a flying bird."[32] If the bird's fate remains uncertain in both *The Window* and *The Difficult Crossing*, in *Nocturne* it successfully eludes disaster. Magritte painted one of two almost contemporaneous versions of this composition, a papier collé and an oil, on a reused canvas that had originally depicted either a landscape or seascape, painted by another hand.[33] Magritte salvaged a portion of this composition, converting it into a picture-within-a-picture (the first of many featured in subsequent works) by adding a burning house to the setting and enclosing the modified scene within an inner "frame." He represented a *bilboquet* standing outside this depicted space, connecting it to the latter scene by portraying a bird wing-

189

ing its way from the flaming house to the *bilboquet*. This was the first instance in which Magritte utilized a bird to symbolize the mother's soul or *anima*, here shown fleeing mortal danger, about to animate a *bilboquet*.[34]

Magritte's repeated depiction of the unstable *bilboquet* was far from the only analogy he employed to emphasize both his mother's wooden qualities and her emotional difficulties. In several other canvases from the late 1920s he implicitly compared her to small, rootless trees perched unsteadily on tabletops, as well as to trees that seemingly grow upside-down, crowns pointed earthward. (A frequent variant on the latter motif shows trees that possess two crowns, one in the normal position, one obscuring the lower trunk.) *The Oasis* (1926; private collection) and *The Cultivation of Ideas* (1927; private collection, Brussels) both present rootless trees perched on tabletops. The two trees of the latter picture form a single crown, a device that transforms them into a metaphor for a striding person about to walk off the table. The latter work should be compared with a lost canvas, *The Scent of the Countryside Lures Them On* (1928?), which portrays a bathing-suit-clad woman moving across a sandy beach; like the rootless trees, she seemingly possesses no feet (presumably, they are buried in the sand), and her heavy limbs closely resemble the humanized tree trunks in *The Cultivation of Ideas*.

Magritte continued this analogy between his mother's abnormalities and trees in another group of pictures representing what appear to be sections cut from theatrical flats, painted to simulate forests. These seemingly useless fragments stand, cast shadows, and generally function as though they were live personages. *The Palace of Curtains* (private collection), a work of this genre from 1927, features fragmented flats depicting trees with Magrittian double crowns.[35] Via his repeated use of such devices as these animated flats, stage curtains, and pictures-within-pictures, the artist created a factitious world in which all is theater, and the spectator the audience viewing an enigmatic performance encoding arcane references.

In *The Empty Mask* (1928; National Museum of Wales, Cardiff), one of the pictures featuring words instead of images, the artist explicitly equated the tree with the body, inscribing "corps humain (ou fôret)" – "human body (or forest)" – in the upper-right corner. As Sylvester points out, when the artist subsequently painted two other versions of *The Empty Mask* that feature pictures in place of words, "four of the six images corresponded to the words in the first version: since the words in one quarter presented an alternative ... he made one version with a forest, the other with a female torso."[36]

Discovery (Fig. 83) depicts a beautiful nude as a contemporary Daphne whose flesh changes to wood before our very eyes. In his discussion of this picture, Hammacher emphasizes that despite Magritte's hostility to psychoanalytic interpretations, it seems impossible to ignore the fact that "Freud saw a connection between wood and the idea of the woman, the

190

mother. He referred to the name 'Madeira,' the wooded island, since it means 'wood' and is derived from the words *mater* (mother) and *materia* (material)."[37] Through this picture Magritte seems to have been sharing with his public his repeated childhood experience of watching his mother turn wooden, unresponsive, and uncommunicative, as she withdrew from outer reality into her inner world.

Magritte's insistent repetition of the woman–wood equation reminds one that his earliest childhood memory involved a recollection, as in a vision, of a large wooden chest that had stood enigmatically near his cradle. This recollection appears to have been another screen memory, a mixture of fact and fiction, recall and revery, that encoded his earliest experience of the repeated metamorphoses that his mother suffered when she became wooden and emotionally unavailable, yet simultaneously confining, like a closed chest.[38]

The implicit connection between wood and fire, suggested by the flame-like patterning of the wood graining as it consumes the flesh of the nude in *Discovery*, becomes more explicit in several of the compartmentalized pictures (characterized by seemingly unrelated images separated by painted frames) that Magritte produced beginning in 1928. Thus, *The Six Elements* (1929; Philadelphia Museum of Art) features a nude female torso centered between scenes of flames and trees (the latter with Magrittian double crowns). *On the Threshold of Liberty* (Fig. 84) includes these same images in a larger repertory of eight scenes, which includes a panel simulating wooden planks.

Magritte's fascination with fire continued throughout his career; he frequently depicted objects being consumed by spontaneous combustion, such as the piece of paper, egg, and key in *The Ladder of Fire* (1934; private collection), burning atop a wooden table that remains paradoxically intact. During the 1940s he frequently portrayed a *bilboquet* with a flaming "mouth," evidently the hybrid offspring of a union between his earlier baluster and a plumber's torch.

Fire, with its intense heat and bright colors, connotes not only warmth and comfort, but excitement, danger, and destruction. In associating fire with memories of his mother, could Magritte have been recalling a very different aspect of her behavior than her woodenness – possibly wild outbursts, periods when, without provocation, like objects undergoing spontaneous combustion, she "ignited" into frenzied excitement or rage?[39]

A written statement that Magritte made about trees suggests that he may also have made some deep-level association between the all-consuming character of fire and his mother's disappearance into "thin air":

Pushed from the earth toward the sun, a tree is an image of certain happiness. To perceive this image we must be immobile like a tree. When we are moving, it is the tree that becomes the spectator. It is witness, equally, in the shape of chairs, tables, and doors to the

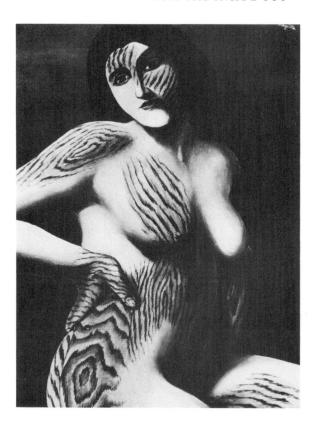

83. Magritte, *Discovery*, 1927. Oil on canvas. Private collection, Brussels;
© C. Herscovici / ARS, New York.

more or less agitated spectacle of our life. The tree, having become
a coffin, disappears into the earth. And when it is transformed into
fire, it vanishes into the air.[40]

Representations of Sadism in Magritte's Early Work

The perversely entitled *Pleasure* (*Girl Eating a Bird*) (Fig. 85), arguably
the most horrifying work Magritte ever created, suggests just how uncon-
trolled the mother's wild outbursts must have been. The canvas depicts a
daintily dressed young girl garbed in proper Belgian lace collar and cuffs.
Her behavior, however, is anything but fastidious: She has just taken a
huge bite from the breast of the living bird she grasps in her hands; its
blood runs down her fingers as she crunches its feathers, bones, and flesh
in her teeth. Meanwhile, several other birds remain perched in the tree
just behind her, seemingly oblivious to the possibility that they may serve

192

84. Magritte, *On the Threshold of Liberty,* 1930. Oil on canvas. Museum Boymans–van Beuningen, Rotterdam; © C. Herscovici / ARS, New York.

as the next course in this grisly meal. Both the girl's costume and her appearance suggest that this image derives from a widely reproduced photograph showing the future Mme Magritte as an adolescent clad in an identical outfit.

The Murderous Sky (1927; Musée National d'Art Moderne, Paris) reads almost like a sequel to *Pleasure:* four dead birds float belly-up in the ether, exposing their mutilated breasts, from which huge chunks have been bitten.[41] Both these canvases portray helpless birds as the victims of a savage predator who, like a wild animal, devours its prey alive. On a symbolic level, this imagery graphically portrays the type of permanent injury that the artist's mother must have inflicted on her sons, wounds that surely left them permanently scarred.[42] His utilization of a photograph of Georgette to star as the antiheroine of this piece demonstrates that, on an unconscious level, his fearfulness, and quasi-paranoid attitudes toward women, played a role in his relationship with his wife,

193

which inevitably took on certain aspects of a mother transference. This attitude is expressed most overtly in *Pleasure*.[43]

Sadism begets sadism, and a number of other canvases from this period reflect the reciprocal rage and murderous impulses that apparently assailed Magritte throughout his childhood. *The Sensational News* (*The Grand News*) (Fig. 86) recapitulates events from the night of the mother's suicide. An adult male humanoid awakens a similar child figure (both characters have knob tops instead of human heads). The child strains forward attentively in bed to listen to the midnight message. In the foreground an open theatrical curtain exposes a shadow box containing the skeleton of a bird. The "grand news" to which the title refers may be the adolescent Magritte's initial sense of relief – it would soon be followed by panic, guilt, and confusion – on learning about the death of his mother, represented here by the skeletal bird in its coffin-like box.

The Comic Spirit (private collection), a gouache from 1927, reveals a "child" murderer about to crush the skull of a sleeping "adult" with an enormous, potato-shaped rock. Perhaps in an effort to blunt the impact of this homicidal message, Magritte portrayed both protagonists as paper lace cutouts (a pseudocollage technique he used in several contemporary canvases; in addition to their other meanings, such images may also parody the fame of Brussels lace). Although it is not clear whether the adult personage in *The Comic Spirit* represents a woman or a man, Magritte later made a statement alluding to his patricidal wishes.[44] *The Comic Spirit*, then, may comment on another aspect of Magritte's tragic childhood: his father's failure either to help his wife or to protect his children adequately against her psychological defects, a failure that may have resulted in the kind of impulses on Magritte's part portrayed in this picture.

The Menaced Assassin or *The Murderer Threatened* (Fig. 87), an unusually large and complex painting from early 1927, recasts the mother's death as a murder rather than a suicide. As Sylvester (who called it the artist's "one narrative picture of consequence") emphasizes, this key work contains prototypes or early examples of many important Magrittian motifs.[45] It is unique in another way as well: It presents past, present, and future pictorial events in a condensed fashion unduplicated in any of Magritte's other paintings. I believe that the central section of the picture, the room that houses the assassin and his victim, symbolizes the pictorial present. The cool, collected assassin, his hat, coat, and valise at the ready, pauses before a gramophone. (Was the murdered woman listening to music in a voluptuous state of nudity when her murderer surprised her?)[46]

The body of the shapely victim rests on a couch behind the murderer; a veil covers her throat, disguising the fact that her head and trunk are out of alignment, presumably because her head has actually been severed from her body. The room gives on a wrought-iron balcony, from which three young men impassively survey the scene. Behind them looms

194

85. Magritte, *Pleasure (Girl Eating a Bird)*, 1927. Oil on canvas. Kunstsamm-lung Nordrhein-Westfalen, Düsseldorf; © C. Herscovici / ARS, New York.

86. Magritte, *The Sensational News (The Grand News)*, 1926. Oil on canvas. Private collection; © C. Herscovici / ARS, New York.

a mountain range (probably based on the slag heaps characteristic of Châtelet); the shape of the predominant peak anticipates the form from which Magritte would later "carve" the stone bird featured in multiple versions of *The Domain of Arnheim*. The appearance of the triplets likewise recalls the fact that the bird in several of the Arnheim paintings hovers above a nest containing three eggs. The many instances of triplet imagery in Magritte's oeuvre must refer to the artist and his two brothers as children. Even though the triplets of the *Assassin* appear in the nominal guise of adults, they witness incidents from their childhoods – in this case, as Magritte seems to have wished to believe, the way in which the father "killed" the mother through cool indifference. (In addition, one wonders whether the father was unfaithful. Waldberg claims that, following Mme Magritte's suicide, her husband formed a series of liaisons – a practice that may well have predated her death.)[47]

In the foreground of *The Menaced Assassin*, bowler-hatted "twins," who represent future time, wait in hiding, apparently planning to trap the murderer as he departs. The twin at the left holds a club shaped like a human limb, while his counterpart carries a heavy net, similar to those used by Roman gladiators.[48] The twins, Magritte's double doppelgängers, represent his punitive wishes toward the father, his desire to expose and eliminate his transgressing parent. Indeed, through his art Magritte succeeded in living out this fantasy, for *The Menaced Assassin* condemns the artist's father as his wife's callous killer, holding him up to the world's censure. Through this device Magritte simultaneously projected his own hostile impulses and underlying guilt toward the dead mother, making explicit that his father (not himself) should be held accountable for her death.[49] The father's culpability, moreover, justified the artist's patricidal fury. *The Menaced Assassin*, then, is not only complex and ambitious; it is also extremely tidy, a painting that permitted Magritte to deny and project his own rage toward the mother, while simultaneously viewing her as an innocent victim, rather than a self-murderer.

Images of Fusion with the Mother

In other works created during his first Surrealist phase, Magritte explored another troubling aspect of his childhood: his sense of oneness with his mother. The vivid imagery in several pictures suggests that the artist may have been involved in a psychological fusion with the mother so profound that he must frequently have experienced difficulty in separating his emotions and reactions from hers. In order to investigate this novel theme, Magritte made clever original adaptations of the Surrealist penchant for producing twin or double images, creating a series of pictures featuring androgynous beings whose ambiguous sexual identity may reflect the fact that Magritte's mother–child merger required him to cross sexual lines.

87. Magritte, *The Menaced Assassin (The Murderer Threatened)*, 1927. Oil on canvas. The Museum of Modern Art, New York; © C. Herscovici / ARS, New York.

He Doesn't Speak or *He Isn't Speaking* (1926; Fig. 88), one of the earliest of these pictures, introduces a new character, a shaven-headed persona whose baldness suggests masculinity but whose delicate facial features seem more feminine. This special alter ego appeared in a number of key paintings through 1931, then disappeared from Magritte's art for good, in contrast to his other doppelgänger, the bowler-hatted man, who remained a fixture in the artist's compositions throughout his career. These bald personages recall figures depicted in the paintings and sculpture of ancient Egypt, a culture whose art especially interested Magritte at the time.

In *He Doesn't Speak,* the bald protagonist, his eyes cast down, his lips tightly closed, appears as a bodiless head floating against a wood-grained, nail-studded ground. The back of his head merges with the forehead of

197

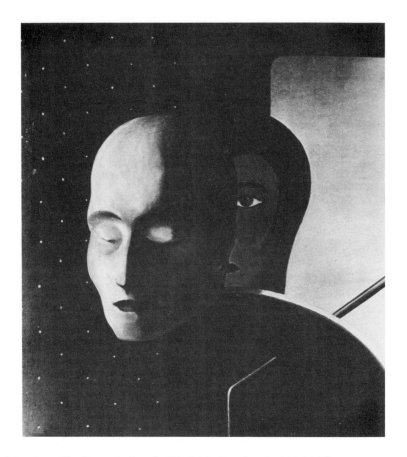

88. Magritte, *He Doesn't Speak (He Isn't Speaking)*, 1926. Oil on canvas.
Private collection; © C. Herscovici /ARS, New York.

his female counterpart, whose single visible eye is wide open, though her
mouth, too, is tightly shut. Like her masculine companion, she resembles
a plaster head more closely than a living person, although she also
recalls contemporary photographs of the artist's wife. (Several years
later, the Magrittes posed for a photograph apparently intended as a send
up of *He Doesn't Speak,* which reversed the male–female positions of
the painting.)

This enigmatic composition suggests that Magritte may have con-
sciously recognized that only his stabilizing relationship with Georgette
permitted him the freedom to "speak" to the world about the intimate
details of his childhood history. He wife became the ventriloquist, as it
were, through whom the artist, here cast in the role of puppet, spoke
without acknowledging that act.

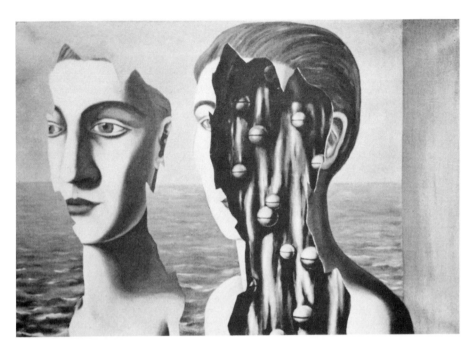

89. *The Secret Double*, 1927. Oil on canvas. Musée d'Art Moderne, Paris;
© C. Herscovici / ARS, New York.

The Secret Double (Fig. 89), from 1927, presents another "plaster"
pair; in fact, it would be more accurate to describe this picture as a repre-
sentation of a single fragmented bust, pictured side-by-side together with
its missing piece. In this instance Magritte has forced us to perform the
work of closure, to reunite the bust with its fragment and form a com-
plete figure once again. Although this androgynous personage has thick
brown hair (closely resembling Magritte's own abundant locks) cut in a
masculine style, the figure's finely shaped lips and arched brows make
the bust read more like an effigy of a young woman with a boyish bob.
The missing fragment reveals that the bust's interior is composed of
grelots clinging to an irregular metallic surface. Here Magritte portrayed
the underlying uncertainty of his sexual identification, as well as his fun-
damental feelings of emptiness. The fragmented state of the bust alludes
not only to his mother's mental disintegration but to his own sensations
of falling apart when her suicide forcibly separated the future artist from
his secret double.

In another variant on this theme, *The End of Contemplation* (1927;
Menil Collection, Houston), the Magrittian twin figures appear as bald,
profile busts, as alike as duplicate reserve heads from an Egyptian tomb.
Both busts have suffered identical mutilation: Their appearance suggests

that a contiguous jagged piece has been hacked or cut away from their lower faces and chests (but the sharp treatment of the saw-toothed broken edges also makes the bust read like cut-paper silhouettes, done violence with a scissors). In this instance, unlike in *The Secret Double,* superimposing the two images would not restore integrity to the figure, any more than Magritte himself could ever completely close over the gaping psychic wounds inflicted by his childhood experiences.

The two celebrated versions of *The Lovers,* both painted in 1928, explore this same motif of fusion (and confusion) with the mother. Both canvases feature virtually identical embracing couples, whose heads are completely veiled. We read one protagonist as male, the other as female, only because the artist suggested this identification by providing glimpses of their sexually differentiated clothing. *La Raison d'être,* a lesser-known gouache from 1928 whose title might be translated as *The Reason for Existence* or *The Justification for Being,* depicts the silhouette of a mannequin in the act of fusing with – or emerging from – a *bilboquet. The Titanic Days* (private collection), painted the same year, offers a much more violent interpretation of a male–female merger, showing a grotesque female nude with heavy limbs and feet struggling against a male figure whose clothed silhouette is entirely contained within her body. Although the artist himself identified this composition as a depiction of rape, it may have encoded another meaning, of which he need not have been aware: the terrible internal struggle against an enforced fusion that threatens to destroy the separate identities of both protagonists.[50] The funereal light and black garb of the male aggressor also support the notion that the picture may simultaneously portray the mother's titanic struggle against Death, who, in the end, will forcibly carry us all off. The latter aspect of this ambiguous work raises an additional question: Did Magritte feel that his mother suicided *because* he was about to succeed in the struggle against fusion and, with the approach of adolescence, liberate himself from her suffocating grasp? In this connection, one recalls that in *On the Threshold of Liberty* (see Fig. 84) from 1930, Magritte included a detailed replica of an actual cannon, with its muzzle aimed right at the compartment containing the effigy of a nude female torso. Although the cannon–nude symbolism has obvious erotic connotations, the very violence of the imagery also suggests the underlying impulse to blow the woman away.

In view of the fact that fantasies of fusion, or merger, with his dead mother remained such a prime characteristic of Magritte's personality structure, it is small wonder that suicidal thoughts and impulses came thick and fast during the first years of Magritte's Surrealist career, the period in which he dealt so openly with extremely disturbing autobiographical material. One of his first meditations of this type, as well as the first composition to feature his bowler-hatted alter ego, *The Musings of a Solitary Walker* (1926; private collection, Brussels), depicts this Magrit-

tian figure strolling beside a river crossed by a distant footbridge. Unbeknownst to the protagonist, a naked female figure (or dummy) floats behind him, the reincarnation of the deceased, yet omnipresent mother, who, like the Lorelei, would forever lure him into the watery depths. The picture's pervasive blue tonalities, relieved only by cold, silvery glimmerings, underline its melancholy character.

The Meaning of Night (Menil Collection, Houston), another eerie, dark canvas from 1927, constitutes the most complex and enigmatic of Magritte's painted references to his self-destructive preoccupations. His bowler-hatted doppelgänger, more mannequin than human, appears twice in this picture, set on the seashore. In one of his incarnations, he faces us, his eyes cast down, his features expressionless. But he – or his twin – is represented again facing the water, as though about to walk into the sea that waits to receive him. Enigmatic, fluffy, fur-like forms dot the beach, bizarre flotsam and jetsam thrown up by the sea. However, these two bowler-hatted gentlemen do not have the beach entirely to themselves. An anthropomorphic furry "sack," poised above the sand, appears to be disgorging a captive woman, whose lacy panties and silk-clad limbs have emerged from this container. But this complex image can also be read as a composite creature, combining a hairy upper body with the lower torso of a woman. This hairy "trunk" possesses two "arms," one in the form of an empty glove (straight out of de Chirico), the other, a pendant limb composed of the same furry material as the sack itself.[51] A third appendage, which can be read either as the creature's tail or as its third arm, reaches out to touch the man facing the water, in a gesture that may be interpreted either as an attempt to comfort – or to urge the protagonist toward his death.

Maybe because Magritte believed that the picture's cartoonish style would belie its grim underlying message, he portrayed his recurring suicidal obsession quite openly in *Check and Mate* (private collection), a gouache from 1926. The action takes place in a small chamber with a checkerboard floor. In a back corner of the room a *bilboquet* careens crazily, as though about to fall; meanwhile, in the right foreground, a young man (represented only as an inordinately large-scale head and arm) raises a pistol to his temple. The implied connection between the endangered status of the *bilboquet* and the young man's desperate action recalls the parallel situation of the two ships in *The Difficult Crossing*.

The Weariness of Life (1927; private collection, Brussels) deals with the artist's suicidal impulses in quite another manner. The picture features two "astronauts"; the more prominent of the pair is represented as an empty, yet seemingly alive, man's suit, which floats off into space from its tabletop launching pad like an inflated balloon. Meanwhile, its companion, a humanoid with a vaguely birdlike head, soars in the opposite direction, extending its abnormally long arms as though diving into

the ether. In this instance, the artist seems to have imagined himself (and his mother?) experiencing a kind of apotheosis in lieu of death. Other motifs, strongly suggestive of such resurrection or ascension fantasies, recur throughout Magritte's oeuvre. To cite just a few examples, *The Vulture's Park* (1926; private collection, Venice) shows a tree growing inside a coffin-like box, while *The Man from the Sea* (1927; Musées Royaux des Beaux-Arts de Belgique, Brussels) portrays a male figure whose stalwart body is surmounted by an incongruous wood-block head. Clad in what appears to be a black, rubber diving suit, he has just emerged from the ocean behind him to assume the pose of the conquering hero.[52] Such motifs probably reflect both Magritte's underlying fantasy that his mother might rise once more from the dead, as well as his corresponding conviction that he might also escape the final destiny that awaits mere mortals.

The Master of Pleasure or *The Master of the Revels* (1926; Fig. 90) might serve as a painted summation of the primary motivating force underlying Magritte's art: his permanently unresolved state of psychic separation from the mother. This composition reintroduces the familiar Magrittian device of the raised theatrical curtain to reveal a corner of a small room. A blind staircase terminating halfway up the back wall of the chamber serves as a ledge that supports a painting. The latter shows a factory or powerhouse situated beside a stream. A "real" rope connects the tall smokestack of this painted building to an "actual" *bilboquet* standing in the room. A tightrope walker makes his perilous way between this *bilboquet* and the painting-within-a-painting. This bizarre little personage's head and torso seem to be composed of two flaming sleigh bells. (Their rounded forms also suggest an underlying reference to the game of ball-and-cup.) Surely this poignant dwarf represents Magritte himself, forever tenuously balanced between his art and his memory, his painting and his past.

The picture's title initially seems ironic; certainly painting such compositions cannot have given the artist pleasure, although the accomplishment probably provided him with a sense of relief. On another level, however, Magritte's ability to make high art from such horrifying dross did demonstrate his mastery over his tragic past. By replicating these events in encoded form in his paintings, he assumed control, forcing us, his viewers, into the role he himself had played during childhood. The canvases of his first Surrealist period present this message with an insistent intensity unmatched in his later oeuvre. Whether this change of style should be attributed primarily to personal, artistic, or practical motivations remains problematical. However, the fact that Magritte was so unusually productive during his first few years as a practicing Surrealist suggests that a gradual mastery of tension may have been an important determinant in effecting this change. Certainly during the 1930s he painted a long series of successful pictures that ultimately gained great popular

90. Magritte, *The Master of Pleasure (The Master of the Revels)*, 1926. Marl-borough International Fine Arts, London; © C. Herscovici / ARS, New York.

approval and secured his artistic reputation. These paintings possess more charm and appeal than many of his canvases of 1925–30, but they sel-dom, if ever, equal the disturbing power he achieved during the fervor of his initial meditations on madness.

8

Homesick and Heartsick

René Magritte's Artistic and Personal Crisis
of the 1940s

B Y the late 1930s, René Magritte had been practicing his unique brand
of Surrealism for well over a decade and had long since perfected his
characteristic manner, combining tightly rendered, smoothly painted fig-
ures and objects depicted in impossible situations or juxtapositions, to
create a vision of the world that violates the laws of nature and the view-
er's sense of reality.[1]

Magritte's artistic effectiveness throughout the 1930s makes his pro-
longed artistic crisis of the 1940s seem all the more unpredictable. How-
ever, as early as December 1941 he was expressing extreme dissatis-
faction with his work and announcing his resolve henceforth to devote
himself to portraying only the beautiful side of life.[2] That resolution bore
strange fruit sixteen months later, when the artist inaugurated his Im-
pressionist, Renoir, or – as he preferred to call it – his "sunlit style." Be-
tween March or April 1943 and the end of 1944, Magritte practiced this
new style almost exclusively; during the three years that followed, he
alternated between this sunlit manner, with its bright colors, bravura
brushwork, and Impressionistic treatment of figure and/or setting, and
his characteristic Magrittian mode.[3] The artist's Impressionist phase was
succeeded by an even more inexplicable development: his short-lived
vache period of 1948, when he produced the most bizarre works of his
entire career. Neither of these atypical styles won favor with the public
or the critics, and most of these pictures were eventually acquired by the
artist's closest friend, the poet Louis Scutenaire, who seems to have been
one of their few partisans at the time. When the Museum of Modern Art
organized its great Magritte retrospective in 1965, it did not include a sin-
gle picture in either style, dismissing the entire problem with a brief
reference to Magritte's Impressionist phase as an unhappy experiment;

about his much more disturbing *vache* pictures, the catalogue maintained a discreet silence.[4]

Why did Magritte persist in these unsuccessful experiments, which he himself allegedly later described as "accursed"? Critics in search of an explanation have cited the artist's reaction to the emotional and physical deprivations of occupied Belgium in World War II as the genesis of his Impressionism, while interpreting his later *vache* paintings as a gesture of defiance toward the French critics and public for what he perceived as a lack of appreciation for his art.[5] Magritte's wartime canvases undoubtedly *do* reflect his reaction to the unpleasant tenor of life during the occupation. As Pablo Picasso noted, even when an artist does not consciously set out to paint an event as horrifying as World War II, it inevitably invades his production.[6] However (after a brief initial panic), Picasso responded to this challenge positively; although many of his wartime paintings reflected a new austerity, he maintained a high level of productivity and effectiveness throughout the occupation years. Magritte's personal history during this period suggests an underlying fragility, which predisposed him to react with disorganization to events that Picasso and other artists accepted with more equanimity.

Exile and Its Consequences

In May 1940, the German armies invaded Belgium. Scoring victory after victory, they rapidly swept toward the capital. Allegedly because of his conviction that he would be persecuted for his limited anti-Nazi activities once the Germans occupied the city, Magritte fled Brussels in advance of the enemy. Accompanied by his closest friends, the Surrealist literary figures Louis Scutenaire, his wife, Irène Hamoir, and the photographer Raoul Übec and the latter's wife, the artist finally arrived in Paris, following an arduous journey made partially on foot. After resting briefly in the French capital, Magritte and the Übecs pushed on to Carcassonne, where they rented a small villa. The Scutenaires briefly joined them there, but soon left for Nice, from which they later made their way back to Brussels.[7]

Magritte's sudden decision to leave Brussels without Georgette at a time when he believed himself – rightly or wrongly – to be in great danger, seems little short of amazing, and flies in the face of all the evidence attesting to their past attachment to one another. Perhaps Mme Magritte's refusal to accompany him was motivated not only by her concern for her older sister, Léontine (the reason sometimes cited), but also by her romantic interest in the poet Paul Colinet, one of her husband's closest friends and a member of the same Surrealist circle in which the artist played a leading role. Magritte, who was painfully aware of this relationship, may have decided to leave, not merely to evade the Germans, but to escape from his uncomfortable domestic situation, while simultaneously teaching Mme Magritte a lesson by absenting himself from home.[8]

Whatever his motivations, the artist soon bitterly regretted leaving Brussels, but his efforts to return were frustrated by the disruption of rail and motor transport attendant upon the German occupation of France and Belgium. After stewing restlessly in Carcassonne for several weeks, he finally decided to attempt the journey on a rented motor scooter. Bidding the Scutenaires and Übecs a dramatic farewell, the artist set off for the faraway Belgian border. To no one's surprise, he reappeared at the Carcassonne villa a few hours later, crestfallen and exhausted. Discouraged by this failure, Magritte engaged in no further vainglorious gestures but stayed put at Carcassonne until he finally succeeded in getting a lift from a Belgian motorist in possession of the documents the occupying German forces demanded from those who wished to cross from France into Belgium.[9]

Once back home, Magritte must have been pleased and relieved to discover that, during his absence, Georgette's association with her paramour had quietly come to an end.[10] In view of Magritte's great devotion to his wife, his prolonged separation from her at a time when the fate of Europe hung in the balance – and perhaps the fate of his marriage as well – must have been extremely painful for the artist. Throughout their marriage, Georgette had always served as his chief inspiration and most important model, and he had produced his first truly original canvases within three years of their 1922 wedding. Hence this creative breakthrough should be attributed not only to the inspiration he derived from the Belgian avant-garde literary figures who introduced him to the seminal example of Georgio de Chirico's paintings, but above all to the healing effects that Mme Magritte exerted on the artist's personality, damaged by the traumatic childhood experiences of living with a mother who suffered from psychotic depressions and eventually committed suicide. (For a more detailed discussion of these issues, see Chapter 7.) Mme Magritte's apparent emphasis on living in an orderly, predictable fashion was probably crucial for Magritte, enabling him to function at his personal and artistic best.)

In the predictable environment that Georgette Magritte provided, the artist could reexperience the more positive aspects of his relationship with his mother, the tender intimacy she sometimes shared with him, the eldest – and perhaps favorite – of her three sons. Magritte's flight alone to Carcassonne rudely interrupted his symbiosis with Georgette, forcibly reminding the artist of the equally abrupt manner in which his mother had forever disappeared from his life. His consequent return to Brussels, and to those aspects of normalcy that the occupation permitted, proved insufficient to restore Magritte's equilibrium completely, and echoes of that disruptive Carcassonne experience reverberated through his art long after the interlude itself had ended, exacerbating the mild depression from which he habitually suffered. (The artist's intimates all concurred in describing him as someone who complained of chronic fatigue, bore-

dom, and vague physical symptoms – all reactions consistent with a constant, low-level depression. This tendency may well have had an hereditary basis; current research strongly suggests that this affective disorder has a genetic component.)[11]

The "Carcassonne effect" made itself felt almost immediately in Magritte's art. Sometime during 1940 – whether before or after his spring flight to France remains unclear – Magritte painted a reprise of his 1926 picture *The Lost Jockey* (see Fig. 80).[12] Earlier, this composition had played a crucial role in his artistic evolution; during 1926, he had created three separate versions of this motif, which he later identified as the first in which he found his (Surrealist) way. Although his 1940 version of the composition seems more polished and assured, it does not differ essentially from those he had created fourteen years earlier. All four compositions depict the jockey as he frantically urges his galloping mount to take flight. But flight is impossible; the rider seems frozen in place, and even if he should succeed in moving, a cluster of gigantic balusters or *bilboquets* blocks his way. These anthropoid creatures, evidently originally inspired by some perfectly ordinary prototype, such as a turned wooden table leg or a chess piece, recur in painting after painting throughout Magritte's career. In Chapter 7, I have presented the visual and psychological evidence indicating that these *bilboquets* symbolized his mother, while the hapless jockey represented Magritte himself, reenacting his unending – but doomed – struggle to flee the enmeshing memories of childhood that threatened constantly to envelop him. It seems entirely appropriate that he should have repeated this composition shortly before – or after – the crucial flight into exile that would threaten him with the loss of the way he had found long before.

While at Carcassonne, Magritte completed *The Wedding Breakfast* (Fig. 91), a gouache that reintroduced a second character from his earlier art: the noble male lion that had starred in *The Traveler* (1933), and *Youth Illustrated* (1937; Edward James Foundation, West Dean, Sussex), both pictures in which the artist had consciously alluded to his own earlier history via symbols intimately associated with his past. By contrast, the autobiographical content of *The Wedding Breakfast* deals with Magritte's actual situation at the time he made the painting.

The Wedding Breakfast depicts its leonine hero in a relaxed but alert state, staring out at the viewer as he reclines on the floor of a room furnished only with a table covered with a white cloth, on which rests a single egg in an egg cup. As several critics have proposed, the lion probably symbolizes its counterpart on the Belgian coat of arms; but on another level it surely represents the artist himself, the leading painter of Belgium, depicted in lonely exile, far from his royal haunts.

Characteristically, Magritte arrived at the picture's title only after considerable indecision; his first thought had been to call it *The Voyage*, in an obvious reference to his own recent travels.[13] His titles invariably

have ironic connotations, and that is doubly true in the case of *The Wedding Breakfast*. Far from being the joyful bridegroom about to celebrate his nuptial feast, the artist was in actuality the troubled husband, starved for signs of his wife's continuing loyalty and affection, and fearful that this relationship, which had been so crucial to his continued emotional well-being, was about to dissolve.

Central elements of Magritte's personal artistic vocabulary, representations of birds and eggs were often used to encode references to his family of origin and early childhood memories.[14] It seems likely that the lone egg featured in *The Wedding Breakfast* again alludes to memories from his past. However, the egg also memorializes recent incidents that Magritte had experienced during his self-imposed exile. As they fled from Belgium into France during the spring of 1940, Magritte and his companions were often forced to make their way on foot when they failed to obtain rides from passing vehicles. As they trudged through the countryside, the artist would frequently stop at wayside farms to purchase eggs. While his companions watched disapprovingly, he devoured these eggs raw, piercing a hole in the shell through which he sucked the contents. He justified his behavior by claiming that long-distance bicyclists also sucked raw eggs to keep up their strength during marathons. Several weeks later, when he made his abortive attempt to flee Carcassonne via motor scooter, he carried along a dozen eggs to sustain him on the road.[15] This peculiar, ritualistic behavior, with its obvious regressive implications, suggests that Magritte's decision to flee to Carcassonne without his beloved Georgette had forcefully recalled to the artist painful memories of the equally abrupt – and eternal – separation from his mother occasioned by her suicide. That tragedy had temporarily shattered the future artist's fragile psychological balance, leading to bizarre, ritualistic behaviors (summarized in Chapter 7) that may well have reflected an underlying psychotic process. Although Magritte's emotional equilibrium was threatened in 1940, as it had been following his mother's death, as an adult artist at the height of his power, he possessed a powerful weapon that had not been available to him as a bereaved adolescent: his creativity. Rather than collapsing into the state of captive impotence in which he portrayed his leonine alter ego, the artist acted decisively, using his artistic skills to transcend his psychological distress while graphically portraying it.

Magritte reintroduced the male lion protagonist in another of his pictures from 1940, the poignant gouache that he finally decided to call *Le Mal du pays,* or *Homesickness* (Fig. 92). The lion again assumes his characteristic Magrittian pose, reclining with his head held high and his left forepaw turned upward to expose the pad. This time he appears not in an enclosed room but on the stone paving of a bridge with a low parapet. Behind him a winged man, rather incongruously garbed in a contemporary business suit, leans over the railing, meditatively studying the mist-

91. René Magritte, *The Wedding Breakfast*, 1940. Gouache. Private collection;
© C. Herscovici / ARS, New York.

enshrouded city surrounding him, its structures obscured by the salmon-pink vapor enveloping them. The artist also executed another, larger version of this motif in oil. Supposedly, he left this canvas unfinished on his easel at the time of his flight into France. If that information is correct, the gouache – which seems more tentative than the oil version – may have been painted a few weeks earlier. However, Magritte did not complete the oil-painted version until early in 1941, and – unless the imminent publication of the relevant volume of the catalogue raisonné disproves this hypothesis – it seems more logical to assume that it was actually the gouache, rather than the oil version of *Homesickness,* that was in process at the time of Magritte's flight.[16]

In any case, the fact that Magritte endowed his protagonist with wings reveals clearly enough that this picture is intimately associated with his Carcassonne interlude one way or the other. As Suzi Gablik proposes, references to the captive condition of Belgium and nostalgia for lost personal freedom seem quite explicit.[17] *La Mal du pays,* after all, can also mean "the country's misfortune," but the setting, title, and other-worldly quality of this painting suggest that far more private, personal associations underlay these rather obvious allusions. A number of Magritte's

works from the late 1920s indicate that he was often preoccupied with suicide during those years. The child of a suicide always remains at risk himself, and Magritte was evidently no exception.[18] In *Homesickness*, the artist portrayed himself as a black-winged Icarus figure brooding at the parapet of a bridge – a setting recalling the fact that, twenty-eight years earlier, his mother had plunged to her death from a similar bridge spanning the Sambre.

Magritte's dark mood persisted long after his return to Georgette and Brussels, and numerous paintings from 1941–2, such as *The Plain of the Air* (1941; private collection), graphically reflect the artist's anxious broodings. In this canvas, a single dark leaf-tree (in Magritte's world, a tree-sized leaf frequently replaces the parent plant) dominates the horizon; springing from the arid soil of a rocky mountain top, it appears silhouetted against an agitated sky, painted with exquisite light effects. Bleakness and desolation prevail; the weather seems unsettled and threatening.

Evidently well aware that his despondency was infecting his art, Magritte wrote his friend the poet Paul Éluard on December 4, 1941, noting that his depression ("crise de fatigue") had nearly ended – but then adding in a parenthetical aside, "*It will never finish, I believe.*" To counter this pessimistic mood, Magritte proposed to replace the "poetic disquiet" that had always characterized his Surrealism with an emphasis on the beautiful side of life. By that, he wrote, he meant "all the traditional paraphernalia of charming things: women, flowers, birds, trees, the atmosphere of happiness.... In summary, it is pleasure that suppresses a series of preoccupations that I want to ignore more and more."[19]

In practice, Magritte evidently found these grim preoccupations difficult to disregard, and his intention to paint only the beautiful side of life almost impossible to achieve. Indeed, as Sylvester points out, many of the artist's 1941–2 paintings convey an ominous mood.[20] For example, in 1942 he executed yet another reprise of *The Lost Jockey* (Fig. 93), one that constitutes a silent measure of the extent to which his despondency had exacerbated during the two-year interval separating this picture from the 1940 version. This time the action unfolds in a barren, wintery landscape with a luminous, mauve-tinted sky; enormous leaf-trees, stripped of all their chlorophyllose fleshy material, stand like silent skeletons, punctuating the snowy plain that the desperate rider (who seems as rooted in place as the trees themselves) must traverse.

Deep Waters (private collection), from these same months, exudes an even more ominous atmosphere. Like so many Magrittian compositions, this canvas situates its protagonists on a terrace overlooking the sea. There we encounter a black-garbed woman accompanied by an enormous raven who perches on a tree stump. On closer inspection, we realize that this female figure is not the representation of a real human being at all, but that of a fabricated dummy, with a plaster head attached to an equally inanimate, stuffed body.[21] Her lifelessness not only recalls the

210

92. Magritte, *Homesickness*, 1940. Gouache. Courtesy The Art Institute of Chicago, Gift of Mr. and Mrs. Leigh B. Block; © C. Herscovici / ARS, New York.

death of Magritte's mother – as does the allusion to the "deep waters" of the title – but also the death-in-life state of depressive withdrawal she surely suffered before her suicide, rendering her as emotionally unavailable as a department-store dummy – a state that Magritte may have feared was now overcoming him as well. Although he frequently portrayed birds, he most often represented doves or eagles; in this instance, the raven probably refers to the narrative poem of the same name by his favorite author, Edgar Allan Poe. Like the doomed hero of the Poe poem, Magritte evidently felt destined to live forever with terrible memories and fears gnawing at his heart.

Sunshine and Shadow: Magritte's Impressionist Style

In an evident effort to inspire himself to think pleasant thoughts and paint joyous pictures, Magritte began studying reproductions of Impressionist masterpieces, and by early 1943 he was painting his first pictures in his Impressionistic or solar style. In the process, he replaced his precise renditions and cool colors with a more pronounced facture and vivid jewel tones.

Magritte always claimed that his sunlit style involved an amalgamation of ideas drawn from Monet, Seurat, and others, as well as from Renoir. Nonetheless, most critics have identified the latter artist as the principal inspiration for Magritte's Impressionism.[22] Certainly, among the artists Magritte mentioned, only Renoir shared his dedication to portraying the female nude, and a number of the Belgian artist's paintings of bathers from the 1940s seemingly derive directly from prototypes created by the French master. Moreover, Renoir had reacted with stronger feelings of self-doubt than had any of his peers to the crisis that swept Impressionism around the end of the 1870s, a fact that may also have encouraged Magritte to identify with him. Convinced that he lacked discipline and draftsmanship, Renoir sacrificed color to form, producing a series of tightly contoured figurative works that scarcely rank among his most successful canvases. In many instances, he also placed carefully modeled nudes in more freely treated landscape settings, a practice that led Pissarro to criticize such compositions because the figures appear as separate entities within them.[23]

To combat *his* crisis, Magritte reversed Renoir's remedy, favoring loosely painted compositions in place of his earlier crisp style. But sometimes, like Renoir in his "needle-like" phase, Magritte set a more tightly contoured figure, such as his *Olympia* (1947; Collection René Withofs, Brussels) in a more impressionistic background – a practice that produced the same discordances in these canvases that Pissarro had noted with respect to Renoir.

In spite of the many parallels one can draw between these artists, no two individuals appear to have been more unlike in their basic attitudes

93. Magritte, *The Lost Jockey,* 1942. Oil on canvas. Private collection;
© C. Herscovici / ARS, New York.

and temperaments than Magritte and Renoir, and the fact that the Belgian master should have chosen the great Impressionist as a figure to idealize seems truly amazing. Sensitive, emotional, joyously committed to his art, Renoir painted with a passion that reflects itself equally in the beauty of his sun-drenched landscapes and the radiant flesh of his bountiful nudes. Magritte, by contrast, constantly strove for – and frequently attained – an ironic detachment or distance from his subjects. As René Passeron has observed, the artist dwelt in a universe of coldness.[24] It is that world that Magritte's paintings conjure up for us – a world in which death reigns and where marble women, staring from blank eyes, alternate as protagonists with identical, robot-like men, all clad in the same bowler hats and dark overcoats, as though cloned by some futuristic machine. No wonder Magritte identified so ambivalently with Renoir, to arrive at a style that simultaneously honored and ridiculed the older master! This element of parody becomes particularly apparent in paintings that closely mirror Renoir's prototypes. For example, Magritte evidently derived the reclining nude depicted in *The Treatise on Light* (1943; George Tranchant, Paris) directly from the central figure in Renoir's 1918 *Bathers;* but in the process Magritte transformed her into a creature of parrotlike brilliance, painting each of her limbs, her torso, and

her head a different vivid hue. *Oceanus* (1943; Fig. 94), recalls the pose of Renoir's *Young Shepherd in Repose* (1911; Museum of Art, Rhode Island School of Design), but parodies that composition by showing the water god staring in fascination at his own erect penis, portrayed as a tiny female nude.[25]

The autoerotic element notable in *Oceanus* recurs in a number of Magritte's other solar-style compositions, such as *The Age of Pleasure* (1946; private collection), depicting a blond nude clasping an enormous *bilboquet* while simultaneously stimulating her own breast.[26] (Note that Magritte portrayed her with a toad clinging to her tresses, as if she were a medieval symbol of lust.) Such preoccupations suggest that the artist was undergoing a kind of emotional regression, a psychological sinking back to a more elementary level, an attitude expressed much more blatantly in *The Happy Life* (1944; private collection). Here the female nude appears suspended from a tree, encased in a giant, transparent bubble, curled up like a fetus in the placenta, still connected to the mother tree by an unbroken umbilical cord. The provocative title reveals all: The parasitic existence of the fetus, nourished and insulated by the mother's body, protected from environmental stress, provides the human being's only period of pure happiness and security.

Revelations such as those provided by *The Happy Life* suggest that the artist's autocritical abilities were weakening, an assumption reinforced by the rather flaccid, unattractive character of his facture in so many of these Impressionistic pictures. The secret of Magritte's earlier artistic successes lay in his ability to depict with seeming objectivity the viewer's deep-level anxieties and uncertainties. In such compositions, he assumes a mastery that we, his spectators, do not share. As the adult artist, he was in command of situations that had puzzled and terrified him as a child; now he puzzles and terrifies his audience instead. Because we share his anxiety without knowing its cause, his Surrealist masterpieces continue to captivate us. But during his Impressionist years, Magritte turned into by-paths so private that they failed to engage his former public. To many observers, these pictures, which no longer displayed Magritte's typical illustrationist convincingness, seemed merely uninteresting, indifferently executed works. Scutenaire's ability to appreciate both these pictures and Magritte's later *vache* creations suggests that he could empathize and resonate with his artist friend at a level of intensity few of Magritte's contemporaries could match.

Nor did the pictures that the artist continued intermittently to execute in his old Magrittian manner, as opposed to his solar style, always reflect the same high level of excellence he had demonstrated earlier. From this period dates the acceleration of his habit of making numerous replicas – slightly varied copies – of important compositions, replicas that seem to add little either to the impact of the first versions or to the artist's ultimate reputation.[27]

94. Magritte, *Oceanus,* 1943. Oil on canvas. Private collection; © C. Herscovici / ARS, New York.

In 1947, Magritte painted *The Liberator* (Fig. 95), a variation on a theme he had originated a decade earlier as *The Healer.* The late psychoanalyst Martha Wolfenstein perceptively interprets this earlier version as Magritte's implicit confession of his internal sensations of death-like emptiness.[28] *The Liberator* reinforces that impression, depicting a humanoid whose head and torso consist only of a stone slab decorated with cutout silhouettes of Magrittian symbols. Beside the figure rests the suitcase that had originally appeared in an early picture widely interpreted as a symbolic reference to the artist's dead mother: *The Central Story* (1928; private collection, Brussels). The humanoid protagonist of *The Liberator* holds in his hand a jeweled object shaped like the monstrance in which the consecrated host is displayed in certain Roman Catholic services. Here, instead, it enshrines a woman's eyes and lips, outlined in pearls. In this picture Magritte once again shares with us his inner feelings of desperation and deadness, the terrible baggage that he was condemned to drag through life, along with the idealized relics of his mother, encased in the jeweled setting of his art. Clearly, the liberation of Europe had failed to liberate Magritte from his personal demons, and he must have

215

concluded that desperate measures would be needed to fend off a further exacerbation of his depression.

Disorder as Style: Magritte's Vache Phase

During the late winter of 1947–8, the artist suddenly found a way out of this emotional morass. Exhilarated by the prospect of his first one-man exhibition in Paris, to be held the following spring, Magritte magically sloughed off his depression and entered a period that his friend Scutenaire aptly designated one of "flashing freedom."[29] Determined to scandalize – rather than enchant – the Parisians, as a kind of punishment for their previous neglect of his role in European Surrealism, Magritte rapidly executed a completely new crop of pictures intended to register as a painted slap in the face to the smug French art-going public.[30]

Magritte prepared for the exhibition in a state of elation; Scutenaire later recalled that he had rarely seen the artist so happy as during the first few months of 1948: "The vigor and rapidity of his work corresponded to the virulence of his subjects. As soon as an idea came to him, Magritte ran to the corner grocer to telephone a friend and joyously described the project to him, and half-an-hour later [he would call again to] announce in triumph, 'It's done.'"[31] In retrospect, Magritte christened these pictures his *vache* paintings, using a word that carries special connotations in French transcending its literal meaning as "cow" to indicate that something is bad, ugly, or vulgar. He apparently selected this title to ridicule French art of the Fauve epoch, an early-twentieth-century style that had by that time entered the sacred annals of art history.

The reception that the French public and critics accorded the artist's *vache* pictures more than satisfied Magritte's desire to shock. The Surrealists were critical, while even such a close friend as Éluard admitted that he would not like to hang any of these pictures on his walls, but preferred the Magrittes of old.[32] The loyal Scutenaire retaliated by composing a mock biography recreating the artist's life in a style allegedly designed to please the Parisians but really designed to mock them. Virtually the only fan of Magritte's *vache* works, the poet also invented the titles for a number of them.[33]

Evidently intended to be both vulgar and funny, Magritte's *vache* pictures instead impressed most viewers as bizarre and shocking. Executed in a broad style similar to that of early comic strips, broadly painted in strident colors that parody the Fauve palette, these pictures, which unabashedly depict the most basic oral and erotic fantasies, often seem as deliberately primitive in content as in execution. For instance, *Famine* (private collection, Brussels) shows five broadly sketched, caricatural male heads with exaggerated, turgid, phallic noses, furiously engaged in biting one another in a cannibalistic frenzy that includes a particularly sadistic variation on fellatio. Another work from these weeks, *The Cripple* (private collection, Brussels), represents an unkempt, hirsute man

95. Magritte, *The Liberator*, 1947. Oil on canvas. Los Angeles County Museum of Art, gift of William Copley; © C. Herscovici / ARS, New York.

with briar pipes sprouting from his forehead, eyeglasses, and mustache, in addition to the four he holds in his mouth.

Magritte carried the notion of the body sprouting bizarre metamorphic "growths" still further in *Pictorial Content* (whereabouts unknown) and *Titania*. The former canvas depicts a yellow-faced man with three birds' heads sprouting from his own, while one of his hips transforms itself into a male profile, and his clothing melts into bright-colored pools at his feet. Despite his fatuous grin, the hero of this piece seems bent on homicide, for he holds a smoking pistol in his right hand, while the thumb and fingers of his left assume dagger-like shapes. *Titania* (Fig. 96) stars a seated nude painted in a mélange of brilliant colors; crazy, caricature faces erupt all over her body, while disembodied eyes and an enormous arm and hand appear in the background.[34]

Near the end of his *vache* phase, the artist painted two larger canvases in a more careful style, *Lola de Valence* (private collection, Brussels) and *The Pebble* (Musées Royaux des Beaux-Art de Belgique, Brussels). Their more characteristic Magrittian appearance probably accounts for the fact that they have been the most frequently reproduced of the works from this period. *The Pebble* again deals with the theme of autoeroticism, showing a female nude simultaneously licking her shoulder and stimulating her nipple.

On the face of it, Magritte's behavior during his *vache* phase seems almost inexplicable. That he should have offered this body of work to the art-going public of 1948 – even as a gesture of defiance – reflects a severe disturbance in judgment. His obvious disappointment regarding the overwhelmingly negative response these pictures evoked reflects his failure to realize how disturbing others would find them. Today's art connoisseurs, accustomed to works featuring quirky (or even psychotic) imagery and explicit sexual references, will no doubt find Magritte's *vache* pictures more acceptable than did the generation of gallerygoers for whom he created these works.[35] It is true that the oeuvre of the contemporary Surrealists, with whom the French art world was thoroughly familiar by 1948, also represented bizarre forms replete with erotic references. However, these features were typically cloaked in a veneer of elegance, sophistication, and subtlety that Magritte (whose previous work had shown these same characteristics) now rejected, to confront his viewers with pictures as deliberately crude in execution as in content.

Magritte's sudden artistic transformation, as well as the concurrent decline of his autocritical abilities, can be comprehended only if one realizes that he must have been suffering from a mild manic episode when he created his *vache* opus.[36] The opportunity to obtain the overdue recognition that the French art world had hitherto withheld apparently jolted Magritte out of his chronic depression and into manic excitement. Descriptions of his behavior during the creation of these paintings seem congruent with the characteristics of individuals in the throes of such an

96. Magritte, *Titania,* 1948. Gouache and pencil on paper. Private collection, Brussels; © C. Herscovici / ARS, New York.

attack.[37] The artist's uncharacteristic cheerfulness, accelerated productivity, and racy vulgarity are all classic attributes of manic personalities.[38] During acute episodes, the manic's intellectual and social controls unravel, revealing shocking ideas and fantasies previously repressed – or at least suppressed.

It was probably during this interval that Magritte executed an untitled drawing showing a man "smoking" his own nose – the latter transformed into a turgid penis and testes, stuffed into a pipe held in his mouth (Fig. 97). This sketch provides a key to the meaning encoded in one of the artist's most popular – and most frequently repeated – compositions, the representation of a briar pipe with the inscription below it, "Ceci n'est pas une pipe." [39]

Coda: Submission and Constriction

Despite – or perhaps because of – the humiliating defeat he had suffered at the hands of the French art world, Magritte defiantly expressed his wish to continue his *vache* experiments, adding by way of explanation: "It's my tendency – slow suicide." Fortunately, his wife intervened, dissuading him from continuing on this disastrous path. By insisting on her preference for "the well-made pictures of yore," a preference to which the artist yielded "especially to please her," Mme Magritte demonstrated once again the constructive influence that she probably exerted throughout her husband's career in countless unrecorded incidents.[40]

But Magritte achieved this submission at considerable cost to himself, and one of his relatively few major late pictorial inventions, *The Empire of Light* (*The Dominion of Light*), suggests the internal state of mild, resigned depression that probably characterized the artist's psychological life during his final two decades. He began working on the first version of this motif in late 1948, but abandoned it unfinished, and did not succeed in completing his prototypical rendition until the following year.[41] Between 1949 and 1967, he created no fewer than sixteen oil and ten gouache variations on this theme, and he left yet another version incomplete at the time of his death in 1967.[42]

These paintings typically represent night and day coexisting in a single time and place. The setting, a middle-class residential area, presumably resembled the Brussels neighborhood where the artist himself dwelt. At street level, darkness and silence prevail; it is deepest night; no one is visible, and only the gleam of an occasional artificial light in an interior testifies to the continued presence of the area's inhabitants. By contrast, the brilliant sky is ablaze with the light of a summer afternoon, and myriads of puffy little clouds skitter across the heavens.

This composition, with its depiction of the simultaneous existence of daylight and darkness in the same area, reads almost like a visualization of the artist's own cyclothymic personality and his rapid alternation during late 1947 from dark depression to bright euphoria. (As I noted earlier, Magritte's imagery suggests that he perceived his mother as a fellow cyclothymic personality.) In his many variations on this motif, Magritte typically represented the earthly level that we all inhabit as the realm of darkness; the kingdom of light remains the property of heaven, beyond the grasp of the artist and his public alike.[43] This characteristic placement of dark–light suggests that these paintings encode another home truth about bipolar disorders: No matter how elated the victim appears at the height of a manic phase, the underlying depression continues to operate below the surface, a never-healing lesion that eventually eats through the manic overlay, once again forcing its way to a decisive position with regard to behavior regulation. Until recent medical advances provided help through drug therapy, such people usually obtained relief only through death – a fact that explains why suicides occurred so fre-

97. Magritte, *Untitled Drawing,* undated. Ink on paper. Private collection;
© C. Herscovici / ARS, New York.

quently with this group. The artist's conduct during his *vache* mania re-
flected such a self-destructive impulse: As he wryly observed at the time,
it revealed his suicidal tendency.

Not only Magritte's subject matter but the formal character of his
post-*vache* production reflected his concurrent constriction and depres-
sion. During the latter part of 1948, he introduced his last important sty-
listic innovation, his so-called stone-age manner. Throughout his career,
Magritte had been fascinated with depicting rocks and boulders, and rep-
resentations of stone reliefs and the like played an increasing role in his
visual imagery during the 1940s. But it was not until after his *vache* peri-
od that he conceived the notion of depicting an entire universe in petrifi-
cation. As Hammacher perceptively observes, Magritte's stone-age com-
positions seemingly portray a disaster that has occurred suddenly – such
as that which struck Pompeii – rather than a process with a more gradu-
al, insidious development.[44]

The quantitative importance of this style in Magritte's late oeuvre sug-
gests that it mirrored his final interior state, reflecting the idea that he had

221

98. Magritte, *Song of Love*, 1950–1. Oil on canvas. Museum of Contemporary Art, Chicago, gift of Joseph and Joy Shapiro; © C. Herscovici / ARS, New York.

reintegrated after the stressful decade of the 1940s only at the cost of suffering a certain permanent constriction, a congealing of his inner life. Subjectively, he probably experienced this process as an internal stoniness, not unlike the wooden quality he had so often imputed to his mother. In one of his most successful stone-age canvases, *The Song of Love* (1950–1; Fig. 98), the painter depicted two androgynous creatures huddled together on the seashore. Neither fish nor human, men nor women, they represent a pair of metamorphic misfits, fish out of water clinging together. In this canvas, does the artist portray his mother and himself isolated together in their unfortunate joint heredity?

That Magritte himself connected the genesis of his constriction with his 1940 flight to France is suggested by one of his most frequent stone-age compositions. He called his variations on this motif *Memory of a Journey* (sometimes followed by a Roman numeral); these canvases typically represent the interior of a room strikingly similar to that featured in the gouache he had painted at Carcassonne, *The Wedding Breakfast* (Fig. 91), except that now the room and its contents have turned to stone. In his 1955 interpretation of the *Memory of a Journey* (Fig. 99), Magritte

99. Magritte, *Memory of a Journey,* 1955. Oil on canvas. Museum of Modern Art, New York, gift of D. and J. de Menil, 1959; © C. Herscovici / ARS, New York.

100. Magritte, *The Flavor of Tears,* 1948. Gouache. Collection Joseph and Joy Shapiro; © C. Herscovici / ARS, New York.

even reintroduced one of the protagonists from the 1940 composition, the noble male lion, presented once again in his reclining pose, but now petrified and accompanied by an equally stony companion, a man in an old-fashioned frock coat. On the wall behind this pair, a painting-within-the-painting shows a ruined, abandoned medieval tower, rent by a tremendous crack. On a symbolic level, the tower seems to represent the artist himself, still erect though terribly damaged by his recent experiences.

But if the artist emerged permanently scarred psychologically by his crises of the 1940s, he nevertheless resolutely maintained his productivi-

224

ty until the very end of his life. If his output during his final two decades added little to his luster, neither did he descend to the level of self-parody practiced by the aged Salvador Dali or by Magritte's first idol, de Chirico. *The Flavor of Tears* (1948; Fig. 100), one of the most poignant and beautiful of the artist's many paintings depicting the metamorphosis of a plant leaf into a bird, may be read as a visualization of his characteristic inner state during his final decades. A sorrowful, lone leaf-bird grows in isolation at the edge of an abyss; with its head bowed in submission like that of Christ before his tormentors, the bird passively submits to the depredations of a caterpillar that devours its flesh. Only a single tear spilling from the bird's closed eye reveals its internal anguish. Like his leaf-bird Magritte endured until the very end, even though the worms of depression continually gnawed at his vitals. Thanks to his great artistic talent, he was largely successful in combatting his constitutional heritage, avoiding the tragic destiny to which his genetic makeup and his mother's example predisposed him.

Notes

Preface

1. The term *artwriting* comes from David Carrier, *Principles of Art History Writing* (University Park, Pa., 1991).
2. For an excellent popular summary of the state of brain research, see the five-part series by Ronald Kotulak, "Unlocking the Mind," *Chicago Tribune,* April 11–15, 1993.
3. See Theodore Reff, *Manet and Modern Paris: One Hundred Paintings, Drawings, Prints, and Photographs by Manet and His Contemporaries,* exh. cat. (Washington, D.C., & Chicago, 1982), no. 24, p. 88.
4. See Mary M. Gedo, "The Meaning of Artistic Form and the Promise of the Psychoanalytic Method," in *Art Criticism* 2, no. 3 (Fall 1986), pp. 1–16.
5. For a further discussion of these issues, using Goya's life-threatening illness of 1792–3 as the example, see John E. Gedo and Mary M. Gedo, "The Healing Power of Art: Goya as His Own Physician," in *Perspectives on Creativity: The Biographical Method* (Norwood, N.J.: Ablex Publishing Corp., 1992), pp. 26–82.
6. Dr. Allan Burke, a Chicago-based neurologist noted for his diagnostic acumen, acted as an enthusiastic participant on the Manet project. In my experience, medical specialists have invariably been more than willing to contribute their time and expertise to such quests.
7. See Mary M. Gedo, "Looking at Art from the Empathic Viewpoint," in *Empathy,* 2 vols., ed. Joseph Lichtenberg, Melvin Bornstein, and Donald Silver (Hillsdale, N.J., 1984), vol. 2, pp. 267–301.
8. For a provocative discussion of this problem, see Carrier, "Manet and His Interpreters," *Art History* 8:3 (Sept. 1985), pp. 320–35. After reviewing the interpretative approaches of the leading Manet scholars, Carrier points out that: "Each account imagines an implied artist.... Concluding, then, that every interpretation is partly personal and probably revisable might seem an uncontroversial summary of my evidence. But none of the major critics admits as much" (pp. 326–8). I agree completely with Carrier's conclusions, although I would add the proviso that what is denied in public may be admitted in private. I have been privy to some amazing "off the

record" confessions from leading authorities concerning the personal significance of their "special" artists for their investigators.

9. Although the essay included in this collection does not specifically address that issue, Paul Gauguin's character and career were profoundly influenced by his double parent loss: He was 16 months old when his father died, and he lost his mother when he was just 19 years of age.

10. For example, I was so sensitive to the misogynist "image magic" with which Picasso infused his *Demoiselles d'Avignon* that several years passed before I succeeded in forcing myself to address this awesome work, a confrontation recorded in Chapter 5 of this volume.

1. *Final Reflections:* A Bar at the Folies-Bergère *as Manet's Adieu to Art and Life*

My neurological consultant, Dr. Allan M. Burke, provided me with copious information on diseases of the central nervous system and on the status of medical knowledge regarding such conditions in the late nineteenth century; all the scientific references in my text were supplied by Dr. Burke. Prof. William Conger put his expertise as to the laws of perspective into practice to help me resolve the visual puzzle presented by the *Bar*. He made the three drawings reproduced as Figs. 10, 12, and 15, and composed the accompanying key for the latter sketch (see the Appendix).

Thanks also to Steven Z. Levine, who graciously sent me, in advance of its publication, a copy of his essay devoted to Manet's *Bar at the Folies-Bergère.*

1. Many authors have described Suzon's figure as iconic, monumental, magisterial, and aloof, without specifically identifying her as a deity. According to Françoise Cachin, the absolute frontality of Suzon's pose suggested to W. Hofman analogies with an antique deity. See F. Cachin, in F. Cachin and C. Moffett, with M. Melat, *Manet: 1830–1883,* exh. cat. (New York, 1983), no. 211, p. 479. For an implicit identification of the barmaid as a divine figure, see C. Lloyd (as in n. 7).

One could cite numerous identifications of Suzon as a prostitute, but for a particularly extreme interpretation of this type, see J. Gilbert-Rolfe, "Edouard Manet and the Pleasure Problematic," *Arts* 62 (Feb. 1988), pp. 40–3.

For Suzon as "an icon of a new society," see Kathleen Adler, *Manet* (New York, 1986), p. 227. For the barmaid as an alienated member of the underclass, consult T. J. Clark, *The Painting of Modern Life: Paris in the Art of Manet and His Followers* (Princeton, N.J., 1984), pp. 253–4.

Raymond Mortimer, who wrote about the *Bar* nearly half a century ago, was probably the first scholar to point to the interpretive dilemma presented by the young woman's image: "Manet's barmaid, like his *Nana* and the girl in the boat in his *Argenteuil,* was considered [by his contemporaries] to be a shameless description of a prostitute.... Today the girl strikes us not as vulgar and venal – she has an archaic or timeless look like a stranger from another world." See R. Mortimer, *Edouard Manet: Un Bar aux Folies-Bergère* (London, 1944), p.10.

2. Adolphe Tabarant, *Manet et ses oeuvres* (Paris, 1947), pp. 423–4, identifies the artist's model as Suzon of the Folies and recounts how she came

228

to Manet's studio to pose. Most scholars believe that a different model, who was also a barmaid at the establishment, posed for the Amsterdam sketch.

3. J. L. Vaudoyer, *E. Manet* (Paris, 1955), n.p., also compares the image of the barmaid with that of an ancient priestess.

4. However, it should be emphasized that, while representing his "real" barmaid as desirable but withdrawn, Manet simultaneously calls attention to her genital area by emphasizing the triangular opening of her jacket, which falls precisely at crotch level. The importance of this "genital tag" is underlined by the duplication of the triangular forms on the labels of the two Bass Ale bottles standing at either end of the bar, and positioned almost in alignment with Suzon's pubic triangle. Nor is it any coincidence that Suzon, her reflection, and that of her mirrored customer are all represented in three-quarter length. Nor do we glimpse the lower limbs of any of the hundreds of balcony occupants. In Manet's imaginary world, all his protagonists, like the artist himself, are deprived of the limbs that would give them mobility.

5. As this work goes to press, a volume of collected essays, examining the *Bar* from a variety of postformalist perspectives, is underway (Univ. South Carolina Press). Edited by Bradford R. Collins, it is tentatively titled *Current Methodologies: 15 Approaches to Manet's* Bar at the Folies-Bergère.

6. See David Carrier, "Manet and His Interpreters," *Art History* 8:3 (Sept. 1985), pp. 324–7.

7. This assessment can be found in Clark, *Painting of Modern Life,* pp. 254–5. An earlier version of this essay appeared in *The Wolf and the Lamb: Popular Culture in France,* ed. J. Beauroy, M. Bertrand, and E. Gergen (Sarasota, Fla., 1977), pp. 223–57.

8. See C. Lloyd, "Manet and Fra Angelico," *Source* 7:2 (Winter, 1988), pp. 20–4.

9. See F. Cachin's review of Clark's *Painting of Modern Life* in "The Impressionists on Trial," *New York Review of Books* (May 30, 1985), pp. 24–7, 30; this quote appears on p. 24.

10. See Lloyd, "Manet and Fra Angelico," p. 24, n. 9.

11. I had the opportunity to study the *Bar at the Folies-Bergère* repeatedly while the painting was on view at the Art Institute of Chicago (Oct. 17, 1987 to Jan. 3, 1988) as part of an exhibit of works from the Courtauld Collection. Although I was struck by the resemblance of Manet's barmaid to images of Christ in his tomb, I assumed that the artist had borrowed her pose from one of the numerous representations of this motif painted by Giovanni Bellini. In point of fact, none of Bellini's depictions – nor, to my knowledge, any other interpretation of this theme – approximates Suzon's pose as closely as the Fra Angelico fresco cited by Lloyd, and I believe he is correct in suggesting that work served as Manet's source.

12. Jacques-Emile Blanche, *Propos de peintre de David à Degas* (Paris, 1919), p. 141, provides this description of Manet's behavior while the *Bar* was in progress.

13. This incident is reported by Tabarant, *Manet et ses oeuvres,* pp. 294–5.

14. In letters written to his wife during the siege of Paris, Manet complained about vague foot troubles that were keeping him from serving his turn at guard duty. For the text of these letters, consult Mina Curtiss, trans. and

ed., "Letters of Edouard Manet to His Wife during the Siege of Paris: 1870–71," *Apollo* 232 (June 1981), p. 113, letter nos. 15 and 16, dated Oct. 16 and 23, 1870, respectively.

Manet recounted the incident involving the alleged snake bite in a letter to his brother, Eugène, dated March 11, 1849. The future artist reported that he had been confined to shipboard for the previous two weeks while recovering from this painful bite, allegedly suffered during an expedition to the forest outside Rio de Janeiro, where his naval training ship was then moored. See E. Manet, *Lettres de jeunesse: 1848–49. Voyage à Rio* (Paris, 1926), pp. 61–2.

15. For a vivid description of these symptoms, see Henri Perruchot, *La vie de Manet* (Paris, 1959), pp. 274–5. He also dates the recurrence of Manet's foot problems to the summer of 1876, rather than 1878; see p. 267.

16. Tabarant, *Manet et ses oeuvres,* pp. 294–5, quotes from a letter (presumably written during the summer of 1878) in which Edmond Duranty informed Emile Zola that Manet's foot trouble had all the habitués of the Nouvelle Athènes (a café frequented by Manet and his friends) abuzz.

17. See Perruchot, *La vie de Manet,* pp. 277–8.

18. In Manet's obituary, Phillipe Burty reports that the artist had succumbed to a slow malady of the central nervous system inherited from his father. For Burty's account, see *La République française,* May 3, 1883.

Assertions that Manet *père* suffered from tertiary neurosyphilis to the contrary, Cachin (in Cachin et al., *Manet: 1830–1883,* exh. cat., no. 3, p. 50) is surely correct in stating that we know not the cause of his death, but only that he was a reclusive invalid during the last four years of his life. Auguste was already partially paralyzed in 1860, when his son painted the double portrait of him and Mme Manet (Musée d'Orsay, Paris), which shows Manet senior seated in an armchair (perhaps because he had lost the use of his lower limbs) with his wife standing beside him.

19. For recent information about *tabes dorsalis* and other neurosyphilitic conditions, consult R. J. Joynt, ed., *Clinical Neurology,* vol. 2, rev. ed. (Philadelphia, 1990); see chap. 28 by R. P. Schmidt, pp. 1–23, esp. pp. 10–14.

See also L. P. Rowland, ed., *Merritt's Textbook of Neurology* (Philadelphia, 1989), sec. 19, "Spirochete Infections: Neurosyphilis," by Rowland, pp. 152–61.

For information concerning the diagnostic problem of distinguishing syphilitic *tabes* from multiple sclerosis, the interested reader should consult H. H. Merritt, Raymond Adams, and Harry Solomon, *Neurosyphilis* (New York, 1946), pp. 283 and 346–7.

20. My consultations with Dr. Burke extended over several months and involved numerous telephone conversations and exchanges of letters. He provided me not only with appropriate bibliographic references, but even with reprints of pertinent materials from his personal library. All references to the literature on neurosyphilis cited in this essay were provided by Dr. Burke.

21. Tabarant, *Manet et ses oeuvres,* p. 395, describes the improvement in Manet's condition following his stay at Bellevue during the summer of 1880. For confirmatory statements from the artist himself, see Wilson-Bareau, ed., *Manet by Himself* (London, 1991), pp. 247–58, for a selection of letters written during his 1880 sojourn at Bellevue.

As the text that follows indicates, Manet may have enjoyed another partial remission during the autumn of 1881. It is probably no coincidence that both these partial – and transitory – improvements occurred in autumn, because Dr. Burke informs me that multiple sclerosis victims typically fare better in the fall. For an authoritative discussion of the nature of multiple sclerosis and its symptomatology, see S. A. Kinner Wilson, *Neurology*, vol. 1, ed. by A. N. Bruce (London, 1940), pp. 148–78.

See also *Practice of Medicine*, ed. by F. K. Tice, vol. 9 (New York, 1923), pp. 317–22, for an account of earlier forms of treatment. The editor recommends both hydrotherapy and imbibing arsenic, therapies also presecribed for neurosyphilis at the time. Tice notes that, although research on multiple sclerosis began in 1835–45, Charcot provided the first real conception of the disease in 1862. "It was he who considered the three leading symptoms – nystagmus, intention tremor, and scanning speech – as manifestations of one disease" (p. 322).

22. For comments about Manet *père*'s health, see n. 17. Perruchot, *La vie de Manet,* p. 275, quotes the artist's comments about the familial rheumatism. Dr. Burke suggested that the "rheumatism" Manet describes may actually have been a hereditary ataxic disease that attacked the central nervous system of afflicted (male?) family members. Any attempt to prove or disprove the existence of such a disorder would require extensive study of familial medical records, assuming such data to be available – and complete enough to be useful.

23. On March 5, 1992, Dr. Burke wrote me: "In 1881, J. M. Charcot, the most eminent French neurologist of his day, delivered a lecture at the Sâlpêtrière (then the leading neurological institute in France), which revealed that he had no idea of the true cause of *tabes* and was just beginning to identify the affected areas of the spinal cord. It was not until 1882 and 1883 that J. A. Fournier and W. Erb finally made the definitive connection between syphilis and *tabes dorsalis*." For Charcot's lecture, see J. M. Charcot, *Lectures on the Diseases of the Nervous System,* second series, trans. and ed. George Sigerson (New York, 1962), "Anomalies of Locomotor Ataxia," pp. 3–24. For the pioneering publications on *tabes,* see W. Erb, "Zur Aetiologie der Tabes Dorsalis," *Berliner Klinische Wochenschrift* 20, p. 481 (Berlin, 1883), and J. A. Fournier, *De l'ataxie locomotrices d'origine syphilitique* (Paris, 1882).

However, it should be noted that, despite their confusion as to the actual cause of *tabes dorsalis,* French neurologists active during the 1860s *were already aware* that syphilitic infections (which they erroneously attributed to a virus, rather than to the spirochete actually responsible) could cause lesions of the central nervous system. The entry on syphilis published in Pierre Larousse, *Grand Dictionnaire Universel du XIX^e Siècle,* vol. 14, pt. 2 (Geneva & Paris, 1982 reprint ed.), pp. 1337–40, provided detailed (and accurate) descriptions of the symptoms of primary and secondary syphilis; the authors also noted that, although investigators had been diligently pursuing investigations into the precise nature of neurosyphilitic lesions, their research had, to date, yielded little useful data. The original French edition of the so-called *Grand Larousse* was published during 1866–79; the most recent research cited in the section on syphilis dates from 1865, providing a terminus ante quem for this entry.

24. See Perruchot, *La vie de Manet,* pp. 274–5, who repeatedly links Manet's memories of the snake bite with recollections of his father's paralytic condition. Although the biographer does not explicitly spell out his theory, he seems to hint that father and son were fellow syphilitics. Whether Dr. Siredey also entertained such suspicions remains an unanswered question. Although he was a family doctor, rather than a specialist, Siredey would certainly have been familiar with the symptoms of the first two stages of syphilis, and he may well have been aware of the ongoing research into neurosyphilis. (As indicated in n. 22, by the time Manet consulted Siredey such investigations had been in progress for at least a decade.) We have no way of knowing whether Siredey shared with Manet any speculations regarding syphilis, although he certainly did make his patient aware that he was suffering from a progressive neurological disorder.

25. Manet repeatedly consulted various herbalists and swallowed whatever they gave him – a dangerous practice that may have caused the gangrenous infection that indirectly led to his death. In a letter written at the beginning of April 1883, Edgar Degas informed a mutual friend, "Manet is done for. Reportedly that Dr. Hureau de Villeneuve has poisoned him with doses of ergotized rye." Quoted in Roy McMullen, *Degas: His Life, Times, and Work* (Boston, 1984), p. 365. Berthe Morisot wrote her brother on March 9, 1883: "Poor Edouard is very ill; his famous vegetarian has very nearly dispatched him into the next world." For this letter, consult *The Correspondence of Berthe Morisot,* compiled and ed. Dennis Rouart, trans. B. W. Hubbard (London, 1957), p. 116.

 Ergot (*Claviceps purpurea*) is a dangerous fungus that possesses potent ability to constrict the blood vessels. Perhaps Manet indirectly caused his own death by ingesting this substance, thereby causing his left foot to turn gangrenous. Dr. Burke assures me that the fact that ergot can cause gangrene is well documented in medical literature.

26. Dr. Burke points out that Manet *could* have been suffering simultaneously from a benign late syphilitic condition *and* an unrelated disease of the central nervous system. (A small percentage of persons with tertiary syphilis never develop the deadly symptoms afflicting most victims.) More likely, the artist, although actually a victim of multiple sclerosis, mistakenly concluded that he was syphilitic.

27. Paul Derval, who served as director of the nightclub for a long period following World War I, states that the links between the institution and prostitution were formed almost as soon as the music hall reopened after the Franco–Prussian War. See P. Derval, *The Folies-Bergère,* trans. L. Hill (London, 1955), p. 6.

 According to Charles Castle, *The Folies-Bergère* (London, 1982), p. 37, this tradition began one cold winter night, when a kindly doorman permitted two half-frozen streetwalkers to enter the *promenoir* behind the stalls. The word spread, and the Folies was soon overwhelmed with prostitutes. Many of them became so unruly that the management drew up a blacklist, eliminating the most objectionable characters. "Cards were printed and distributed to the prettiest, best-behaved, and best-dressed of these women, and ladies unaccompanied by gentlemen were not admitted to the promenoir except on presentation of these cards. The passes were valid for two weeks only, and every fortnight the general manager of the

232

Folies-Bergère received the 'promenoir ladies,' as they were called, and held a parade to decide which of them he would allow to renew their cards – a sort of organized form of prostitution" (pp. 37–8).

Critics and literary lights of the times emphasized the close ties between the music hall and prostitution. The most celebrated of these accounts are those provided by J. K. Huysmans, "Les Folies-Bergère en 1879," reprinted in his *Croquis parisiens* (Paris, 1886), p. 24, and by Guy de Maupassant in *Bel-Ami*, Heritage ed. (New York, 1968), pp. 11–15.

The prevalence of prostitutes at the Folies-Bergère and other public entertainment centers reflects both the enormous increase in their numbers in late-nineteenth-century Paris and the simultaneous breakdown of the institution of the *maisons de tolérance,* the government-inspected and licensed bordellos. (The vast building program of Baron Haussman, initiated under Napoleon III, eliminated the slum neighborhoods in which most of the *maisons de tolérance* had been located, resulting in the deregulation and dispersal of prostitutes throughout the urban area.) For a more detailed discussion of prostitution in France during the late nineteenth century, see Alain Corbin, *Women for Hire: Prostitution and Sexuality in France after 1850,* trans. Alain Sheridan (Cambridge, Mass., 1990).

See also Charles Bernheimer, *Figures of Ill Repute: Representing Prostitutes in Nineteenth-Century France* (Cambridge, Mass., 1989).

28. Robert Herbert, *Impressionism* (New Haven, 1988), p. 309, n. 42, suggests that both Huysmans and de Maupassant "had a writer's interest" in exaggerating the role of the Folies as a prostitutes' market.

29. See Guy de Maupassant, *Bel-Ami*, p. 13.

30. See Clark, *The Painting of Modern Life,* pp. 205–58. Although the author entitles this chapter "A Bar at the Folies-Bergère," he devotes the bulk of his text to an examination of the sociopolitical significance of cafés-concerts and an analysis of the subversive implications of songs performed by Thérésa, a café-concert singer of the period who never, to my knowledge, performed at the Folies-Bergère. Clark's commentary on Manet's painting per se begins on p. 239; see esp. pp. 252–4. He not only interprets the interaction between barmaid and customer as an assignation, but reads into this encounter connotations of class divisions and social alienation that were undoubtedly operative but seem unlikely to have preoccupied Manet as either a younger participant in, or an ailing observer of, such scenes. Without ever explicitly claiming that Manet consciously intended to convey such social messages through his art, Clark's interpretation could easily lead one to conclude that the artist had been deeply concerned about such issues. Although Manet expressed pro-Republican sentiments in his paintings and prints, no evidence can be cited, in either his oeuvre or his behavior, to suggest that he experienced the attitudes toward class distinctions that Clark seemingly attributes to him. To the contrary, as Harry Rand points out, "[Manet] clung tenaciously to his class identity, even while actively engaged in a profession that advanced the inquisition of the assumptions governing society…. The confusion of his mixed conservatism and progressivism has haunted the studies of his work since his own time." See H. Rand, *Manet's Contemplation at the Gare Saint-Lazare* (Berkeley, 1987), p. 58.

233

31. Perruchot, *La vie de Manet,* pp. 40–3, claims that, following this incident, Manet's commanding officer warned the cadets against consorting with the slave-prostitutes of Rio because of their high rate of syphilitic infection. The captain may well have issued such a warning, but Perrochot's further assertion that he cautioned that syphilitic infection would lead to general paresis or locomotor ataxia is, of course, sheer invention; as indicated by the *Grand Larousse* entry on syphilis cited in n. 23, the connections between tertiary syphilis and diseases of the central nervous system were only vaguely understood two decades after Manet's voyage to Rio.

32. See Pierre Daix, *La vie de peintre d'Edouard Manet* (Paris, 1983), p. 29.

33. For the artist's comments, see Manet, *Lettres de jeunesse,* pp. 52, 58. In an undated letter to his mother, he mentions that the female slaves were generally nude to the waist, and that although most of them were ugly, "I have seen some who are pretty enough" (p. 52). In the letter to his cousin, Jules Dejouy, dated February 26 [1849], Manet again notes that, although many of the black women are ugly, the mulattos are nearly all pretty (p. 58). With his cousin, Manet was a bit more forthcoming about his activities during the festivities: "Carnival passed in an amusing enough manner; *I have come to see myself,* like everyone, *as both victim and agent.* All the women of the town positioned themselves at their open windows from three in the afternoon, and threw on all the men who passed lemons or balls of wax filled with water, which cover the individual with water when they break. Gentlemen are permitted to return the favor; for my part, I took advantage of the permission; in the evening there was a masked ball in imitation of Paris." (Italics and punctuation correction mine.)

34. In the letter to his cousin Jules cited in the preceding note, the artist mentioned only that the presence of serpents interfered somewhat with the pleasures of the forest expedition. But in the missive to his brother dated March 11, Manet claimed that, while strolling in the forest, he had been bitten in the foot by a reptile. "My foot became horribly inflamed, and I suffered [the pain of] martyrdom."

35. For a general discussion of the cult of the dandy and its relationship to that of the flâneur, see Ellen Moers, *The Dandy: Brumell to Beerbohm* (London, 1960), esp. chap. XII, "Baudelaire," pp. 271–83. Nils Sandblad, *Manet: Three Studies in Artistic Conception,* trans. Walter Nash (Lund, 1954), "*La Musique aux Tuileries,*" pp. 17–107, presents an extensive discussion of Manet's relationship to Baudelaire and the latter's influence on the young painter.

 The literature devoted to the Baudelaire–Manet relationship has proliferated in recent years. Larry L. Ligo has published extensively on this topic; see, for example, his "*Baudelaire's Mistress Reclining* and *Young Woman Reclining in Spanish Costume:* Manet's Pendant Portraits of His Acknowledged 'Mistresses,' Baudelairian Aesthetics and Photography," *Arts* 62 (Jan. 1988), pp. 76–85, which provides additional bibliography.

 See also D. Druick and P. Zegers, "Manet's 'Balloon': French Diversion, The Fête de l'Empereur, 1862," *Print Collector's Newsletter* 14 (May–June 1983), pp. 38–46.

36. Antonin Proust, full of admiration for this affectation, comments that, as much as Manet tried to play the gamin, he never managed to be vulgar.

("*On le sentait de race.*") See A. Proust, *Edouard Manet: Souvenirs,*
L'Echoppe ed. (Paris, 1988), p. 9.

37. For example, see Daix, *La vie de peintre d'Edouard Manet,* pp. 71–2, who
asserts that Manet's relationship with Victorine Meurent was "sensual" as
well as professional. This assumption may well be correct, but in the ab-
sence of confirmatory documentation it should be presented as specula-
tion, not fact. See also Seymour Howard, "Manet's Men's Women," *Arts*
59 (Jan. 1985), pp. 78–80, who presents a sophisticated psychological
portrait of the artist as a man whose "active heterosexual interests and
habits" reflected complex underlying attitudes toward women – and to-
ward the self.

38. For Jeanniot's comments, see Etienne Moreau-Nélaton, *Manet Racconté
par lui-même,* vol. 2 (Paris, 1926), pp. 95–6.

39. Manet's paternal ancestry included wealthy landowners and local offi-
cials at Gennevilliers, as well as distinguished magistrates in Paris. The ar-
tist's mother came from a line of army officers and diplomats; her father
had served as the French ambassador to Sweden.

40. Among other things, his father allowed Edouard to study art (although
that certainly was not Manet *père*'s profession of choice for his son). He
also provided the young man with the kind of generous allowance that
permitted him to travel abroad several times, and to maintain an elegant
life-style when at home. Proust, *Edouard Manet: Souvenirs*, pp. 18–20,
recounts several incidents that portray Manet *père* as more supportive and
indulgent toward his charming eldest son than one might anticipate.

41. On Mme Manet as the doting mother and her collusion with Edouard to
keep his alliance with Mlle Leenhoff a secret, see Perruchot, *La vie de
Manet,* pp. 47–67, esp. pp. 61–3.

42. On the secrecy surrounding Manet's marriage, see ibid., pp. 143–4. Even
the members of his intimate circle knew nothing about Manet's long-
standing relationship with Suzanne. He did not inform his close friend, the
poet Charles Baudelaire, of his pending nuptials until the night before he
left for Holland to be married! Manet waited for a full year after his fa-
ther's death to legalize his relationship with Suzanne; although this might
be considered a sign of filial respect, several Manet scholars have linked
his delay to his wish to secure his inheritance before acting.

43. During the last seven years of his life, the aged Léon Koëlla (who had re-
sumed his original surname after learning as an adult that he had been so
identified at the time his birth was officially registered) wrote Tabarant
several times in response to questions the latter raised while preparing his
biography of Manet. These letters are preserved in the Tabarant Archive
at the Morgan Library, New York, which graciously provided me with
photocopies of the original texts, as well as with typed transcripts.
 Koëlla began the letter dated December 6, 1920, with a statement pre-
sumably elicited by Tabarant: "In the Manet and Leenhoff families, I said
always godfather and godmother; in the world, it was my brother-in-law
and my sister. [It was a] family secret about which I never knew the final
word, having been coddled and spoiled by both of them, who fulfilled all
my fantasies. We lived happily the three of us, especially myself, who had
not a care and did not have, then, any question to raise about my birth."
Despite Léon's claim that he habitually called Mme Manet "godmother"

(*marraine*), both in this letter and in an earlier one dated Dec. 4 (which may have provoked Tabarant's query about Léon's parentage), he repeatedly referred to Suzanne as "ma mère" (my mother). As his slips reveal, Léon was well aware of his true relationship to Suzanne, and – perhaps unconsciously – chose to communicate that intelligence to Manet's biographer. Tabarant, *Manet et ses oeuvres*, p. 18, notes that Léon's birth record had disappeared during the fire of 1871 that destroyed the Hôtel de Ville. In a new document dated March 19, 1900, Mme Manet reaffirmed that Léon was her son, again identifying the mysterious M. Koëlla as his father.

Although Koëlla was 32 at the time of Manet's final illness and death, his description of the way everyone behaved toward him makes it clear that Léon continued to be treated like a child (or a mental defective) not only by the members of his household, but also by the consulting physicians involved in the artist's care. These letters, written when Koëlla was nearly 70, still convey the rather ingenuous tone of one who grew old without growing up.

44. For the rather vague evidence offered in support of the contention that Auguste Manet was actually Léon's father, see Curtiss, "Letters of Edouard Manet to His Wife," p. 379. She cites "a highly distinguished and reliable writer, a relation by marriage of the Manet family," who informed "a close friend" that Manet *père* had fathered Léon. Curtiss buttresses this claim by citing the artist's will, which left everything to his wife, with the provision that Léon Leenhoff inherit from her. "'I believe that my brothers will find this entirely natural,' he wrote. The implication seems to be that the brothers would accept without question a half-brother as heir to a share of the family fortune." In contrast to Curtiss, as I read this statement, it simply confirms that the artist's brothers realized that Léon was, indeed, a Manet without in any way counterindicating that he was Edouard's son.

For a perspective on the question of Léon's paternity, as well as an interpretation of the artist's will more congruent with my own views, see Steven Kovacs, "Manet and His Son in *Déjeuner dans l'atelier*," *Connoisseur* 181 (Nov. 1972), pp. 196–202.

Daix, *La vie de peintre d'Edouard Manet*, pp. 33–4, convinced that Léon was, indeed, Manet's son, dismisses all arguments about his paternity as "absolutely devoid of sense."

Rand, *Manet's Contemplation at the Gare Saint-Lazare*, p. 57, offers an ingenious proposal that Léon Edouard Koëlla's name may have encoded confirmation that his parents were Leen[hoff] and Edouard [Manet].

45. "Splitting" of the mind was first noted by S. Freud in 1927 in "Fetishism," reprinted in English in the Standard Edition of the *Complete Psychological Works of Sigmund Freud*, vol. 21, trans. and ed. James Strachey et al. (London, 1961), pp. 49–57. It is a condition in which mutually contradictory convictions are maintained simultaneously by nonpsychotic individuals. Such incoherence is made possible through disavowal of the significance of one or the other condition.

Manet's friend Proust seems to have been well aware that Manet responded to his illness with this kind of splitting; for his insightful comments, see Proust, *Edouard Manet: Souvenirs*, pp. 55–62.

46. Biographers generally agree that Manet suffered two episodes of what I have dubbed "creative paralysis." The first occurred in response to the up-roar that greeted the exhibition of *Olympia* in the Salon of 1865; the sec-ond followed the critical and economic failure of the special one-man ex-hibition he staged during the fair of 1867. During both episodes the artist withdrew from his friends and ceased working. Proust, *Edouard Manet: Souvenirs*, pp. 33–5, provides vivid accounts of the artist's behavior during both episodes.

47. The correspondence of Berthe Morisot includes several accounts of Ma-net's inconsiderate or ambivalent behavior toward her. He obviously en-joyed playing on her jealousy of Eva Gonzalès, who became his only pupil in 1869 and temporarily replaced Morisot as his model of choice. That he succeeded all too well in nettling Morisot is quite evident from her com-ments. For a particularly egregious example of such behavior, see her let-ter of August 13, 1870, to her sister Edma; see Rouart, *Correspondence of Berthe Morisot*, p. 38.

 Although we have less information about the nature of Suzanne Leen-hoff Manet's responses to similar provocations, we may be sure that Manet played the same hostile, teasing games with his wife, and no doubt with his mother as well. The fact that Suzanne was fat and plain cannot have inspired her with confidence in such situations. Berthe Morisot's mother recounted a visit to the artist's studio that provides some indica-tion of his wife's reactions to his provocations: "I have taken the books back to Manet, whom I found in greater ecstasies than ever in front of his model, Gonzalès. His mother made me touch her daughter-in-law's hands, saying that she was feverish; the latter forced a smile and reminded me that you had promised to write to her. As for Manet, he did not move from his stool" (pp. 36–7).

 Such behavior anticipates the readiness with which Manet would pro-ject his fury about his illness onto his mother and wife.

48. Proust, *Edouard Manet: Souvenirs*, p. 57, sympathetically notes that, as Manet's illness progressed, he showed himself increasingly severe with those to whom he was most attached.

49. Ibid., pp. 58–9.

50. See the artist's letter – dated July 8, 1882, and addressed to 'Sphinx' at *L'Evénement* – reproduced by Wilson-Bareau, *Manet by Himself*, p. 266.

51. See George Mauner, *Manet Peintre-Philosophe: A Study of the Painter's Themes* (University Park, Pa., 1975), chap. 5, "The Mirror," pp. 149–62; this quote appears on p. 149.

52. For the iconography of this painting, see Moffett (in Cachin et al., *Manet: 1830–1883*, exh. cat., no. 12, pp. 70–2), who also provides further refer-ences to the extensive literature it has generated. One wonders whether, by portraying Léon seated alone on the opposite bank of the river from his mother and "father," Manet wasn't alluding to the child's equivocal sta-tus as an offspring born on the wrong side of the marriage bed.

53. The first picture in which Léon appeared as Manet's alter ego seems to have been the *Boy with a Sword* (1861; Metropolitan Museum of Art, New York). As Moffett suggests (in Cachin et al., *Manet: 1830–1883*, exh. cat., no. 14, pp. 70–2), the painting not only constitutes an homage to Velázquez and Goya, but may also allude to the artist's accomplish-

ments as a swordsman. (In 1870, he challenged the critic Edmond Duran-
ty to a duel in which the painter slightly wounded his adversary. On this,
see Tabarant, *Manet et ses oeuvres*, p. 115.) Léon subsequently appeared
in a great many of his "father's" pictures, including *The Luncheon in the
Studio,* discussed below in the section "References to the Artist's Earlier
Oeuvre in the *Bar.*"

54. The Rue Mosnier was celebrated for the number of independent prosti-
tutes who resided there. Cachin (in Cachin et al., *Manet: 1830–1883,* exh.
cat., no. 158, p. 396), suggests that the description of this street and its oc-
cupants presented in Emile Zola's *Nana* might have been inspired by an
amused account provided by Manet.

55. To cite just a few examples of such readings, see Bradford Collins, "Ma-
net's *Rue Mosnier Decked with Flags* and the Flâneur Concept," *Burling-
ton Magazine* 117 (November 1975), pp. 709–14. See also Ronda Kasl,
"Edouard Manet's *Rue Mosnier:* "Le pauvre a-t-il un patrie?" *Art Journal*
44, 1 (Spring 1985), pp. 49–58.

56. This coincidence was not lost on Paul Isaacs; see Isaacs, "The Immobility
of the Self in the Art of Edouard Manet," unpub. dissertation, Dept. His-
tory of Art and Architecture, Brown University, 1976, p. 121.

57. In proposing this mural cycle, Manet sought to take advantage of the
French government's program, instituted during the 1870s, that subsi-
dized the creation of large-scale decorative projects for public buildings.
As Patricia Mainardi points out, Manet's attempt to secure this commis-
sion shows that "interest in such projects was not limited to partisans of
the Grand Tradition." See Mainardi, *The End of the Salon: Art and the
State in the Early Third Republic* (Cambridge & New York, 1993), pp.
58–9.

58. See Mauner, *Manet Peintre-Philosophe,* chap. 5, pp. 149–50. Manet's ges-
ture also provides further evidence of this underlying ambivalence about
his role and status in contemporary French art and art politics. For volu-
minous evidence of the parallel ambivalence of the French government
concerning its proper role as a sponsor of the arts during the early years of
the Third Republic, see Mainardi, *The End of the Salon.*

59. See Theodore Reff, *Manet and Modern Paris: One Hundred Paintings,
Drawings, Prints, and Photographs by Manet and His Contemporaries,*
exh. cat. (Washington, D.C., & Chicago, 1982), no. 1, p. 30.

60. A photograph taken by Nadar around 1865 reveals that Manet was al-
ready suffering from significant hair loss; it is reproduced as the frontis-
piece of the Cachin et al. 1983 exhibition catalogue.

61. See Tabarant, *Manet et ses oeuvres*, p. 355.

62. Ibid., pp. 355–6, also calls attention to the strained posture in which Ma-
net depicts himself as symptomatic of his illness.

 Isaacs, "Immobility of the Self," pp. 120–1, sees another reference to
the artist's illness in the "deformed" treatment of his left hand in the *Self-
Portrait with a Palette;* Isaacs interprets this as another of numerous death
symbols he perceives in Manet's oeuvre – this time, one referring to the
artist's own demise.

63. See Francis V. O'Connor, "The Psychodynamics of the Frontal Self-
Portrait," in *Psychoanalytic Perspectives on Art,* ed. M. M. Gedo, vol. 1
(Hillsdale, N.J., 1985), pp. 167–221.

64. Mauner, *Manet Peintre-Philosophe,* chap. 4, "Immortality," pp. 109–48, points out the preoccupation with death that characterized so much of Manet's oeuvre and presents detailed discussions of significant examples, including both pictures cited here.

 Isaacs, "Immobility of the Self," chap. 2, "Death and Vanitas in the Art of Manet," pp. 110–81 and passim, also explores the artist's preoccupation with themes of mortality.

65. The only obvious allusion of this type from the 1870s occurs in the *Portrait of Berthe Morisot with Hat, in Mourning* (1873; private collection), for which she modeled shortly after the death of her father.

 However, Mauner, *Manet Peintre-Philosophe,* pp. 143–6, apparently convinced that the artist, rather than the sitter, chose to portray the singer as Hamlet, cites Manet's *Portrait of Fauré in the Role of Hamlet* (Kunsthalle, Hamburg) from 1877 as another example of such themes. Mauner may well be correct. At any rate, it is interesting to note that Edmond Bazire, who visited Manet's studio immediately after his death, commented that he saw this portrait of opera singer Jean-Baptiste Fauré hanging between the artist's two self-images of 1878–79. See Bazire, *Manet* (Paris, 1884), pp. 132–3.

66. Mauner, *Manet Peintre-Philosophe,* pp. 142–4, provides a relevant commentary on this painting.

67. See Proust, *Edouard Manet: Souvenirs,* pp. 64–5. Characteristically, after making this extraordinary confession, Manet quickly changed the subject and recounted a comic misadventure he had suffered several years earlier.

68. On this, see n. 46 above.

69. I am grateful to John E. Gedo, who based this observation on his extensive clinical experience.

70. The literature devoted to the roles of these varied influences in Manet's art is too extensive to list here; the interested reader should consult the catalogue of the 1983 Manet exhibition by Cachin et al. See also Herbert, *Impressionism,* and Reff, *Manet and Modern Paris,* exh. cat., who provide additional examples of Manet's relationship to popular illustrations, as well as to the art of his contemporaries. See also Anne C. Hanson, *Manet and the Modern Tradition* (New Haven, 1977).

 For a more extensive discussion of Manet's responsiveness to Japanese art, see the entries on Manet in Klaus Berger, *Japonisme in Western Painting from Whistler to Matisse,* trans. David Britt (Cambridge & New York, 1992).

71. As I noted in the introduction, Manet's depictions of these motifs convey a heady sensuality and erotic charge seldom found in Degas's determinedly objective, detached treatment of such themes.

 As has often been pointed out, Manet's work from these years also reflects the influence of contemporary naturalistic novelists, especially Zola.

72. See Juliet Wilson-Bareau, *The Hidden Face of Manet: An Investigation of the Artist's Working Processes,* exh. cat., with an essay by John House (London, 1986), p. 71.

 For additional details on the role of the café and café-concert in late-nineteenth-century French art and life, see Reff, *Manet and Modern Paris,* exh. cat., "The Café and Café-Concert," pp. 73–93. See also Herbert, *Impressionism,* chap. 3, "Café and Café-Concert," pp. 59–91.

73. This quotation appears in Reff, *Manet and Modern Paris,* exh. cat., no. 21, p. 82.

74. For his full discussion of this pastel, see Kurt Martin, *Edouard Manet: Water Colours and Pastels,* trans. Robert Allen, exh. cat. (London, 1959), pp. 18–20 and no. 30.

 See also Novelene Ross, *Manet's* Bar at the Folies-Bergère *and the Myths of Popular Illustration* (Ann Arbor, 1982), p. 5; see, too, Moffett (in Cachin et al., *Manet: 1830–1883,* exh. cat.), no. 166, pp. 409–10.

75. Martin, *Edouard Manet,* pp. 19–20.

76. Although Manet had depicted various outcasts – gypsies, beggars, itinerant musicians, and the like – during the 1860s, these pictures (with the possible exception of *The Street Singer,* painted around 1862), not only specifically allude to the art of the past, but also share the somewhat artificial character of works conceived and executed in the studio. By contrast, *The Rue Mosnier with Flags,* with its outdoor setting and Impressionist palette, reflects the immediacy of firsthand observation and independence from earlier prototypes.

77. The only hard information Derval, *Folies-Bergère,* p. 15, supplies is that he "reconstructed the place from top to bottom in 1926" without ever closing the theater or interrupting performances. This was accomplished by prefabricating completely new interiors for the hall and auditorium and covering the old walls with them piece by piece. As a result, "there are always two of everything at the Folies-Bergère."

78. For the earlier history of the site – and the structure – that later housed the Folies-Bergère, see Derval, *Folies-Bergère,* pp. 5–6, and Castle, *Folies-Bergère,* pp. 15–17. When the music hall closed its doors at the end of 1992, after losing more than six hundred thousand dollars that year, few expected it would ever reopen. Surprisingly, nine months later the refurbished theater was back in business, featuring a scintillating new revue "that often derives its humor through gentle parody of the many-feathered past of the Folies-Bergère." For this quote and additional details see Roger Cohen, "Feathers! Androgyny! The Folies-Bergère Reopens," *New York Times,* Thursday, Sept. 30, 1993, pp. B1–2.

79. This letter, dated Sept. 15, 1870, is reproduced in Curtiss, "Letters of Edouard Manet to His Wife," p. 380, no. 4.

80. Castle, *Folies-Bergère,* pp. 20–7, gives an informative account of Sari's stewardship of the Folies-Bergère.

81. For these details, see the quotation from de Maupassant on p. 8.

82. Ross, *Manet's Bar,* p. 75, reproduces this gushing description.

83. Adler, *Manet,* p. 224, fig. 218, includes an especially clear reproduction of an engraving depicting the garden level of the Folies-Bergère as it appeared in 1880. Castle, *Folies-Bergère,* p. 21, reprints another engraving of the period, which shows a trained elephant and acrobats performing in the garden while prostitutes simultaneously solicit formally dressed men.

84. See Derval, *Folies-Bergère,* p. 8.

85. The *Cambridge Guide to American Theatre,* ed. Don B. Wilmeth and Tice L. Miller (Cambridge & New York, 1993), p. 220, describes the Hanlon-Lees as "knockabout comedians who introduced a new style of stage farce." The troupe consisted of six English-born brothers, who took the name of Lees in honor of their trainer, carpet acrobat John Lees. During

the 1880s, two of the Hanlon brothers, William and Edward, settled in Massachusetts, where they developed and promoted comic extravaganzas. Their relocation has sometimes led to the misidentification of the troupe as American in origin. (This reference does not mention "Little Bob," who was, in any case, not a member of the Hanlon family.)

For additional information about the Hanlon-Lees and their raucous act, see Castle, *Folies-Bergère,* p. 24.

86. For this engraving, see Wilson-Bareau, *Hidden Face of Manet,* exh. cat., p. 79, fig. 100.

87. Wilson-Bareau, *Hidden Face of Manet,* exh. cat., p. 78, suggests that the performer might be Miss Lorna Dare. However, Castle, *Folies-Bergère,* pp. 23–4, notes that Dare, an American "and proud of it," always wore a red, white, and blue costume representing the American flag, with "'stars' on her abdomen and 'stripes' on her thighs." The green booties Manet's trapeze artist wears do not fit Dare's color scheme.

88. See de Maupassant , *Bel-Ami,* pp. 12–13.

89. Consult Wilson-Bareau, *Hidden Face of Manet,* exh. cat., p. 78.

90. According to Tabarant, *Manet et ses oeuvres,* p. 415, Manet refused to hear anything further about hydrotherapy, so Dr. Siredey, surrendering to the terms set by his difficult patient, simply recommended rest anywhere except at the seashore. Manet opted for Versailles, where he stayed from late June until early October. According to Dr. Burke, time has proven that Manet's judgment about the dubious value of hydrotherapy in such instances was right on the mark.

91. It should be noted that the Salon of 1881 was the first organized by the Société des artistes Français. In January of that year, the French government officially relinquished control over the fine arts exhibition that it had sponsored for nearly two hundred years. Antonin Proust, as fine arts administrator, introduced major changes in the regulations for the 1881 Salon. For details about the government abandonment of the Salon, and the fate of the latter under the control of the artists themselves, see Mainardi, *The End of the Salon,* esp. pp. 80–9. The fact Manet was awarded his first-ever medal by the liberalized jury of the 1881 Salon was probably no coincidence.

See also ibid., pp. 65–6, for a discussion of the constructive role Antonin Proust played in elevating the position of the decorative arts in France. Mainardi points out that, during Gambetta's short-lived government of 1881, the arts administration became a separate ministry, the Ministry of Arts, with Antonin Proust as its first, and only, minister.

92. Wilson-Bareau, *Hidden Face of Manet,* exh. cat., pp. 77–8, and p. 89, nn. 109, 110, provides the complete text of Léon's entries in the original French as well as in English. Of course, by identifying Manet's bar as located on the "première étage," Léon referred not to the ground floor (the *rez-de-chaussée* in French), but to what we would call the second floor.

93. For the complete letter, see Wilson-Bareau, *Manet by Himself,* p. 224.

94. For the artist's uncharacteristically frank admissions of his poor state of health, see the letters he wrote that summer to Stéphane Mallarmé and Eva Guérard-Gonzalès, reproduced in Wilson-Bareau, *Manet by Himself,* pp. 262–3.

95. See Tabarant, *Manet et ses oeuvres,* pp. 421–3.

96. Ibid.
97. Wilson-Bareau, *Hidden Face of Manet,* exh. cat., p. 96, n. 62, believes that Suzon posed for both the sketch and the definitive painting. Most scholars assume that a different barmaid modeled for the *esquisse,* an opinion in which I concur. See, e.g., Cachin (in Cachin et al., *Manet: 1830–1883,* exh. cat., no. 211, p. 484) and Ross, *Manet's* Bar, p. 7.
98. See Tabarant, *Manet et ses oeuvres,* p. 425.
99. Jeanniot specifically mentions that he visited the artist in January (1882). See his statement, reproduced in Moreau-Nélaton, *Manet Raconté par lui-même,* vol. 2, pp. 95–6.
100. As previously noted, Manet's recent paintings of cafés and cafés-concerts prefigured his use of the mirror in the *Bar.* However, other artists with whom Manet was in contact were also experimenting with similar motifs at the time, and one of their compositions might have influenced him. Cachin (in Cachin et al., *Manet: 1830–1883,* exh. cat., no. 211, pp. 480–1) not only lists related paintings, but also cites a possible literary precedent in Zola. Ross, *Manet's* Bar, pp. 4–7, offers other examples of related works that Manet might have known.
101. Pointing out that the photograph made by Lochard in 1883 does not correspond to the present appearance of the Amsterdam sketch, Tabarant, *Manet et ses oeuvres*, p. 424, argues that the lower section of the canvas was repainted following the artist's death.

 Wilson-Bareau, *Hidden Face of Manet,* exh. cat., pp. 78–9 and p. 89, nn. 113–14, reports that the x-radiographs of the painting made at the Stedelijk Museum revealed that the canvas had been cut on the top, bottom, and left edges and then restretched, but she does not provide definitive information about its possible repainting.

 Whether or not the Amsterdam sketch was later reworked, many of the artist's other paintings met this fate following his death, as Charles Stuckey has demonstrated. See Stuckey, "Manet Revised: Whodunit?" *Art in America* 71 (Nov. 1983), pp. 159–75, 239.
102. For her comments about the x-ray findings, see Wilson-Bareau, *Hidden Face of Manet,* exh. cat., pp. 79–83 and p. 96, n. 61.

 See also R. Bruce-Gardner, Gerry Hedley, and Carline Villers, "Impressions of Change," in *Impressionist & Post-Impressionist Masterpieces: The Courtauld Collection,* exh. cat. with essays by Dennis Farr, John House, et al. (New Haven, 1987), pp. 30–2. Bruce-Gardner et al. note that "the final reflected head of the waitress appears very opaque on the X-radiograph, and examination of the paint surface shows it to be one of the most reworked and least satisfactory passages in the entire painting. The brushwork is congested and lacks lucidity. This is in complete contrast to the man's head, which is painted directly and confidently in a brief, sketchy technique that recalls Manet's late paintings and is clearly legible on the X-radiograph" (p. 32).
103. See Gaston La Touche, "Edouard Manet souvenirs intimes," *Le Journal des arts* (January 15, 1884), p. 2. La Touche fondly describes the repeated visits he made to Manet's atelier while the *Bar* was in progress; he specifically mentions modeling for the gentleman reflected in the mirror, but does not mention posing for the small-scale figure shown on the balcony. However, Tabarant, *Manet et ses oeuvres,* p. 424, identifies both

La Touche and Dupray among the occupants of the balcony. (On this point, see also n. 108, below.)

104. See Wilson-Bareau, *Hidden Face of Manet*, exh. cat., p. 82 and Bruce-Gardner et al., *Impressionist & Post-Impressionist Masterpieces*, exh. cat., p. 30.

105. Consult Wilson-Bareau, *Hidden Face of Manet*, exh. cat., p. 82.

106. Ibid.

107. Ibid., p. 82 and p. 89, n. 116, notes that the pastel portrait of Méry Laurent that Manet used as his "model" was, in turn, made from a photograph, rather than from Laurent in person. This essay is not the appropriate place to explore Manet's use of photographs; however, like a number of his peers, the artist clearly used photographic images as an *aide-mémoire*.

108. J. P. Bouillon believes that La Touche modeled for the small-scale figure in the balcony, but questions the accuracy of his assertion that he also posed for the reflected customer. Bouillon notes that La Touche apparently informed Achille Segard that he had modeled "for one of the two personages situated to the right of the barmaid" in the Courtauld canvas. Pointing out that only a single figure appears in the right corner of the canvas, Bouillon suggests that La Touche probably suffered a memory lapse. However, as subsequent radiographic investigation has revealed, Manet did, in fact, depict two different male models in this role; La Touche, who followed the evolution of the *Bar* closely, was probably aware that he had replaced the original model (most likely again Dupray). For Bouillon's reservations see "Un Visite de Félix Bracquemond à Gaston La Touche," *Gazette des Beaux-Arts*, 75 (March 1970), pp. 176–7, n. 20. (See also n. 103, above.)

109. Although Tabarant, *Manet et ses oeuvres*, p. 424, notes that, in addition to Méry Laurent, one can – with difficulty – identify the visages of La Touche and Dupray, to date no one has successfully identified the latter's image among the personages in the balcony.

110. Quoted in Moreau-Nélaton, *Manet Raconté par lui-même*, vol. 2, p. 95. Jeanniot's account suggests that, even at this advanced stage of his illness, Manet continued to refuse to acknowledge publicly his awareness of the imminence of death. Jeanniot's observations about Manet's working procedures tally closely with the descriptions provided by La Touche, "Edouard Manet souvenirs intimes," p. 2.

111. See Ross, *Manet's Bar*, p. 6. Adler, *Manet*, p. 225, also identifies the site of Manet's painting as "one of the many small bars that lined the walls of the great winter garden."

112. Herbert, *Impressionism*, p. 79, like the present writer, locates Manet's bar on the balcony level.

　　See also Wilson-Bareau, *Hidden Face of Manet*, exh. cat., pp. 77–8, for her somewhat ambiguous identification of the location of Manet's bar.

113. Leenhoff's notation does not clarify whether Manet's bar was located between the first and second or the second and third pilasters. However, the first pilaster was one of a pair of supports located side by side to reinforce the corner. (They are clearly represented in the poster by Cheret reproduced in Herbert, *Impressionism*, p. 79.)

114. For example, a wood engraving of 1872, which depicts the Hanlon-Lees in performance at the Folies-Bergère, represents their rigging strung from this truss; it is reproduced in Wilson-Bareau, *Hidden Face of Manet,* exh. cat., p. 79, fig. 100.

115. De Maupassant specifically alludes to this feature in the passage from *Bel-Ami* cited on p. 8.

116. Although a number of Manet scholars have described the chandeliers as electrified, Derval, *Folies-Bergére,* p. 8, is – for once – very specific that they were gas fired. Writing about the theater as it appeared in 1886, he notes: "In those days there were already five electricians at the Folies; they were known as 'projectionists' and worked with oxygen lamps. *The auditorium was lit with compressed gas* and every night, about midnight, a 'gas cart' drew up outside the Folies to refuel the theater for the following day's performance" (italics mine).

117. See Hanson, *Manet and the Modern Tradition,* p. 205, for these quotes.

118. The bottle of wine or liquor shown at the far left, on whose label the artist recorded his signature and the year, stands side by side with the bottle of Bass Ale; yet, in the mirror, the ale appears *behind* the bottle bearing his signature. Four bottles of champagne nestle cheek by jowl with the ale, but in the mirror, one of the quartet peeps forth from the niche between the "real" Suzon's arm and waist, while the reflections of its fellows, fragmentarily represented, remain dutifully in place. None of the objects arrayed along the right side of the countertop is replicated in the mirror, with the single exception of the neck of the champagne bottle shown directly above Suzon's reflected cuff; the reflections of the other objects are presumably masked by the mirror images of the barmaid and her customer.

119. This quotation comes from a written personal communication by Prof. Conger, dated March 4, 1993 (italics mine).

120. Ibid.

121. For his extensive – and perceptive – analysis of the sources and implications of *Music in the Tuileries,* see Sandblad, *Manet: Three Studies,* pp. 17–64 and passim.

122. Ibid., esp. pp. 37–9.

123. The relationship of Manet's imagery to popular illustrations of this type forms the principal focus of Ross's 1982 monograph, *Manet's* Bar, in which she provides copious examples of such popular prints.

124. For Manet's relationship with Baudelaire, consult nn. 35 and 42, above.

125. See Rowland, "Spirochete Infections: Neurosyphilis," p. 152.

126. The quotation comes from Cachin (in Cachin et al., *Manet: 1830–1883,* exh. cat., no. 98, p. 294). See also Daix, *La vie de peintre d'Edouard Manet,* pp. 187–8.

127. For Cachin's comments, see Cachin et al., *Manet: 1830–1883,* exh. cat., no. 98, p. 292. Many features of this enigmatic painting have never been deciphered, including the iconographic significance of the "maid" and the seated gentleman shown behind Léon. For an interpretation of this symbolism that accords with my own views, see Kovacs, "Manet and His Son," pp. 196–202, esp. p. 199. Kovacs, who calls attention to the fact that the "maid" holds a bulbous coffeepot inscribed with an M, suggests that she represents Suzanne Manet, while the engraved coffee serv-

er refers to her pregnancy with the artist's son, Léon. Kovacs interprets the bearded male figure – posed by Auguste Rousselin, a minor artist and summer neighbor of Manet's – as the latter's alter ego.

128. For this quote, see Daix, *La vie de peintre d'Edouard Manet*, pp. 187–9.

129. See Tabarant, *Manet et ses oeuvres*, p. 232. See also Alain de Leiris, "Manet and El Greco: The Opéra Ball," *Arts* (Sept. 1980), pp. 95–9.

 For an alternative reading, see Linda Nochlin, "A Thoroughly Modern Masked Ball," *Art in America* (Nov. 1983), pp. 188–201.

130. For this quote consult Lloyd, "Manet and Fra Angelico," pp. 23–4.

131. Fra Angelico was not the only artist to portray the dead Christ with outstretched arms. To cite just one example, Giovanni Bellini, who executed many representations of the dead Savior, represented him in this pose in a canvas now in the Museo Poldi Pozzoli, Milan. It seems unlikely that Manet would have been familiar with this particular composition, but he may have come across versions by other painters that show Christ with outstretched arms.

132. As Lloyd, "Manet and Fra Angelico," pp. 22–3, points out, Manet sketched several figures from *The Mystical Crucifixion* and later used another of Angelico's frescos from the monastery, *Saint Peter Martyr Enjoining Silence* as the basis for his etching, *Silentium*.

133. Ernest T. DeWald, *Italian Painting: 1200–1600* (New York, 1961), p. 246, notes that this picture marks an important change in Fra Angelico's treatment of his religious subject matter.

134. Although the position of Suzon's arms and hands seems closer to those of the Christ in the fresco version, the more erect position of his head in the Louvre predella is closer to the barmaid's. Another fresco representing *Christ Rising from the Tomb,* painted either by Angelico or his school, survives in cella 26 at San Marco. Like the Louvre predella panel, it depicts the Virgin and St. Dominic in the foreground. It is usually attributed to a follower of Angelico's known only as the Master of Cella Two. The Louvre panel is probably by the same hand.

135. Excellent color reproductions of each of the seven predella panels can be found in Lawrence Gowing, *Paintings in the Louvre* (New York, 1987), pp. 50–5.

136. See the quotation cited above in n. 67.

137. This phrase comes from Mauner, *Manet Peintre-Philosophe*, p. 113; for his perceptive analysis in its entirety, see pp. 111–14.

138. For a purely political interpretation of *The Dead Christ with Angels*, diametrically opposed to those of Mauner and myself, see M. P. Driskel, "Manet, Naturalism, and the Politics of Christian Art," *Arts* 60 (Nov. 1985), pp. 44–54. The fact that Manet did not create this composition until two years after his father's death by no means negates the possibility that it was a painted elegy: Chapter 3 illustrates several instances of such delayed reactions on the part of the young Picasso, and I have encountered numerous additional examples of this type in my formal interviews and informal contacts with living artists who have candidly shared their personal motivations with me.

139. For detailed information about such sarcophagi, as well as illustrations of hundreds of examples, see *Jahreszetten-Sarkophage,* ed. by Peter Kranz, vol. 5, pt. 4 of *Die Antiken Sarkopharreliefs* (Berlin, 1984).

140. See Cachin (in Cachin et al., *Manet: 1830–1883,* exh. cat.), no. 211, p. 478.
141. See the artist's account in the undated letter to his mother included in Manet, *Lettres de jeunesse,* pp. 55–6, and in the letter to his cousin Jules Dejouy dated February 26 [1849], pp. 58–9.
142. Flaubert's supposed statement attesting to his identification with the heroine of his most famous novel, *Madame Bovary,* was attributed to him by a contemporary writer and friend, Amélie Bosquet.
143. The information that the bracelet contained a lock of Manet's baby hair comes from Julie Manet, the daughter of Berthe Morisot and Eugène Manet. See Alain Clairet, "Le bracelet de l'Olympia: Genèse d'un chef-d'oeuvre," *L'Oeil* 133 (April 1983), pp. 37–9.

 Steven Z. Levine's essay, "Manet's Man Meets the Gleam of Her Gaze: A Psychoanalytic Novel," is scheduled to appear in the forthcoming collection tentatively titled *Current Methodologies: 15 Approaches to Manet's* Bar at the Folies-Bergère (ed. Bradford R. Collins).
144. This quotation comes from Mauner, *Manet Peintre-Philosophe,* p. 161, who comments: "Only a part of the girl belongs to [the world of the mirror], and Manet has dissociated that part of her nature from the other part, viewed as aloof from the sensual surroundings."
145. Mary Magdalene was especially venerated in France because of the legend – emphatically rejected by the Catholic church – that she had lived out her final years as a penitent hermit in Sainte-Baume, in Provence. The well-known Parisian church, the Madeleine, is named for her.
146. Fra Angelico's depiction of *The Pious Women at the Tomb* (cella 8, San Marco) combines this motif with that of the resurrection and features a three-quarter-length view of Christ in glory hovering above the empty sarcophagus (the latter placed, in typical Angelican fashion, parallel to the foreground plane) into which the Magdalene peers. Her encounter with the risen Christ immortalized in *Noli me tangere* (cella 1) is portrayed as occurring just outside the grotto containing his sarcophagus.
147. Isaacs, "Immobility of the Self," pp. 493–5, associates this empty chair with the equally unpopulated park bench depicted in *My Garden* (1881, private collection), interpreting both empty places as (conscious) references to the artist's approaching death.

2. *Wrestling Anew with Gauguin's* Vision after the Sermon

Our gratitude to Ziva Amishai-Maisels, who introduced the authors to one another, and who also provided valuable suggestions during the course of the essay's development. Thanks, too, to Peter Zeghers for his helpful suggestions about bibliography, as well as for granting us access to reprints of hard-to-obtain materials, and to Aaron Sheon, who also provided valuable bibliographic information.

1. Because all the surviving letters Gauguin wrote during 1888 are reproduced in Victor Merlhès, ed., *Correspondence de Paul Gauguin* (Paris, 1984), we have not provided duplicate references to the van Gogh–Gauguin correspondence published in Douglas Cooper, ed., *Paul Gauguin: 45 Lettres à Vincent, Théo et Jo van Gogh* (Staatsuitgeverij, The Netherlands, 1983). The latter also contains the letters exchanged be-

tween the two artists after 1888. For the quotation that introduces this essay, see Merlhès no. 165, pp. 230–3. Hereafter, letters by Gauguin cited in the text will be followed by a parenthetical reference to their Merlhès (M.) number.

Although we have identified the paintings by Gauguin discussed in this essay by their present locations, rather than by their catalogue raisonné listings, the reader interested in the data contained in the latter should consult Georges Wildenstein, *Gauguin*, ed. by Raymond Cogniat and Daniel Wildenstein, vol. 1 (Paris, 1964).

2. This quotation comes from the Douay Version of The Old Testament, 1826 ed. (Nashville, 1950). Gauguin, of course, would have known a French edition of this same authorized translation of the bible from the Latin vulgate. Until 1894, when a new edition of the Catholic bible was published, the version in widest use in France was that authorized by the faculty at Louvain in 1550 and reprinted more than two hundred times during the following centuries. For further details, consult the *New Catholic Encyclopedia,* vol. 2 (San Francisco & Toronto, 1967), s.v. "French Versions," pp. 480–1. The Jaboc (or Jabbok) in Gilead formed the northern boundary of the Amorites (Joshua 12:2); it is now the Zarqa in Jordan.

3. See G.-Albert Aurier, "Symbolism in Painting: Paul Gauguin," *Mercure de France* 2, no. 15 (March 1891), pp. 155–65.

4. Emile Bernard, "Notes sur l'école dite de Pont-Aven," *Mercure de France*, 48, no. 168 (December 1903), pp. 679–80.

5. In addition to the essay cited in n. 4, see also the following publications by Emile Bernard: "Lettre ouverte à M. Camille Mauclair," *Mercure de France*, 14, no. 66 (June 1895), pp. 332–9; *Souvenirs inédits sur l'artiste peintre Paul Gauguin et ses compagnons lors de leur séjour à Pont-Aven et au Pouldu,* preface by René Maurice (Lorient, France [1939]). Consult also Emile Bernard, "L'Aventure de ma vie," in *Lettres de Paul Gauguin à Emile Bernard* (Geneva, 1954), pp. 11–56. See also the posthumous statement, published by the artist's son, Michel-Ange Bernard Fort, of yet another version of these events, "La Verité sur les relations d'Emile Bernard et de Paul Gauguin," *Art Documents,* no. 39 (Dec. 1953), pp. 6–7.

6. This quotation appears in Frèches-Thory's entry on *The Vision* in the catalogue of the 1988–9 Gauguin retrospective. See Richard Brettell, Françoise Cachin, et al., *Gauguin,* exh. cat. (Washington, D.C., 1988), no. 50, p. 102. The relationship between Gauguin's wrestling figures and those portrayed in Hokusai's *Mangwa* prints has been widely recognized, while the tree of *The Vision* has commonly been identified with the Hiroshige print, *Plum Estate, Kameido,* 1857.

7. See Ziva Amishai-Maisels, *Gauguin's Religious Themes* (New York, 1985) p. 14 and p. 60, nn. 13,14. Gauguin's claim that he possessed Inca blood derived from a myth promulgated by his maternal grandmother, Flora Tristan, the illegitimate daughter of a poor Parisienne and an aristocratic Spanish colonialist from Peru, Don Mariano de Tristan de Moscoso. Although the latter came from a high-born Aragonese family, Flora falsely claimed that he counted an Incan princess among his ancestors.

8. For an illuminating discussion concerning the complex questions surrounding Gauguin's conception of primitivism, as well as the relationship between his ideas and the attitudes prevalent in the late nineteenth centu-

ry, see Kirk Varnedoe, "Gauguin," in William Rubin, ed., *Primitivism in 20th Century Art: Affinity of the Tribal and the Modern,* exh. cat. (New York, 1984), pp. 179–209.

9. See John Rewald, *Post-Impressionism from van Gogh to Gauguin,* 3rd. ed. (New York, 1978), pp. 171–2.

10. As Martha Ward notes, the works Gauguin showed in the eighth Exposition of the Independents in 1886 displayed a great deal of diversity – a fact that the critics who reviewed the exhibition often failed to recognize. According to Ward, among those who took any note of the artist's entries, only Paul Adam "demonstrated a familiarity with Gauguin's exploration of Symbolist primitivism. Gauguin's critical reception at the eighth exhibition may well have fired his ambition. Though Adam and, to a lesser extent, [Félix] Fénéon provided sympathetic accounts of his works, Gauguin nevertheless appeared in their reviews ... in the position of a stepping-stone on the way to Neo-Impressionism. Soon after the exhibition Gauguin dissociated himself from Seurat and Signac by refusing to appear with them in the August show of the *Societé des artistes indépendants.* And within a year, Gauguin had so radically developed the primitivism of his art that no critic could easily have dismissed him as a mere student of Impressionism." See M. Ward, "The Eighth Exhibition," in Charles S. Moffet, ed., *The New Painting: Impressionism 1874–1886* (Geneva, 1986), pp. 429–30.

 The issue of Gauguin's competitiveness with Seurat merits further exploration from both art-historical and psychodynamic aspects. Voijtech Jirat-Wasiutynski, "Paul Gauguin's Paintings, 1886–91: Cloisonism, Synthesism and Symbolism," *RACAR* 9, nos. 1–2 (1982) suggests that Gauguin's active search for a synthesist style "capable of capturing the essential traits of scenes from Breton life" was "provoked" by Seurat's succès de scandale in the 1886 Indépendants' exposition, in which he showed his revolutionary canvas, *Sunday Afternoon on the Island of La Grande Jatte* (or *A Sunday at La Grande Jatte,* as it is now called) for the first time: "Having rejected Seurat and Neo-Impressionism, he turned to Degas' ballerinas and bathers, for poses and gestures. His search centered in particular on the development of a synthetic drawing style. Merete Bodelsen has rightly pointed to the important contribution of Gauguin's ceramic work during the winter of 1886–87 to the firming up and simplifications of contour lines and the consequent increase in their power to characterize forms. The development of Gauguin's synthetic drawing – and its corresponding emphasis on shape and the flattening of space – continued, even accelerated in the tropical light of Martinique" (p. 38).

11. In the English verse translation of M. B. Anderson, Canto One of *The Divine Comedy* begins:

 > Midway the path of life that men pursue
 > I found me in a darkling wood astray,
 > For the direct way had been lost to view.

 See *The Divine Comedy of Dante Alighieri,* trans. and annot. M. B. Anderson (New York: 1944), p. 3.

12. Laval, a native of Brittany, met Gauguin during the latter's first stay at Pont-Aven in 1886. Their Caribbean voyage of 1887 further undermined Laval's health, already weakened by the chronic tubercular infection that

would eventually kill him. Laval, forced to remain behind in a Martinique hospital when Gauguin sailed for France, followed his friend to Pont-Aven as soon as he was well enough to travel.

13. In an account written many years after the fact, Bernard listed several additional men who became disciples of Gauguin during 1888. At least one of these artists, Jacob Meyer de Haan, painted with Gauguin in Brittany in 1889, not 1888. See Bernard, *Souvenirs inédits*, p. 9.

14. Although he portrayed Gauguin as unfriendly to him in 1886, Bernard also mentioned being invited to the older artist's studio that summer, "where I saw pictures that reminded me very much of Pissarro and Puvis de Chavannes. My lack of enthusisam made him more chilly toward me." See Bernard, *Lettres de Paul Gauguin,* pp. 12–13.

 Jirat-Wasiutynski notes that Bernard provoked quarrels with Gauguin during the winter of 1887–8, over the latter's disdain for Seurat and the other Neo-Impressionists. According to Jirat-Wasiutynski, Bernard's behavior suggests "that his combativeness prevailed even though he shared Gauguin's dislike of the 'petit point.' We also know, however, that Bernard admired Gauguin's recent paintings of Martinquan natives, which he had seen at Theo van Gogh's in late 1887 or early 1888." See Voitech Jirat-Wasiutynski, "Emile Bernard and Paul Gauguin: The Avant Garde and Tradition," in *Emile Bernard 1868–1941: A Pioneer of Modern Art,* exh. cat. (Zwolle, The Netherlands, 1990), p. 49.

15. Rewald, *Post-Impressionism,* pp. 56–60 and 502, 504, provides a concise summary of Bernard's personality and early career, as well as the frustrations he endured at the hands of his tyrannical father. Van Gogh and Bernard worked together in a little studio that the young man had constructed in the garden of his family home at Asnières, until Vincent quarreled with Bernard *père,* "who showed no confidence whatsoever in his son's artistic calling" (p. 56). Thereafter, the two artists met to paint together on the banks of the Seine. For a first-person account of Bernard's activities during 1886–8, see Bernard, "Lettre ouverte," pp. 332–9 and "Notes sur l'école," pp. 675–83, esp. pp. 675–7.

16. For van Gogh's extant letters to Bernard, see *The Complete Letters of Vincent van Gogh*, ed. V. W. van Gogh, trans. J. van Gogh-Bonger and C. de Dood, 3 vols. (Greenwich, CT, 1959), vol. 3, pp. 473–527. (Hereafter cited parenthetically as CLVG3, followed by the number of the letter in question.)

17. At different times in his life, Bernard provided varying – and occasionally contradictory – accounts of the events of this period. In fact, he sometimes belies himself in the course of a single publication. In the 1954 "L'Aventure de ma vie," Bernard reports on p. 30 and again on p. 49 that his mother and sister joined him at Pont-Aven in 1888. However, in "Note 1" on p. 57 of the same volume, he states: "I passed my vacation at Pont-Aven (August–September), coming from Saint-Briac, where only my sister was with me. We found Gauguin at Pont-Aven at the Pension Gloannec [*sic*], where we also stayed." Amishai-Maisels, *Gauguin's Religious Themes,* p. 65, n. 51, concludes that the variation that has Madeleine accompanying the artist from Saint-Briac is probably accurate: "it would explain why Gauguin greeted [Bernard] so warmly, when in 1886 he had no time to waste on him."

Although Gauguin mentioned Bernard's presence at Pont-Aven in a letter to Schuffenecker postmarked August 14 (M. 159), many scholars have assumed that Emile and his sister did not arrive until mid-August. The fact that Gauguin signed the painting he presented to Mme Gloanec on her fête day – which fell on August 15 – not with his own name, but with that of "Madeleine B," indicates that the young woman must have been in Pont-Aven long enough by that date to have aroused Gauguin's interest.

18. The artist wrote Theo van Gogh on October 7 or 8, announcing that Mme Bernard, who would be leaving for Paris in a day or two, had agreed to deliver several new paintings to Theo on her return (M. 167). Presumably, Madeleine returned to the capital with her mother. Although the question has never been explored in the literature, it seems entirely possible that Gauguin's subsequent decision to accept van Gogh's invitation to join him in Arles was directly related to the fact that Madeleine was no longer on the scene.

19. Gauguin and his comrades took their meals in a small side room at the inn, while the academic painters, led by Gustave de Maupassant, dined at the "Grande Table" in the main dining room. Sérusier, who had contacts in the latter group, took his meals with them. His reluctance about approaching Gauguin may have been reinforced by the contempt with which de Maupassant viewed the master and his fellow "Impressionists." See C. Boyle-Turner, *Paul Sérusier* (Ann Arbor, 1983), p. 9.

20. Boyle-Turner, pointing to the fact that the artist never exhibited this painting during his lifetime, argues that "neither Sérusier nor Gauguin ever considered the work a finished painting, but saw it, rather as the demonstration of a working method, a way in which to begin a synthesist painting." Ibid., p. 15.

21. Rewald, *Post-Impressionism*, p. 253.

22. For further details about Sérusier's relationship with Gauguin, see M. Guicheteau, *Paul Sérusier* (Paris 1976), pp. 11–41. On Sérusier's role in the formation of the Nabis, consult Boyle-Turner, *Paul Sérusier*, pp. 17–34 and passim. See also Charles Chassé, *The Nabis and Their Period*, trans. Lund Humphries (New York, 1969), pp. 43–54 and passim.

23. For a more detailed discussion of the evolution of the Nabis movement, see Chassé, *The Nabis and Their Period*.

24. During his sojourn at Saint-Briac in the spring of 1988, Bernard encountered the young Symbolist poet and art critic, G.-Albert Aurier, who responded enthusiastically to the bold new works the artist had painted there. Bernard subsequently introduced him to all his artist friends, including Gauguin. Aurier took an active role in founding the *Mercure de France,* in which many articles devoted to avant-garde art appeared, including his own 1891 essay (see n. 3) on the Symbolist movement, which played an important part in promoting Gauguin's reputation among the artistic avant-garde.

25. For a more complete exploration of Bernard's role in directing Gauguin's attention to Breton religious art, consult Amishai-Maisels, *Gauguin's Religious Themes*, pp. 16–20 and passim.

As Kirk Varnedoe points out, Gauguin's primitivism was rooted in eclecticism, an attitude nowhere more evident than in his ceramic produc-

tion, which combines elements derived from a wide range of sources. On the artist's primitivism as "a model of impurity," see Varnedoe, "Gauguin," pp. 184–5.

For photographs of Gauguin's ceramic production from this period, see Christopher Gray, *Sculpture and Ceramics of Paul Gauguin* (Baltimore, 1963), pp. 12–32.

26. On Madeleine's espousal of local costume, see Bernard, *Souvenirs inédits,* p. 15. Her photograph in Breton costume appears on p. 17.

27. Françoise Cachin, for example, states: "It is well known that Gauguin fell in love with Madeleine, who appears to have preferred Laval." See Cachin in Brettell et al., *Gauguin,* exh. cat., p. 106.

28. Bernard, *Souvenirs inédits,* p. 11.

29. Ibid., p. 17.

30. Cachin suggests that the truncated picture behind Madeleine's head – a reproduction of a detail from an engraving by J. L. Forain depicting the backstage life of two young ballerinas – may have been intended to contrast "the virtuous gravity of the model" with the frivolous, promiscuous existence led by many young dancers of the day. See Cachin in Brettell et al., *Gauguin,* exh. cat., no. 51, p. 106.

31. For the complete text of this letter, see M. 173. As numerous scholars have pointed out, androgyny was a fashionable preoccupation of the Symbolists, and one that Gauguin frequently featured in his art.

According to Bernard, "L'Aventure de ma vie," p. 61, n. 2, his father interecepted this letter and, "not comprehending the ideas it contained, found them dangerous. He wrote a violent letter to Gauguin forbidding him to correspond with Madeleine." Gauguin apparently did not try to contact Madeleine again until late 1889 or early 1890, when he appended a note to her on the reverse of a letter he wrote Emile from Le Pouldu. In this letter he offered the young woman his ceramic *Self-Portrait as a Grotesque Head* (Musée d'Orsay, Paris), but she evidently refused the gift. Both this note to Madeleine and the accompanying letter to Emile are reproduced in Bernard's "L'Aventure de ma vie," as letter 9, pp. 89–90. On the significance of the *Self-Portrait as a Grotesque Head,* see Cachin in Brettell et al., *Gauguin,* exh. cat., no. 65, pp. 128–9.

In the absence of definitive proof to the contrary, it is tempting to assume that Gauguin created his *Vase in the Form of a Woman's Head* (Dallas Museum of Art), which was completed in the winter of 1889, *in response to* Madeleine's rejection of his ceramic. Although this piece has traditionally been identified as a portrait bust of Mme Schuffenecker, Deborah Goodman, a research assistant who worked on the Gauguin retrospective, suggested to Charles Stuckey that it actually portrays Madeleine Bernard. See C. Stuckey, "L'Enigme des pieds coupés," in *Gauguin: Actes du colloque Gauguin, Musée d'Orsay 11–13 janvier 1989* (Paris 1991), p. 53 and n. 15. When the Gauguin retrospective was shown at the Art Institute of Chicago, the bust was installed in close proximity to the artist's painted portrait of *Madeleine Bernard,* a juxtaposition that irrefutably demonstrated the accuracy of Goodman's observation.

Although Gauguin's vase-portrait emphasizes Madeleine's glamour, it also teems with evidence of the artist's deep ambivalence toward his subject, whom he has depicted as the temptress Eve, with a faun-like ear and

a snake twined in her tresses in lieu of a ribbon. So that there could be no mistake about the symbolic import of the reptile as the snake of Eden, Gauguin represented a second serpent on the rear of the ceramic, coiled in a tree.

The vase also features bizarre anatomical details suggestive of the artist's underlying violent fantasies toward Madeleine: The bottom plane of the vase bisects the young woman's breasts just below the nipples, as though they had been sliced through. This motif is once more echoed on the rear of the piece, which features the subject's "severed" hand clutching her bald crown, her thumb slipped into a flap of flesh partially cut away from her head, to reveal a woundlike opening, apparently intended to hold flowers. Surely the history of art reveals no more ambivalent homage to one's beloved!

A year later, during the winter of 1890–91, Gauguin painted *The Loss of Virginity* (Chrysler Museum, Norfolk, Va.), a composition rich in symbolic connotations, including suggestions of the artist's continued ambivalence and bitterness toward Madeleine, as well as toward her brother. The painting represents a nude maiden lying stiffly in a meadow, with her arm around a fox (the latter explicity identified by the artist as the "Indian symbol of perversity"), who rests his paw on her breast. In her other hand, she clasps a blood-red iris, symbol of her sexual penetration.

During his 1888 sojourn at Pont-Aven, Bernard had depicted his virginal sister lying (fully clothed) in the Bois d'Amour in a pose so similar to the one Gauguin adopted for his fallen woman as to render his mockery unmistakable. The fact that he substituted for Madeleine the figure of Juliette Huet, a young woman whom he seduced and subsequently abandoned, pregnant, when he departed for Tahiti in April 1891, strongly suggests that he had not yet renounced his designs on Mlle Bernard. For a rich discussion of the iconography of *The Loss of Virginity* and its interconnections with Bernard's *Madeleine in the Bois d'Amour,* consult Andersen, *Gauguin's Paradise Lost* (New York, 1971), pp. 98–108.

32. Amishai-Maisels, *Gauguin's Religious Themes*, pp. 30–1.
33. The relevant passages can be found in the beautiful epistle that van Gogh sent Bernard at the end of June 1888: "[Christ] lived serenely *as a greater artist than all other artists,* despising marble and clay, as well as color, working in living flesh." Later in this same missive, he observed: "I don't like the Roi-Soleil any more than you do – to me he seems more of an extinguisher, this Louis XIV – my God what a lousy bore in general, this sort of Methodist Solomon. I don't like Solomon either, just as I don't like the Methodists the least little bit; Solomon seems a hypocritical heathen to me...." (CLVG3: B8)
34. Amishai-Maisels, *Gauguin's Religious Themes*, pp. 21–2.
35. The letter in which Gauguin informs van Gogh of the existence of this album has disappeared, but Vincent mentioned this fact to Theo in an undated letter written in August 1888 (CLVG3: T521). Throughout his correspondence with Bernard, van Gogh adopted a very fatherly tone, providing his younger colleague with constructive criticisms of the latter's compositional drawings and counseling him on every aspect of his existence, from his artistic development to his diet and the regulation of his sexual life. For examples, see the letters to Bernard, CLVG3, pp. 473–527.

36. During the second half of June, while Bernard was suffering his religious crisis, van Gogh returned to one of his seminal themes, *The Sower* (Rijksmuseum Kröller-Müller, Otterlo, The Netherlands), creating a new version of the composition that depicted his protagonist silhouetted against a vibrant sun. He later reworked this painting extensively, transforming it into a work that Pickvance has described as deliberately exploiting a language of color symbolism. See Ronald Pickvance, *Van Gogh in Arles*, exh. cat. (New York, 1984), no. 49, p. 103. The artist included a sketch of his initial version of the painting in a letter to Bernard written during the second half of June; see CLVG3: B 7; illus. p. 492. In mid-July, van Gogh noted in a letter to Bernard (B18) that he had sent the younger artist an independent drawing of the second, definitive version of the canvas, along with eight additional sketches. The drawings by van Gogh, which Bernard assembled in an album and shared with Gauguin, undoubtedly included this sketch.

 Although the theme of the sower is replete with biblical associations, neither the painting nor the two drawings just mentioned appears to contain any overtly religious symbolism. However, in a recent monograph, Tsukasa Kodera argues that van Gogh's late depictions of rural themes, such as the sower, reveal a "naturalization of religion," accomplished by the "manipulation and transformation of the church motif in his work." As one of his major examples, Kodera points to the fact that Vincent's earlier depictions of the sower – a seminal motif in his art – represented "a church tower precisely at the back of the sower's head. This unnatural and somewhat peculiar manner of composition shows clearly how van Gogh manipulated the motifs to stress the religious implications of the sower." However, when the artist returned to this motif following his move to Arles, he typically showed the sun occupying the place in the composition that had belonged to the church in the earlier versions. See T. Kodera, *Vincent van Gogh: Christianity versus Nature* (Amsterdam & Philadelphia, 1990), pp. 22–39, esp. pp. 29–30. The fact that in a letter to Theo written on June 16 (CLVG3: T503), Vincent compared the color symbolism of *The Sower* to that employed by Eugène Delacroix in one of his religious paintings, *Christ on the Sea of Galilee*, suggests that Kodera's point may be well taken. Whether Bernard and Gauguin would have recognized the religious symbolism encoded in the composition of *The Sower* remains a moot point; however, Bernard, if not Gauguin, would surely have been familiar with the many biblical allusions to this theme.

37. Many participants fulfilled penitential vows during the course of the pardons. Penances typically included acts such as traveling barefoot the entire route to the locale of the pardon, or circling the church enclosure three times on one's knees while saying the rosary, etc. Some locales also boasted a special fountain dedicated to the saint honored in the pardon, and the faithful often bathed in these waters. On such customs, see Yann Brekilien, *La vie quotidienne en Bretagne* (Paris, 1966), pp. 204–6.

38. The pardon at Pont-Aven no longer exists in the traditional form described here. The so-called pardon now held there on the first Sunday in August has assumed the character of a town fair.

39. In most areas, presumably including Pont-Aven, the events of Saturday evening featured the lighting of a special fire by the parish priest; typically

built on the nearest promontory, these large bonfires illuminated the surroundings, turning the nearby fields glowing red. See Brekilien, *La vie quotidienne,* p. 205. See also Katherine Macquoid, *Through Brittany: South Brittany* (London, 1877), p. 262. This practice was surely a vestige of Celtic ceremonies featuring sacred fires.

The church that was the site of the celebration remained open throughout the night, lit by hundreds of candles, which illuminated the stained-glass windows. Pilgrims congregated there to offer prayers, sing hymns, light tapers, and kiss the relics exposed before the choir. During this vigil, especially devout – or especially penitent – participants circled the church on their knees. Many pilgrims remained in the church until daybreak, some to fulfill penitential vows, others – especially the indigent drawn to the festivities in the hopes of securing alms – because they had no place to spend the night. See Brekilien, *La vie quotidienne,* pp. 204–6.

40. Mendicants and cripples lined the road, begging the pilgrims to guarantee forgiveness of their sins by acts of charity, and even offering to perform penances as surrogates for alms givers. For further details, see Brekilien, *La vie quotidienne,* pp. 204–5.

41. According to Brekilien, these youths not only vied to see who could carry their heavy burdens throughout the procession without wavering, but also engaged in a bloody combat at the end, battering one another with their banners and statues until they fell to pieces (customs probably also derived from ancient Celtic practices); ibid., pp. 207–8. These battles became so bloody, even resulting in fatalities, that the Breton bishops finally issued an ordinance forbidding them; from 1856 on, this ordinance was enforced by police supervision.

42. For details, consult Macquoid, *Through Brittany,* pp. 280–1, and Brekilien, *La vie quotidienne,* p. 208. For illustrations of paintings depicting aspects of nineteenth-century pardons, see also G. P. Weisberg, "Vestiges of the Past: The Brittany Pardons of Late Nineteenth-Century French Painters," *Arts* 55, no. 3 (Nov. 1980), pp. 134–8.

43. For information on the Breton costumes, see Macquoid, *Through Brittany,* pp. 276–7. Consult also Jean Choleau, ed., *Costumes et chants populaires de Haute-Bretegne* (Paris, 1954).

44. Macquoid, *Through Brittany,* pp. 260–1.

45. These wrestling matches were apparently very rough. P. J. Hélias, who describes the now-discontinued pardon formerly held at Loc (Brittany), emphasizes the bloody nature of these contests, noting that, at the close, "Men covered with blood would take the sunken roads that led home savoring their triumphs or pondering their defeats." According to Hélias, the Loc pardon was finally abolished because of drunkenness and pitched battles associated with the festivals. See P. J. Hélias, *The House of Pride: Life in a Breton Village* (New Haven, 1978), p. 122.

Sérusier's painting *Breton Wrestling Match* (Fig. 23), which depicts a match he witnessed probably during the pardon held at Pont-Aven in 1893, features a smartly uniformed military or police official, who stands in a prominent spot immediately behind the contestants, presumably both to keep order among the spectators and to prevent the contestants from brutalizing one another.

46. Apparently convinced of the falsity of Bernard's claim that Gauguin had

plagiarized his work, Herban completely rejects the notion that *The Vision* could have been inspired by the pardon at Pont-Aven, which occurred *after* Emile's arrival. Herban proposes that Gauguin's canvas memorializes instead aspects of the Pardon of Saint Nicodemas held in Saint Nicholas-des-Eaux in Morbihan on August 4–5 in 1888. See Matthew Herban, "The origin of Paul Gauguin's *Vision after the Sermon, Jacob Wrestling with the Angel* (1888)," *Art Bulletin* 59, no. 3 (Sept. 1977), pp. 415–20. The statement quoted above can be found on pp. 417–18.

However, it seems unlikely that the Morbihan celebration could actually have been the source of Gauguin's inspiration. First of all, Morbihan is sixty-five miles from Pont-Aven, and we have no proof that the artist and his band ranged that far afield in their search for interesting religious festivals to attend. Second, the women of Morbihan wore dark blue or black bonnets, whereas those portrayed in *The Vision* wear the white headdresses characteristic of Pont-Aven.

Finally, by the late nineteenth century, the Pardon of Saint Nicodemas had evidently fallen into a state of decline. By the time Katherine Macquoid attended this pardon around 1875, many of the rituals formerly associated with it had either been abandoned or were observed in a much diluted manner. See Macquoid, "The Fair of St. Nicodème," *Temple Bar* 46 (Jan.–April 1876), pp. 386–99. For example, the custom of blessing the cattle, once a feature of the occasion, had fallen into disuse (p. 396). Although she witnessed the procession of clergy and choristers around the bonfire, Macquoid made no mention of seeing cattle being led through the glowing ashes (a feature Herban suggests as the inspiration for the vermilion background of *The Vision*) perhaps because this custom, too, had been abandoned. According to Macquoid (p. 393), apart from the ritual shaving of eligible bachelors and the ceremony surrounding the lighting of the bonfire (pp. 397–9), few vestiges of the time-honored rituals once associated with this pardon were still practiced by the time she visited there; instead, she describes the celebration primarily as an occasion for commerce and drunkenness. During their visit, Macquoid and her party saw no indication that preparations for the wrestling matches and dancing, supposedly scheduled for the second day of the fête, were underway (perhaps because these features had also fallen into a moribund state), so they decided to push on at the close of the first day's activities (p. 399).

47. For the complete text of this letter, see M. 165. Aurier's account, "Symbolism in Painting: Paul Gauguin," pp. 155–6, which was surely based on information obtained from Gauguin, provides very detailed descriptions of the church in which the sermon took place, and of the appearance and vocal characteristics of the priest who delivered the homily. Although the critic probably embellished Gauguin's factual account to make it more poetic, Aurier's essay definitively traces the inspiration for the picture to a specific sermon heard by the artist.

48. Bernard, "Notes sur l'école," pp. 679–80.

49. A recent expression of such skepticism comes from Frèches-Thory (in Brettell et al., *Gauguin,* exh. cat., no. 50, p. 103), who argues – in a rather confused statement – that Gauguin had begun *The Vision* in mid-August: "The dispute between Bernard and Gauguin has caused so much ink to flow that we need only outline it here. Basically, when Bernard arrived in

Pont-Aven in mid-August, he either brought with him or immediately painted the annual pardon at Pont-Aven, which took place on 16 September 1888."

50. Ibid., p. 102.

51. For van Gogh's comments to his brother about Gauguin's current projects during the latter's tenure in Arles, see CLVG3: T558a–563.

52. Both men made use of virtually identical visual "raw material," but they achieved strikingly different results. Sérusier stuck to the facts: He granted his two contestants pride of place and scale in the foreground of his canvas, while massing the small-size spectators at the back of the picture plane, where they perform only a minor decorative function. By contrast, Gauguin focused – to great dramatic effect – on a group of female spectators and their marvelous costumes. By isolating his biblical wrestlers in their own compartmentalized space, Gauguin simultaneously directed our attention to the two hallucinatory contestants, who have been willed into existence by the visionary powers of the pious peasant women.

53. Herban, "Origin of Paul Gauguin's *Vision*," p. 419, contrasts the image of the bearded, unredeemed Jacob with the appearance of the clean-shaven, redeemed bachelors whom Gauguin would have observed during the Breton pardons. However, he does not specifically identify the male figure in the right foreground as a redeemed bachelor, as this essay does; rather, Herban calls him a priest, without elaborating on his structural or symbolic role in the painting, except to note that he would have commemorated the Eucharistic sacrifice in the mass (p. 417).

54. Ibid., p. 420. For Herban, Jacob's contest with the angel symbolizes the struggle for truth and redemption that constituted prerequisites for receiving God's blessing and undertaking the journey into the promised land. He notes that this motif is repeated by the introduction of the apple tree (specifically identified as this species by the artist in his letter to van Gogh), the instrument of humanity's fall from grace and, by implication, a reference to our rescue by Christ's voluntary martyrdom. Herban suggests that the cow not only symbolizes the bovine offerings to the sun god made by the pagan Celtic ancestors of the Bretons, but also alludes to the animal sacrifices made by the Jews of the Old Testament, such as that recounted in Ezekiel 43:18–27. For Herban, Ezekiel's offering was "both an archetype of Christ's sacrifice and also the redemptive act, which the priest shown in the painting would commemorate in the Eucharist each Sunday morning" (p. 417).

According to Herban, this implicit emphasis on the mass and the Eucharist is reinforced by the vermilion background of *The Vision*, which recalls the fact that the people who attended pardons were offered gifts of bread made of buckwheat, a grain that takes on a reddish tone as it ripens. The bread, of course, again refers to the Eucharistic sacrifice and the communion of the faithful (p. 419).

55. See Amishai-Maisels, *Gauguin's Religious Themes*, p. 31.

56. It should be noted that Aurier, "Symbolism in Painting: Paul Gauguin," pp.155–6, fails even to allude to the image of the young man, much less to identify him as the artist's alter ego. Nor does Aurier point to the special role of the youthful virgin. These omissions seem all the more significant in view of the fact that the critic surely discussed the painting with Gauguin

himself, who evidently withheld this crucial information from Aurier, just as he had from his friend van Gogh.

57. Jirat-Wasiutynski, "Paul Gauguin's Self-Portrait with Halo and Snake: The Artist as Initiate and Magus," *Art Journal* 46, no. 1 (Spring 1987), pp. 25 and 28, nn. 16–18, also identifies these two images as those of Gauguin and Madeleine. He proposes that Gauguin appears here in the role of a priestly magus, whereas Madeleine represents the initiate experiencing the vision. He argues that Gauguin's celebrated letter to Madeleine, written around October 15–20 (M. 173), in which he counseled her to be androgynous, reveals his familiarity with the writings of Joséphin Péladan, who published a series of esoteric novels during the 1880s dealing with the character of the magus. The author "gave many of his magi artistic talents, and he placed the magus in an elite that he characterized as having descended from the fallen angels" (p. 25).

58. Gauguin would soon openly portray himself as *Christ in the Garden of Olives* (Norton Gallery of Art, West Palm Beach, Fla.), which depicts the Savior agonizing as the moment of his betrayal approaches.

59. Our gratitude to Dr. John E. Gedo for this observation, personal communication, March 1991.

60. The interested reader should consult the Appendix for a synopsis of aspects of the story of Jacob relevant to this essay.

61. Mark Roskill was the first to point out this formal analogy. See Roskill, *Van Gogh, Gauguin, and the Impressionist Circle* (Greenwich, Conn., 1970), pp. 104–5. Wayne Andersen, *Gauguin's Paradise Lost*, pp. 60–1, also notes this resemblance. Although Andersen's interpretation of *The Vision* is generally congruent with our views, his claim that Gauguin borrowed the cow (and the red background of his painting) from a bovine portrayed in Piero di Cosimo's *Forest Fire* seems open to question.

62. Bernard, "Notes sur l'école," p. 680, was probably the first person to call attention to the resemblance between Gauguin's contestants and the Hokusai wrestlers. Several scholars have argued that although Gauguin certainly utilized the Hokusai prints to develop the posture of Jacob and the angel, their pose cannot be identified with any single work from the series. See, e.g., Wladyslawa Jaworska, *Gauguin and the Pont-Aven School*, trans. Patrick Evans (New York, 1972), pp. 23–4. Amishai-Maisels disagrees, pointing out that, although Gauguin reversed the figures, his source was the pair of wrestlers illustrated on the center top of pp. 52–3 in Hokusai's *Mangwa* album no. 6. See Amishai-Maisels, *Gauguin's Religious Themes*, pp. 25 and 63, n. 40. For his assessment of the role Japanese art played in Gauguin's artistic evolution in general, and in the genesis of *The Vision* in particular, see Varnedoe, "Gauguin," p. 185. See also Varnedoe's *A Fine Disregard: What Makes Modern Art Modern* (New York, 1989), pp. 89–94, 193, and passim.

Consult also Denise Delouche, "Gauguin et le thème de la lutte," in *Gauguin: Actes du colloque Gauguin,* pp. 157–71, both for the author's interesting comment about the importance of this motif in Gauguin's work during the summer of 1888, and for her reproduction of several late-nineteenth-century illustrations of Breton wrestlers.

63. Andersen, *Gauguin's Paradise Lost*, p. 60.

64. See Herban, "Origin of Paul Gauguin's *Vision*," p. 415. Jirat-Wasiutynski

argues that, contrary to Herban's assertion, Gauguin portrayed only eleven women. The ambiguous treatment of the figures clustered in the upper-left corner permits them to be read as either four or five figures. Like Herban, we count twelve women, the last of them all but concealed by the foliage of the apple tree. It should be noted, however, that at the time of the incident depicted in *The Vision,* Jacob's twelfth son, Benjamin, had not yet been born, although Rachel was pregnant with him at the time. For Jirat-Wasiutynski's comments and Herban's response, see the Letters to the Editor, *Art Bulletin* 60, no. 2 (June 1978), pp. 397–8.

65. The muted, red-brown hue of the apple tree permits it visually to sink into the vermilion ground, transforming it into a streambed.

66. The setting itself, as well as the sermon Gauguin apparently heard there, may have played a role in the genesis of *The Vision.* As previously noted, by the time he painted this picture, the artist, in company with the Bernards, had probably been attending services at the Pont-Aven church for several weeks. Amishai-Maisels, *Gauguin's Religious Themes*, pp. 30–1, suggests that, during the course of services, Gauguin's wandering attention may have been attracted to the striking effects created by the figures of the pious women of the parish, clad in their luminous coifs, silhouetted against the stained-glass windows of the apse. These windows, dating from c. 1875, depict large-scale figures, rendered with minimal grisaille modeling, against vivid red or blue backgrounds. Amishai-Maisels points out that the similarity of the heads portrayed in the painting to those viewed against stained glass is heightened by the touches of chrome yellow that Gauguin added to the faces and to the tree, "so that they seem to reflect light filtering through windows located to the right, where the fight takes place."

67. In two letters, both written around October 8 and addressed to Schuffenecker and Theo van Gogh (M. 167 and 168, respectively), the artist repeated the information that his offer had been rejected, but did not specify the name of the church in question.

68. See Bernard, "L'Aventure de ma vie," pp. 27–8. By signing the painting in this manner, Gauguin proclaimed his affiliation with the noble Peruvian family from which his maternal grandmother, Flora Tristan, was descended. (For additional details, see n. 7.)

69. Ibid., pp. 27–30.

70. Subliminal faces can be found in a number of Gauguin's works from this period. A face emerges from the waterfall behind the struggling boys depicted in *Children Wrestling* (1888, Josefowitz Collection); the artist concealed his self-portrait in the foreground bush of the *Old Women of Arles* (1888, Art Institute of Chicago).

No one has examined Gauguin's subliminal double-images in as much detail as they deserve. These images are certainly intentional, and were probably meant to draw the viewer into a deeper discourse with Gauguin's art; but they may also have had a profoundly personal meaning, of which the artist himself may not have been fully aware.

For one of the few discussions of Gauguin's hidden images, see Alan C. Bienholz, "Double Images Reconsidered: A Fresh Look at Gauguin's *Yellow Christ,*" *Art International* 211 (Oct.–Nov., 1977), pp. 26–34.

71. In his final text, *Avant et Après,* Gauguin mentioned that his mother had a small collection of Peruvian vases and silver figurines, which were destroyed when her home in St. Cloud was burned on January 25, 1871, by the invading Prussian army. For the artist's comment, consult the more readily available English version, published as *Paul Gauguin's Intimate Journals,* trans. Van Wyck Brooks, with a preface by Emile Gauguin (Bloomington & London, 1968), p. 194. The Peruvian source of a number of Gauguin's ceramics has frequently been noted, but the archaic nature of the hidden faces in *The Vision* has not been pointed out in the literature.

72. For this letter, see M. 168. Gauguin's statement that *The Vision* was not only painted for a church, but is a picture *of a church* has always puzzled critics. Aurier, "Symbolism in Painting: Paul Gauguin," pp. 155–6, poetically explains that the eloquence of the village priest had cast such a spell over his congregation that the church, its furnishings, and the priest himself "dispersed into vapors" before their eyes, while his voice alone became visible, "imperiously visible." Another possible explanation for the artist's comment suggests itself. In the letter he wrote van Gogh about the painting (M. 165), Gauguin followed his description of the apple tree with this enigmatic statement: "Le terrain, vermillon pur. A l'église il [i.e., the apple tree] descend et devient brun rouge." Jesus had said, "Where two or three are gathered together in my name, there I am also," implying that the body of true believers, rather than a physical structure, constitutes the church. Perhaps Gauguin intended the five heads in the foreground of *The Vision,* into which the red-brown tree trunk descends, to represent the church.

 However, in a personal communication, Jirat-Wasiutynski indicated that he believes the artist was referring to the way the red light descended within the church, that is, toned down to red-brown in the dim luminosity of the stained glass. For yet another interpretation of Gauguin's meaning, see Herban, "Origin of Paul Gauguin's *Vision,*" pp. 418–19.

 One last possibility should also be considered. As previously noted, Brekilien, *La vie quotidienne,* p. 206, mentions that the size of the crowds attending the special high masses held in conjunction with pardons invariably exceeded the capacities of the churches, forcing most of the devout to participate in front of the structure, rather than within it. Perhaps Gauguin's statement literally alluded to the fact that his canvas represented a group of pious peasants who were mesmerized by the sermon *while participating outdoors in the mass being celebrated within the church.* To the authors, this explanation seems the most persuasive.

73. Gauguin's painting provoked a scandal at the exhibition. Among the critics who reviewed the show, only Octave Maus singled the picture out for praise. See O. Maus, "Le Salon des XX à Bruxelles," *La Cravache,* no. 417 (February 16, 1889), p. 1.

74. Although Aurier's article was written before the auction took place, it was not published until after the event. Despite the tardy appearance of the article, the sale was quite successful, adding 9,350 francs to Gauguin's coffers. For further details, consult Rewald, *Post-Impressionism,* pp. 438–45.

75. Bernard, *Souvenirs inédits,* p. 12, later claimed that his sister had rushed up to Gauguin at the auction and cried, "M. Gauguin, you are a betrayer. You have done my brother a grave injustice. You have stolen his style, by which you now claim so much on your own behalf." Whether Madeleine ever uttered the statement which her brother attributes to her remains an unresolved question.

Bernard, like Gauguin, had extensive contacts with the Symbolist literati. Among the few writers who refused to be impressed by Gauguin, Félix Fénéon was receptive to Bernard's poisonous influence, and he published in *Le Chat Noir* (May 23, 1891) a piece entitled "Paul Gauguin," an ironic attack on the artist. For these and other details of the Bernard–Gauguin relationship in 1890–1, see Rewald, *Post-Impressionism,* pp. 405–56, esp. p. 422 and n. 30, p. 455, and pp. 444–7. See also Jirat-Wasiutynski, "Emile Bernard and Paul Gauguin," pp. 53–7.

The letters from Madeleine to her brother included by Henri Dorra in his selections from Bernard's unpublished correspondence reflect her appreciation of Gauguin's style. See Dorra, "Extraits de la correspondance d'Emile Bernard des débuts à la Rose Croix (1876–1892)," *Gazette des Beaux-Arts,* 6th ser., no. 96 (Dec. 1980), pp. 235–42.

In January or February 1892, Madeleine wrote her brother a perceptive and encouraging letter, designed to calm his resentment against Gauguin. She quoted from the article published by J. Durelle in *L'Echo de Paris,* Dec. 28, 1891, which praises Bernard's independent style and denies that his work resembled that of Gauguin. For Madeleine's letter, see Rewald, *Post-Impressionism,* p. 498, n. 10. Durelle's essay appeared in response to a small exhibition of works by Anquetin, Lautrec, Dennis, Bonnard, and Bernard, held in Paris in December 1891. Durelle interviewed all five participants and quoted Bernard at length. For the text of this interview, see Rewald, op. cit., pp. 462–3.

76. For his comment about Madeleine's costume, see Bernard, *Souvenirs inédits*, p. 11.

77. Ibid., p. 15. In 1893, Bernard left France and traveled extensively abroad before settling in Cairo, where Laval joined him. Madeleine followed her fiancé to Cairo, where she cared for him until his death of tuberculosis in 1894; the following year, she, too, succumbed to a tubercular infection. Bernard stayed on in Cairo until 1904, except for brief trips to the continent, and a longer, three-month stay in Paris in 1901. He married a Lebanese woman, Hannah Saati, in 1894, with whom he had five children, at least three of whom died in infancy or shortly thereafter.

During his 1901 stay in Paris, Bernard met Andrée Fort, the sister of the poet, Paul Fort, and she returned to Cairo with the artist, whose wife eventually left him because of this liaison. He returned to France permanently in 1904, dividing his time between Paris and Tonnerre. He was active as a writer as well as a painter and in 1905, he founded *La Rénovation Esthetique,* a reactionary journal dedicated to the revival of Catholic liturgical art and the promulgation of the extremely conservative views he now espoused.

For a recent account of Bernard's life, consult the chronology by M. A. Stevens in *Emile Bernard 1868–1941,* exh. cat., pp. 92–102, from

which these facts were drawn. In the same catalogue, see also Zirat-Wasiutynski's essay, "Emile Bernard and Paul Gauguin," pp. 48–67.

78. See Bernard, "Lettre ouverte," pp. 332–9. This quotation appears on p. 334.

79. See Bernard, "Notes sur l'école," pp. 675–82.

80. Consult Bernard, *Souvenirs inédits*, p. 9.

81. Bernard-Fort, "La Verité sur les relations," p. 7. This article is filled with other errors, in addition to the claim that Gauguin had followed Pissarro into Seurat's divisionism, a style that Gauguin always professed to despise and certainly did not adopt. Bernard's 1939 *Souvenirs inédits* contains factual errors of a similar kind.

82. For these quotations, see CLVG3: T539. See also Merlhès, *Correspondence de Paul Gauguin*, no. LXX, pp. 225–7, for a digest of quotations referring to Gauguin and Bernard, culled from van Gogh's correspondence of this period. See also the artist's letters to Bernard from these same weeks (CLVG3: B15–19). For the most recent information on the Bernard–Gauguin relationship during 1888 and thereafter, consult Jirat-Wasiutynski, in *Emile Bernard 1868–1941*, exh. cat., pp. 48–67.

83. Bernard, *Souvenirs inédits*, p. 11.

84. See Jirat-Wasiutynski, "Paul Gauguin's Paintings, 1886–91," p. 42. Consult, too, Jirat-Wasiutynski, "Emile Bernard and Paul Gauguin," p. 51, where the author observes: "Gauguin had, in a very real sense, painted the symbolic religious image that Bernard would have wanted to produce. No wonder the young artist experienced, as Vincent van Gogh reported, awe and fear at his elder's skill and assimilative powers! Resentment was not far behind: *The Vision after the Sermon* became the focus of all of Bernard's future claims of primacy as though he wanted to reclaim it as his own painting."

 For his part, there can be no question that Gauguin sincerely admired Bernard's *Breton Women*. Before leaving Pont-Aven in October 1888, Gauguin traded an unidentified canvas of his own (perhaps the portrait of Madeleine, which once belonged to Bernard) for the *Breton Women*, which he took with him to Arles, where he showed it to van Gogh, who pronounced it "superb" (CLVG 3: T562). Sometime that fall, van Gogh made a watercolor version of Bernard's picture, known today as *Breton Women and Children*. In discussing this watercolor, Pickvance, *Van Gogh in Arles*, exh. cat., no. 125, p. 213, observes: "[Van Gogh's] profound admiration for this painting is therefore fully documented. Never, however, did he think of it as a pardon, a painting with religious overtones, or as a rival prototype or a catalyst to Gauguin's *Vision after the Sermon* (*Jacob Wrestling with the Angel*), painted at Pont-Aven in September 1888."

 It seems inconceivable that Bernard would have so readily agreed to exchange his *Breton Women* for a canvas by Gauguin had the younger artist been convinced *at the time* that Gauguin had plagiarized his composition in creating *The Vision*. Significantly, Bernard either repressed the fact that this exchange had occurred, or at least fails to mention it in any of his published remarks about this controversy.

85. Sven Loevgren, *The Genesis of Modernism: Seurat, Gauguin, van Gogh & French Symbolism in the 1880's*, trans. (Bloomington & London, 1971),

pp. 127-8, comments about the Bernard canvas: "Even a superficial glance at Bernard's *Bretonnes dans la prairie*, will show that the work is completely devoid of the rich and complex structure that characterizes Gauguin's painting. Bernard's canvas rather gives the impression of a series of robust figure studies on a sketchbook sheet. The picture has no emotional amplitude; all the interest is centered around the folklore. Vincent van Gogh copied the picture in water colors and gouache the same autumn and could not resist the temptation to improve it. In other words he gave his copy a coloristic and psychological center of interest around which the other figures were spontaneously grouped."

86. In his reevaluation of the Bernard–Gauguin problem, Victor Merlhès comes down squarely on Gauguin's side. For his review of the crucial events and interactions between the two artists, as well as his assessment of Bernard's role in the creation of *The Vision,* consult V. Merlhès, *Paul Gauguin and Vincent van Gogh, 1887–1888: Lettres retrouvées, sources ignorées* (Tahiti, 1989), pp. 79–98. We are grateful to Peter Zhegers for calling our attention to this volume.

87. See also Mary Ann Stevens's intelligent discussion of the Bernard–Gauguin controversy and the question of "precedence in the 'invention' of pictorial symbolism." Stevens, "Figures in Landscape," in *Emile Bernard 1868–1941,* exh. cat., pp. 141–7, esp. pp. 143–6.

88. Jirat-Wasiutynski, "Paul Gauguin's Paintings, 1886–91," p. 42.

89. The crystallization of a paranoid system in Bernard's thoughts points toward the possibility that his actual grievance vis-à-vis Gauguin was the latter's preference for Madeleine, rather than for Emile himself. (His seeming opposition to Gauguin's courtship of his sister could have been fueled by his unconscious jealousy about her triumph within this triangle.) As Freud first stated in 1911, if men experience homosexual impulses that are utterly unacceptable to them, they are likely to transform them into hatred; such an unjustified attitude is then frequently rationalized on the basis of fantasies of some kind of persecution. "Psychoanalytic Notes on an Autobiographical Account of a Case of Paranoia (Dementia Paranoides)," Standard Edition of the *Complete Psychological Works of Sigmund Freud,* vol. 12, trans. and ed. James Strachey et al. (London, 1958), pp. 3–84. Freud summarized this in the formula: "I do not love him; I hate him. I hate him [only] because he hates and injures me."

3. The Archaeology of a Painting: A Visit to the City of the Dead beneath Picasso's La Vie

An earlier version of this material appeared in *Arts Magazine* 56:3 (November 1981), pp. 116–29.

1. See Theodore Reff, "Themes of Love and Death in Picasso's Early Work," in *Picasso in Retrospect,* ed. Sir Roland Penrose and Dr. John Golding (New York & Washington, D.C., 1973), pp. 11–47, esp. pp. 21–8.

2. Marilyn McCully and Robert McVaugh, "New Light on Picasso's *La Vie,*" *Bulletin of the Cleveland Museum of Art* (Feb. 1978), pp. 67–71.

3. E. A. Carmean, Jr., *Picasso: The Saltimbanques,* exh. cat. (Washington, D.C.), 1980, p. 17.

4. Sincere thanks to the Conservation Department of the Cleveland Museum of Art for making this loan possible. However, only the intervention of Timothy Lennon made it possible for me to deal with the numerous x-rays of this enormous canvas. He reassembled and mounted the composite radiographs, then devoted several hours to discussing their revelations with me. Thanks also to Faye Wrubel and Barry Bauman, then Assistant Curators of Conservation, who also devoted much time and energy to this project and joined with Lennon and me in studying the x-rays.

5. For these details, see Josep Palau i Fabre, "1900: A Friend of His Youth," *Homage to Picasso,* ed. by G. di San Lazarro (New York, 1971), pp. 3–12. Palau i Fabre does not repeat this hypothesis in his more recent study, *Picasso: The Early Years, 1881–1907,* trans. Kenneth Lyons (Barcelona, 1985), pp. 338–42. However, he incorrectly states that the painting was acquired by M. Saint-Gaudens.

6. The nude staring at the viewer has sometimes been identified as a man, but I agree with McCully and McVaugh, "New Light on Picasso's *La Vie*," p. 67, who identify all the figures in the background canvases as female.

7. Ibid., p. 67.

8. Ibid.

9. Ibid.

10. Lennon, Wrubel, Bauman, and myself agreed about this observation during discussion before the x-rays, August 5, 1981.

11. For details about Casagemas's history, see Palau i Fabre 1985, pp. 194–99, 210–14, and passim. The information about Casagemas's previous suicide attempt was originally published by Reff, "Themes of Love and Death," in an appendix entitled, "Manolo's Account of the Suicide of Casagemas," pp. 46–7. Manolo Hugué was a contemporary and friend of Picasso and Casagemas.

 See also John Richardson, with the collaboration of Marilyn McCully, *A Life of Picasso,* vol. 1, 1881–1906 (New York, 1991), pp. 118–21, 170–5, 180–2, 210–13, and passim for additional information about Casagemas.

12. For this period, see Richardson and McCully, *A Life of Picasso,* vol. 1, chap. 11, "First Trip to Paris," pp. 159–75.

13. For a recent official description of the etiology and symptoms of depression, see *Treatments of Psychiatric Disorders: A Task Force Report of the American Psychiatric Association,* vol. 3 (Washington, D.C., 1989), pp. 1751–66 and 1925–40.

14. This story appears in the sources cited in n. 11. The official police report of the incident is reprinted in Pierre Daix and Georges Boudaille, *Picasso: The Blue and Rose Periods, A Catalogue Raisonné of the Paintings, 1900–1906,* compiled with the aid of Joan Rosselet, trans. Phoebe Pool (Greenwich, Conn., 1967), p. 338.

15. See Mary M. Gedo, *Picasso – Art as Autobiography* (Chicago, 1980), n. 29, pp. 266–7.

16. For details see Richardson and McCully, *A Life of Picasso,* vol. 1, p. 181.

17. Two of these works were originally published by Daix and Boudaille, *Picasso: The Blue and Rose Periods,* cat. VI, pp. 5–6. For their belated inclusion in the catalogues raisonnés, see Christian Zervos, *Pablo Picasso,*

33 vols. (Paris, 1932–78), vol. XXI, nos. 177–9. (Hereafter, these catalogues will be referred to as Z. I, II, etc., with illustration numbers following a colon.) Z. XXI: 178, is now in the collection of the Musée Picasso, Paris; the other canvases remain in private hands.

18. McCully and McVaugh, "New Light on Picasso's *La Vie*," p. 67.
19. It was drawn on the reverse of a printed invitation, from the Secretary General to the Director of the Official School of Fine Arts, to the unveiling of a memorial portrait of a deceased professor, Bartolomeu Robert. See Gary Tinterow, *Master Drawings by Picasso*, exh. cat. (Cambridge, Mass., 1980), p. 48.
20. For this quotation, see Palau i Fabre, *Picasso: The Early Years*, p. 342.
21. Pierre Cabanne, *Pablo Picasso: His Life and Times*, trans. Harold J. Salemson (New York, 1977), reports that Picasso remembered working on the picture in his new studio.
22. This account appears in Jaime Sabartés, *Picasso: An Intimate Portrait*, trans. Angel Flores (New York, 1948), pp. 92–3.
23. See Reff, "Themes of Love and Death," pp. 13, 17, and passim.
24. Sabartés, *Picasso: An Intimate Portrait*, p. 96, specifically mentions that he saw the artist at least once a day throughout this period. One can only conclude that Picasso apparently deliberately deceived his friend about the history of this canvas.
25. Lennon made this remark in conversations held on August 5 and 7, 1981.
26. Reff, "Themes of Love and Death," p. 19, also points out many of these correspondences.
27. Ibid.
28. The letter in which the artist describes a preparatory drawing for this painting is reproduced in Jaime Sabartés, *Picasso: Documents Iconographiques*, trans. Felia Leal and Alfred Rosset (Geneva, 1954), doc. no. 84. Tinterow, *Master Drawings by Picasso*, exh. cat., p. 46, n. 3, points out that because Picasso's rather illegible handwriting has been mistranscribed, and the word *mère* misread as *soeur*, "the painting was for many years believed by several historians – Penrose, Reff, and others – to represent a prostitute and a nun."
29. The participants appear nude in many of the preparatory drawings for *Evocation* and *The Mourners*.
30. See J. E. Cirlot, *Picasso: Birth of a Genius* (New York & Washington, D.C., 1972), p. 151, nos. 262–4; p. 153, no. 267.
31. Daix and Boudaille, *Picasso: The Blue and Rose Periods*, p. 55, plausibly propose that Picasso worked on this painting during the summer of 1902.
32. Tinterow, *Master Drawings by Picasso*, exh. cat., p. 46, offers this hypothesis.
33. See Cirlot, *Picasso: Birth of a Genius*, p. 151, nos. 262–4; p. 269, no. 962.
34. Consult Reff, "Themes of Love and Death," p. 28, and Cirlot, *Picasso: Birth of a Genius*, p. 140, no. 238.
35. See [Gyula Halász] Brassaï, *Picasso and Company*, trans. Francis Price (New York, 1966), pp. 55–6.
36. Reff, "Themes of Love and Death," p. 28, and Tinterow, *Master Drawings by Picasso*, exh. cat., p. 52, citing Reff, both list Jan Runnqvist, *Minotauros – en Studie i Forhallendet Mellan Iknografi och Form i Picassos*

Kunst (Stockholm, 1959), p. 14, as the source of this identification. How-
ever, Runnqvist's account (pp. 11–15) is rather ambiguous, and it is not
clear whether he is referring to this self-portrait or to one of Picasso's con-
temporary sketches representing the unidentified bearded artist (Fontana?)
in his studio.

37. Josep Palau i Fabre, *Picasso by Picasso, Selbsbildnisse*, exh. cat. (Stuttgart,
 1970), pp. 90–1, was probably the first to identify this image as a self-
 portrait.

38. For these images, see Cirlot, *Picasso: Birth of a Genius*, p. 269, nos.
 960–1.

39. Phoebe Pool reports this observation in "The Picasso Exhibition: The
 Most Important Four Rooms," *Burlington Magazine* 102 (Sept. 1960),
 pp. 287–8.

 See also Françoise Cachin, *Gauguin*, trans. B. Ballard (Paris, 1990;
 Eng. ed.), pp. 268–9. The crouching posture of the figure in *Where Do
 We Come from?*, which Cachin compares with Picasso's similar image,
 recurs in a number of Gauguin's most important works. Derived from his
 observation of the similar pose of a Peruvian mummy figure, this image
 was always associated with death in Gauguin's oeuvre.

40. These drawings are reproduced in Cirlot, *Picasso: Birth of a Genius*,
 p. 96, nos. 159–60; p. 103, nos. 176–7; p. 109, no. 186; pp. 118–19,
 nos. 199–201; p. 233, nos. 655–9; p. 233, nos. 664, 665, 667; p. 233,
 no. 672.

41. Ibid., p. 103, no. 176; and Z. VI: 80–4.

42. To date, relatively few of Picasso's early paintings have been subjected to
 x-radiographic exploration; in the absence of sufficient data, one cannot
 draw definitive conclusions about the significance of his procedures in
 painting over discarded compositions. The Conservation Department of
 the Guggenheim Museum, New York, recently reported on their extensive
 study of Picasso's 1904 painting *Woman Ironing*. X-radiographs of the
 picture revealed that a three-quarter-length portrait of a mustachioed man
 lurks beneath the image of the woman. This male figure has been tenta-
 tively (and, I believe, correctly) identified as Picasso's tailor, Soler, whom
 the artist had depicted in two other works of 1903. Before covering the
 tailor's figure with that of the woman, Picasso turned his support upside
 down. For details and illustrations, see Elizabeth Estabrook, "The Man
 Behind the *Woman Ironing*," *Guggenheim Magazine* 3 (Summer 1993),
 pp. 44, 68. (Parenthetically, it seems interesting to note that Picasso chose
 to cover an image of a maker of clothing with that of a woman engaged in
 maintaining garments.)

43. See n. 19 above.

44. For numerous additional examples of Picasso's susceptibility to anniversa-
 ry reactions, see Gedo, *Picasso – Art as Autobiography*.

45. See ibid. for numerous illustrations of Picasso's lifelong separation prob-
 lems; for specifics about his three sojourns in Paris, consult chap. 3, pp.
 23–56. For the genesis of this difficulty, see chap. 2, pp. 7–26.

46. See ibid. for information concerning Picasso's special treatment of the
 images of special friends, esp. pp. 81–104, which discuss his avoidance of
 depicting Braque and Eva in clearly recognizable form.

47. For details about Picasso's early childhood, including his school phobia, see ibid., chap. 2, pp. 7–26. Richardson dismisses my conclusion that Picasso suffered from a school phobia; I can respond only by invoking my years of clinical experience with children to insist that Picasso manifested all the classical signs of a child with this problem. For Richardson's counterargument, see Richardson and McCully, *A Life of Picasso*, vol. 1, pp. 32–4. This is not the forum in which to engage in a lengthy debate about Picasso's phobic behavior, but it should be noted that Richardson and McCully provide additional examples of clear-cut phobic behavior on the artist's part, although without comprehending their phobic character.

48. I am deeply indebted to Françoise Gilot, who has repeatedly shared her intimate knowledge of Picasso with me. This information was imparted during our initial interview of September 3, 1977, and supplemented by further discussion on July 7, 1981.

49. Picasso misinformed every biographer about the date of Conchita's death; not until the Museo Picasso in Barcelona published a chronology of the artist's early life, based on family documents acquired with the bequest, did the correct date of her demise become known. See *Museo Picasso: Catalogo I, 1971*, p. 17. Interestingly enough, although the artist also misinformed Gilot, he correctly stated that Conchita had been 8 (not 4, as she would have been had she died in 1891) at the time of her death.

50. Although she correctly perceives that Picasso was convinced he was responsible for Conchita's death, Arianna Stassinopoulos Huffington presents a psychological reconstruction of the impact of this tragedy on the artist's subsequent beliefs and behaviors with which I completely disagree. For this interpretation, see Stassinopoulos Huffington, *Picasso: Creator and Destroyer* (New York, 1988), p. 30.

51. Although most biographers recognize, and often focus upon, the destructive character of Picasso's relationships with women, they overlook the fact that he initiated each of these relationships as a rescue operation. To cite just one example, Huffington's 1988 biography is oriented around her conception of the artist as a kind of divine monster-destroyer. His destructiveness was certainly an important component of his personality structure, but his guilt and need to attempt rescues that were inevitably doomed to failure was equally strong.

52. Gilot first shared these ideas with me during our interview of September 3, 1977.

53. The oil panel is illustrated in Cirlot, *Picasso: Birth of a Genius*, p. 49, no. 75. The lamp and the table with the open drawer that occur in so many of the sketches related to *Last Moments*, as well as in the painting proper, probably reproduce furnishings from Conchita's sickroom that impressed themselves indelibly on Picasso's memory. For relevant sketches of the father (now in the Museo Picasso, Barcelona), see ibid., p. 42, no. 76; p. 76, no. 127; p. 190, no. 331; p. 191, no. 337; etc.

54. Cabanne, *Pablo Picasso: His Life and Times*, p. 25, reports that Don José applied for the transfer in February and received it on March 17, 1895. He probably took up his new teaching duties following the Easter recess.

55. For their observation on the thematic connection linking *The Tragedy* to

Woman and Child on the Shore, see Daix and Boudaille, *Picasso: The Blue and Rose Periods,* cat. VII, p. 212, no. 21.

56. See Anthony Blunt and Phoebe Pool, *Picasso, The Formative Years* (Greenwich, Conn., 1962), illus. 115.

57. See Reff, "Themes of Love and Death," p. 27.

58. For this passage, see Gedo, *Picasso – Art as Autobiography,* pp. 50–2.

4. *A Youthful Genius Confronts His Destiny: Picasso's* Old Guitarist *as a Prognostication of His Future*

A previous version of this essay appeared in *The Art Institute of Chicago Studies* 12:2 (1986), pp. 152–65.

1. The prostitutes, procuresses, madmen, and beggars that Picasso painted between 1900 and 1904 have many counterparts in the art of Goya, as do the bullfight scenes later so intimately associated with the contemporary master. As an elderly artist, most markedly in his so-called erotic engravings of 1968, Picasso returned to many Goyesque themes.

2. For an extensive discussion of the artist's relationship with Casagemas and the impact of the latter's suicide on Picasso, see Chapter 3. However, it should be noted that Picasso held himself accountable for Casagemas's death because he had deserted his friend after attempting to rescue him. Picasso clearly believed that if he abandoned a person, that individual would perish – an attitude that made it especially difficult for him to separate from his parents.

3. For this comment, see Josep Palau i Fabre, *Picasso: The Early Years, 1881-1907,* trans. Kenneth Lyons (Barcelona, 1985), p. 336.

4. Picasso earned the fare back to Barcelona by hawking *The Mistletoe Seller* (private collection, Paris), a painting that strangely anticipates his subject matter of nearly a year later. The picture shows an extremely emaciated, bearded (and presumably blind) beggar accompanied by a small boy helper or guide whom the old man treats with tender consideration. Both the protagonists and the style prefigure such works of late 1903 as *The Old Jew* (see Fig. 51). For reproductions of these and other works from this period, see Pierre Daix and Georges Boudaille, *Picasso: The Blue and Rose Periods, A Catalogue Raisonné of the Paintings, 1900–1906,* compiled with the aid of Joan Rosselet, rev. English ed., trans. Phoebe Pool (Greenwich, Conn., 1967), cat. 8, nos. 4, 5; cat. 9, nos. 29–34.

5. Alfred H. Barr, Jr., was one of the first critics to point out Picasso's early debt to El Greco. See his *Picasso: Fifty Years of His Art* (New York, 1966), pp. 29, 48, and passim. Barr and others have also emphasized the importance of medieval sculpture as a source for Picasso's exaggerated anatomical depictions of the Blue Period. In this connection, it is interesting to compare *The Old Guitarist* with sculptures such as the representation of David on the south porch of the great Spanish pilgrimage church at Santiago de Compostela, for their similar elongations and cross-limbed postures.

6. Palau i Fabre, *Picasso: The Early Years,* p. 352, notes that a sketchbook from October 1903 shows in embryonic form the artist's subject matter during the autumn and early winter; it included various sketches of blind

men and blind singers. A drawing Picasso sent to a friend in Paris on November 30, 1903, shows the model who later appeared as *The Old Guitarist*.

7. Although Picasso did not actually suffer physical deprivation during the Blue Period, except perhaps during his brief third stay in Paris, he did not have much ready cash either, so such a creative reuse of materials was important.

8. In addition to Timothy Lennon, I owe a debt of gratitude to several other staff members of the Art Institute of Chicago who discussed the x-rays of *The Old Guitarist* with me. The late William R. Leisher, then Executive Director of Conservation, graciously shared his time and expertise with me. Neal Benezra, who was Curator of Twentieth-Century Painting and Sculpture at the time, and Courtney G. Donnell, currently Associate Curator in that department, also provided helpful observations and input.

9. The tiny rendition of a guitar that the artist later appended to the left margin of the Barcelona sketch seems especially provocative, suggesting that, on some preconscious level, Picasso had already associated this female figure with the image of a guitar. For a translation of the poem also inscribed on this sketchbook sheet, see R. W. Johnson, "Picasso's *Old Guitarist* and Symbolist Sensibility," *Artforum* 13 (Dec. 1974), pp. 56–62, esp. p. 59.

10. Several other paintings from the same period also seem to portray this model, though sometimes depicted as a more morose figure than in the *Blue Nude*. See Daix and Boudaille, *Picasso: The Blue and Rose Periods,* cat. 9, nos. 16, 18, and 19, for pictures not reproduced here.

11. These sketches for a decorative fireplace were all made in Barcelona, suggesting that the (apparently unrealized) commission originated there. The sole surviving design for the entire structure depicts two contrasting couples seated across from one another: On the left side of the fireplace, two young lovers embrace; across from them, a pair of emaciated elders stretch their hands toward the flames. Two closely related drawings of the lovers reveal that Picasso originally portrayed himself in the role of the young man. These sketches, which seem to be related formally and thematically to *La Vie,* as well as to *The Old Guitarist*, confirm once again the close conceptual and chronological ties linking these two paintings. These drawings are all illustrated in Palau i Fabre, *Picasso: The Early Years,* pp. 344–5, figs. 890–7, who assigns them to June 1903. A quick ink sketch included in this group (fig. 893) shows a child of about four embracing a sorrowful, emaciated mother; unlike the other female figures reproduced on these pages, she is not nude, but clad in a long gown and mantle. If this image really dates from the same period as the other seven sketches, as Palau i Fabre asserts, it constitutes another thematic link between *La Vie* and *The Old Guitarist*. Her appearance and garb seem more closely related to the maternal figure of *La Vie* than to the robust young woman concealed beneath *The Old Guitarist*.

12. See Johnson, "Picasso's *Old Guitarist* and Symbolist Sensibility," pp. 58–9, for extensive quotations from an essay devoted to this idea that appeared in *Arte Joven* in 1901, an ephemeral journal for which Picasso served as art editor.

13. Ibid., pp. 61–2. Anthony Blunt and Phoebe Pool, *Picasso, The Formative Years* (Greenwich, Conn., 1962), p. 6, also note that interest in Nietzsche

was in the air, but suggest that Picasso probably got his information sec-
ondhand from others.

14. Nietzsche's implicit conception of the artist as prophet, best exemplified by
his *Zarathustra*, must have strongly appealed to the adolescent Picasso
and buttressed him in his struggle to justify leaving his family.

15. For additional details, see Mary M. Gedo, *Picasso – Art as Autobiography*
(Chicago, 1980), pp. 27–56; see also chap. 3, 5, and 6.

16. See ibid., pp. 7–26; see also Chapter 3, n. 47, of the present volume.

17. To add to Picasso's emotional distress around the holiday season, he asso-
ciated it with the birth of his sister next in age, Dolores, as well as with the
terrible earthquake that struck his native Málaga during the Christmas
season of 1884. For a more extensive discussion of these events and their
impact, see Chapter 5. Also, Concepción's death on January 5, 1895 (see
Chapter 3), indicates that she must have been severely ill throughout that
Christmas season.

18. This kind of fluidity in developing his images occurred in many of Picasso's
early paintings. For a discussion of the complex instances of this type in-
volved in the evolution of *La Vie* and *Les Demoiselles d'Avignon*, see
Chapters 3 and 5, respectively.

19. See John Berger, *The Success and Failure of Picasso* (Harmondsworth,
Middlesex, England, 1965), pp. 43–4.

20. An inscription on the back of this painting indicates that it was completed
in Picasso's family home, not in his studio; Palau i Fabre, *Picasso: The
Early Years*, p. 359, suggests that the artist painted this at the very end of
1903, while waiting to move into a new studio. The sketch – showing the
boy who appears in *The Old Jew*, along with another sketch of the model
for *The Old Guitarist*, still not in his definitive pose – suggests that *The
Old Guitarist* may have been painted later still. The close resemblance be-
tween the pose of the guitarist and that assumed by the figure in *Woman
Ironing* (1904, Solomon R. Guggenheim Museum, New York), adds to
this impression. The latter is one of Picasso's last Blue Period pictures.

21. John Richardson, *A Life of Picasso, vol. 1, 1881–1906,* with the collabo-
ration of Marilyn McCully (New York, 1991), pp. 277–9, interprets the
artist's response to his father's progressive visual deterioration as "nothing
if not Oedipal." He attributes Picasso's decision to paint *The Old Jew* in
his parents' apartment as a "symbolic blinding" of Don José. In my opin-
ion, neither the visual nor the psychological evidence supports such a
reading of either the composition or its creator's attitude toward his fa-
ther. To the contrary, Don José's disability undoubtedly made the pros-
pect of separating himself definitively from his family all the more difficult
for Picasso.

5. Art as Exorcism: Picasso's Demoiselles d'Avignon

An earlier version of this material appeared in *Arts Magazine* 55:2 (Octo-
ber 1980), pp. 70–81.

1. Quoted in Dore Ashton, *The Documents of 20th Century Art: Picasso on
Art, a Selection of Views* (New York, 1972), p. 38.

2. The exact dates when Picasso began and abandoned this canvas have nev-
er been precisely ascertained. Pierre Daix suggests that the first campaign

of work on the *Demoiselles* took place from February or March 1907 to the end of the May, the second from about June to July. He cites as evidence for this a quotation from Kahnweiler that he saw the picture in its definitive state when he visited Picasso's studio for the first time, "in the early summer of 1907." However, I have not been able to find this phrase in either the English or the original French edition of the volume to which Daix refers. The only specific date Kahnweiler mentions in this section of the book is March 21, 1907, when he visited the Salon des Indépendants. He mentions no specific date or time of year when discussing this initial visit to Picasso's studio. The English account of this visit begins, "So one day I set off." See Daniel-Henry Kahnweiler with Francis Crémieux, *The Documents of 20th Century Art: My Galleries and Painters* (New York, 1971), trans. Helen Weaver, intro. John Russell, pp. 34–9. See also the original French version, *Mes galeries et mes peintres: Entretiens avec Francis Crémieux* (Paris, 1916), pp. 38–42. For Daix's statement, consult Pierre Daix, *Picasso: The Cubist Years, 1907–1916, a Catalogue Raisonné of the Paintings and Related Works,* text by Daix, catalogue compiled by Daix and John Rosselet, trans. Dorothy Blair (Boston, 1979), p. 18. Daix also cites, in favor of his chronology, evidence he has compiled to show that Picasso was busy with the *Nude with Drapery* during the late summer of 1907. It is difficult to see why this fact would keep the artist from simultaneously reworking the *Demoiselles.*

In response to questionnaires submitted to him by Alfred H. Barr, Picasso acknowledged that he had later reworked the right two-fifths of the *Demoiselles.* However, when Barr subsequently tried to press the artist into admitting that this repainting might have occurred after the summer of 1907, Picasso was noncommittal. See Alfred H. Barr, Jr., *Picasso: Fifty Years of His Art,* reprint ed. (New York), 1966, p. 56 and note, p. 257. As Barr suggests, it seems logical to assume that the artist did, in fact, repaint the right portion of the canvas after a significant lapse of time. He had followed a similar procedure in completing his portrait of Gertrude Stein the previous autumn; he also worked in a similar fashion during the autumn of 1910, when he returned to Paris with several incomplete canvases begun on vacation, but brought to completion later in his regular studio. Picasso's evasiveness about the chronology of the *Demoiselles* is characteristic of his general evasiveness about this painting.

See also the more recent proposal concerning the chronology of the painting provided by William Rubin, "From narrative to 'Iconic' in Picasso: The Buried Allegory in *Bread and Fruitdish on a Table* and the Role of *Les Demoiselles d'Avignon,*" *Art Bulletin* 65, 4 (Dec. 1983), pp. 627–35, and Appendix I, p. 642.

3. The *Demoiselles* status as the first proto-Cubist picture has been challenged by William Rubin; see his "Cézannism and the Beginnings of Cubism," in *Cézanne: The Late Work,* exh. cat., ed. W. Rubin (New York, 1977), pp. 151–202, but esp. pp. 152–4. Rubin argues that this picture cannot really be considered Cubist, and marshals evidence to support his contention that Braque painted the first pictures that can truly be so called. Leo Steinberg states his disagreement with this interpretation in "Resisting Cézanne: Picasso's *Three Women.*" *Art in America* (Nov.– Dec. 1978), pp. 115–33. This led to a further exchange of essays between

these two scholars, which appeared in a single issue of *Art in America* (Mar.–Apr. 1979); see Steinberg, "The Polemical Part," pp. 115–25, and Rubin, "Pablo and Georges and Leo and Bill," pp. 128–47.

4. In Mary M. Gedo, *Picasso – Art As Autobiography* (Chicago, 1980), pp. 81–107 and passim, I emphasize the importance of the artist's close association with Braque for the development of Picasso's Cubist style. I believe that the uncharacteristic serenity of his production during 1909–14 reflects the steadying influence of his Norman friend on the mercurial Picasso. See also the discussion of this question by Rubin, "Pablo and Georges and Leo and Bill," pp. 130–1.

5. Ashton, *Documents of 20th Century Art: Picasso,* pp. 38–40.

6. See, for example, John Golding, *Cubism: A History and an Analysis, 1907–1914,* rev. American ed. (Boston, 1968), pp. 47–9. See also Daniel-Henry Kahnweiler, *The Documents of Modern Art: The Rise of Cubism,* trans. Henry Aronson (New York, 1949), pp. 6–7; and Robert Rosenblum, *Cubism and Twentieth-Century Art,* rev. ed. (New York, [1967]), p. 9.

7. The writings of Pierre Daix probably reflect Picasso's "official" viewpoint in these matters. See Daix, *Picasso: The Cubist Years,* pp. 23–38, as well as his article "Il n'y a pas 'd'art Nègre' dans *Les Demoiselles d'Avignon,*" *Gazette des Beaux-Arts* 74 (Oct. 1970), pp. 247–70.

8. See Christian Zervos, *Pablo Picasso,* 33 vols. (Paris, 1932–78), vols. I, II (pt. 1), VI, and XXVI. (Hereafter, these catalogues will be referred to as Z. I, II, etc., with illustration numbers following a colon.)

9. Daix, *Picasso: The Cubist Years,* p. 191.

10. Although the artist's Cubist works seem to constitute an exception to this generalization, they, too, contain many private references that are still in the process of being deciphered. For example, see William Rubin, *Picasso in the Collection of the Museum of Modern Art,* exh. cat (Greenwich, Conn., 1972), pp. 62–72 and 204–6. The author discusses the imagery of several important and enigmatic Cubist still-life paintings with the artist himself; as one might expect in the case of Picasso, the objects and references in these pictures were actually quite personalized.

 For a contrasting sociopolitical reading of the *Demoiselles* and other works of this period, see Patricia Leighton, *Re-Ordering the Universe: Picasso and Anarchism, 1897–1914* (Princeton, N.J., 1989), chaps. 3 and 4, pp. 74–124, esp. 84–95.

11. Leo Steinberg, "The Philosophical Brothel," pt. 2, *Art News* 71 (Oct. 1972), p. 38, quotes Rubin, who specifically questioned the artist about the man with the skull.

12. See Fernande Olivier, *Picasso and His Friends,* Heinemann ed., trans. Jane Miller (London, 1964), pp. 94–5. Françoise Gilot shared these ideas with me in a personal interview in La Jolla, Calif., September 3, 1977.

13. Gedo, *Picasso – Art As Autobiography,* chap. 4, pp. 57–80.

14. Barr, Jr., *Picasso: Fifty Years of His Art,* pp. 45–6.

15. Daix, *Picasso: The Cubist Years,* p. 14, emphasizes the importance of the Ingres canvas for Picasso's conception of *Figures in Pink.*

16. For a time, Apollinaire edited a magazine devoted to physical culture. The notion evidently amused Picasso, for his poet friend closely resembled a plump pear in shape, and was given to no exercise more strenuous than

lifting his fork. Picasso created a number of caricatures depicting Apollinaire as a microcephalic "Mr. Atlas" type. Several of these are reproduced in Pierre Daix and Georges Boudaille, *Picasso: The Blue and Rose Periods, A Catalogue Raisonné of the Paintings, 1900–1906*, compiled with the aid of Joan Rosselet, rev. English ed., trans. Phoebe Pool (Greenwich, Conn., 1967); see cat. D XII, 21–4, p. 272.

17. Françoise Gilot repeatedly alludes to what she calls Picasso's "Bluebeard complex," his interest in retaining an attenuated relationship with all the women who had ever been important to him; she also notes the relish with which he recalled a wrestling match in which Marie-Thérèse Walter and Dora Maar contested for his affections. See Françoise Gilot and Carlton Lake, *Life with Picasso* (New York, 1964), pp. 210–12, 235–42, and passim.

18. Ten oils by Cézanne were shown at the Salon d'Automne of 1905, another ten in 1906. In June 1907, the Galerie Bernheim-Jeune exhibited seventy-nine of his watercolors, and that November – presumably after Picasso had abandoned the *Demoiselles* in its present state – the Salon d'Automne showed fifty-six Cézanne paintings in a memorial exhibition. Most critics are convinced that Picasso probably knew Cézanne's work as early as 1901, through contacts with the dealer Ambrose Vollard, who held an extensive number of works by the French master.

19. Picasso's procedure in painting the Stein portrait was quite atypical; earlier, he had not required that anyone pose for him for extended periods, as she did. The subject herself recognized that this unusual procedure indicated Picasso was at a watershed in his art. See Gertrude Stein, *Picasso*, Beacon ed. (Boston, 1959), pp. 7–8. Several years later, the artist inaugurated his high Cubist phase by painting the portraits of three friends (Wilhelm Uhde, Ambrose Vollard, and D. H. Kahnweiler), for which the subjects had to pose almost endlessly. It seems quite appropriate that this autobiographical artist used depictions of friends to inaugurate important new stylistic phases.

20. Although the resemblance of these figures to Iberian sculptures has often been cited, the color and texture of Picasso's personae from these months seem more reminiscent of terra-cotta sculptures. Both his simplifications and the sturdy cylindrical limbs of these 1906 women show a certain similarity with the treatment of such features in Japanese Haniwa figurines. I do not mean to suggest that the latter served as an important – or even peripheral – source of inspiration for Picasso. It does seem possible, however, that he studied archaic sculptures from a wide variety of cultures during this period. His female figures from 1906 and early 1907 also show a kind of generalized similarity with Gauguin's painted and sculpted renditions of Tahitian idols. Some of Picasso's earlier paintings of 1901–2 strongly reflect his admiration for Gauguin, and the latter's interest in such art forms certainly would not have escaped Picasso. For a much more extensive discussion of the relationship between Picasso's work of late 1906 and 1907 and Iberian art, as well as the art of Gauguin, see William Rubin, "Picasso," in *Primitivism in 20th Century Art: Affinity of the Tribal and the Modern,* exh. cat., ed. W. Rubin (New York, 1984), pp. 241–340, esp. pp. 241–52 and nn. 1–37, pp. 334–5.

21. Compare, for example, Z. I: 371 and 372; 363 and 373; 367 and Z. II (pt. 1): 1. Picasso specifically denied to Daix that the female heads he painted during the autumn of 1906 had been based on a specific model, but I find it difficult to accept this statement literally in view of the obvious resemblance between these heads and that of Fernande. See also Daix, "Il n'y a pas 'd'art Nègre'," pp. 266–7.

22. Although Picasso later claimed that he did not begin work on the picture until the spring of 1907, this statement probably should not be taken literally. As Daix, "Il n'y a pas 'd'art Nègre'," p. 191, points out, "It is practically impossible to establish any significant line of demarcation between the research of the autumn of 1906 and that which culminated in the great canvas." I believe that Picasso may have retrospectively distorted and condensed the history of the *Demoiselles*, perhaps, in part, because he wished to conceal the details of his lengthy struggle from the public.

23. Max Kozloff, "Cubism and the Human Comedy," *Art News* 71 (Sept. 1972), p. 36, suggests that the physiques of these women reflect that of the artist himself.

24. David Douglas Duncan, *Picasso's Picassos: The Treasures of La Californie* (New York), n.d., pp. 50–1.

25. Daix, *Picasso: The Cubist Years*, pp. 14–18 and 26–7, emphasizes the importance of Ingres's *Turkish Bath*, Derain's *Three Bathers*, and Matisse's *Blue Nude (Souvenir of Biskra)* for Picasso. Both the latter pictures were shown at the Salon of Indépendants that opened on March 20, 1907, while Picasso was in the midst of his researches for the *Demoiselles*. Daix attributes the violence of Picasso's revisions to the canvas to his competition with these two contemporaries. Rubin, "Cézannism and the Beginnings of Cubism," p. 157, also stresses the impact of Derain's *Three Bathers* on Picasso. See also Kozloff, "Cubism and the Human Comedy," pp. 36–7, who mentions Manet's *Olympia* and the works of Toulouse-Lautrec as precedents for the *Demoiselles*. Michael Marrinan, "Picasso as an 'Ingres' Young Cubist," *Burlington Magazine* 119 (Nov. 1977), p. 756, emphasizes the importance of Ingres's *Grand Odalisque* for Picasso, who owned a reproduction of this work and created sketches after it while working on the *Demoiselles*. Robert Rosenblum, "The *Demoiselles d'Avignon* Revisited," *Art News* (Apr. 1973), pp. 45–8, suggests Goya, Lautrec, and Degas as additional sources. This list provides a minimal sample of the range of opinions available.

26. Golding, *Cubism*, p. 50.

27. See Theodore Reff, "Themes of Love and Death in Picasso's Early Work," in *Picasso in Retrospect*, ed. Sir Roland Penrose and Dr. John Golding (New York & Washington, D.C., 1973), pp. 43–4.

28. See Lionello Venturi, *Cézanne: son art – son oeuvre* (Paris, 1936), no. 122. This little panel once belonged to Ambrose Vollard, and it is possible that Picasso knew the picture through his contacts with the dealer.

29. In 1979, the Museo Picasso in Barcelona mounted an exhibition featuring the artist's juvenile erotica. See the review of this exhibition by Hilton Kramer in the *New York Times* (May 29, 1979), sec. 3, p. 7. Kramer emphasizes the explicit quality of these sketches, many of them depicting Picasso's chums in action with the girls.

30. Josep Palau i Fabre, *Picasso en Cataluña* (Barcelona, 1966), pp. 62–6, reports that the artist spent several weeks in a house of ill fame around the time of the riots, and that he covered the walls of the room in which they harbored him with paintings. John Richardson dismisses this story, arguing that there is no evidence that the youth left home during 1899 or lived in a brothel. See Richardson, *A Life of Picasso, vol. 1, 1881–1906,* with the collaboration of Marilyn McCully (New York, 1991), p. 109. If Richardson is correct and the story is mythical, it seems possible that Picasso himself might have been its source. He was equally creative as automythologizer and visual artist.

31. For additional aspects of the 1901 quarrel and its aftermath, see the Chapter 4. See also Gedo, *Picasso – Art As Autobiography,* pp. 33–7. Although Picasso's paintings from this period strongly indicate that his mother was the object of his fury, we learn very little about her role in the quarrel from the artist's biographers. See, for example, Roland Penrose, *Picasso: His Life and Work,* Icon ed. (New York, 1973), p. 61. He emphasizes how much Picasso's uncle Salvador disapproved of the boy's behavior and how the quarrel meant "the last disillusionment for Don José. His son had finally broken loose and would no longer accept the guidance that he felt he ought to give. His last role as a parent had come to an end, and he relapsed into old age, disillusioned and sad." Richardson, *A Life of Picasso,* promotes a similarly idealized vision of the artist's mother throughout the first volume of his ongoing biography of Picasso.

32. Patrick O'Brian, *Picasso: A Biography* (New York, 1976), p. 111.

33. Reff, "Themes of Love and Death," p. 19, suggests that the contrasting treatment of the protagonists in this painting reflects Picasso's fondness for consigning women to the ranks of either goddesses or doormats. For one of numerous examples of Picasso's comments to this effect, see Gilot and Lake, *Life with Picasso,* p. 84.

34. Daix and Boudaille, *Picasso: The Blue and Rose Periods,* cat. D VII,1.

35. Leo Steinberg, "The Philosophical Brothel," pt. 1, *Art News* 71 (Sept. 1972), p. 21.

36. Steinberg, "The Philosophical Brothel," 2 pts., includes photographs of several studies for the *Demoiselles* that were previously unknown and unpublished. They were subsequently included in Z. XXVI.

37. Ibid., pt. 2, p. 39.

38. Ibid.

39. Steinberg, "The Philosophical Brothel," pt. 1, p. 26.

40. Daix, *Picasso: The Cubist Years,* p. 193, no. 14.

41. Steinberg, "The Philosophical Brothel," pt. 1, p. 26.

42. Ibid.

43. Quoted in Steinberg, "The Philosophical Brothel," pt. 2, p. 38.

44. Ibid.

45. The best reproduction of this famous photograph is probably the one published in Jaime Sabartés, *Picasso: Documents Iconographiques,* trans. Felia Leal and Alfred Rosset (Geneva, 1954), as doc. no. 44.

46. Picasso discussed this painting with Jerome Seckler, who interviewed him in 1945. This interview is reproduced in Ashton, *Documents of 20th Century Art: Picasso,* pp. 135–42. The artist confirmed Seckler's impression that the little sailor represented himself. When asked why he had

shown himself as a sailor, Picasso explained that it was because he always wore a sailor's jersey, and showed Seckler the one he had on that day (pp. 135–6). Unfortunately, Seckler, intent on eliciting an explication of the political symbolism he was convinced the painting encoded, did not ask Picasso a number of pertinent questions, such as why he had depicted himself as a small child.

47. See Gedo, *Picasso – Art As Autobiography,* pp. 7–26, 156–68 and passim. The artist also reacted strongly to the birth of his two children by Gilot, especially that of his daughter, Paloma; on this, see ibid., pp. 210–19. Gilot supplies much information about the artist's reaction to, and inter-actions with, his children. See Gilot and Lake, *Life with Picasso,* esp. pp. 164–5, 178–9, 254–6, where she describes his behavior immediate-ly after the birth of the children. During the panel discussion that conclud-ed the symposium "Picasso: The Psychology of a Minotaur," held at New York University on March 26, 1988, Gilot spoke about Picasso's atti-tude toward his children, explicitly confirming my impression that he had been more upset following the birth of Paloma than of their son, Claude.

48. Jaime Sabartés, *Picasso: An Intimate Portrait,* trans. Angel Flores (New York, 1948), p. 6, quotes the artist's recollection that, at the time of the Málaga earthquake, his maternal grandmother and the two aunts lived with Picasso and his parents.

49. Pierre Cabanne, *Pablo Picasso: His Life and Times,* trans. Harold J. Salemson (New York, 1977), p. 92.

50. For an extensive discussion of Picasso's childhood, see Sabartés, *Picasso: An Intimate Portrait,* pp. 3–12, 31–41. See also Richardson, *A Life of Picasso,* vol. 1, chaps. 1 and 2, pp. 13–55.

51. Cabanne, *Pablo Picasso,* p. 47. Richardson, *A Life of Picasso,* vol. 1, pp. 67–8, not only accepts Picasso's stories of his sexual precocity but sug-gests the future artist may have undergone his sexual initiation in Corun-na, before the family moved to Barcelona in 1895, when the future artist was 14.

52. See Steinberg, "The Philosophical Brothel," pt. 2, p. 39.

53. Reff, "Themes of Love and Death," pp. 19–28, examines the theme of "sacred and profane love" in Picasso's early oeuvre.

54. Consult Cabanne, *Pablo Picasso,* p. 113.

55. For information about Picasso's uncle, see Jaime Sabartés, *Picasso: Docu-ments Iconographiques,* trans. Felia Leal and Alfred Rosset (Geneva, 1954), pp. 297–8 and passim, and Penrose, *Picasso: His Life and Work,* pp. 41 and 61.

56. Gilot conveyed this information during a personal interview held Sept. 3, 1977. Picasso evidently caught syphilis, not gonorrhea, since the latter is a self-limiting disease in men. The first truly effective treatment for syphilis was developed in 1910 by Paul Ehrlich; presumably, then, Picasso's treat-ment took place after that date.

For a further discussion of Picasso's attitudes about female sexuality and syphilis, see the "Conclusion" of Charles Bernheimer's *Figures of Ill Repute: Representing Prostitution in Nineteenth-Century France* (Cam-bridge, Mass. & London), 1989, pp. 266–320, which is devoted to the *Demoiselles d'Avignon.*

57. Picasso made this statement to Kahnweiler; it is quoted in Ashton, *Documents of 20th Century Art: Picasso,* p. 153.

58. See Gerald Kamber, *Max Jacob and the Poetics of Cubism* (Baltimore & London), 1971, pp. xi–xii.

59. Olivier, *Picasso et ses amis,* pp. 65–70, provides a fond reminiscence of Max's talents as a female imitator.

60. Francis Steegmuller, *Apollinaire: Poet among the Painters* (New York, 1963), provides ample information concerning the poet's mother and his relationship with her; see esp. pp. 3–60 and passim.

61. Ibid., pp. 156–65, 275–7.

62. Perhaps the most famous description of such a disruption involved Picasso's partial rupture with Marie-Thérèse following Maya's birth. Sabartés, *Picasso: An Intimate Portrait,* pp. 103–37, presents a vivid account of Picasso's behavior at that time. See also n. 47, above.

63. For more on this, see n. 19.

64. See Gilot and Lake, *Life with Picasso,* pp. 72–3. For a more detailed discussion of these ideas and my assessment of the personalized implications of Picasso's handling of the Cubist portrait, see Gedo, *Picasso – Art As Autobiography,* pp. 81–112.

65. For a vivid description of the aberrant behavior exhibited by Picasso's first wife, Olga, see Gilot and Lake, *Life with Picasso,* pp. 207–10 and passim. Although the popular press has created a very romanticized vision of Marie-Thérèse, the truth about her personality and behavior was a good deal more complex and less pleasant. Someone who knew Marie-Thérèse personally has provided me with a wealth of details showing that Mlle Walter's reality testing was indeed shaky. This confidential information jibes perfectly with the description of Marie-Thérèse that Frank Perls provides in "The Last Time I Saw Pablo," *Art News* 73 (Apr. 1974), pp. 38–9. In view of her evident psychological fragility, it is scarcely surprising to learn that Marie-Thérèse committed suicide on October 20, 1977, four years after the artist's death, and just days before what would have been his ninety-sixth birthday. In the same article, p. 41, Perls presents a brief description of Jacqueline Roque (the second Mme Picasso) that reveals her to have been the same type of brittle, controlling personality depicted by Gilot and Lake, op. cit., pp. 357–63. Both O'Brian, *Picasso: A Biography,* p. 424–5, and Cabanne, *Pablo Picasso,* pp. 452–53, present very similar descriptions of Jacqueline's desperate behavior during the weeks just before Picasso acquiesced and took her to live with him. She apparently threatened to commit suicide unless he did so. Her threats were all too real; following her husband's death, she suffered repeated severe depressions before taking her own life in October 1986.

 Among the artist's loves about whom we have adequate information (we know very little, for example, about the important mistress of his Cubist years, Eva Gouel, who succumbed to tuberculosis in 1915), only Olivier and Gilot seem to have been made of stouter stuff, and it is probably no accident that they were the only two of his major mistresses who gained enough distance on their experiences to write about him.

66. Erwin Panofsky, *Studies in Iconology: Humanistic Theories in the Art of the Renaissance,* Torchbook ed. (New York, 1962) discusses the motif of

Time as revealer and pays particular attention to the imagery of Bronzino's enigmatic work. This painting shares a number of provocative features with the *Demoiselles*. In both cases, the revealer stands at the left periphery of the canvas with her face in profile; both figures recall sculpted models. The "Truth" that both figures expose deals specifically with female sexuality, and both canvases feature female figures at once seductive and horrifying. One wonders whether Picasso knew reproductions of Bronzino's painting; if so, it might have played some role in shaping his final conception of his figure of Truth in the *Demoiselles*.

67. See Barr, Jr., *Picasso: Fifty Years of His Art*, p. 55 and note, p. 257.
68. Rubin provides an extensive review of the entire history of the question of the relationship between the *Demoiselles* and African art, as well as offering a number of proposals concerning other sources for the painting in tribal and primitivizing art. See Rubin, "From narrative to 'Iconic' in Picasso," pp. 627–36 and Appendixes VII–IX, pp. 645–7. For a still more extensive discussion of Picasso's relationship to primitivism (including its role in the evolution of the Demoiselles), see Rubin, "Picasso," in *Primitivism in 20th Century Art,* exh. cat., pp. 241–340, esp. pp. 260–8.
69. See André Malraux, *Picasso's Mask,* trans. and annot. June Guicharnaud with Jacques Guicharnaud (New York, 1964), pp. 10–11. Italics mine. In this same conversation, Picasso kept emphasizing how amazed he was by Braque's attitude toward these pieces. For Braque, they were merely works of art, which the French master did not even find hostile. This fundamental difference in attitudes provides another illustration of the interactions between Picasso and Braque that helped to make them such ideal partners. Braque's calmness in the face of these powerful magical objects must have reassured Picasso greatly.
70. For his argument that the *Demoiselles* should not be considered unfinished, see Rubin, "From narrative to 'Iconic' in Picasso," pp. 635–6, and Appendix IX, pp. 647–8.

6. *Art as Autobiography: Picasso's* Guernica

This essay was originally published in *Art Quarterly* 2:2 (Spring 1979), pp. 191–210, a journal sponsored by the Metropolitan Museum of Art.

1. The artist himself called his oeuvre autobiographical: "I paint the way some people write their autobiography. The paintings, finished or not, are the pages of my day journal, and as such they are valid." Françoise Gilot and Carlton Lake, *Life with Picasso* (New York, 1964), p. 123.
2. William Rubin, *Picasso in the Collection of the Museum of Modern Art,* exh. cat. (Greenwich, Conn., 1972), pp. 168 and 238, n. 8, points out that we simply do not know how long Picasso worked on this canvas. He started it in the late autumn of 1944 and continued to work on it at least until the following July. When it was exhibited in a Picasso retrospective held in the Palazzo Nazionale of Milan in 1953, the catalogue noted that final changes on the canvas had been made as late as 1948. For an interpretation of the emotional conflicts that might have interfered with Picasso's progress on this painting, see Mary M. Gedo, *Picasso – Art As Autobiography* (Chicago, 1980), pp. 205–7, which suggests that Picasso associated

this picture with Dora Maar and the psychotic break she suffered during the spring of 1945. Rubin's hypothesis that two of the most prominent corpses in the canvas strongly resemble the artist and Dora would add weight to my interpretation.

3. Pierre Cabanne, *Pablo Picasso: His Life and Times,* trans. Harold J. Salemson (New York, 1977), p. 303, lists the friends and acquaintances with whom Picasso discussed Goya and *The Third of May, 1808.*

4. Rubin, *Picasso in the Museum of Modern Art,* exh. cat., p. 238, n. 7.

5. Goya's 1817 painting of *Sts. Justa and Rafina,* which hangs in the sacristy of Seville Cathedral, depicts in the right frontal plane the broken remains of a Roman statue of Venus, which the sister saints had been commanded to worship. This painting is reproduced by José Gudiol, *Goya,* vol. 4 (Barcelona, 1971), p. 867. Anthony Blunt, *Picasso's Guernica* (New York, 1969), presents an extensive discussion of the relationship between this mural and Picasso's own oeuvre, and offers as well suggestions concerning other sources in the art of the past that might have inspired Picasso.

6. Many years later, Picasso described this period as the worst time of his life. See David Douglas Duncan, *Picasso's Picassos: The Treasures of La Californie* (New York, n.d.), p. 111.

7. Dore Ashton, *The Documents of 20th Century Art: Picasso on Art, a Selection of Views* (New York, 1972), pp. 133–41, reproduces the interview Picasso held with Jerome Seckler in 1945 in which the artist provided this interpretation of *Guernica*.

8. Roland Penrose, *Picasso: His Life and Work,* Icon ed. (New York 1973), p. 306.

9. The preparatory drawings for *Guernica* are illustrated in Christian Zervos, *Pablo Picasso,* 33 vols. (Paris, 1932–78). (Hereafter, these catalogues will be referred to as Z. I, II, etc., with illustration numbers following a colon.) See Z. IX: 1–65, for *Guernica* and its studies. The first five studies appear in Zervos, vol. IX, in chronological order as nos. 1–5.

10. Z. IX: 9; see also nos. 20, 28, and 29.

11. See also Z. VIII: 214–15, 217–19, 226–30, etc., to give just a few examples of this savagery, also apparent in Picasso's prints from this period.

12. See Herschel B. Chipp, "Guernica: Love, War, and the Bullfight," *Art Journal* 33, 2 (Summer 1973), p. 109.

13. Rudolph Arnheim, *The Genesis of a Painting: Picasso's* Guernica (Berkeley, Los Angeles, & London, 1973), pp. 51–2 and 86.

14. Ibid., p 52. For the first five sketches of the mother and child, see Z. IX: 12–16.

15. See Arnheim, *Genesis of a Painting,* p. 50.

16. See Jaime Sabartés, *Picasso: An Intimate Portrait,* trans. Angel Flores (New York, 1948), pp. 5–6. Italics mine. The earthquake began on the evening of December 25, 1884, and aftershocks continued for several days. Picasso's sister, Delores, was born on December 28, 1884. On December 28, 1884, the *New York Times* reported that 600 people in Málaga province had died as a result of the quake, which was accompanied by widespread property loss; the Málaga cathedral, hospital, and other public buildings suffered extensive damage. See *New York Times,* December 28–31, 1884.

17. See Arnheim, *Genesis of a Painting,* p. 34.

18. Ibid.
19. See Chipp, "Guernica," p. 109.
20. See Sabartés, *Picasso: An Intimate Portrait*, p. 7. In a personal interview with the writer on September 3, 1977, Françoise Gilot expressed skepticism that Picasso really began attending bullfights as early as Sabartés reports – she suggests that the artist probably was 5 or 6. The impression these events made upon his imagery is so profound, however, that I am inclined to think Sabartés was correct in ascribing Picasso's attendance to such a tender age.
21. See Gedo, *Picasso – Art As Autobiography*, pp. 8–11 and passim.
22. During our interview, Gilot revealed that Picasso expressly told her he had left Spain to get away from his domineering mother. I am well aware that the view presented here concerning Picasso's relationship with his mother runs counter to the descriptions presented in most biographies of the artist. Skeptics should reread the accounts furnished by Sabartés, Penrose, et al. to note *how little detail* about the artist's mother these biographers actually present. By contrast, both these books and Jaime Sabartés, *Picasso: Documents Iconographiques,* trans. Felia Leal and Alfred Rosset (Geneva, 1954), provide much more detailed information about Picasso's father. The latter emerges as a real flesh-and-blood person, with faults as well as virtues; Picasso's mother, by contrast, is presented as a personality of plastic perfection.
23. Fernande Olivier states that, during the early years of their relationship, Picasso slept until four or five in the afternoon, then worked all night. Fernande Olivier, *Picasso and His Friends*, Heinemann ed., trans. Jane Miller (London, 1964), p. 53.
24. See Penrose, *Picasso: His Life and Work*, p. 315.
25. See Sabartés, *Picasso: An Intimate Portrait*, pp. 7 and 27.
26. See Michael Grant and John Hazel, *Who's Who in Classical Mythology* (London, 1973), pp. 341–44. *The New Century Handbook of Greek Mythology and Legend*, ed. Catherine B. Avery (New York, 1972), pp. 457–63. Oskar Seyffert, *Dictionary of Classical Antiquities*, rev. ed., add. by Henry Nettleship and J. E. Sandys (Cleveland & New York, 1969), pp. 506–7.
27. David Greene and Richard Latimore, *Euripides: The Complete Greek Tragedies* (Chicago, 1944–59), vol. 3 of 4, *Hippolytus*, trans. David Greene, p. 212.
28. See Sabartés, *Picasso: An Intimate Portrait*, pp. 30–5. Gilot's biography of her years with Picasso provides many examples of the artist's fragile sense of self and vulnerability to disintegration. See Gilot and Lake, *Life with Picasso*, pp. 229–32, where she describes, among other incidents, Picasso's enraged reaction because Gilot gave their crippled gardener some of the artist's old clothing: Picasso was convinced he would become as misshapen as the gardener. Other incidents related by other biographers substantiate Gilot's accounts.
29. See Grant and Hazel, *Who's Who in Classical Mythology,* pp. 90 and 327.
30. One should not overlook the fact that, in *The Dream and Lie of Franco* (see Fig. 69, scene five), Picasso portrays the Franco monster as a polyp-headed horse, whom the heroic bull promptly attacks and disembowels. By implication, Picasso's last sketch for *Guernica* from May 1 (Fig. 71),

which shows the horse giving birth to the infant Pegasus, symbolically equates the mare-mother with the Medusa, another death-dealing monster. The horse's potential destructive powers are again affirmed in the third sketch from May 1 (Fig. 77), which represents the animal as a zoomorphic bomber plane. The fluidity of identities and roles implicit in these images, which seemingly equate the mare-mother both with the Medusa and with Franco – two death-dealing monsters – supports the hypothesis that, on an unconscious level, Picasso viewed his mother as a monstrous being and was convinced that his internal "devil" was a direct outgrowth of her destructive influence. For additional details on Picasso's mother and his relationship with her, consult Gedo, *Picasso – Art As Autobiography*.

31. Since this essay originally appeared in 1979, well over one hundred articles and books about *Guernica* have been published. For additional interpretations and recent bibliographic references, see Hershel B. Chipp, *Guernica: History, Transformations, Meanings* (Berkeley, Los Angeles, & London, 1988) and Ellen C. Oppler, ed., *Picasso's Guernica: Illustrations, Introductory Essay, Documents, Poetry, Criticisms, Analysis*, Norton Critical Study in Art History (New York, c. 1988). This latter volume includes contributions from scholars espousing a wide variety of viewpoints. The lengthy introductory essay by Oppler, pp. 47–142, covers some of the same ground as Chipp's volume and includes numerous references not cited here.

7. *Meditations on Madness: The Art of René Magritte*

An earlier version of "Meditations on Madness: The Art of René Magritte" originally appeared in *In the Mind's Eye: Dada and Surrealism,* edited by T. A. R. Neff, in 1985, and published jointly by the Museum of Contemporary Art, Chicago, and the Abbeville Press.

1. For the titles, dates, and locations of oil paintings executed between 1925 and 1930, I have relied on the first volume of the catalogue raisonné. For details, consult David Sylvester and Sarah Whitfield, *Oil Paintings 1916–1930*, vol. 1 of *René Magritte: Catalogue Raisonné*, 5 vols. (London, 1992–3), ed. D. Sylvester.

2. This famous quotation, reprinted everywhere, originally appeared in Louis Scutenaire, *René Magritte* (Brussels, 1947), pp. 71–2. It is the sole reconstruction of the events surrounding his mother's suicide that Magritte ever produced. It is quoted in its entirety in the more readily accessible Suzi Gablik, *Magritte* (Boston, 1976), paperback ed., p. 22.

3. Sylvester quotes the accounts that appeared in several Belgian newspapers at the time of Mme Magritte's disappearance and the subsequent recovery of her body seventeen days later. Although Magritte's story implies that he had been present when his mother's corpse was recovered, this was not the case. His romantic account of the body's appearance scarcely tallies with the advanced state of decomposition in which it must have been found. See David Sylvester, "Portraits de Magritte," trans. Anne Perez, in *Rétrospective Magritte*, exh. cat. (Charleroi, Belgium, 1978), pp. 52–3. For additional details concerning the death of Magritte's mother, such as

whether or not René viewed her corpse, as well as his possible artistic responses to this tragic event, see also D. Sylvester, *Magritte: The Silence of the World* (New York, 1992), pp. 10–30, and Sylvester and Whitfield, *Oil Paintings 1916–1930*, pp. 8–9.

4. See Elena Calas, "Magritte's Inaccessible Woman," *Artforum* 17, 7 (Mar. 1979), p. 24. For a discussion of the problems faced by the children of suicides, see A. C. Cain, ed., *Survivors of Suicide* (Springfield, Ill., 1972).

5. See Martha Wolfenstein, "The Image of the Lost Parent," in *The Psycho-analytic Study of the Child,* vol. 28, ed. Ruth S. Eissler, Anna Freud, Marianne Kris, and Albert J. Solnit (New Haven & London, 1973), p. 446.

6. The newspaper accounts reproduced by Sylvester, "Portraits de Magritte," pp. 52–3, describe Mme Magritte as a neurasthenic individual who had often threatened suicide. One report indicates that she suffered from "a very cruel malady," whose pains caused her to flee her home the night of her suicide. (English translations of these same accounts are provided in Sylvester, *Magritte: The Silence of the World,* pp. 8–9.) At my request, A. M. Hammacher graciously agreed to ask the artist's widow, Georgette Magritte, whether she knew any further details about the artist's mother in particular and the family history in general, but this attempt proved quite unproductive (personal communication, Oct. 11, 1984).

7. In the late "Interviews de Houston, décembre 1965," included in René Magritte's *Écrits complets*, ed. André Blavier (Paris: Flammarion, 1979), p. 617, the artist noted, "I painted sixty paintings in 1926, but that was a youthful explosion.... I paint far fewer now." According to Sylvester and Whitfield, *Oil Paintings 1916–1930*, p. 57, "Between the start of 1926 and the opening of his show at [the gallery] Le Centaure on 23 April 1927, Magritte did nearly seventy paintings. Between then and his departure for Paris in mid-September, about twenty-five. In Paris, in the last three months of 1927, about thirty-five. In the course of 1928, he produced rather more than a hundred paintings. From the beginning of 1929 until ... February/March 1930, he did forty-odd." Sylvester credits Magritte's heightened productivity in 1926–7 to the fact that he had signed a contract with his dealers at the beginning of 1926 that provided him with a monthly stipend for paintings. For further details about Magritte's production during these years, consult vol. 1 of the catalogue raisonné (Sylvester and Whitfield, op. cit.).

8. See Louis Scutenaire, *Magritte,* trans. Eleanor Hodes (Chicago, 1948), pp. 13–14. *The Palace of Curtains II* features one of the earliest, if not the earliest, instance in which Magritte contrasted light and darkness in a single canvas. The left-hand "curtain" with its dark, corrugated, metallic surface rather resembles the interior of some primitive sarcophagus. The right-hand curtain-figure, by contrast, presents a seemingly transparent view of sky and clouds. However, the fact that the sky scene interrupts the background setting depicting double-crowned trees counters this impression of transparency. If my reading of the leftmost curtain as sarcophagus-like is accurate, the picture also prefigures the numerous later paintings by Magritte that would feature animated coffins.

9. A. M. Hammacher, *René Magritte,* trans. J. Brockway (New York, 1973), p. 76, points out this distinction. Some of the paintings with invented

forms depict images apparently inspired by the artist's fascination with the strange shapes assumed by melted lead pieces used in a contemporary children's game.

10. In an interview with the artist's widow published in René Passeron, *René Magritte*, trans. Elisabeth Abbott (Chicago, 1972), p. 12, Passeron asked Mme Magritte: "Things that happen in childhood often have a lasting influence. Did Magritte ever speak to you of his?" She responded: "René never spoke of his mother; he never confided anything about his relations to me. Neither the past nor the future interested him, only the present. He did not have a family feeling and he loved only his wife, his Pomeranian dog, his 'home' to the exclusion of everything else."

At my request, Dr. Hammacher once again specifically asked Mme Magritte about these same issues. She replied that the mother's suicide had occurred before she met the artist, and that he never mentioned it to her. She noted that his brother (one assumes she meant Paul, who was much closer to the artist and his wife than was Raymond) behaved in the same way. "It was a kind of family taboo." Mme Magritte did know the artist's father but never heard from him or anyone else about "things that happened between him and his wife." When Dr. Hammacher suggested that the artist's mother might have been "neurasthenic" (i.e., depressed), Mme Magritte agreed, but – one senses – with some reluctance (personal communication, Oct. 11, 1984).

11. For his accounts, see Scutenaire, *René Magritte,* and idem, *Magritte.* These texts are reprinted in his *Avec Magritte* (Brussels, 1977), which see. See also Patrick Waldberg, *René Magritte,* trans. Austryn Wainhouse (Brussels, 1965), pp. 35–58. The latter volume includes interesting information based on the author's first-hand observations, as well as his interviews with Paul and Raymond Magritte.

During an interview conducted by J. Stévo late in the artist's career, Magritte was asked if he had been marked by his mother's suicide. The artist responded affirmatively, only to launch into an immediate antipsychological tirade. Magritte's vehement denouncement suggests that he was well aware that psychological inquiry could illuminate aspects of his art and life that he not only did not wish to share with his public, but that he did not even wish to confront within himself: "Of course, such things cannot be forgotten. Yes, it left its mark, but not the way you think. But I don't believe in psychology any more than I believe in will power, which is an imaginary faculty. Psychology doesn't interest me. It claims to reveal the flow of our thoughts and emotions; its efforts are contrary to what I know; it tries to explain a mystery. The only mystery is the world. Psychology concerns itself with false mysteries. It is impossible to say whether my mother's death had any influence or not." Quoted in Sylvester and Whitfield, *Oil Paintings 1916–1930*, p. 9, from Jean Stévo, "Le surréalisme et la peinture en Belgique," *L'Art Belge*, numero René Magritte (Jan. 1968), p. 61.

12. The family moved several times during Magritte's childhood and adolescence. He was born in Lessines; two years later the Magrittes moved to Gilly. From 1904 to 1913, they resided in Châtelet, but following Mme Magritte's suicide Léopold and his sons relocated to Charleroi, where René attended school until late 1915, when he moved to Brussels alone

to attend the Academy of Art. The following autumn, his family joined him there, where his father eventually purchased a townhouse, which he converted into a combination dwelling and factory, where the stock cubes he was by then engaged in manufacturing and selling were produced. For these and other details concerning Magritte's early history, consult Sylvester, *Magritte: The Silence of the World,* pp. 7–35. This information, based on years of research by Sylvester and his associates, differs in some details from previously published accounts.

13. At the time of her death, Mme Magritte shared a bedroom with her youngest son, Paul. According to earlier accounts, confirmed in Sylvester, *Magritte: The Silence of the World,* p. 10, her husband locked her (and Paul) into this chamber every night, but during the early morning hours of February 25, 1912, she managed to escape to her death. In view of Paul's probable traumatic reaction to this tragedy, it is scarcely surprising to learn from a hitherto unpublished account reproduced in ibid., p. 32, that the boy later refused to sleep in a conventional bedroom. A classmate of René's at the Royal Academy who visited the Magritte home in Brussels noted that Paul slept on a large staircase landing equipped with a settee and a photographer's tripod, on which a candle rested. From this vantage point, the informant noted, Paul could keep an eye "on all the comings and goings" of the family. René may have adopted equally peculiar sleeping habits. According to this friend, "The [Magritte] house had three floors. Not all the rooms were inhabited. On the top floor there were two or three rooms in which there were easels and little else. And Magritte had this top floor all to himself. In one room there was a pile of old clothes, and when he was tired he would go and lie down on it. He must have had a bedroom somewhere, I suppose, but I never saw it."

14. Extremely disturbed mothers often select one child to be the family scapegoat, encouraging the siblings to join in abusing the chosen victim – a fact that may well be relevant in this case. Waldberg, *René Magritte,* p. 51, describes a scene he witnessed between René and Paul Magritte: "We detected the winks and smiles the two men exchanged when we heard them, one at sixty-six and the other at sixty-two, evoke that association of long ago [i.e., their childhood alliance against Raymond] and understood that the old complicity is still alive." Waldberg suggests that this animosity was exacerbated once the boys reached adulthood, because Raymond quickly became prosperous, while his two brothers remained impoverished for many years. He also described a conversation with Raymond Magritte in which the latter characterized his world-famous artist-brother as "an ass." Despite the apparent disdain suggested by this comment, Raymond purchased – and retained throughout his lifetime – a number of paintings by his brother; they have remained in the family's possession and are currently in the collection of Raymond's daughter. For identification of early paintings purchased by Raymond long before his brother achieved international fame, see Sylvester and Whitfield, *Oil Paintings 1916–1930.*

15. This photograph is reproduced in Harry Torczyner, *Magritte: Ideas and Images,* trans. Richard Miller (New York, 1977), p. 23. The fact that the picture was obviously the work of a professional photographer need not vitiate its reliability as an index of family attitudes. It may be that the Magrittes naturally formed an arrangement that inspired the grouping memo-

283

rialized in the photo, but it is equally likely that the photographer simply instinctively responded to subliminal cues informing him of family dynamics. Family therapists are increasingly utilizing informal and posed photographs for insights into intrafamilial relationships. For a popular account of this development, see Jane E. Brody, "Photos Speak Volumes about Relationships," *New York Times*, July 17, 1984, pp. 21, 25.

16. See Scutenaire, *Avec Magritte*, p. 31.

17. David Sylvester, *Magritte*, exh. cat. (New York & Washington, D.C., 1969), p. 14, makes a similar observation. To Sylvester's list of pictures with such "divine" self-references, I would add *The Annunciation* (1930; Tate Gallery, London), a painting that seems to encode symbolic references to the artist's mother as the Virgin Mary – and perhaps as the future mother of a god to be named René Magritte.

18. Magritte's most explicit identification of himself with the pigeon or dove occurred in *The Man in the Bowler Hat* (1964), an apparent self-portrait in which the artist characteristically obliterated his own face, substituting the body of a white dove for his features. His earliest version of *The Healer* or *The Therapist* (1937; Collection Baron Urvater) depicts an individual whose upper torso and face have been replaced by a bird cage containing two doves. That same year, Magritte posed for a photo mock-up of this work in which he is depicted in the role of the healer.

 Doves appear with great frequency throughout Magritte's oeuvre, along with birds of several other species, especially in his late renditions of bird–leaf metamorphoses. He seemed equally preoccupied with bird–egg metamorphoses, and also frequently associated symbols of his mother with birds. For example, *The Uncertainty Principle* (1944; private collection) depicts a nude woman whose shadow assumes the form of a bird with spread wings. It seems likely that in this instance – as in many of Magritte's compositions (among them, *Nocturne* and *The Difficult Crossing*, both discussed later in this chapter) – the bird represents the maternal anima or soul. As J. E. Cirlot notes in *A Dictionary of Symbols*, trans. J. Sage, foreword H. Read (London, 1982), "The interpretation of the bird as symbolic of the soul is very commonly found in folklore all over the world." Cirlot also points out that the use of the bird as a visual symbol for the soul has been traced back to the ancient Egyptians, who gave the concept concrete form by depicting birds with human heads: "in their system of hieroglyphics it was a sign corresponding to the determinative *Ba* (the soul), or the idea that the bird flies away from the body after death. This adrocephalous bird appears also in Greek and Romanesque art, and always in the same sense" (pp. 25–6).

 For additional confirmatory commentary on the symbolic meaning of birds and bird cages, see Ad de Vries, *Dictionary of Symbols and Imagery*, rev. ed. (Amsterdam & London, 1981), pp. 47–9.

 Beryl Rowland, *Birds with Human Souls: A Guide to Bird Symbolism* (Knoxville, 1978) provides much more detailed information on the individual significance of various species. See especially her entry on the dove, pp. 41–8.

19. Cited in numerous sources, this quotation comes from Waldberg, *René Magritte*, p. 48. In the interview with Passeron, *René Magritte*, p. 12, Mme Magritte made light of the artist's bizarre religious behavior during

childhood: "As a small boy he used to tease the maid-servant, Anaïs, by making the sign of the cross at table or by setting up altars in his bedroom.... Child's play!" It seems quite likely that Mme Magritte – and perhaps the artist himself during his later years – gradually realized that the public might regard this behavior as pathological, and so attempted to dismiss it as mere caprice.

20. Scutenaire, *Avec Magritte*, p. 21, explains Magritte's irregular academic record as follows: "He was very young when he lost his mother. Bounced from town to town by a busy father, his studies – if they were long – were fragmentary and his education left to servants." For further details about this period, see n. 12, above.

21. The artist himself provided this reminiscence in a public lecture entitled "The Lifeline," delivered in Antwerp on November 20, 1938. It appears in the original French in Magritte, *Écrits complets*, pp. 103–30, and in a shortened form on pp. 142–8 of the same text. Torczyner, *Magritte: Ideas and Images*, pp. 213–16, published the abbreviated version in English. None of the accounts makes clear exactly how old Magritte was when he undertook these cemetery explorations, nor how many summers of his childhood he spent with his grandmother. In his "Esquisse Autobiographique," in *Écrits complets*, Magritte mentions spending his vacations at Soignies and exploring the cemetery there in a context suggesting either that he may have been much older when he undertook these explorations or, conversely, that he continued to engage in the activity into early adolescence. In any case, as Wolfenstein, "The Image of the Lost Parent," p. 452, suggests, the artist seemed to fuse memories of these excursions with his underlying wish magically to restore his mother to life.

22. A *screen memory* may be defined as "a recollection from childhood (which may or may not prove to be historically true); it characteristically has a high valence for the individual. When successfully decoded, it turns out to have a latent meaning like a dream; usually this meaning has applicability to a broad area of the child's inner life" (John E. Gedo, personal communication).

23. For a concise history of Magritte's relationship with the writers who played key roles in the genesis of the Surrealist movement in Belgium, consult Sarah Whitfield, "Magritte and His Accomplices," in *Magritte*, exh. cat. (London, 1992), pp. 25–48. See also Sylvester, *Magritte: The Silence of the World*, pp. 45–7, 52–9, and passim.

 Magritte and his literary friends were all great admirers of Fantômas, the antihero of pulp detective stories written by O. Souvestre and Marcel Allain, as well as of films by Louis Feuillade, whose bizarre cinematic effects are widely believed to have influenced Magritte's imagery. Waldberg, *René Magritte*, pp. 11–17, provides an especially good discussion of Fantômas and his fascination for Magritte. For a summary of the impact of Feuillade's imagery on Magritte, see Sylvester, op. cit., pp. 20, 98, esp. 104–5.

24. Hammacher, *René Magritte*, p. 18, notes that Magritte rejected dreams as a source for his paintings, but then quotes from a statement by the artist that reveals "the situation is not so simple as Magritte's outright rejection of the dream would make it seem." In his lecture "The Lifeline," Magritte provided a vivid description of awakening one morning after a night spent in a room with a caged bird, to misperceive the bird as an egg. (His *Elective*

Affinities [1933; private collection] depicts this substitution.) This experience revealed to him "a new and astonishing poetic secret" concerning the hidden affinity of bird and egg. For the various versions of Magritte's lecture, see n. 21. Magritte's reminiscence reveals that he did make use of hypnopompic techniques for inspiration, apparently without realizing that this was the case.

25. The artist frequently juxtaposed images of *grelots* with figures or objects associated with his mother. For example, several versions of *Memory* depict a *grelot* in combination with a plaster or marble head of a woman, shown bleeding from what appears to be a gunshot wound to the temple. This picture has been widely interpreted as a reference to the suicide of Magritte's mother. The artist's pictorial association of these bells with other references to his mother arguably dates from *The Silvered Chasm* (1926). (This picture, along with five other early oils featuring *grelots,* is reproduced in color in Sylvester, *Magritte: The Silence of the World,* pp. 94–5.) I suspect that bells of this type were worn by some of the horses used to pull carriages in Mme Magritte's funeral cortege.

26. Ibid., p. 48, provides an assessment of Magritte's relationship with his wife generally congruent with the view presented here. He also furnishes additional biographical data not available when this essay was originally published. For instance, he reveals that, soon after their marriage, Georgette suffered one or more miscarriages, and that Magritte became so frightened by this threat to her health that the couple decided to remain childless.

 Sylvester suggests that Georgette seems to have functioned as both mother and daughter to the artist, who spoiled her shamelessly, but was nevertheless extremely dependent on her.

 En passant, the author also makes the startling disclosure that, the artist's devotion to his wife notwithstanding, he made regular "quick" visits to brothels, with Georgette's knowledge and – apparently – approval! Mme Magritte's later history (briefly reviewed in Chapter 8) suggests that she was no prude. The artist's recourse to prostitutes indicates that he required some type of unusual sexual activity in which Georgette was unwilling to engage – or in which he was unwilling to ask her to participate. The nature of the artist's imagery – his frequent use of anthropomorphosized objects to represent female figures – suggests that his sexual requirement may have involved fetishism. (Fetishists derive sexual pleasure from interacting with objects or discrete anatomical parts – such as feet – rather than with a partner viewed as a whole being.)

27. Magritte attached great importance to the titles of his paintings, which were typically chosen after the picture had been completed. Hammacher, *René Magritte*, pp. 25–30, provides a good discussion of the importance of titles to the artist, as well as the varied methods he used to select them. Hammacher notes: "According to what Magritte's surviving relatives and friends have said, the titles sometimes came about through Magritte's own invention, but also very often through discussions with others, at soirées, on the telephone or in letters, when a painting would be made the subject of discussion" (p. 25).

 I believe that, if one wishes to decipher the psychological meanings that the artist's pictures held for their creator, one must treat Magritte's titles

with the utmost seriousness. The fact that he sought assistance from others, and sometimes even accepted titles wholly invented by friends, need not render these titles personally less meaningful for him. His intimates, after all, must have been able to select titles that resonated with the underlying significance of the work for the artist.

28. Ibid., p. 68.

29. Although many aspects of the artist's first Surrealist style reflect the potency of de Chirico's example, Magritte borrowed images from a variety of other sources. Max Ernst also exerted an important influence on Magritte during his first Surrealist years, and Sylvester and Whitfield both provide numerous instances of Magritte's borrowings from Ernst. For additional telling examples of similarities between Ernst's early Surrealist imagery and that of Magritte, consult William A. Camfield, *Max Ernst: Dada and the Dawn of Surrealism*, exh. cat. (Munich, 1993).

 Magritte not only used the pulp detective stories featuring Fantômas as sources of inspiration; he also borrowed the illustrations provided in widely available reference books, such as the *Nouveau Larousse Universel* (as in n. 30).

 Magritte's experiences as the creator of illustrations for advertisements also helped to shape his high art. However, the fact that Magritte incorporated borrowed images should not be interpreted to mean that the resulting pictures were any less personal; he undoubtedly chose such images because they struck a deep, responsive chord in his fantasies. Moreover, as Sylvester and Whitfield, *Oil Paintings 1916–1930*, no. 137, p. 209, also note, Magritte transformed all his borrowings into uniquely original creations.

30. Sylvester, *Magritte: The Silence of the World*, pp. 14–15, points out that this is only one of several possible interpretations to which this enigmatic work lends itself. The sphargis makes another airborne appearance in *The Secret Player* (1927), where it hovers above two young men engaged in a ball game. The sphargis represents a good example of Magritte's borrowed imagery; as Sylvester, op. cit., p. 98, demonstrates, it comes from an engraving reproduced in the 1926 edition of the *Nouveau Larousse Universel*, which the artist owned. During his first Surrealist phase, Magritte frequently derived images from such popular reference works.

31. For the importance of bird imagery in Magritte's oeuvre, see n. 18. Chapter 8 provides additional details about the artist's later use of bird–egg symbolism.

32. Quoted in Sylvester, *Magritte: The Silence of the World*, pp. 62–3, who points to the similar window–bird–hand imagery occurring in a Max Ernst picture of 1923, *At the First Clear Word*; for color reproductions of both works, see p 62.

33. For further details about *Nocturne*, including a photograph of the x-ray of the underlying composition, consult Whitfield, *Magritte*, exh. cat, no. 6, n.p. Whitfield believes that the oil predates the papier collé version of this picture (no. 129), a conclusion in which I concur, primarily because the latter picture seems less tension-filled and dramatic.

34. For additional details about Magritte's repeated use of bird symbolism, as well as references to the history of the bird–soul equation, see n. 18 above.

35. Magritte reused titles, just as he recycled images; *The Palace of Curtains*, clearly a favorite, was applied to several several different paintings the artist completed between 1926–30.

36. See Sylvester, *Magritte*, exh. cat., p. 5. Another series of pictures that Magritte painted during 1927–30 feature both words and images; however, the "names" written beneath the objects do not correspond to the things depicted. For example, the 1930 version of *The Interpretation of Dreams* (another favorite title applied to several different pictures) features six objects, each accompanied by a name that bears no relationship to it; for example, a woman's slipper is identified as the moon ("la Lune") and a man's hat as "snow" ("la Neige"). Pictures of this type demonstrate a schizophrenic misuse of language – a phenomenon with which Magritte was no doubt intimately acquainted from his childhood experiences with a psychotic mother.

37. See Hammacher, *René Magritte*, p. 88. One wonders whether Magritte had actually read the French translation of Freud's *Interpretation of Dreams,* published in 1926. Despite his later hostility to psychoanalysis, the artist may have been stimulated to dip into Freud through his contacts with André Breton and others. At least the symbolism in *Discovery* seems almost deliberate in its emphasis.

38. Wooden chests, coffins, and the like often appear in Magritte's paintings. For example, in *The Daring Sleeper* (1928; Tate Gallery, London), the androgynous protagonist rests in a "bed" that closely resembles a lidless, wooden coffin turned on its side. In *Homage to Mack Sennett* (1934; Musée Communal, La Louvière, Belgium), an open wooden armoire reveals, neatly hung up, a woman's nightgown with live, luminous breasts. This strange picture makes one wonder whether the future artist treasured items of his mother's clothing following her death. Shoes and other objects that may have been associated with Magritte's mother recur in his iconography and may be related to the possible fetishistic behavior mentioned above in n. 26. Mirrors, often reflecting painted wood graining rather than an image, probably allude to his mother's narcissism, as well as to her recurring wooden unresponsiveness to others.

39. Perhaps Magritte's mother's excitable, inappropriate behavior and poor judgment even led her to engage in some type of sexual activity with her oldest son. The eroticism in which the artist's images symbolic of his mother are steeped support such a speculation. However, Waldberg, *René Magritte*, p. 53, reports that the two older Magritte boys later boasted that they had enjoyed the favors of one or more of the mistresses their father took following their mother's death. If this report is true, it presumably could account for such strange, sexualized imagery.

40. Quoted in Torczyner, *Magritte: Ideas and Images*, p. 109.

41. Whitfield, *Magritte*, exh. cat, no. 21, n.p., describes the birds as having been shot. However, in view of the temporal and thematic links this picture shares with *Pleasure,* it seems to me more likely to assume that they, too, have suffered the fate of the bird depicted in *Pleasure*.

42. We know very little about Raymond Magritte's adult adjustment except that he was a successful businessman. The limited information concerning the youngest son, Paul, suggests that he must have been quite an unusual

personality, to put it mildly. See, for example, Waldberg, *René Magritte,* p. 51, for an account of Paul's bizarre behavior during the course of a social evening spent in the artist's home. See also Gablik, *Magritte,* p. 23, for a brief description of Paul, along with a quotation from one of his writings, which she labels his "strange pseudo-dissertations." At least as a young man, Paul seems to have been quite dependent on his oldest brother and the latter's wife. Sylvester, *Magritte: The Silence of the World,* pp. 120-1, notes that, shortly after René and Georgette Magritte moved to the outskirts of Paris in 1927, Paul followed them and soon became "a very present member of the household." Although he lived in a rented room nearby, Mme Magritte recalled that he took all his meals at their home and constantly used their piano to practice his songs. (He earned his living at the time by playing and singing in bars.) Sylvester's account suggests that Paul's dependent behavior continued to rankle Georgette long after the events in question.

43. According to Scutenaire, *Magritte,* p. 14, Magritte was inspired to create *Pleasure* by seeing his wife eating a chocolate bird. As previously noted, the lace-trimmed coat worn by the protagonist in this painting closely corresponds to an outfit once owned by the future Mme Magritte.

 However, a painting in the Musées Royaux des Beaux-Arts, Brussels – a work with which Magritte was surely familiar – may also have had some part in inspiring *Pleasure*. *La Filette à l'oiseau mort,* by an unknown Netherlandish master of the early sixteenth century, shows a solemn-faced child clasping a dead bird. The artist no doubt intended this painting as a memento mori, a reminder that even the young and innocent must confront the inevitability of death. Still, the little girl's enigmatic expression, which may be read as either somber or sinister, lends a disquieting note to the composition, leading one to wonder whether she played a causative role in her pet's death. I am grateful to Michael Gnat, production editor for this volume, for calling this work to my attention.

44. In a statement quoted in Torczyner, *Magritte: Ideas and Images,* p. 90, Magritte discussed the motif of the "patricidal rose," pointing out that in *The Backfire* (1942; private collection), a painting that virtually duplicates the 1912 cover of *Fantômas* (as in n. 23, above), which showed the antihero of the title as an evil superman towering over Paris, he replaced the knife grasped by Fantômas with a rose. (For illustrations of both versions, see Gablik, *Magritte,* figs. 40 and 41, pp. 50-1.) Several times Magritte depicted a rosebush on which a flower and a dagger grow side-by-side. In 1936, he painted *Checkmate,* which stars two anthropomorphic chess pieces and shows the bishop stabbing the king to death.

45. This quotation comes from Sylvester, *Magritte,* exh. cat., p. 4. *The Murderer Threatened* is one of two extant paintings by Magritte (*Pleasure,* discussed above, is the other) that correspond rather closely to texts composed in 1927 by the artist's friend, Paul Nougé. Whether Magritte executed these pictures to fit Nougé's programs, or Nougé created the descriptions to correspond to Magritte's preexisting pictures, remains an unresolved problem. That same year Magritte and Nougé did collaborate to create two booklets for which the artist supplied the illustrations and the poet the text. Whatever the facts, it is clear that Nougé played an impor-

tant role in Magritte's creative life during this period. For Nougé's texts and further details about his joint publications with Magritte, consult Sylvester, *Magritte: The Silence of the World,* pp. 106–9.

46. As Sylvester has suggested (*Magritte,* 1969 exh. cat., p. 4), the horn of the gramophone was surely the prototype for the tuba that so often appears in subsequent Magrittian compositions, paired with the female nude. Does this association reflect the fact that the artist's mother spent a good deal of time unavailable to her children while listening to the gramophone?

47. In view of Mme Magritte's mental illness, attempts by the father to seek feminine companionship outside his home would seem understandable enough. On this subject, see Waldberg, *René Magritte,* p. 53, and Sylvester, *Magritte: The Silence of the World,* p. 14, who states that Jeanne Verdeyen, engaged as governess to the Magritte children following their mother's suicide, soon became Léopold's mistress. According to the account furnished by Magritte's classmate, quoted in n. 13, René introduced her to his friend as "dad's mistress" and her child as "a bastard son." Apparently she remained the father's companion until his death, and René eventually became quite attached to her. According to Sylvester, op. cit., p. 46, the artist described her as his "second mother" in a letter to Georgette (presumably written in 1922).

48. Sylvester, *Magritte: The Silence of the World,* pp. 104–5, reproduces two stills from Louis Feuillade's 1913 film *Fantômas* that may have inspired the image of the "twins" in *The Menaced Assassin.*

49. However, one should not overlook the fact that the assassin is portrayed as a young man, the apparent peer of the twins and triplets who silently survey him. It may be that, in his image of the murderer, Magritte condensed references both to his father and to his hated brother, Raymond. In either case, the statement about Magritte's use of this device to project his own guilt seems equally valid (i.e., "It was not I but my wicked father – or my evil brother Raymond – who destroyed my mother").

50. Magritte provided this interpretation of a drawing for the composition in a letter he wrote Marcel Lecomte at the time. It is quoted in Sylvester and Whitfield, *Oil Paintings 1916–1930,* no. 235, pp. 276–7.

51. Ibid., no. 136, p. 207, suggest that the furry character of so much of the imagery in *The Meaning of Night* reflects Magritte's work in designing a furrier's catalogue that was published the same year he created this work.

52. Whitfield, *Magritte,* exh. cat, no. 17, n.p., comments about the protagonist of *The Man from the Sea:* "[H]is status as one of the most vigorous heroes in the surrealist pantheon is recognized in his pose – that of a Greek or Roman warrior. The helmet has been transformed into a block of wood, with painted scrolls instead of plumes, and the shield into a jagged fragment of window."

8. Homesick and Heartsick: René Magritte's Artistic and Personal Crisis of the 1940s

A previous version of this material appeared in John E. Gedo and Mary M. Gedo, *Perspectives on Creativity: The Biographical Method* (Norwood, N.J.: Ablex Publishing Corp., 1992), pp. 83–118.

1. Although scheduled for imminent publication, the pertinent volumes of the catalogue raisonné detailing Magritte's oeuvre during the period covered in this essay have not yet appeared as this manuscript goes to press. The interested reader should consult vols. 2–5 when they appear. See David Sylvester, ed., *René Magritte: Catalogue Raisonné*, 5 vols. (London, 1992–3). In the absence of this information, I have relied on D. Sylvester, *Magritte: The Silence of the World* (New York, 1992) to supplement information previously available concerning the artist's personal and professional history, as well as the present location of works. This volume also provides additional data about Magritte's relationship to leading Belgian literati, as well as to the international Surrealist movement, important aspects of his career that this essay, focused so closely on his most intimate personal reactions, does not address in any detail. The reader might also wish to consult Patrick Waldberg, *René Magritte,* trans. Austryn Wainhouse (Brussels, 1965), pp. 179–332, who discusses the artist's association with the French Surrealist movement and provides a useful documentation section that includes reproductions of several French Surrealist periodicals to which Magritte contributed. For the artist's relationship with the Belgian Surrealists, see *René Magritte und der Surrealisme in Belgien,* exh. cat. (Brussels, 1982). See also Sarah Whitfield, "Magritte and His Accomplices," in *Magritte,* exh. cat. (London, 1992), pp. 25–48.

 Although René Magritte, *Écrits complets*, ed. André Blavier (Paris: Flammarion, 1979) comprises a potential treasure trove of the artist's statements, as well as copious references relating to every aspect of his career, its eccentric organization makes it so frustrating to use that only the most determined reader will wish to consult it.

2. Quoted in David Sylvester, "Portraits de Magritte," trans. Anne Perez, in *Rétrospective Magritte,* exh. cat. (Charleroi, Belgium, 1978), p. 71.

3. According to additional information supplied in Sylvester, *Magritte: The Silence of the World,* p. 259, between March or April 1943 and the end of 1944, Magritte painted fifty pictures, all but two of them in the solar style that Sylvester calls "quasi-impressionist": "[T]he following year he painted about twenty pictures, only five of which were in that style. Then, from the start of 1946 to the spring of '47 he painted twenty pictures most of which were quasi-impressionist and sixty gouaches about half of which were."

4. See James Soby, *René Magritte,* exh. cat. (New York, 1965), p. 15, n. 17. The sole reference the catalogue makes to Magritte's *vache* phase occurs in the following footnote: "The word 'accursed' does not apply, as is often thought, to what Magritte has called 'L'époque vache.' The latter phase applies only to a period of months in 1948 when Magritte was assembling rather hastily an exhibition of his paintings to be held in Paris, where his name was beginning to be forgotten, except among *aficionados,* due to the isolation imposed by the war."

5. Louis Scutenaire, *Avec Magritte* (Brussels, 1977), pp. 108–9.

6. Quoted in Alfred A Barr, Jr., *Picasso: Fifty Years of His Art* (New York, 1966), p. 223.

7. My information on the details of this journey derive primarily from a letter I received from Dr. Hammacher (personal communication, Feb. 7, 1987) summarizing his interview with the Scutenaires, combined with descrip-

tions contained in Irène Hamoir's printed brochure, *Le Vocatif* (1981, Belgium), n.p. – the published version of a 1975 letter from her to the late psychoanalyst Martha Wolfenstein (who had been writing a book about Magritte, left unfinished at her death), describing this interlude in detail. Magritte and the Scutenaires had not planned in advance to leave Brussels together, but they happily joined forces when they encountered one another at the Brussels railroad station. Magritte selected Carcassonne as his destination because he had a contact there, the invalid Surrealist poet Joë Bousquet, who aided the artist and his friends in finding lodging, etc. During their Paris stopover, Magritte temporarily lost sight of the Scutenaires, but as soon as he learned of their whereabouts, he wrote, inviting them to join him in Carcassonne. They accepted the invitation but did not stay very long, perhaps because the villa Magritte had rented proved to be too small and lacking in amenities.

The account of this period recently published by Sylvester, *Magritte: The Silence of the World*, pp. 250–1, contains essentially the same information reported here. He did not succeed in uncovering any new factual data concerning Magritte's purported anti-Nazi activities and simply repeats Claude Spaak's assertion that the artist was fearful that "the Nazis would be out to get him in revenge for political statements he had made" (p. 250).

8. Sylvester, *Magritte: The Silence of the World*, pp. 48, 241–2, 250, provides additional data about Magritte's domestic situation during the late 1930s that has not, to my knowledge, been published until now. According to Sylvester, during the course of the repeated professional visits Magritte paid to London during the late 1930s, where he executed a group of paintings commissioned by Edward James, he began an affair with a beautiful English woman, Mrs. Sheila Leggs. Thus engaged, the artist encouraged (indeed, apparently provided tacit permission to) his friend, the Surrealist poet Paul Colinet, to initiate the liaison with Mme Magritte that subsequently developed. But the artist soon proved unable to tolerate the situation he had wrought. He forbade Colinet to visit *chez* Magritte, and even involved the law in a bizarre episode in which he and a policeman followed his wife to a rendezvous with her lover. In a still more grotesque incident, Magritte wrote Colinet a letter in which he gave "precise and coarse instructions on how to pleasure his wife." Meanwhile, "Georgette pursued the affair with determination. She would go out in the afternoon in the company of a teenage girl who was a friend of hers and of her husband's and would leave their young friend waiting in a café while she went to see her lover. She talked to Magritte, seriously, about a divorce" (p. 242).

9. Hamoir, *Le Vocatif*, n.p.

10. According to Dr. Hammacher, by the time Magritte returned to Brussels in August of 1940, his wife had severed the relationship with Colinet, and the entire episode soon ceased to be mentioned by members of the artist's circle, until a scandal-mongering author included an account of it in a book published several years after Magritte's death (which had occurred in 1967). Mme Magritte subsequently initiated a legal proceeding against the author, but the judge ruled in the latter's favor. Dr. Hammacher could not recall the author's name, and my efforts to learn more about this pub-

lication (including whether it reprinted Magritte's letter to his alleged rival) have thus far failed to bear fruit.

Sylvester does not precisely date the end of Mme Magritte's affair with Colinet, but his account seems generally congruent with the information provided by Dr. Hammacher, except that Sylvester makes no mention of the lawsuit.

11. For the latest official descriptions of the etiology and symptoms of depression and related disorders of mood, especially the manic–depressive, or bipolar, syndrome, as it is now known, see *Treatments of Psychiatric Disorders: A Task Force Report of the American Psychiatric Association*, vol. 3 (1989, Washington, D.C.), pp. 1751–66 and 1925–40). See also *American Handbook of Psychiatry,* ed. Silvano Arieti, vol. 3, Adult Clinical Psychiatry, ed. S. Arieti and E. B. Brody (1974, New York), pp. 449–90). See also A. M. Nicholi, ed., *The New Harvard Guide to Psychiatry* (1988, Cambridge, Mass. & London), pp. 309–36. For a historical review of this syndrome, consult E. Wolpert, *Manic–Depressive Illness: The History of a Syndrome* (New York, 1977).

12. Questions concerning the precise chronological sequence of Magritte's production during this period can be provided – if at all – only by the publication of the pertinent volume of the catalogue raisonné. In the absence of definitive data, it is tempting to speculate that Magritte may have painted his 1940 version of *The Lost Jockey* before, rather than after, his flight into France.

13. Harry Torczyner, *Magritte: Ideas and Images*, trans. R. Miller (New York, 1977), p. 31, reproduces a letter Magritte wrote at Carcassonne on July 2, 1940, informing the Scutenaires that he planned to call this painting *Ce qui est beau est un oeuf* (what is beautiful is an egg), a title that Paul Éluard had proposed to him. However, the artist later changed his mind and rechristened the picture *The Wedding Breakfast*. His first idea for the title, *The Voyage,* seems congruent with the interpretation, presented below, that several versions of the compositions titled *Memory of a Journey (Souvenir of a Voyage)* that Magritte painted during the 1950s memorialize this traumatic 1940 interlude.

14. Paintings by Magritte featuring birds, eggs, and egg–bird metamorphoses are too numerous to mention; an extensive essay could be written about the significance of this imagery in his art. Torczyner, *Magritte: Ideas and Images*, pp. 159–61, devotes a special section to Magritte's representations of birds. Magritte himself was fond of describing an incident in which he had spent the night in a room that housed a live bird in its cage. When the artist awakened the next morning, by "a magnificent error" he saw an egg in the case in the place of the bird. He subsequently alluded to this misperception in *Clairvoyance* (1936; private collection); in this rare overt self-portrait, the artist represented himself seated before his canvas, ostensibly painting a still life from a setup consisting of a single egg resting on a cloth-covered table. However, the canvas on his easel depicts not an egg, but a bird in flight. The artist recounted this incident in a lecture entitled "La Ligne de vie" ("The Lifeline"), originally delivered in 1938 and subsequently published in several versions; Suzi Gablik, *Magritte* (Boston, 1976), paperback ed., Appendix II, pp. 182–6, provides an English translation of the revision originally published in 1940. For additional details

about Magritte's bird imagery and its psychoiconographic significance, consult Chapter 7, esp. n. 18. (For more on "The Lifeline," see that chapter's n. 21.)

15. Hamoir, *Le Vocatif,* n.p.

16. Sylvester, *Magritte: The Silence of the World,* pp. 254–56, notes that Magritte first described and sketched this composition in a letter to his patron, Edward James, written on August 30, 1939, as Hitler was poised on the brink of invading Poland. The artist claimed to James that he had already brought off this work, "which seems to me to introduce a new poetic atmosphere into my painting." However, he did not actually finish the oil version of this motif until 1941. Sylvester does not mention Magritte's gouache on the same theme, and one wonders whether it was, in fact, the latter composition to which he referred in his letter. The gouache does not quite correspond to the oil in every respect and seems more tentative than the latter – characteristics that would argue for its earlier date.

 Sylvester also emphasizes the special importance of *Homesickness,* which he perceives as a critical transitional painting, foretelling an imminent stylistic change in Magritte's oeuvre. The author compares the 1941 work to a canvas Magritte had created in 1926, *The Musings of a Solitary Walker.* (For a description of the latter picture, consult Chapter 7.) In *Homesickness,* Sylvester writes, Magritte transforms the "brutal allusion to the dead," that characterizes the 1926 work into "an elegiac mood, sad but non-threatening."

17. Gablik, *Magritte,* p. 65.

18. For detailed examples of the multiple devastating effects on the offspring of a parent's suicide, see A. C. Cain, *Survivors of Suicide* (Springfield, Ill., 1972). The sources cited in n. 11 provide further information regarding the familial incidence of the bipolar syndrome and related suicide rates.

19. For these quotes, see Sylvester, "Portraits de Magritte," p. 71.

20. Ibid.

21. Whitfield, *Magritte*, exh. cat, no. 84, n.p., provides some fascinating information about the plaster head featured in *Deep Waters*: "The head is copied from a plaster cast of an original piece of sculpture which has not been identified. The plaster was stocked by the Maison Berger, the artists' materials shop run by Magritte's sister-in-law [Léontine Berger,] who thought, mistakenly, that it was a cast of the celebrated death mask of a young suicide, *L'Inconnue de la Seine* [an unknown girl whose body was probably recovered from the river in the late 1880s]. Its interest for Magritte, however, surely lay in the deathly stillness of the features. He went on to make this cast the subject of one of his most famous [and frequently repeated] images, the bloodied head of *La Memoire (Memory)*, the first version of which dates from the following year." Variants of this composition all represent the plaster head bleeding from a gunshot wound to the right temple.

 Although Whitfield speculates (no. 84, n. 2) that the original of this cast probably came from some Northern European funerary monument of the late 1890s or early 1900s, its real origin scarcely matters. The important point is that Magritte *believed* that it memorialized a young woman who had chosen the same method of suicide as his mother, a conviction that

lends support to the validity of interpretations involving the personal associations underlying both *Deep Waters* and *Memory*.

A 1965 photo of Magritte in his studio shows the artist standing next to the plaster case of the so-called *L'Inconnue de la Seine,* which has been mounted on his studio wall. Someone (presumably Magritte himself) has added a real ribbon to the hair of the plaster cast. The photo is reproduced in Jacques Meuris, *René Magritte* (New York, 1991), p. 156.

22. Torczyner, *Magritte: Ideas and Images*, p. 187, reprints a translation of a letter in which Magritte discussed this issue. The artist wrote: "As for the reproach of imitating Renoir, there is some misunderstanding. I have done pictures 'after' Renoir, Ingres, Rubens, etc., but without using Renoir's particular technique, but rather that of Impressionism, including Renoir, Seurat, and others. In this regard, some of my recent pictures, according to the subject, have required me to use my former technique (smooth, polished painting), but with lighter colors, severity being banished. SEVERITY IS FURTHER AWAY, less measurable." (Letter to André Breton of June 24, 1946; the capitalization is Magritte's.)

It might also be noted that, in changing from a more tightly rendered, crisper style to the looser, more painterly technique of his Impressionist phase, Magritte followed the example of his idol, Giorgio de Chirico, who adopted a similar approach in many of his later works.

23. Quoted in John Rewald, *Post-Impressionism: From van Gogh to Gauguin*, 3rd ed. (New York, 1978), p. 60.

24. See René Passeron, *René Magritte*, trans. Elisabeth Abbott (Chicago, 1972), pp. 36–7.

25. Sylvester, *Magritte: The Silence of the World,* pp. 259–60, makes the same observations concerning the sources of these paintings.

26. Sylvester, "Portraits de Magritte," p. 72, notes that "the subversive quality of the imagery" in so many of Magritte's Impressionist paintings presents a jarring contrast to their formal character. He points out, for example, that in both *Oceanus* and *The Age of Pleasure*, "the grace of the style contrasts with the brutal frankness of the erotic pleasantry" in a disconcerting manner.

27. Magritte began the practice of creating numerous replicas and variants of previous works during the mid-1930s. According to Sylvester, *Magritte: The Silence of the World,* p. 237, nearly half the works the artist sent to the Julian Levy Gallery for his first American show (held in January 1936) consisted of such replicas and variants. There is no indication that the dealer urged the artist to execute these duplicates, none of which found a buyer at the time. For additional information about Magritte's repetitions, see Sylvester, op. cit., pp 237–40 and 298–306. See also n. 42, below.

28. See Martha Wolfenstein, "The Image of the Lost Parent," in *The Psychoanalytic Study of the Child*, vol. 28, ed. Ruth S. Eissler, Anna Freud, Marianne Kris, and Albert J. Solnit (New Haven & London, 1973), p. 449.

29. See Louis Scutenaire, *Magritte*, trans. Eleanor Hodes (Chicago, 1948), p. 16.

30. Magritte showed fifteen oils and ten gouaches from this group in his Paris show. However, Sylvester, *Magritte: The Silence of the World,* p. 269, notes that the artist actually produced two more oils and twelve additional gouaches in this style. Although all thirty-nine pictures were painted

within the brief time span of five or six weeks of March and April 1948, the artist back-dated a number of them to 1947 to disguise the fact that they had been created with such rapidity. Sylvester cites numerous other instances in which Magritte back-dated works for financial advantage. He notes that the artist also engaged in "criminal activity" during 1943–6, when he "steadily faked paintings and drawings in the styles of Picasso, Braque, de Chirico, Ernst and others" which a friend disposed of for him, often through the sales room at the Palais des Beaux-Arts (p. 254).

31. For this quote, consult Scutenaire, *Avec Magritte,* p. 113.

32. See Gablik, *Magritte,* p. 152.

33. Ibid., Appendix V, pp. 188–92, reprints Scutenaire's mock biography, "René Magritte of Yore," both in the original French and in an English translation. According to Sylvester, *Magritte: The Silence of the World,* pp. 269–70, Scutenaire supplied virtually all the titles for Magritte's *vache* works, and Irène Hamoir invented a number of the images. The enduring collaboration between Magritte and Scutenaire undoubtedly reflected their shared convictions about art and, most likely, shared attitudes toward life. The psychological significance of artistic partnerships of this type presents a fascinating, but relatively unexplored, problem.

34. The erupting heads sprouting from Titania's body suggest concretizations of the fantasy of dissolving into an assembly of homunculi. Ideas of this kind probably reflect childhood identifications with different caretakers in their various aspects (e.g., the "good" mother, the "bad" mother, the "indifferent" mother, etc.). In the past, psychoanalysts often referred to such fantasied figures as "introjects." For a more contemporary discussion of this phenomenon, as well as an extensive bibliography, consult J. Greenberg and S. Mitchell, *Object Relations in Psychoanalytic Theory* (Cambridge, Mass., 1983).

35. Friends associated with the New York art world inform me that after viewing the Magritte retrospective (exhibited at the Metropolitan Museum of Art during September 9–November 21, 1992), a number of New York–based artists registered enthusiasm for the Belgian master's impressionist and *vache* output. By the time this book appears, this enthusiasm may have translated itself into concrete examples.

36. Without discussing the implications of the term, Sylvester, *Magritte: The Silence of the World,* p. 268–75, also calls Magritte's behavior of early 1948 "manic." He notes (p. 268) that the artist's literary output during 1946–7 (which included a number of deliberately vulgar and mocking tracts) anticipated the euphoria that would later invade his paintings. Sylvester also discerns the germs of the full-blown caricatural style that Magritte would develop during his *vache* phase in certain of the smaller vignettes he created in 1945 to illustrate an edition of *Les Chants de Maldoror,* published in Brussels in 1946.

37. For more detailed descriptions of typical manic behavior, consult the references listed above in n. 11.

38. Torczyner, *Magritte: Ideas and Images,* p. 193, reproduces a letter of Magritte's from May 12, 1948, in which the artist indicated some awareness of his changed psychological state: "[O]wing to the ambience and its psychological or Freudian influence, I am having quite decent and regular erections here [in St. Mandé, Seine]. It would be interesting to see if this

continues as one gets used to living here?" Perhaps one of the beneficial side effects of Magritte's manic episode was a return to potency. At least, this passage suggests that he had been experiencing difficulties in this re-gard, a symptom quite commonly found among depressed men.

39. The extant visual evidence suggests that, during the prolonged period of internal turmoil following his mother's death, the adolescent Magritte turned to autofellatio as a self-comforting ritual that simultaneously pro-vided him with the illusion that he could sustain or nourish himself. I be-lieve that the memory of this secret adolescent practice continued to haunt the mature artist, who encoded these reminiscences in the playful imagery of his famous series featuring a briar pipe, accompanied by the inscription "Ceci n'est pas un pipe" (This is not a pipe). Magritte ultimately decoded this image himself in this 1948 drawing depicting a man "smoking his own pipe," so to speak. The oil version of *The Cripple,* which portrays an indi-vidual sprouting bizarre growths of pipes from several areas of his head, may refer to this same perversion in a slightly more veiled fashion. For a more extensive review of the biographical data, plus illustrations of the relevant images that led to this conclusion, see Mary M. Gedo, "Adden-dum: It Certainly Was Not a Pipe!" in *In the Mind's Eye: Dada and Sur-realism,* exh. cat., ed. T. A. Neff (New York, 1985), pp. 85–9.

It seems likely that the peculiar habit of sucking raw eggs, which Ma-gritte developed during his stressful odyssey of 1940, represented (wheth-er on a conscious or unconscious level remains an unresolved question) a semiacceptable – albeit rather unappetizing – substitution for these adoles-cent masturbatory practices.

40. Quoted in Sylvester, "Portraits de Magritte," p. 73.

41. Although Magritte did not develop this theme fully until 1948–9, A. M. Hammacher, *René Magritte,* trans. J. Brockway (New York, 1973), pp. 126–7, cites the 1939 gouache *Good Fortune* as a precedent for the *Em-pire of Light* series. He describes this composition as "an unusually fine and early solution to the problem of fusing night and day to form a single landscape.... In an apparently simple evening landscape, Magritte sum-marizes a wealth of experience of light in three categories which are sepa-rate and distinct in time."

42. Sylvester, *Magritte: The Silence of the World,* p. 304, argues that Magritte created the numerous versions of *The Empire of Light* out of economic necessity. No doubt the artist did paint a number of variations of his most successful inventions for financial reasons; however, I believe his motives for repeating himself often transcended such incentives. It seems likely that, given free choice, he elected to recycle motifs, such as *The Lost Jockey* and *Memory* (see n. 21, above), to name but two examples, with which he resonated on a deeply personal level.

As Sylvester himself points out (pp. 238–9), the artist's first experi-ments in the deliberate creation of duplicates proved quite unsuccessful. (See n. 27, above, for details.) As he grew older, the artist doubtless be-came more shrewd about selecting motifs, media, and formats destined for repetitions, and his dealers ultimately did a brisk business in Magrittian variants.

Many critics identify the artist's Paris period of 1927–30, when he was full of new ideas, as his finest hour. If his later oeuvre is not always of

equal interest, it is not because he did not create great pictures to the very end. One can only assume that, for a variety of reasons, including the emotional crises discussed in this essay, the artist's inspiration in later years was more variable, and that his penchant for repeating popular compositions permitted a mechanical quality to infect some of his later replicas. Of course, the same criticism can be directed at variants created by numerous other artists through the centuries.

To put it another way, one might state that Magritte set himself the most difficult of tasks, for his was an art based not only on compositional and painterly skills, but on originality of concepts. Perhaps the miracle is that he managed to come up with so many marvelous – and marvelously disconcerting – inventions during a career that spanned forty-plus years.

43. In at least one painting from this series, *God's Drawing Room*, Magritte reversed his usual light–dark sequence to depict a daylight landscape with a nocturnal sky. However, in a contemporary letter to Gablik, the artist complained vociferously about this composition, which he called "a total failure" (Torczyner, *Magritte: Ideas and Images*, p. 179). Whether Magritte created additional exceptions to his typical rendition showing the earth shrouded in darkness, while daylight prevails in the sky, must await publication of the catalogue raisonné of the late work. With the exception of *God's Drawing Room*, all versions known to me follow his more typical formula.

44. See Hammacher, *René Magritte*, pp. 140–2, who adds: "It is no mere coincidence that during the same period Magritte also encased the living in coffins – that is, removed them from direct sight." Hammacher refers here to Magritte's adaptations of two famous paintings, J. L. David's *Madame Recamier* and E. Manet's *The Balcony*, which transform the protagonists of these celebrated works into anthropomorphic wooden coffins that assume the poses adopted by the original personae, shown in duplicates of their settings. These paintings impress one as mockeries of the resurrection fantasies (specifically, the conviction that his mother would one day rise again from the dead) to which many of the artist's earlier compositions allude. (Chapter 7 cites several examples of this type.)

As Hammacher also points out, Magritte's preoccupation with death and life after death mirrors the similar concerns of his favorite author, Edgar Allan Poe, an artist whose family history was equally tragic.

Index

Note: Artworks and publications are alphabetized separately under the given artist or writer.